DIETZ

LEST *We* FORGET

❊ THE GREAT WAR ❊

World War I Prints
from the Pritzker Military Museum & Library

INTRODUCTION BY **SIR HEW STRACHAN** ❊ HISTORY BY **MICHAEL W. ROBBINS**

2018

Library of Congress Cataloging-in-Publication Data
Title: Lest We Forget: The Great War
By: Pritzker Military Museum & Library and Michael W. Robbins with a foreword by
Colonel (IL) Jennifer N. Pritzker, IL ARNG (Retired), introduction by Sir Hew Strachan,
and afterword by Colonel Robert J. Dalessandro, USA (Retired).
Description: pages: full color prints and black and white photographs with narrative; cm.
Includes appendix, bibliographical references, and index.
Identifiers: ISBN 978-0-9989689-0-2 (Hardcover) ISBN 978-0-9989689-1-9 (e-book)
Subjects: LCSH: 1. World War, 1914-1918 – History. 2. World War, 1914-1918 –
Pictorial works. 3. World War, 1914-1918 – Posters. 4. World War, 1914-1918 – Propaganda.
5. World War, 1914-1918 – Social aspects. 6. Imperialism. 7. World War, 1914-1918 –
Germany. 8. World War, 1914-1918 – France. 9. World War, 1914-1918 – Great Britain.
10. World War, 1914-1918 – Russia. 11. World War, 1914-1918 – United States.
Names: Pritzker Military Museum & Library, author | Robbins, Michael W., author |
Dalessandro, Robert J., contributor | Strachan, Hew, contributor |
Pritzker, Jennifer N., contributor.

Classification: LCC D522.P757 2018 | DCC 940.3022/2

Executive Editors: Colonel (IL) Jennifer N. Pritzker, IL ARNG (Retired), Kenneth Clarke
Designer: Wendy Palitz

Poster permissions: All posters in this book are owned by the Pritzker Military
Museum & Library. Print No. 8, Louis Raemaekers © 2017; Print No. 27, Lucian Bernhard
© 2017 Artists Rights Society (ARS), New York / VG Bild-Kunst, Bonn; Print No. 43, Geo
Dorival & Georges Capon © 2017 Artists Rights Society (ARS), New York / ADAGP, Paris;
Print No. 89, Vojtech Preissig © 2017 Artists Rights Society (ARS), New York / OOA-S,
Prague; Print No. 97, Vojtech Preissig © 2017 Artists Rights Society (ARS), New York /
OOA-S, Prague. Every effort has been made to contact all copyright holders.

To access the Pritzker Military Museum & Library's collection of tens of thousands of
artifacts, posters, prints, and books about WWI, go to www.pritzkermilitary.org/wwi or visit
the Pritzker Military Museum & Library in person at 104 South Michigan Avenue, Chicago,
Illinois. To learn more about the United States World War One Centennial Commission
visit www.worldwar1centennial.org.

The trade edition of *Lest We Forget: The Great War* was preceded by a limited edition
of 100 numbered copies with a unique tip-in page and case.

First Edition

Cover photograph: The American advance on St. Mihiel, September 1918. (U.S. Army/National Archives)

Endpapers: "On the Step: The 131st U.S. Infantry at Chipilly Ridge," James Dietz, America, 2017.
© Pritzker Military Museum & Library

ARE YOU IDLE TO-DAY?

THE BOYS IN THE TRENCHES ARE NOT

U. S. DEPARTMENT OF LABOR

W. B. WILSON,
Secretary of Labor.

ISSUED THROUGH
U. S. EMPLOYMENT SERVICE

For additional copies address Roger W. Babson, Chief, Information and Education Service,
Department of Labor, 1706 G Street N. W., Washington, D. C.

PRINT NO. 1 AMERICA, 1918. "ARE YOU IDLE TODAY?" U.S. DEPARTMENT OF LABOR

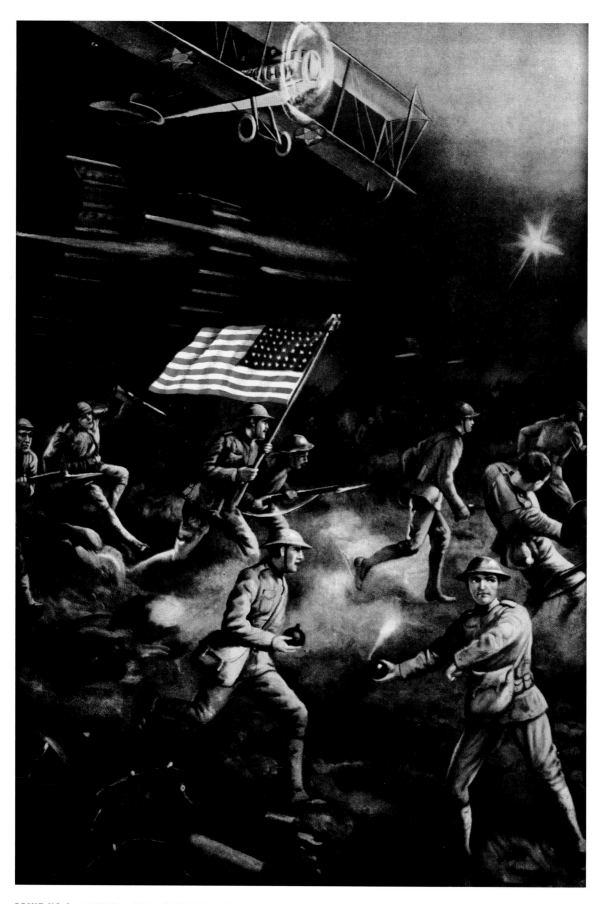

PRINT NO. 2 AMERICA, 1918. "OVER THE TOP: DOUGHBOYS, TANKS AND AIRPLANES."

TABLE OF CONTENTS

FOREWORD

On February 18, 1995, when I was a historian assigned to the State Area Command while serving with the Illinois National Guard, I conducted an oral history with World War I veteran Lawrence Westerman. A son of German immigrants, from a German-speaking home, Westerman enlisted as a private in the Illinois National Guard in June 1916. He was deployed to guard the Mexican border during General John J. Pershing's Mexican Expedition.

During World War I, Westerman's unit, the 1st Infantry Regiment of the Illinois National Guard, known as the Dandy 1st, became the 131st Infantry Regiment, 66th Brigade, 33rd Division. The unit was deployed to France in May 1918. The name change of the Dandy 1st was part of the nation's total war effort in which the federal government extended far more control over the military than in previous conflicts. Then a first lieutenant, Westerman participated in the climactic Hundred Days' Offensive, and used his German language skills to communicate with German POWs while deployed in the trenches. Wounded by artillery shrapnel on August 8, 1918, Westerman spent more than a year recovering and was discharged from the hospital and the United States Army in 1920. After the war, like many of his fellow WWI veterans, Westerman became involved with the American Legion, helping found American Legion Post 310, Chipilly 131st Infantry Post, as a way to commune with his fellow soldiers and to remember those who didn't come home.

The story of citizen-soldier Lieutenant Westerman is a microcosm for America and its involvement in The Great War. He and millions of his fellow soldiers from all walks of life fought in the conflict "over there" that continues to shape our world. Today, Daesh (ISIS) is fighting to reestablish a caliphate in Iraq, Syria, and Turkey—thus seeking to redraw national borders that were created as a result of World War I. Americans are still experiencing the effects of the WWI-era expansion of power of the United States federal government.

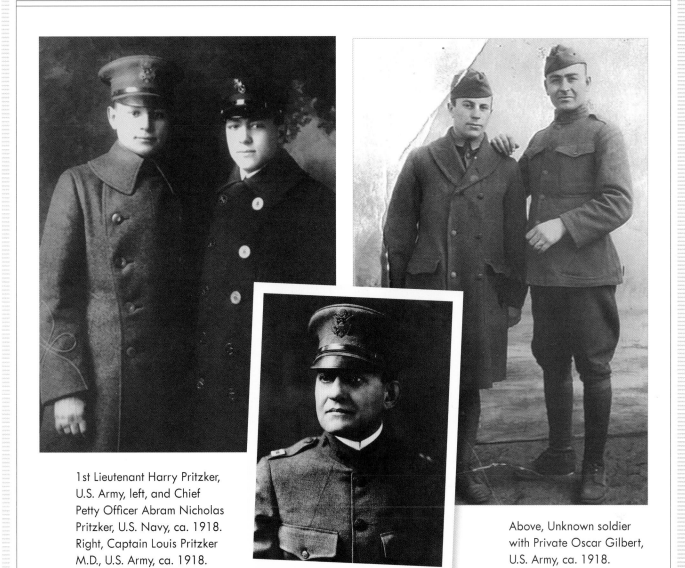

1st Lieutenant Harry Pritzker, U.S. Army, left, and Chief Petty Officer Abram Nicholas Pritzker, U.S. Navy, ca. 1918. Right, Captain Louis Pritzker M.D., U.S. Army, ca. 1918.

Above, Unknown soldier with Private Oscar Gilbert, U.S. Army, ca. 1918.

That war's history must be studied in detail if we are to understand the end of the colonial era and the reasons for the Second World War. The scale of WWI was so large that it is almost inhuman, and thus the only way we will truly understand the impacts it had on humanity is from the artifacts and evidence of the war that have survived to this day, and by knowing the personal stories of soldiers like Westerman.

The Pritzker Military Museum & Library's World War I poster collection, a small part of which is featured in this book, preserves the propaganda and other messages of the belligerent nations. While it is impossible to learn the details of the war through posters alone,

they provide us with insights into why and how the war was fought. The Museum & Library's WWI collection of oral histories, posters, artifacts, letters, and journals, and other similar collections from around the world, matter a great deal to humanity if we are to understand why wars are fought and how to avoid their horrors. Similarly, this book is an important part of the work of the United States World War One Centennial Commission. Doughboys erected thousands of WWI monuments across this great nation so that their war would be remembered, and now 100 years later it is our turn to continue their work—lest we forget.

One such memorial in Illinois was described in an article in the *Chicago Tribune* on August 10, 1964, under the headline, "Chipilly Woods Honors 131st."

"More than 2,000 American Legionnaires and members of their families witnessed the dedication yesterday of the Chipilly 131st Woods in the Skokie division of the county forest preserves at Lee and Grant Roads, Northbrook. The formal naming of the tract for the 131st was in recognition of the 90 years of distinguished military service by the Illinois National Guard unit. On August 9, 1918 it won the battle of Chipilly ridge in France, at a great cost of lives and its victory was a factor in hastening the end of World War I three months later...."

My grandfathers, Abram Nicholas "A.N." Pritzker and Oscar Gilbert, served in World War I, as did my great uncles Harry Pritzker and Wolf Gilbert and my great-great-uncle Dr. Louis Pritzker. My personal reasons for helping observe the centennial of World War I are directly tied to commemorating their service and that of all who serve. It is my hope that readers of this book will be personally inspired to understand World War I for reasons of family history, politics, world history and affairs, and peace, so that they too will become involved in the current commemoration of the Great War, not only during the centennial years of 2017-2019, but far into the future.

—*Colonel (IL) Jennifer N. Pritzker,*
IL ARNG (Retired)

INTRODUCTION

When television and film producers make documentaries about the First World War, they naturally turn to the moving images shot at the time. The war was the first to be adequately recorded by and for the cinema. These are contemporary sources captured by a modern medium. And yet today's producers frequently display their dissatisfaction with the result. Some "colorize" the film, reckoning that today's audiences will have only a limited appetite for images in black and white. The films are silent and so they impose sound, most often music, to stimulate the emotions of their audiences and create a mood, whether or not it is that which the original makers of the film had in mind. To convey their narrative, they also add words, but they too can be divorced from the footage that now serves as an accompaniment. These anachronisms arise, perversely even if directly, from the technological innovation that the camera provided in 1914. While film—whether in moving or in still images—is the first pictorial resource to which publishers and producers will turn when addressing the First World War, its technology is now dated.

In 1914-18 the poster embodied a mature—not an emergent—technology. Today's audiences expect sound and color. Such criticisms do not apply to the poster. They did not need sound then, and they don't now. They were already using color when the war broke out. The enduring influence of the First World War poster provides its own supporting evidence. Many of its motifs would be replayed in the posters of World War II, and its most famous images and ideas find echoes in advertising campaigns to this day. A century ago the poster was at the apogee of its power.

As a result modern illustrators of the war turn to the poster as they do not turn to other forms of graphic art. The drawings and paintings of the war are largely confined to a subset of outputs labeled "the history of art," not "the history of the war." The war is valued for

what it did for Cubism or Expressionism rather than for what it did to the world. General histories of the conflict rarely prefer the fluid drawings of a front-line soldier to the "reality" of the photograph. Posters on the other hand do more than provide stock images. Because they were tools of propaganda, they tell us what the war was about. They reflect back to us why and for what people thought they were fighting. They simplified the message, they conveyed it pictorially, and they provided evidence of national differences and state priorities.

The most important common theme of the Great War poster was the need to pay for the war. The best of those from Germany, France, and Austria-Hungary urged the population to subscribe to war loans. Their language is—more often than not—patriotic. However, they also bear testimony to the terms of the loan, the rate of interest, and the expiry date for the return of the capital. From the outset of the war Germany set out to fund its effort by borrowing from its own citizens, issuing nine war loans between September 1914 and September 1918. France's national defense bonds, as prewar treasury bonds were renamed in September 1914, proved consistently popular with smaller investors. The posters mixed an appeal to individual pockets, by spelling out secure rates of interest, with a reminder of the greater goals for which nations were fighting. Even in 1918 French calls for subscriptions were repeating the refrain of 1914: The aim was victory and freedom.

Britain was an outlier. Alone of the major belligerents at the war's outbreak it had an effective taxation system. It therefore only issued three war loans, and they were targeted at financial institutions and large private investors. It did not need loans to mop up the unspent money in workers' pockets when income tax could do the job more effectively. So Britain issued posters to raise not money but men. Continental European armies conscripted their soldiers; Britain did not. When Secretary of State for War Lord Kitchener decided in August 1914 that he needed a mass army to fight a major continental war he could only get the men through voluntary enlistment. The most famous British posters of 1914-15 were issued by the Parliamentary Recruiting Committee.

JOURNÉE DE L'ARMÉE D'AFRIQUE
ET DES TROUPES COLONIALES

DEVAMBEZ, PARIS

PRINT NO. 3 FRANCE, 1917. "ARMY OF AFRICA AND COLONIAL TROOPS DAY." LUCIEN JONAS

Posters also serve as evidence of war's democratizing effects. The autocracies did not use images of their own monarchs to embody their ideas of empire: When Kaiser Wilhelm appeared in a poster (and his helmet and upturned mustache were well-suited to the medium), he did so on those of Germany's enemies and in order to embody the militarism they were bent on extirpating. The personifications of the state portrayed on billboards for domestic purposes were either mythical, like Marianne, Britannia, Germania, St. George, John Bull, or Uncle Sam, or long dead. The shadows of the great commanders of "the last great war," Napoleon, Wellington, Blücher, and Suvorov, hovered over the shoulders of the generals in 1914-18. The fighting of the war's opening months created new national heroes: Hindenburg and Ludendorff for Germany, Joffre and Joseph-Simon Gallieni for France, and possibly Kitchener for Britain. But this was not a roll call to which others were added, with the possible exception of Foch, the victorious Allied generalissimo. Instead the hero was the common man or woman, and above all the common infantryman, dogged and uncomplaining, but essentially nameless.

Many of the posters in this beautiful book are from the United States and a significant number are Canadian. These too show national priorities. North America, one of the world's great granaries, was not in danger of starvation, but many parts of Europe were, particularly by 1917-18. Food was a constant refrain: The poster made food a weapon that would win the war, and so metaphorically conscripted the farmer for the nation's effort. It was also a vehicle to legitimate America's role in the war. Much of Europe and of areas adjacent to it was starving. Herbert Hoover's contribution to famine relief foreshadowed the humanitarian objectives which would also justify America's use of military force in subsequent conflicts. As Woodrow Wilson put it to the Senate on January 22, 1917, in anticipation of U.S. entry to the war, his aim was "a peace that will win the approval of mankind, not merely a peace that will serve the several interests and immediate aims of the nations engaged."

—*Sir Hew Strachan*

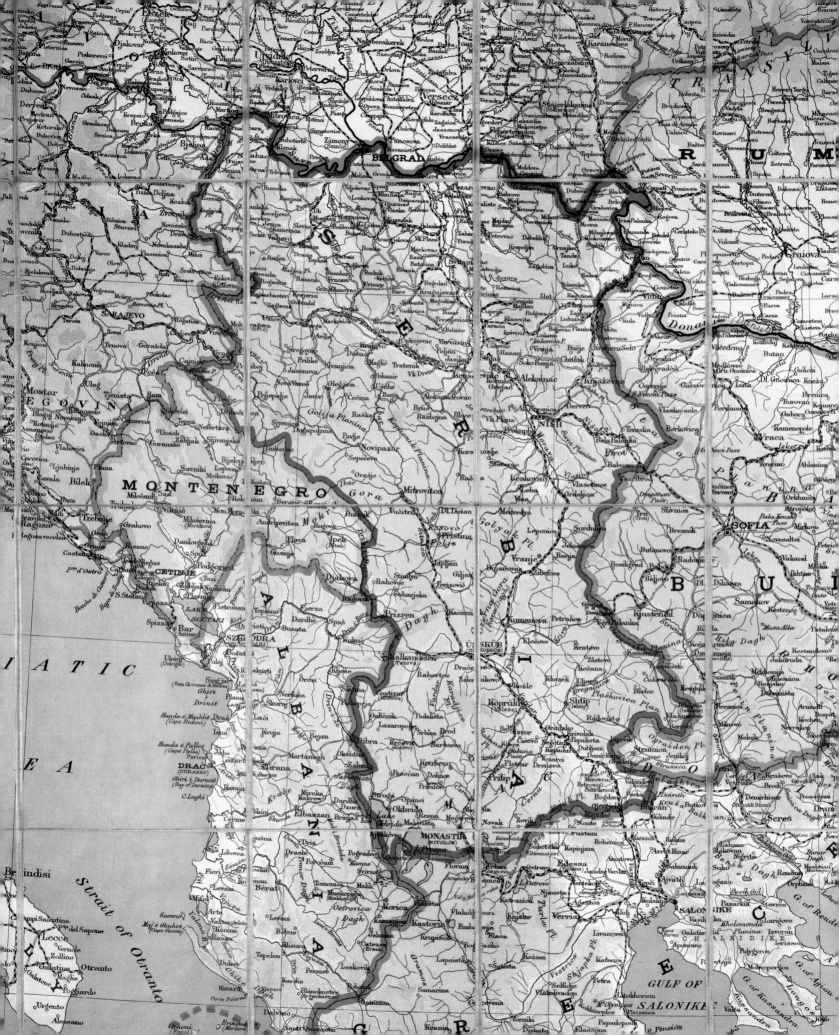

Choosing WAR

When war broke out in Europe in the summer of 1914 in a flurry of declarations, it brought an end to a long-standing way of life and a long-standing way of war. At the outset, Europe was dominated by empires and some newly unified nation-states, and was largely ruled by crowned heads. At the war's end four years later, the empires were weakened or destroyed, and the crowns had fallen away. And wars were no longer "Napoleonic" matters of horses and swords and aristocratic officers, or limited set-piece battles marked by élan and glory. Instead, combat became industrial-scale slaughter involving such technological innovations as mass production, rapid-force automatic weapons, chemical weapons, high explosives, internal-combustion engines, submarines and torpedoes, aircraft, and electronic communications—and it engulfed entire civilian populations.

In the troubled Balkan states, Sarajevo (upper left) was site of the assassination that ignited the war.

Over the span of four years, the war evolved in stages, starting with swift attacks across national frontiers, which sprang from a widespread belief that to be successful, the war must be short and immediately devastating—a matter of weeks or months, not years. Few believed that a long war would be advantageous. That was especially true of Germany, the nation that started the shooting.

But once the initial fast-moving attacks slowed, and the national mobilizations brought vast armies to the field, the sides became more closely matched and the chances for a decisive breakthrough waned. The maneuver warfare of the first months gave way to the stalemate of parallel defensive trench systems, which on the Western Front eventually stretched from Switzerland to the North Sea. Other fronts, in the East, in Italy, and in Turkey, were initially less static, but scarcely less futile or indecisive, as the various armies proved unable to solve the challenges of machine guns and barbed wire, of high-powered massed artillery, of deep entrenchments and enormous numbers of effectives. The middle period of the war became a matter of attrition, of "bleeding the enemy" to death. Then, toward the end, after Russia had collapsed out of the war politically and militarily in 1917, Germany was able to concentrate its resources and manpower on breaking through the Western Front. But the Allies withstood the hammer blows of the Ludendorff offensives until Germany no longer had the resources to overcome its losses—just at the hour when America's entry into the war brought over a million fresh soldiers to the Western Front. The war ground to a halt with an armistice in November 1918.

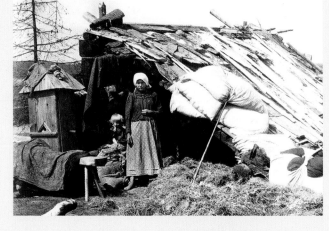

A Russian Polish woman and child in a makeshift shelter, 1914. Civilians were often caught between warring armies.

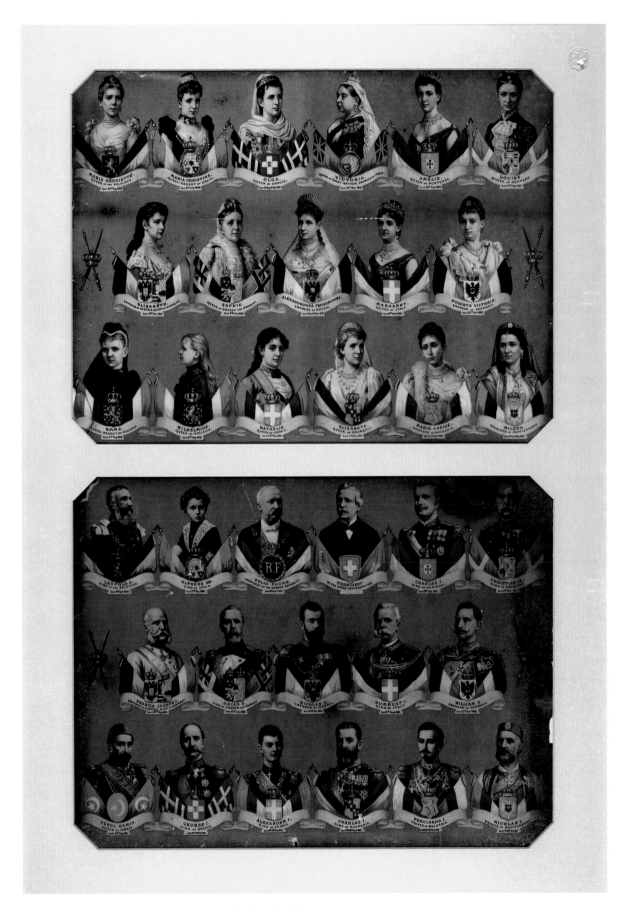

PRINT NO. 4 CA. 1895. "EUROPEAN ROYALTY CA. 1895."

THE TRIGGER EVENT

The war that broke out in the summer of 1914 also brought an abrupt end to a century of occasional short, sharp conflicts among kingdoms and other nations jockeying for power, independence, and new possessions, mostly in the Mediterranean and the Balkans. Since 1815 and the finale of the Napoleonic age, there were years of comparative peace in Europe but some costly conflicts as well: fighting between Greeks and Turks in the early 1820s; a revolt in Paris in 1848; the Crimean War of 1853-56; fighting over the unification of Italy in the 1860s; the brief, bitter Franco-Prussian War in 1870; and the Balkan Wars of 1912-13, which, it turned out, were something of a prelude to the Great War that began in 1914.

The assassination of Archduke Franz Ferdinand, heir to the Austrian throne, and his wife in Sarajevo, capital of Bosnia-Herzegovina, on June 28, by Bosnian Serb nationalist and "Black Hand" terrorist Gavrilo Princip, touched off a chain reaction of diplomatic protests, riots, ultimatums, diplomatic miscalculations, and declarations of war.

The many European alliances that had been formed in the troubled prior decades did not cause the war, but did ensure a continent-wide war: Germany, unified in 1871, was allied with Austria-Hungary (also known as the "Dual Monarchy") and with newly unified Italy in the Triple Alliance. Countering that alliance were France and Russia in what was called the Entente—which was informally joined and supported by the United Kingdom. Complicating those alliances was the fact that Russia considered itself the protector of all Slavic peoples, including many in the turbulent Balkans, notably Serbia.

Archduke Franz Ferdinand, unpopular heir to the Austro-Hungarian throne, 1914.

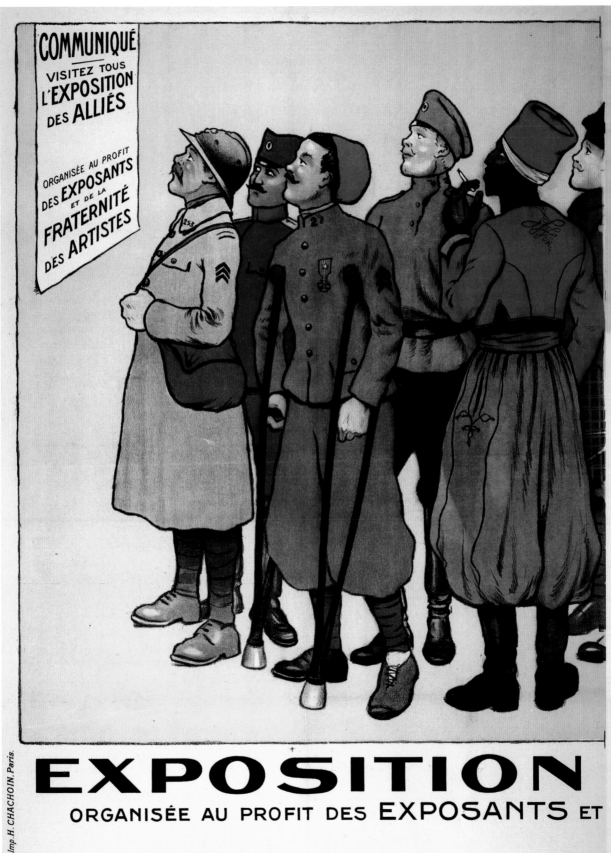

PRINT NO.5 FRANCE, 1918. "THE EXHIBITION OF THE ALLIES." ROBERT DE CONINCK

In the years leading up to the war, nationalism was in the air over Europe, and militarism was its leading form of expression. Many of the nations were harboring grievances at neighboring states over what they saw as injustices, slights, or wrongs to be righted. Many were also apprehensive about the growing economic and military might of the German nation. Some of the signatories of the various treaties also viewed war as an extension of regular diplomacy and hence had built up significant military power, both defensive and offensive. So, in fear and dread of what their opposite numbers were doing or might be planning, most of the European countries embarked on military build-ups. They fell into an arms race. Tragically, the arms they embraced were unlike any that the world had fought with in the past. Advances in technology had brought more accurate long-range rifles, reliable rapid-fire machine guns, heavier and more accurate artillery, motor vehicles, aircraft, more powerful explosives—and effective submarines.

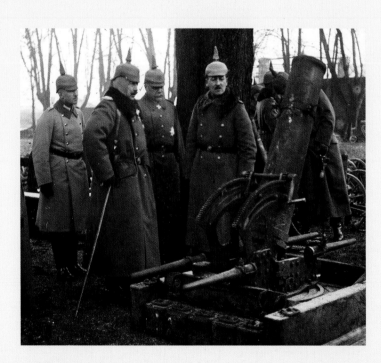

Kaiser Wilhelm II and staff inspect British mortar captured at the Battle of Cambrai, November 27, 1917, in this image by German combat photographer Walter A. Heinsen.

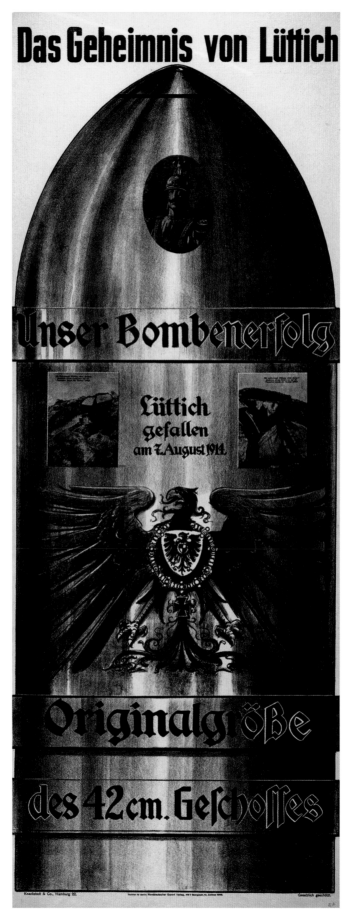

PRINT NO. 6 GERMAN, 1914. "THE SECRET OF LÜTTICH: OUR BOMBING SUCCESS." KNACKSTEDT & CO.

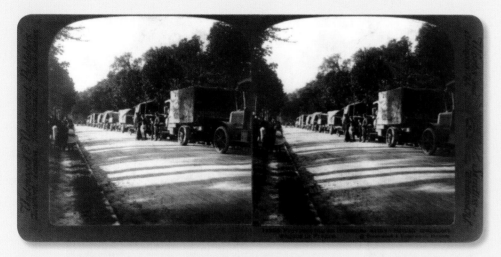

Motorized British transport wagons haul supplies for frontline troops in France, 1915.

Germany was at the center of one major alliance at the time when its rapid win in the Franco-Prussian War had strengthened the dominance of the military in its political and social life. The Kaiser, Wilhelm II, was at the outbreak of war the emperor who ruled the country. He, and the country itself, were overwhelmingly militaristic and ambitious. They sought greater power, and respect, from their European neighbors and believed that a short, sharp war, like the one that had so stunned France in 1870, was their path to greatness. They *desired* war. Accordingly, they planned for it meticulously. Their Schlieffen Plan called for a rapid attack through neutral Belgium to outflank the French army and sweep toward Paris and a quick victory.

GRIEVANCES AND TREATIES

France had been smarting at the loss of its provinces, Alsace and Lorraine, to Germany in 1871 and was anxious to regain them. Its Plan 17, in April 1914, called for a straight-ahead attack on the German frontier aimed at Lorraine. In the event, France's Lorraine Offensive launched on August 4 was meant to regain those lost provinces.

PRINT NO.7 RUSSIA, 1915-1916. "WAR LOAN 5½%."

Russia, having been humbled and defeated in the Far East war with Japan in 1904-05, learned some valuable lessons and embarked on a crash program to build up its industries and restore its shattered army and navy—all with the help of its new ally, France.

Britain, with the world's largest empire and the world's most powerful navy, had the smallest army among the European powers and, with its determination to steer clear of military entanglements on European soil, saw little reason to join the continental build-ups. But Germany's decision to acquire a powerful navy to match its already powerful army, provoked Britain into a maritime arms race, matching dreadnought with dreadnought, as the top class of battleships was called. Britain, an island nation, simply could not risk losing its global maritime dominance. More immediately, it could not afford to lose control of the English Channel.

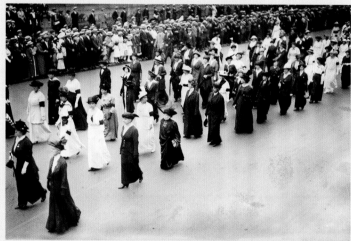

American women march down Fifth Avenue in New York in a silent parade for peace, August 29, 1914.

Within the two other European empires, the Austro-Hungarian Dual Monarchy and the ancient, stretched out Ottoman Empire, many "submerged" nationalist and ethnic entities were in potential and actual revolt, seeking independence and preparing to fight for it.

In the summer of 1914, Europe was thus a political and military powder keg. And the young Black Hand terrorist, Princip, lit the fuse.

Reacting to Archduke Franz Ferdinand's murder, anti-Serb riots broke out the next day. Diplomats of the treaty-bound nations began to discuss the implications. If Austria mobilizes to attack Serbia, will Germany support that move? And what if Russia honors its commitment to defend Serbia?

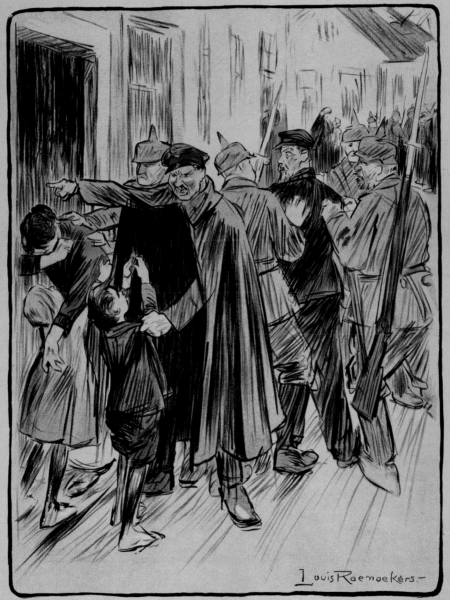

Esposizione Raemaekers
100 Disegni di un neutro

Le deportazioni nel Belgio
"Tuo padre! lo portiamo con noi a fare delle munizioni."

Stab. Caimo e C. - Genova

PRINT NO. 8 ITALY, 1914-1918. "WE ARE TAKING YOUR FATHER TO MAKE MORE MUNITIONS." LOUIS RAEMAEKERS

Assured of Germany's backing, Austrian diplomats sent Serbia an ulti-
matum that contained affronts to Serbian sovereignty, one they believed
would not be accepted.

What followed was weeks of Europe's national leaders and diplomats
cautiously weighing alternative courses of action, and making a series of
fateful decisions. Their alliances and varied levels of preparation for war
made those decisions agonizingly difficult, but the courses decided upon
appear, in rueful hindsight, like a diplomatic train wreck in slow motion.
One by one, they opted for war:

On July 28, Austria declared war on Serbia.

On July 30, Russia mobilized in support of Serbia.

On August 1, Germany declared war on Russia.

On August 3, after sending an ultimatum to Belgium, Germany
invaded Belgium, Luxembourg, and France.

On August 4, Britain declared war on Germany.

On August 11, France invaded German-held Alsace and Lorraine.

On August 16, Germany captured the Belgian stronghold at Liège,
and the British Expeditionary Force landed in France.

The Great War had begun.

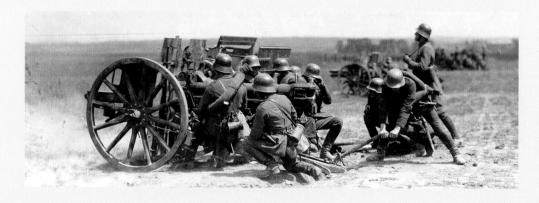

German artillery
on the Western Front,
which stretched for
400 miles through
France and Belgium.

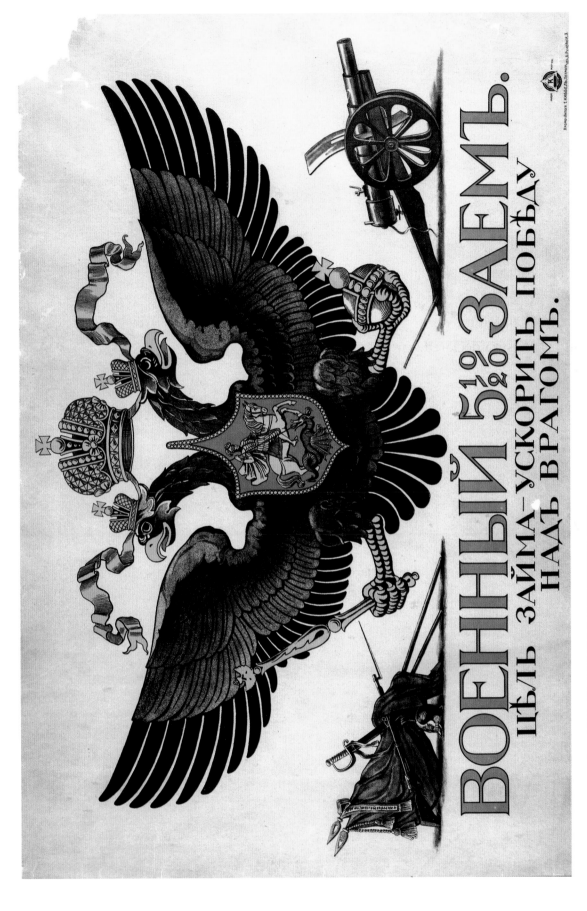

PRINT NO. 9 RUSSIA, 1915–1916. "WAR BONDS FOR VICTORY." T. KIBBEL

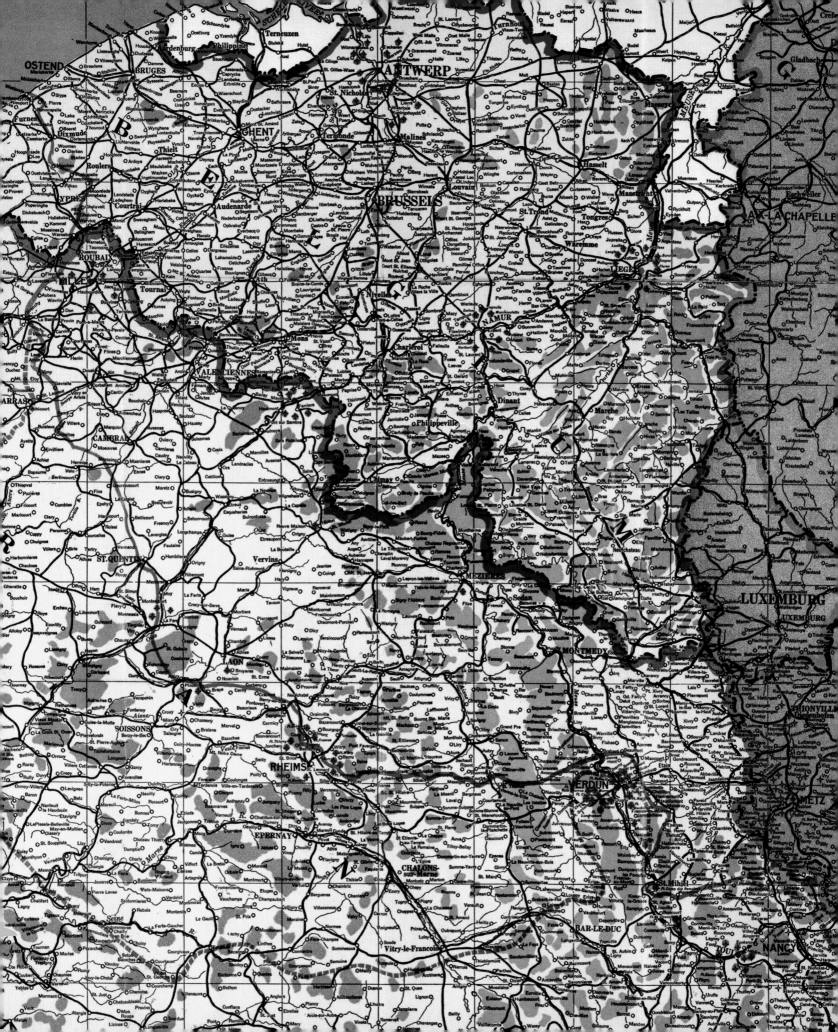

1914

When all the diplomatic dominoes had fallen and a multi-nation war in Europe became a fact, one surprisingly common early reaction was enthusiam. The popular excitement was born of a nationalist fervor that in much of Europe had been building for decades, sparked by pride in the newly united countries, like Germany and Italy, and by revolutionary zeal in ethnic regions of the shaky Ottoman Empire and the fractious Austro-Hungarian Dual Monarchy. National identity, national pride, and national honor were front of mind everywhere. In many countries, the abrupt declarations of war were greeted with popular demonstrations, with flags and patriotic music, and with rallies and speeches. The challenges of conducting a war were seen as a test of national strength and even manhood, in a misplaced application of the social Darwinism that was a strong intellectual current at the time.

Belgium and Luxembourg were invaded by a million-strong German army on August 3, 1914.

Adding to the widespread sense that a war was a kind of contest, nearly a sporting event, most believed it would be a very short "game" with a clear-cut winner, and over in a matter of weeks. Militarism, expressed in the many build-ups of national armies and navies, exerted a gravitational pull toward open warfare. Along with the excitement and enthusiasm, other darker emotions greeted the drum roll of news about mobilizations and ultimatums, declarations of war and troop movements: Anxiety, fear, dread, and foreboding filled many hearts. No one could, of course, have predicted the overwhelming bloody tragedy that lay in the future, though some of the people caught up in the rush to war did grasp what was about to befall Western civilization. On the evening of August 3, 1914, after Britain's Parliament agreed to support its ally Belgium, and Germany declared war on France, British Foreign Secretary Edward Grey famously observed: "The lamps are going out all over Europe; we shall not see them lit again in our lifetime."

Foreign Secretary Sir Edward Grey aligned Britain with France and Russia against Germany.

The realities soon overmatched the enthusiasms and patriots' rhetoric. Armies rode and marched in large numbers toward—and through—national borders. Following war plans worked out in advance, the vast armies heaved into motion. On August 3, Germans troops penetrated Russia's Polish territory, while the main German thrust, employing over a million soldiers in seven armies, advanced on Luxembourg and Belgium (in accord with Germany's Schlieffen Plan to outflank France's border defenses). The next morning, the

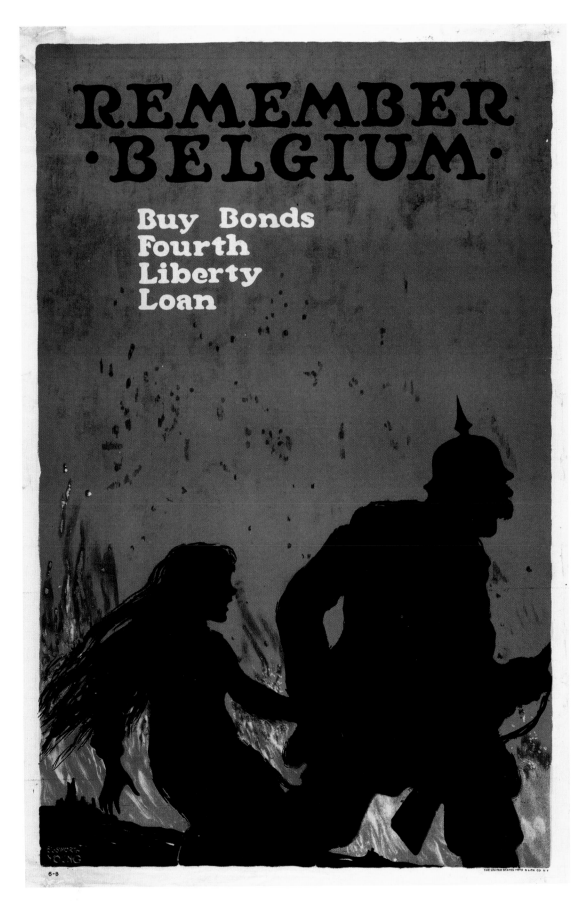

PRINT NO. 10 AMERICA, 1918. "REMEMBER BELGIUM." ELLSWORTH YOUNG

Germans swept into Belgium on a15-mile-wide front, in a flagrant violation of that nation's neutrality. Germany had calculated that France could thus be overwhelmed and defeated in a matter of weeks.

A STUNNING SURPRISE

But events immediately turned unpredictable and began spinning out of control. Britain, France, Russia, and Belgium, along with other European nations, were stunned by the scale, speed, and ferocity of the German offensive.

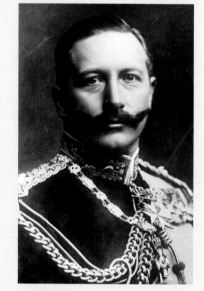

Germany's bellicose emperor, Wilhelm II, backed Austria-Hungary's declaration of war against Serbia.

Belgium, like France, had hardened defenses that were widely thought to be unbreakable. Prominent among them were the dozen forts at Liège. Miscalculations abounded in the early days of the war. The initial German assault was met with and stalled by the unexpectedly vigorous and deadly resistance by the outnumbered and outgunned Belgians. Then the Germans settled in with a surprise of their own, enormous and powerful siege guns provided by fabled Austrian arms maker Skoda, that proceeded to pound and pulverize the Liège forts one by one until the last, Fort Loncin, was completely wrecked.

With so many European nations holding colonial territories and adhering to their many treaty obligations, the fighting spread far and wide and began to seem like a world war. In the first weeks of hostilities, fighting occurred not only in Belgium, France, Poland, Serbia, and East Prussia, but also in the South Pacific, the South Atlantic, the Mediterranean, the North

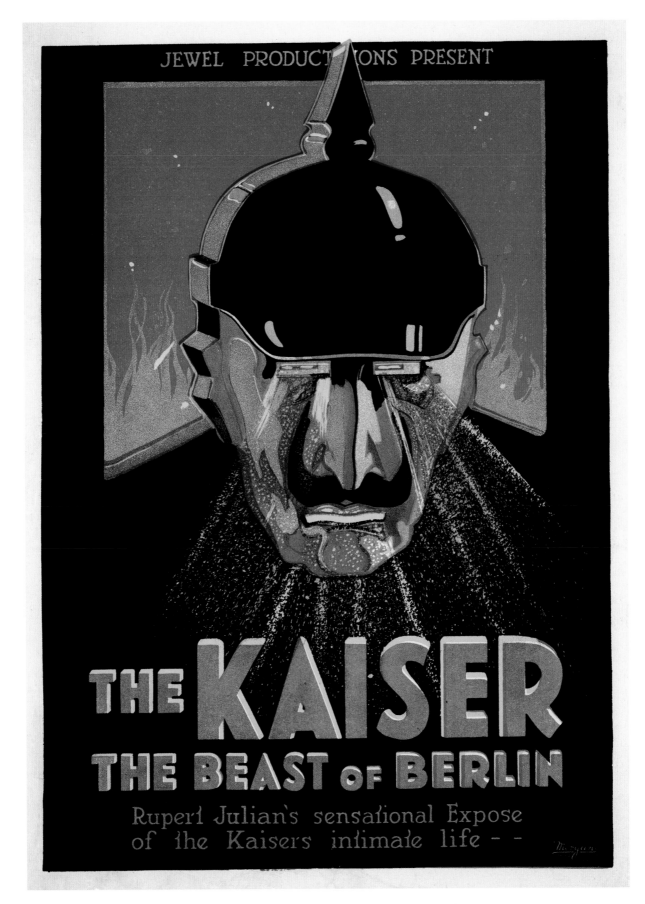

PRINT NO. 11 AMERICA, 1918. "THE KAISER: THE BEAST OF BERLIN." MORGAN LITHO.

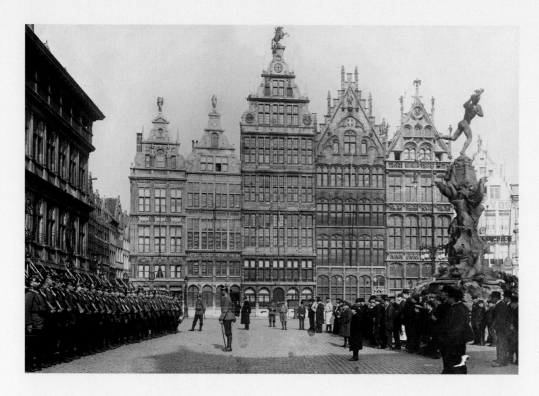

Antwerp, Belgium, one of Europe's largest seaports, fell to the Germans in October 1914.

Sea, Togoland, Cameroons, German East Africa, Nigeria, and British East Africa. Also far from the clash of arms in Europe, government leaders and diplomats in Washington, D.C., Tokyo, and China viewed the outbreak of war with alarm, affirmed their neutral status, offered to mediate, and declared their distant support for one side or the other. They began to find ways to further their national interests—in the case of Japan and China— by taking up arms against their neighbors.

In an early action that signaled that this war would be like none other, Germany sent a bomb-laden Zeppelin to fly over Liège and drop explosives on its civilians. The number killed was small, but the implications of the aerial attack were ominous and far-reaching.

German leaders, acting on their belief that only a brief and overwhelming offense could bring them victory, quickly showed that with their

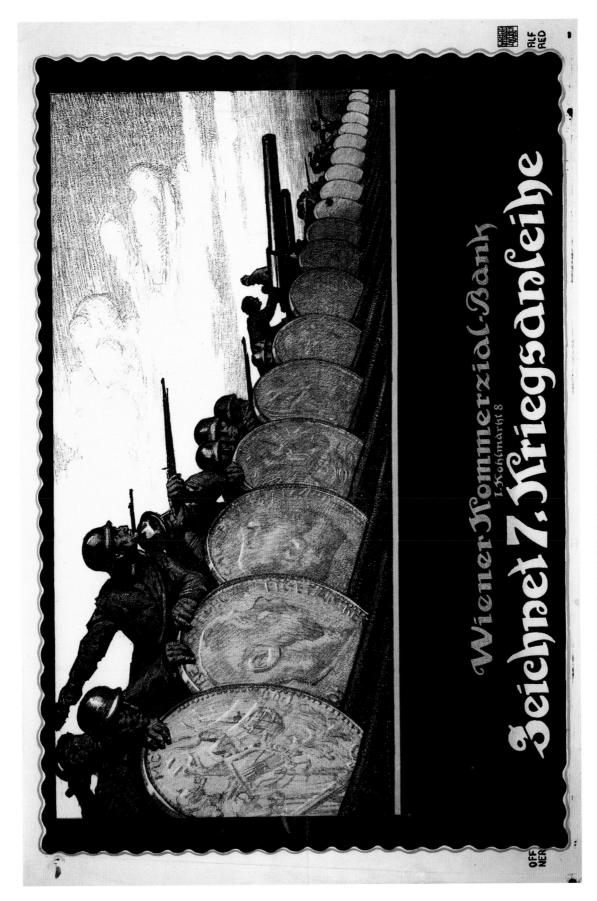

PRINT NO.12 AUSTRIA, 1917. "SUBSCRIBE TO THE 7TH WAR LOAN." ALFRED OFFNER

powerful military machine they meant to break rules, customs, cities, and peoples, starting with Belgium. What they showed the nations in their path—and the world—was atavistic brutality. Imagining "fifth columnists," guerrilla snipers, and what were termed *francs-tireurs* everywhere among the terrified Belgian populace, German soldiers "retaliated" by shooting thousands of civilians and, in one especially outrageous episode, sacking the ancient university town of Louvain and burning its historic library. It was a gratuitous act that handed the Allies a long-lasting propaganda advantage. Overnight, the perception of Germany as a civilized country was transformed into the view that it was instead a land of barbaric "huns" capable of any atrocity.

In the event, despite the speed of the initial German attack, the Schlieffen Plan was quickly unhinged by the unexpected Belgian resistance and the prompt mobilizations of France, Russia, and Britain. Elements of the British Expeditionary Force (BEF) began landing at Le Havre on August 9 and

British artillery comes up to the front in 1916. An estimated 8 million horses and mules were killed during the war.

FORWARD!

Forward to Victory
ENLIST NOW

PRINT NO. 13 ENGLAND, 1915. "FORWARD!" LUCY KEMP-WELCH

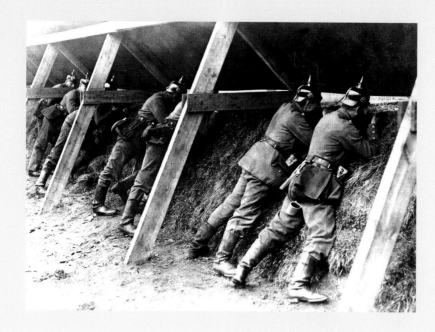

German soldiers take aim from the fire step of a well-constructed trench on the Belgian front lines.

France activated its own Plan 17 with a thrust at the German left flank on August 13. Moreover, the very size and swiftness of the German offensive overtaxed its logistical capabilities, and its vast armies in the field soon outran their supplies of food and ammunition and their effective lines of communication.

With the German offensive slowing and the Allied build-up growing, the two forces collided in the first week of September at the Marne River east of Paris; the Allies counterattacked in the war's first great battle on the Western Front.

The Germans' Schlieffen Plan had projected a vast pincer closing on Paris, but in the execution, their left side called for reinforcement to counter the French strength east of Paris, leaving the right pincer weaker and vulnerable to being flanked by the French Sixth Army and the BEF. On the French side, commander in chief General Joseph Joffre realized that neither

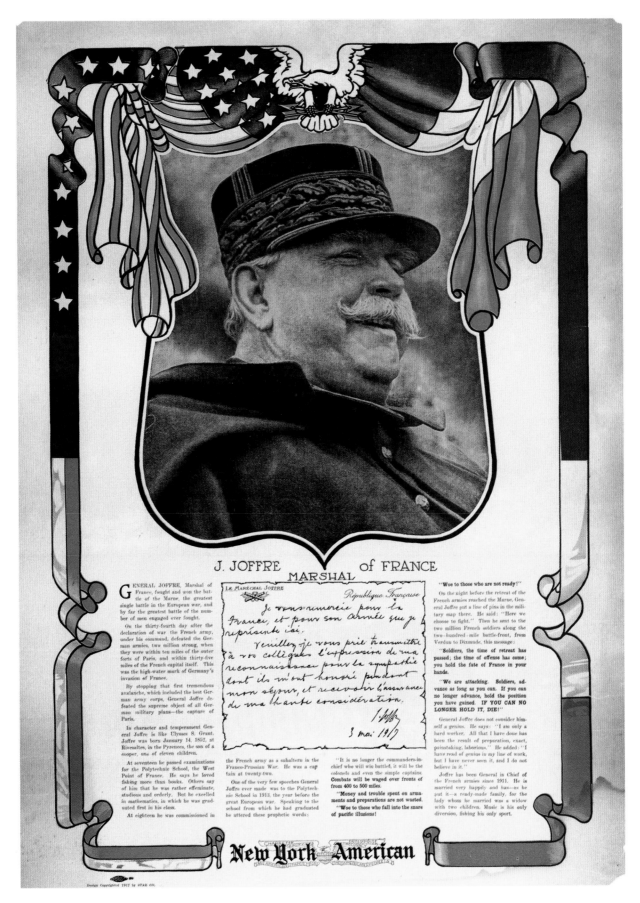

J. JOFFRE of FRANCE
MARSHAL

GENERAL JOFFRE, Marshal of France, fought and won the battle of the Marne, the greatest single battle in the European war, and by far the greatest battle of the number of men engaged ever fought.

On the thirty-fourth day after the declaration of war the French army, under his command, defeated the German armies, two million strong, when they were within ten miles of the outer forts of Paris, and within thirty-five miles of the French capital itself. This was the high-water mark of Germany's invasion of France.

By stopping that first tremendous avalanche, which included the best German army corps, General Joffre defeated the supreme object of all German military plans—the capture of Paris.

In character and temperament General Joffre is like Ulysses S. Grant. Joffre was born January 14, 1852, at Rivesaltes, in the Pyrenees, the son of a cooper, one of eleven children.

At seventeen he passed examinations for the Polytechnic School, the West Point of France. He says he loved fishing more than books. Others say of him that he was rather effeminate, studious and orderly. But he excelled in mathematics, in which he was graduated first in his class.

At eighteen he was commissioned in the French army as a subaltern in the Franco-Prussian War. He was a captain at twenty-two.

One of the very few speeches General Joffre ever made was to the Polytechnic School in 1913, the year before the great European war. Speaking to the school from which he had graduated he uttered these prophetic words:

"It is no longer the commanders-in-chief who will win battles, it will be the colonels and even the simple captains. Combats will be waged over fronts of from 400 to 500 miles.

"Money and trouble spent on armaments and preparations are not wasted.

"Woe to those who fall into the snare of pacific illusions!

"Woe to those who are not ready!"

On the night before the retreat of the French armies reached the Marne, General Joffre put a line of pins in the military map there. He said: "Here we choose to fight." Then he sent to the two million French soldiers along the two-hundred-mile battle-front, from Verdun to Dixmude, this message:

"Soldiers, the time of retreat has passed; the time of offense has come; you hold the fate of France in your hands.

"We are attacking. Soldiers, advance as long as you can. If you can no longer advance, hold the position you have gained. IF YOU CAN NO LONGER HOLD IT, DIE!"

General Joffre does not consider himself a genius. He says: "I am only a hard worker. All that I have done has been the result of preparation, exact, painstaking, laborious." He added: "I have read of genius in my line of work, but I have never seen it, and I do not believe in it."

Joffre has been General in Chief of the French armies since 1911. He is married very happily and has—as he put it—a ready-made family, for the lady whom he married was a widow with two children. Music is his only diversion, fishing his only sport.

New York American

Design Copyrighted 1917 by STAR CO.

General Michel Manoury nor the BEF was moving in the right direction to roll up General Alexander von Kluck's First Army and stop the German advance, and rushed to correct their movements. Both sides were struggling mightily with command-and-control issues in handling such enormous, spread-out forces—four to six entire armies clashing over some 60 miles of front lines. Gaps opened in their long front lines, as both sides sought to maintain contacts with adjacent units. After several days of bitter back and forth fighting, it became obvious that the French Sixth Army was over-extended and vulnerable to German counterattack. Reinforcements were desperately needed and in one of the burgeoning war's most unusual events, the commander of the Paris garrison, lacking more conventional means of moving troops, ordered the confiscation of the city's taxis. Overnight, a motley caravan of taxis, buses, and other civilian vehicles crawled to the front, bearing some 4,000 soldiers.

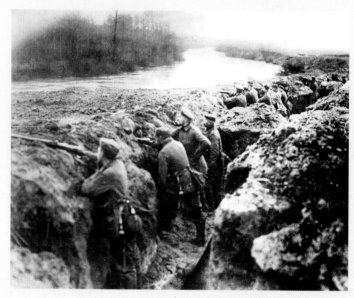

German troops entrenched along the Aisne River in France, 1914.

After a week of fighting, the ever-cautious and increasingly unstable German commander Helmuth von Moltke, who directed the offensive from his headquarters in Luxembourg over 100 miles from the front lines, decided that retreat was his only viable option—thus abandoning the Schlieffen Plan. During the first week in September, the French began a counterattack on their right, but the Germans, worn down by lack of reinforcements, adequate food, and water, were in no condition to halt the French. They withdrew eastward to a new defensive line at the Aisne River, and a shaken von Moltke was replaced by Minister of War Erich von Falkenhayn.

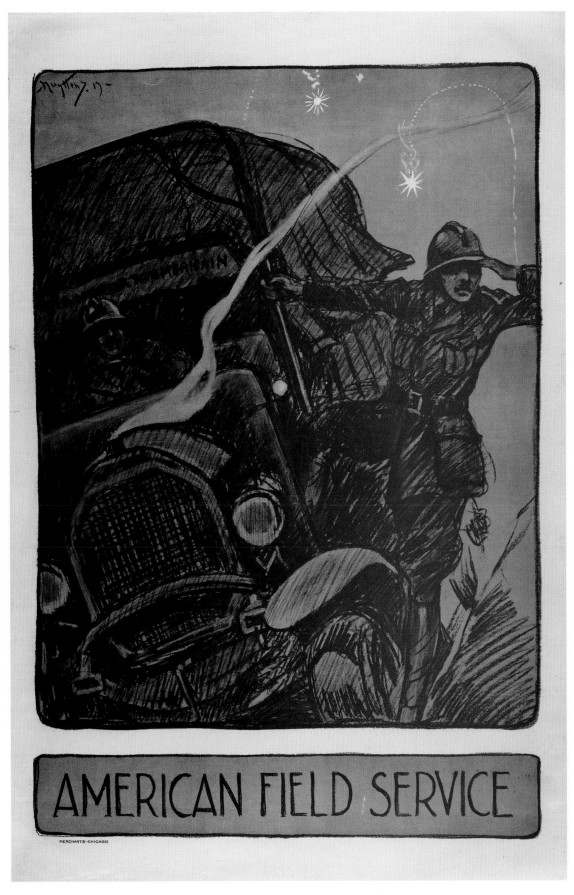

PRINT NO. 15 AMERICA, 1917. "AMERICAN FIELD SERVICE." JOSEF PIERRE NUYTTENS

While most accounts of the Great War emphasize the events on what quickly became known as the "Western Front" in Belgium and France, mobilization and deployment of military forces in eastern Europe quickly unfolded on a large scale. Russia, with the greatest population (over 160 million) and the largest army (well over a million) of all the combatant countries, began within days of the war declarations to field some 800,000 troops in anticipation of a fight with Germany. But the Germans initially planned only a holding action against Russia while it hopefully defeated France.

The Russian military, though, preferred offense to defense and elected in mid-August to strike Germany first, hastily sending two entire armies to attack East Prussia—their First Army under General Pavel von Rennenkampf and their Second Army under General Aleksandr Samsonov. The German Eighth Army defending East Prussia was outnumbered about 3-to-1 by the Russians, but they held nearly every other possible advantage: superior training, weapons, intelligence, communications, rail-borne mobility, aerial reconnaissance, and above all, leadership. The Russians divided their forces and sought to encircle and trap the Eighth Army, but the two Russian armies were unable to communicate or coordinate their actions. Their soldiers, mostly illiterate and barely trained, fought hard, but their commanders were essentially clueless.

The outcome, named the Battle of Tannenberg after a local village, was a near-catastrophic fiasco for the Russians who were out-generaled (by Paul von Hindenburg and Erich Ludendorff) and out-maneuvered. Toward the end of August, it was the Russian Second Army that got encircled and destroyed, suffering over 150,000 casualties; during their panicky retreat, commander Samsonov committed suicide. Hindenburg and Ludendorff were hailed in Germany as heroes and military geniuses, and went on to lead the German effort for the rest of the war.

General Pavel von Rennenkampf was relieved of command in November 1914 for failures on the battlefield.

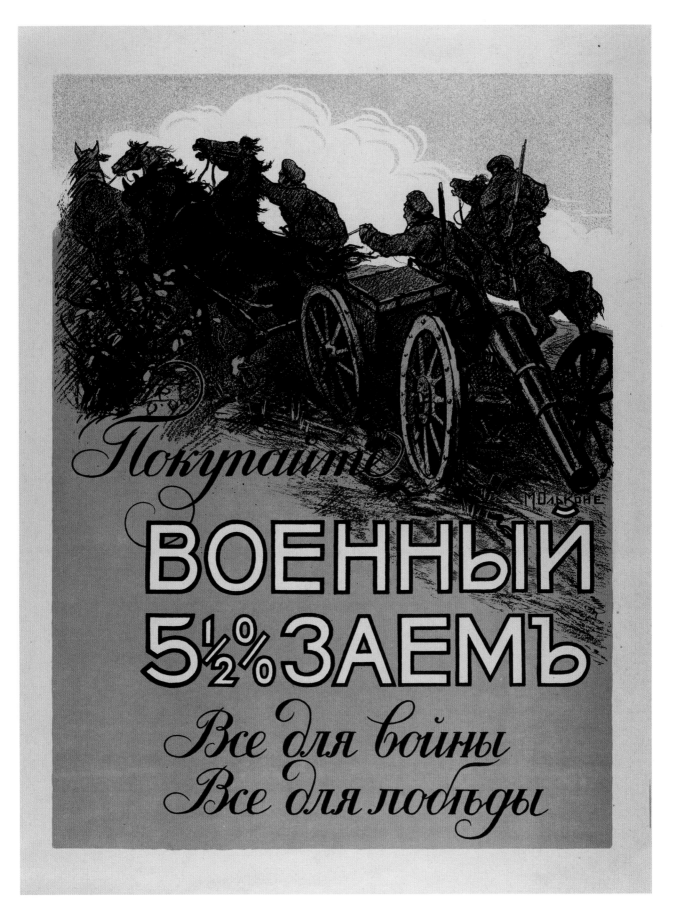

PRINT NO.16 RUSSIA, 1915-1916. "EVERYTHING FOR THE WAR, EVERYTHING FOR VICTORY." M. OLKONE

TRENCH WARFARE

After the brief initial campaigning, characterized by maneuver warfare, the Great War settled into what would soon emerge as a frustrating stalemate, especially on the Western Front, but also on the Eastern and Southern Fronts.

The Germans and the Allied armies of France, Britain, and eventually the United States, conducted their costly campaigns from parallel systems of trenches that stretched from Switzerland to the North Sea. Evenly matched in numbers and weaponry, neither side could achieve more than local and short-lived breakthroughs in a war of unprecedented attrition where "progress" was measured in meters and casualties in tens of thousands.

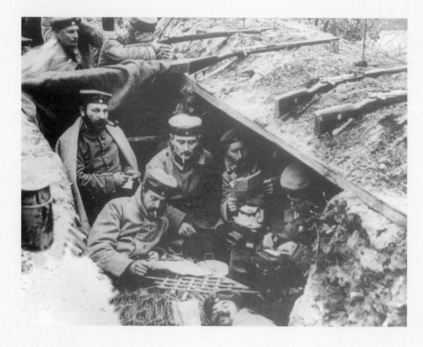

German soldiers enjoy a moment of peace in their trenches, 1916.

L'Impérial Cambrioleur

ÉPISODES DE LA GUERRE 1914
Les Estampes populaires G. W. D. - n° 3.

Le Kronprinz profite de son séjour au Château de Baye pour le dévaliser. Il choisit les objets les plus précieux, les fait emballer en sa présence et expédier en Allemagne.

PRINT NO.17 FRANCE, 1914. "THE IMPERIAL THIEF." EUGENE COURBOIN

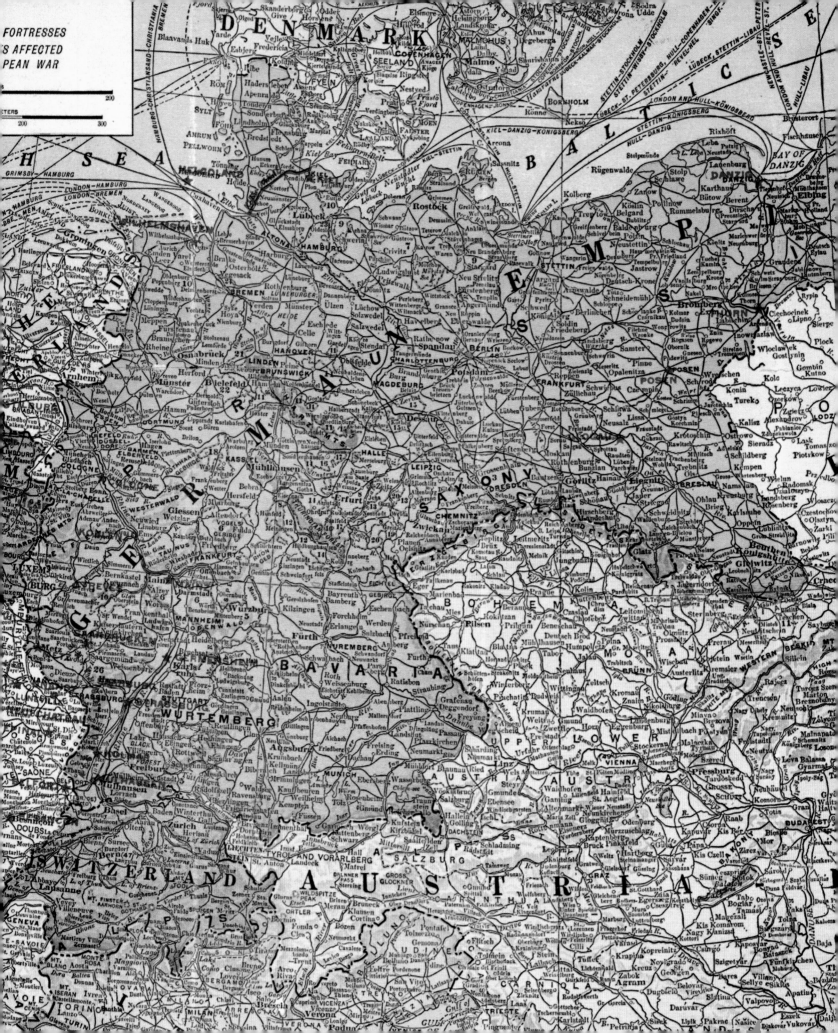

PROPAGANDA

N o one who has viewed World War I posters can doubt that propaganda is an art. Stating a strong case for the rightness of one's cause, in words and pictures, is not a new development, but during the years 1914 to 1918, the ingenuity, impact, and effectiveness of the graphic posters reached new heights of sophistication and power. Even now, a century later, many of the strongest images and words remain memorable and famous, their messages stated with undiminished clarity. ❖ These innovative posters carry an importance that transcends their status as art objects: The Great War was the first major war in which national governments organized and conducted propaganda campaigns that sought to influence public opinion, both to support the nation's war effort and to create a negative image of opposing nations. This first "total war" elevated the importance of government control of information, that is, the importance of propaganda.

Among belligerent nations mounting propaganda campaigns, Germany had the toughest time "selling" its aggressive behavior.

Each of the combatant nations—and some that were not fighting—mounted some sort of organized propaganda campaign. They aimed to unite and rally their citizens to explain and justify their reasons for fighting the war—many of those reasons defensive in nature—to promote a sense of patriotism and nationalism in their civilian populations, to encourage men to volunteer for the armed services, and to demonize their enemies. Simply put, nations sought to make themselves look good and their opponents look bad. Nearly all relied upon simplistic, even crude, stereotypes of people, both positive and negative, to get their points across. They utilized symbols of national identity—such as flags—and characteristics often associated with courage, steadfastness, heroism, and the nobility of personal sacrifice.

As the war dragged on, nations also sought to raise money—wars are very expensive—often through the sale of bonds to their citizens, and to influence public opinion in allied and neutral nations, both overtly through such public statements as these posters, and covertly through clandestinely planting stories in both domestic and foreign newspapers.

TO SUPPORT THE WAR

Another consequence of the prolonged fighting was its growing impact on civilian populations, which were faced with mounting numbers of casualties and a growing sense of the horrors of combat. Home-front privations such as shortages of food, fuels, important supplies of all kinds, and of consumer goods had potentially negative influences on citizens' support of the war effort.

Different nations adopted different strategies and methods to accomplish these aims, which varied with the type of government, the extent of

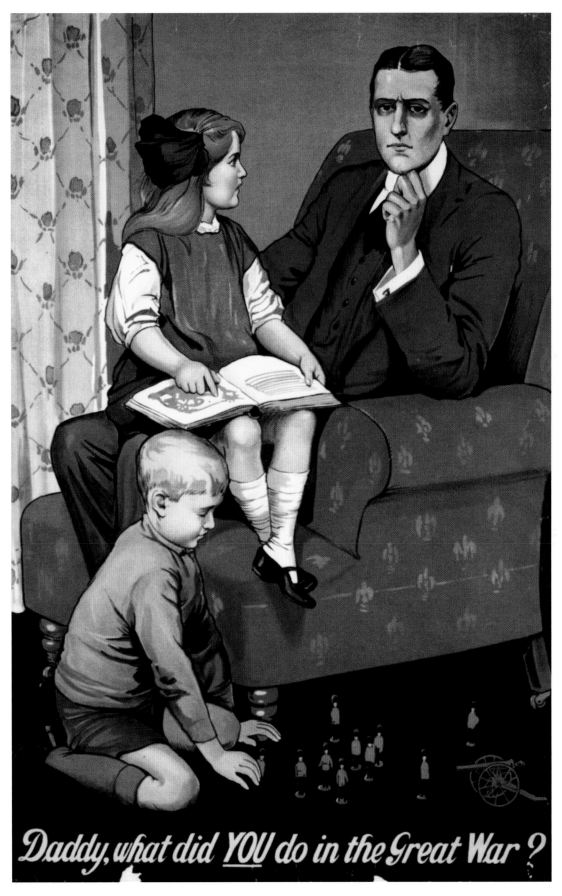

Daddy, what did **YOU** do in the Great War?

PRINT NO.18 ENGLAND, 1915. "DADDY, WHAT DID YOU DO IN THE GREAT WAR?" SAVILE LUMLEY

its control over its population, its military organizations, and its media including posters, cinema, newspapers, magazines, books, and cartoons. Not all of what is now considered propaganda emanated from government agencies and actions; many voices in the private sectors also had their say about supporting the war, enduring home-front sacrifices, praising their soldiers, and denigrating their enemies.

Moreover, the war began during the early days of what might truly be considered "mass" media, following the development of high-speed printing presses and of sophisticated cinema that was reaching ever-greater popularity.

Britain began mounting a wide-ranging and sophisticated propaganda campaign almost immediately following the declarations of war, and its posters are among the most effective and memorable. The British army, though quite small at the outset, was a professional organization with trained and experienced officers. It was a volunteer army, so without conscription to fill the ranks, the government sought to encourage and persuade its citizens to join the military. Its propaganda, especially its well-designed posters, relied on patriotism, moral suasion, peer pressure, a sense of duty, and at least early in the war, appeals to a sense of adventure and daring—even suggesting that fighting in the war could be glamorous and romantic.

The Honourable Artillery Corps, England's oldest regiment, trains recruits at Aldershot, the country's largest army camp, 1914.

Much of Britain's propaganda effort was overt and directly sponsored by the government—in 1915, Parliament published a *Report of the Committee on Alleged German Outrages*, known as the Bryce Report, a document filled with distortions and unsubstantiated claims that condemned German

MEN OF LONDON!

Remember!
WE MUST HAVE MORE MEN SO **JOIN NOW**
and help to shorten the Duration of War

GOD SAVE THE KING

ISSUED BY THE PUBLICITY DEPARTMENT, CENTRAL RECRUITING DEPÔT, WHITEHALL, S.W. ANDREW REID & CO., LTD., 50, GREY STREET, NEWCASTLE-UPON-TYNE.

PRINT NO. 19 ENGLAND, 1915. "MEN OF LONDON! REMEMBER!" ANDREW REID & CO.

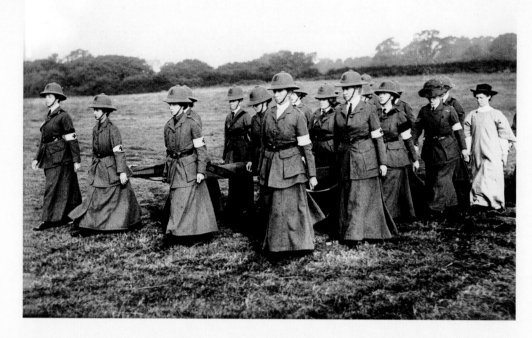

Some 10,000 British women served in France with the Women's Army Auxiliary Corps, freeing up men for the front lines.

forces for their atrocious behaviors in Belgium and France in the early days of the war. A substantial percentage of Britain's propaganda was generated and distributed by a secret agency known as Wellington House that purported to be a private and independent enterprise. It was, in fact, a government bureau that specialized in planting stories in the press, and even books published by regular commercial outlets. Later in the war, the government established an official Ministry of Information, run by some veteran "press lords."

A significant portion of Britain's propaganda was directed toward the leaders and citizens of the United States through an entity named the American Ministry of Information, which sought to steer American opinion to a pro-British position.

AT THE FRONT!

Every fit Briton should join our brave men at the Front.

ENLIST NOW.

PRINT NO. 20 ENGLAND, 1915. "EVERY FIT BRITON SHOULD JOIN OUR BRAVE MEN AT THE FRONT." ES&A ROBINSON LTD.

GERMANY'S MESSAGE

German propaganda was anything but subtle, and was directly the work of the government. The nation was often fighting an uphill battle when it came to public relations. From the outset, the German military—which was widely blamed for starting the war—handed numerous propaganda opportunities to the Allies: the brutal behavior of its army in Belgium; its introduction of weaponized poison gas on the battlefield; the torpedoing of the passenger liner *Lusitania*; and the widely publicized 1915 execution of British nurse Edith Cavell by a German firing squad in Brussels.

Despite its preemptive invasion strike through Belgium and into France, Germany sought to portray its aggressive actions to the German people as a defense against Britain and France, who were allegedly thwarting Germany's rightful growth and expansion to world-power status.

When during the final years of the war, the German civilian population was suffering from a wide range of shortages including food, Germany blamed the British naval blockade for hundreds of thousands of civilian casualties. And in a more pervasive sense, Germany portrayed the war to its own people as a righteous defense of its historical high *Kultur* against the decadence of the western Allies. Thus, in Germany as in the other combatant countries, the war was presented as an existential struggle to defend and preserve an established and valued way of life, as well as the nation that embodied that culture. Accordingly, much of the propaganda assumed a moral tone—an apocalyptic battle between Good and Evil.

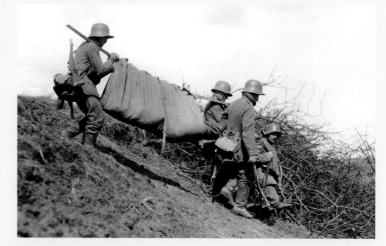

German soldiers carry a seriously wounded comrade off the battlefield in France, March 1917.

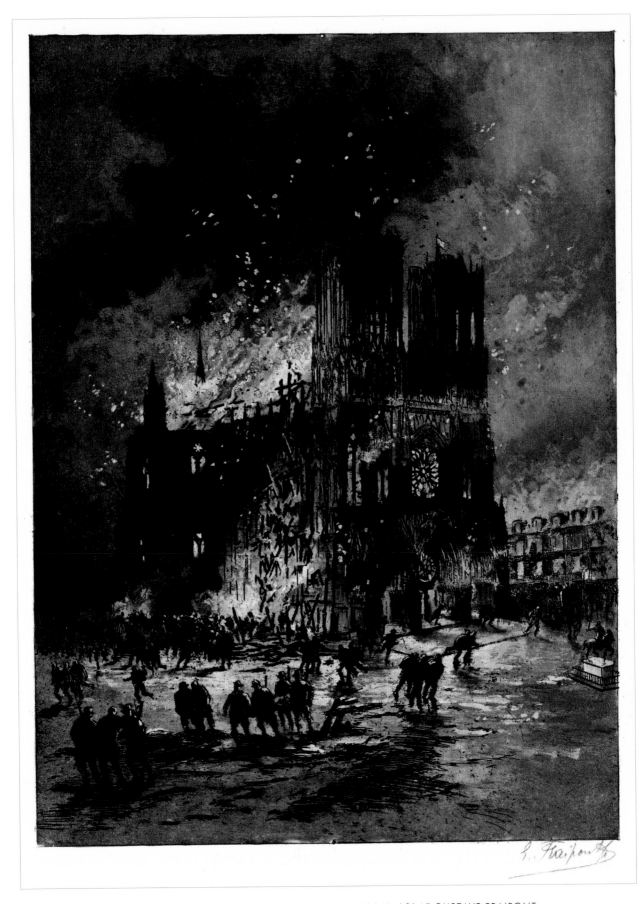

PRINT NO. 21 FRANCE, 1915. "THE DESTRUCTION OF REIMS CATHEDRAL, 1914." GUSTAVE FRAIPONT

Germany also sought to influence public opinion in the neutral United States via an official government agency, the German Information Service, that was set up in New York in the first year of the war. It issued a steady stream of press releases for use by American newspapers on a wide range of pro-German, anti-Allied nations subjects. The German government even purchased and published an American daily newspaper, the *Evening Mail*.

France, like Germany and Russia, relied upon conscription to fill the ranks of its military (Britain did not introduce a draft until 1916), hence French propaganda efforts were not focused on cajoling or shaming young men into volunteering to serve.

Internal propaganda aimed to sustain the morale and fighting spirit (èlan) of those in uniform and at the front, and to remind soldiers and civilians alike of the consequences of an enemy victory. In France, where memories of the sudden stinging defeat inflicted by Prussia in the Franco-Prussian War of 1870-71 lingered along with the angst of losing Alsace and Lorraine, few needed reminding of what was at stake.

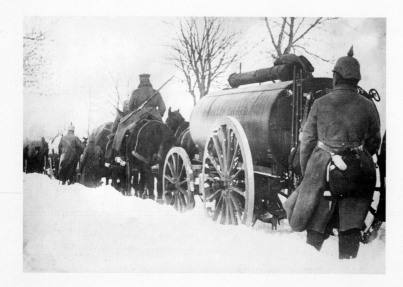

German field bakery mobile ovens wait out the Second Battle of the Masurian Lakes on the Eastern Front, February 1915.

PRINT NO. 22 RUSSIA, 1917. "YEAR 1914 (OUR RESURRECTION)."

Most of the combatant nations funded their war efforts largely by direct appeals and selling bonds or some other loan instrument to their own civilian populations. Britain financed much of its military through taxes so an important element of propaganda amounted to relentless public appeals for money, often blended with reminders of the righteousness of their cause, the need for civilians to accept the wartime privations and sacrifices, and especially the central importance of defending the homeland.

AMERICA'S MESSAGE

America officially entered the war against Germany on April 6, 1917. But propaganda, both internal and external, was a fact of its political life well before Congress declared war. The traditional antipathy against "foreign entanglements" was a longstanding and powerful sentiment in a United States that believed itself buffered by the Atlantic and Pacific oceans. The country was also torn by the conflicting ties and allegiances of its vast population of immigrants from the United Kingdom, the Scandanavian countries, Italy, Eastern European countries—and from Germany.

Years of heated debate and a series of shocking actions by Germany finally tipped the scale in favor of joining the Allies: the 1915 sinking of liner *Lusitania* on a voyage from New York with over 100 American citizens on board; the 1917 Zimmermann Telegram, intercepted and made public by British intelligence, which cajoled Mexico into joining Germany against America and promised the return of Texas, New Mexico, and Arizona as a reward; and the resumption in early 1917 of unrestricted submarine warfare by the German navy, which essentially made neutrality all but impossible for a major maritime nation like the U.S.

Among the many challenges facing the United States as it entered a global war in the fourth year of unprecedented bloodshed were the

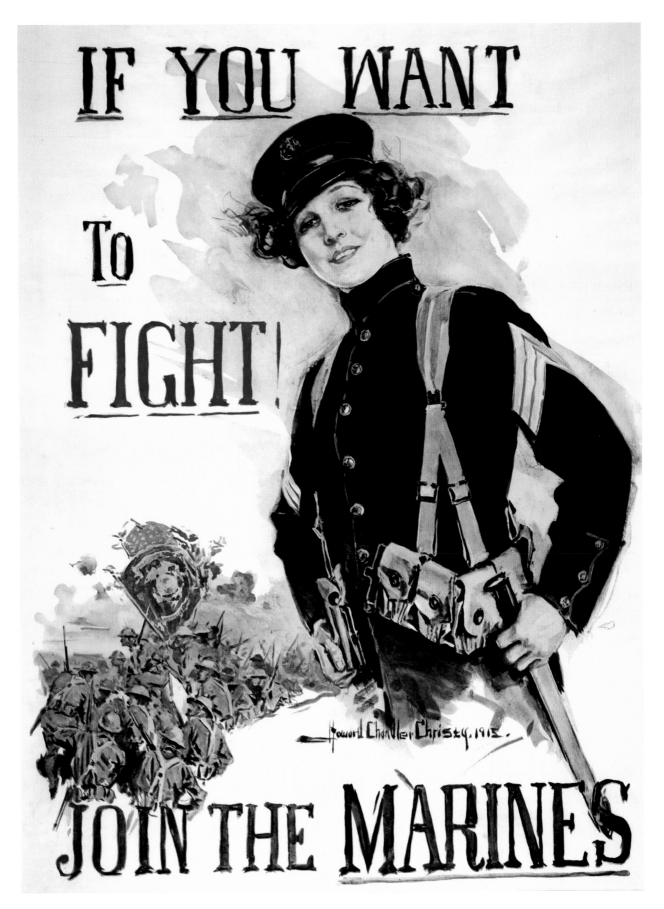

PRINT NO.23 AMERICA, 1915. "IF YOU WANT TO FIGHT! JOIN THE MARINES." HOWARD CHANDLER CHRISTY

urgent expansion and training of its unprepared armed forces (its army then numbered only about 100,000 men). A draft—dubbed the Selective Service—got underway in May 1917. A panoply of industries was mobilized to produce war materiel, and the military was given priority access to the nation's railroads and shipping. Finally, the American people had to prepare for participation in and the consequences of the ongoing massive armed struggle that had been consuming much of Europe.

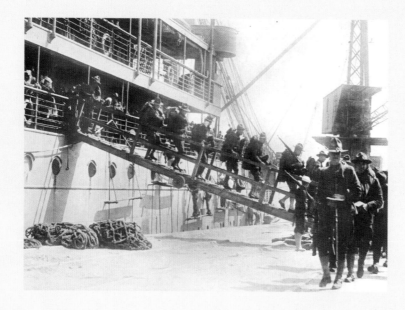

More than 2 million American troops crossed the Atlantic to serve in Europe during the war.

Many of those challenges were addressed in a public education campaign that was highlighted by the posters produced by some of America's most accomplished graphic artists, including James Montgomery Flagg, Howard Chandler Christy, John E. Sheridan, Charles Dana Gibson, and Haskell Coffin. As the war went on and the public information campaigns broadened and intensified, a good many effective posters were produced on behalf of non-government organizations like the American Red Cross and the YMCA.

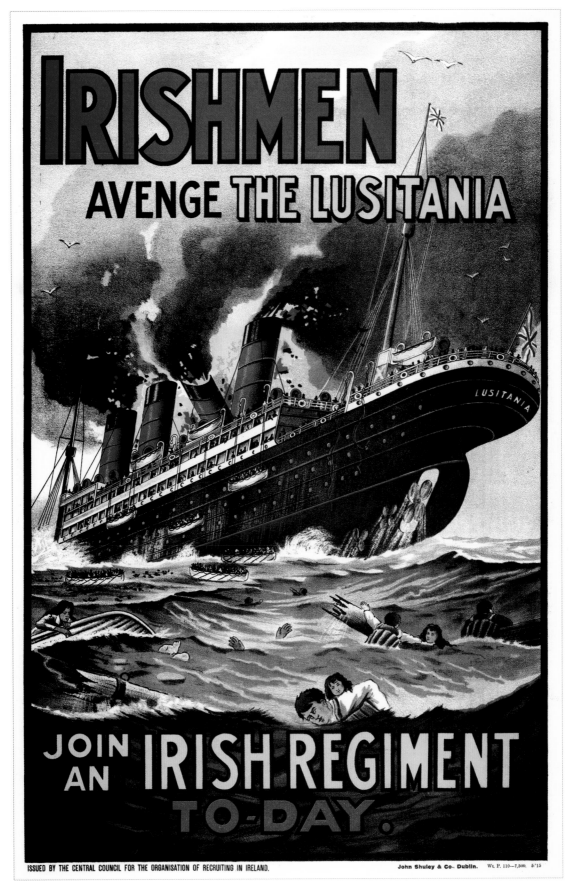

PRINT NO. 24 IRELAND, 1915. "IRISHMEN AVENGE THE LUSITANIA." JOHN SHULEY & CO.

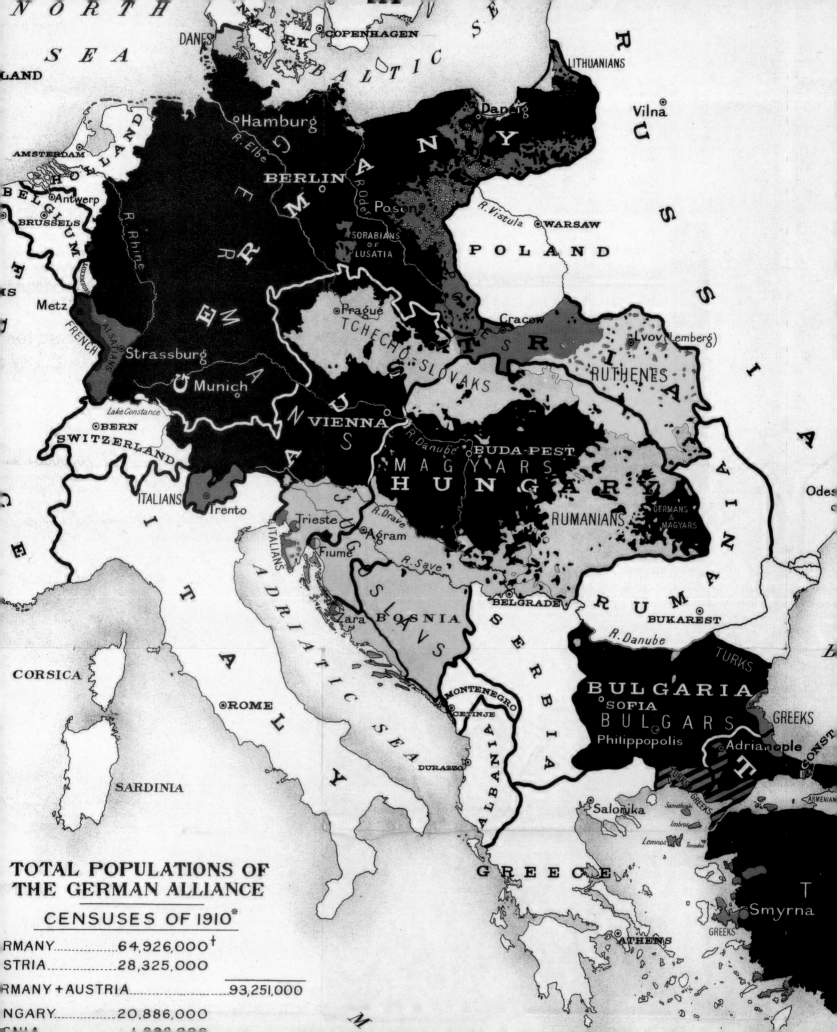

NORTH SEA

DENMARK

COPENHAGEN

BALTIC SEA

LITHUANIANS

DANES

Danzig

Vilna

LAND

Hamburg

R. Elbe

GERMANY

BERLIN

R. Oder

Posen

R. Vistula

WARSAW

POLAND

AMSTERDAM

HOLLAND

SORABIANS OF LUSATIA

Antwerp

BELGIUM

BRUSSELS

R. Rhine

Cracow

Lvov (Lemberg)

Prague

TCHECHO-SLOVAKS

A U S T R I A

RUTHENES

Metz

FRENCH

ALSATIANS

Strassburg

Munich

GERMANS

VIENNA

R. Danube

BUDA-PEST

M A G Y A R S

H U N G A R Y

Lake Constance

BERN

SWITZERLAND

Trieste

R. Drave

Agram

RUMANIANS

GERMANS & MAGYARS

Odes

ITALIANS

Trento

Fiume

R. Save

ITALIANS

Zara

BOSNIA

S L A V S

BELGRADE

S E R B I A

R U M A N I A

CORSICA

ADRIATIC SEA

I T A L Y

MONTENEGRO

CETINJE

BUKAREST

R. Danube

TURKS

ROME

DURAZZO

ALBANIA

BULGARIA

SOFIA

B U L G A R S

GREEKS

Adrianople

CONST

SARDINIA

Philippopolis

Salonika

Samothraki

TURKS GREEKS

Lemnos

Tenedos

Imbros

ARMENIAN

G R E E C E

ATHENS

GREEKS

Smyrna

TOTAL POPULATIONS OF THE GERMAN ALLIANCE

CENSUSES OF 1910*

RMANY	64,926,000†
STRIA	28,325,000
RMANY + AUSTRIA	93,251,000
NGARY	20,886,000

The CENTRAL POWERS

At the beginning of the war, Germany and the Austro-Hungarian Empire (the Dual Monarchy) constituted the Dual Alliance. It was expanded in November 1914 to include the Turkish Empire, the remnant of the ancient Ottoman Empire. Those nations became known as the Central Powers, which were later joined by the Kingdom of Bulgaria. ❖ That was one side in World War I. The Central Powers were led from the outset by the young and newly unified (in 1871) Germany. With a population of some 67 million and the strongest economy and best army in Europe, Imperial Germany, led by Kaiser Wilhelm II, was ambitious, expansionist, militaristic, and confident that it could win any war on the Continent. ❖ Austria-Hungary was a junior partner in that alliance. Its population totaled about 50 million, but led by Emperor Franz Josef I, it was ethnically divided and comparatively weak economically and militarily.

The Central Powers (Germany, Austria-Hungary, Bulgaria, and Turkey) fought in all directions, surrounded by enemy nations.

Turkey did not join the Central Powers until Russia declared war on the Ottoman Empire, following Turkish fleet attacks on Russia's Black Sea ports. The empire was ruled by Sultan Mohammed V until the last months of the war in 1918. The real ruling power during the war was held by Minister of War Enver Pasha, Minister of Marine Cemal Pasha, and Minister of the Interior Talat Pasha.

Bulgaria, with 4 million people led by King Ferdinand, was neutral at first, with its people and its military bruised by their experience in the Balkan Wars of 1912 and 1913. It joined the Central Powers in mid-October 1915 when it declared war on Serbia.

Italy was a special case: Before war actually broke out, the newly unified nation (1871) generally sided with the Central Powers, although it had long coveted the region along the southern Alps and the Adriatic coast that was held by Austria; accordingly, Italy's initial stance of neutrality was largely a matter of national opportunism—waiting to see which side looked most likely to win. In the spring of 1915, Italy signed a secret treaty

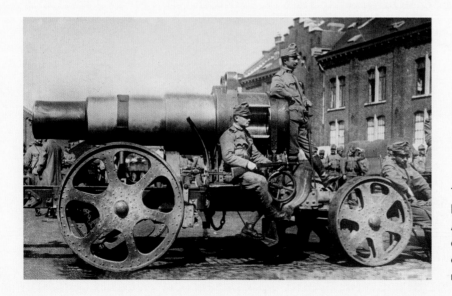

The Skoda 305mm howitzer, developed by Austria-Hungary, fired armor-piercing shells that could penetrate 6 feet of reinforced concrete.

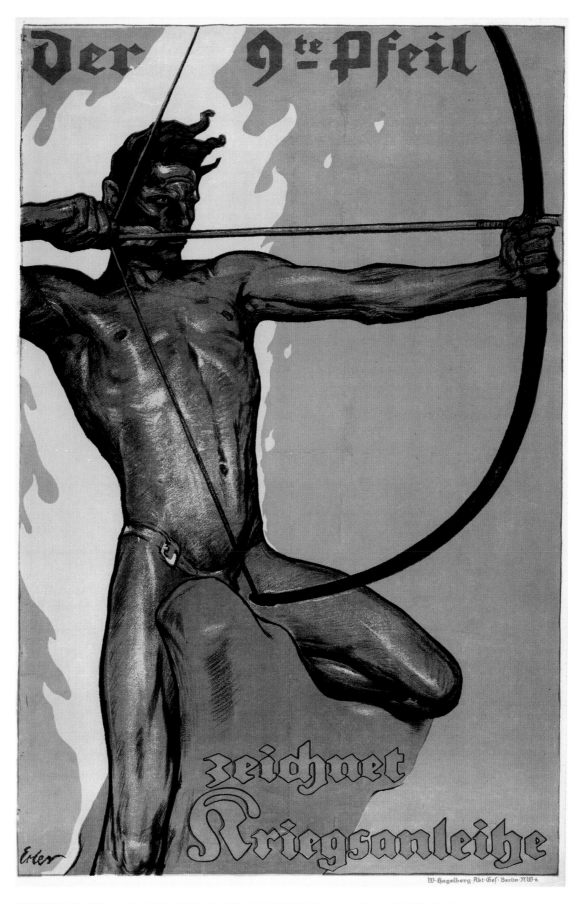

PRINT NO.25 GERMANY, 1918. "9TH ARROW: SUBSCRIBE TO WAR LOANS." FRITZ ERLER

with the Allies (whose cynicism matched Italy's opportunism), in which Italy was promised those Austrian lands in return for Italy's military support, and Italy declared war on the Central Powers in May.

GERMAN MILITARISM

While the war was touched off in the Balkans by the June 28, 1914, assassination of Archduke Franz Ferdinand, the heir to the Austro-Hungarian throne, and then spread outward through the multiple alliances of many European nations, it was Germany that started the shooting war on the morning of August 4, 1914. It invaded Belgium and the Netherlands—its preliminary step in a long-planned conquest of France.

Germany, like most other European nations in 1914, was a monarchy (only Switzerland and France were not) and it saw war in 19th-century terms, as a generally acceptable adjunct of statecraft fought in set-piece battles by professional armies with evenly matched weaponry. Following the shocking defeat of Russia by Japan in 1905, the major powers in Europe began to engage in an arms race, growing their armies and navies—many of them eyeing each other with competitive suspicion. By 1914, Germany had expanded its standing army to over 860,000 men before mobilization for the war, which would put about 4 million men under arms.

German field marshal August von Mackensen watches his troops cross into Romania via pontoon bridges over the Danube River, November 1916.

PRINT NO. 26 AMERICA, 1918. "HEARTS OF THE WORLD." GRANT E. HAMILTON

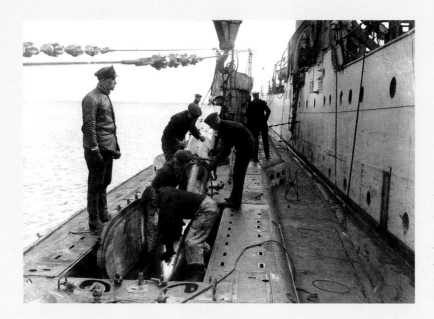

Torpedoes are loaded onto a German U-boat. Submarine warfare took a fearful toll on the Allies, who lost 5,000 ships between 1914 and 1918.

WHY GERMANY FOUGHT

An ambitious nation, Germany under the kaiser aspired to be the premier power among the countries of Europe, and it was the dominant nation of the Central Powers throughout the war. It believed that another major war with rival France was inevitable and planned for years to initiate and win that war. The alliance between Russia and France in 1891 raised the spectre of having to confront two powerful rivals flanking Germany. Moreover, in an age of global colonization, Germany—and the kaiser in particular—believed that a strong navy was the key to world power, and embarked on building a fleet to compete with the British Empire and its dominance of the high seas. Germany was also in commercial competition with Britain and France over their colonies in Africa and the Pacific and, with those nations, in picking up the pieces of the collapsing Ottoman Empire. Germany's plan to build a railroad from Berlin to Baghdad was viewed by the Allies as an especially provocative move.

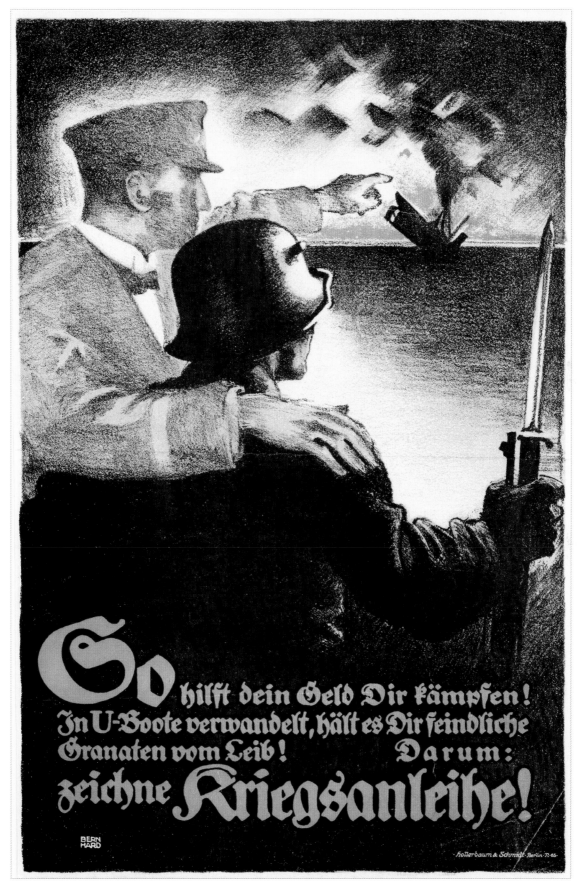

PRINT NO. 27 GERMANY, 1917. "THAT IS HOW YOUR MONEY HELPS YOU FIGHT!" LUCIAN BERNHARD

Austria-Hungary had joined with Germany in 1879 as the Dual Alliance. Linguistically and geographically it was a natural get-together, but Austria-Hungary was an empire in decline and the Habsburg rulers struggled with a host of problems. Widespread ethnic tensions within their borders were a major headache, especially those driven by the independence movements in the nearby Slavic states. The growth of Serbia was seen by Austria-Hungary as a major threat to regional stability, given the significant and restless Serb minorities in both parts of the Habsburg Empire—not to mention the enormous and troubled Russian nation on its borders, which saw its role as the leading protector of Slavic peoples everywhere. Austria-Hungary was simply a beleaguered empire, surrounded by nations, regions, and ethnic groups clamoring for its breakup and for pieces of its territory, and it fought largely to preserve its fractious empire. When war came Austria-Hungary would prove to be a highly problematic partner to Germany.

Despite their diplomatic ties, Germany and Austria-Hungary had no significant military cooperation and no real plans for coordination in the event of war. The Habsburg Empire had a real army of some 415,000 at the outbreak of the war, and quickly mobilized nearly 2 million soldiers.

Turkey's peacetime army numbered about 235,000, with a reserve force of about a million men. With full mobilization, the army eventually grew to a strength of about 2.5 million. The empire also had a navy with four battleships and several cruisers and other smaller ships, and its naval forces amounted to some 8,000 men.

Charles I, the last Austro-Hungarian emperor, ignored the German alliance and began secret peace negotiations with France in 1917.

American Women's Hospitals

HEADQUARTERS
637 Madison Ave.
New York

HELP WOMEN PHYSICIANS FIGHT DISEASE AND DEATH IN SERBIA and the NEAR EAST

SEND REMITTANCES TO
AMERICAN WOMEN'S HOSPITALS

PRINT NO. 28 AMERICA, 1917-1918. "HELP WOMEN PHYSICIANS FIGHT DISEASE AND DEATH." AMERICAN WOMEN'S HOSPITALS

RULERS AND GENERALS

The personalities, experiences, and limitations of the political and military leaders of the Central Powers were influential in their rush to war and in how the war would be conducted in the coming years.

Kaiser Wilhelm II, the ruler of Germany, was a shallow person, a weak leader, and an ardent militarist who liked showy displays and nearly always appeared in public in some extravagant uniform. As the war went on, he wielded less and less power and was effectively a figurehead, while the real power was held by the German general staff, and especially by Erich Ludendorff and Paul von Hindenburg who rose to power and prominence together following their swift and brilliant defeat of two Russian armies at Tannenberg in early 1914.

Chief of staff of the German armies for the first years of the war was a career officer, General Erich von Falkenhayn. In 1916, stymied by German reverses in major battles on both the Eastern and Western fronts, he was relieved of the chief position.

Kaiser Wilhelm rides out in a cavalry uniform, complete with the *Totenkopf* (death's head) symbol on his fur busby.

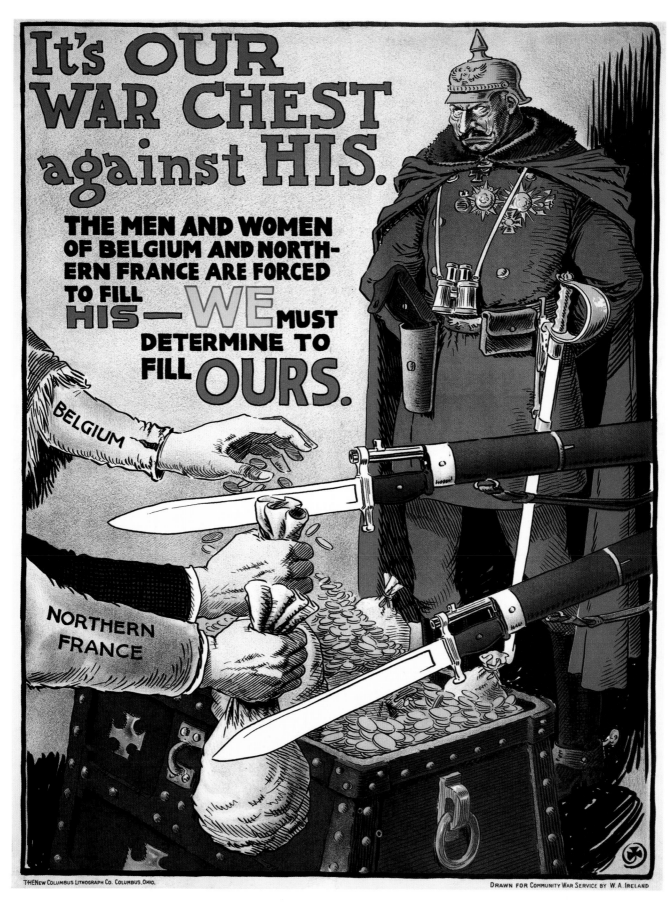

PRINT NO. 29 AMERICA, 1917-1918. "IT'S OUR WAR CHEST AGAINST HIS." WILLIAM ADDISON IRELAND

Austro-Hungarian heavy artillery pounds the mountainous terrain on the Italian Front.

In Austria-Hungary, Emperor Franz Josef I was 84 years old when the war began and had been emperor for 66 years. His polyglot empire was also showing signs of age amidst centrifugal pressures. Initially, he was reluctant to attack Serbia—he rightfully feared the consequences—but he was pressured by his foreign minister Leopold, Count Berchtold, and his chief of staff Field Marshal Franz Conrad von Hötzendorf, who was positively lusting for a war with their obstreperous and militaristic Serb neighbors. In the end, the emperor yielded to their machinations and went to war in an effort to hold his empire together. It was Austria-Hungary's patently unacceptable diplomatic ultimatum, pushed by Berchtold and Hötzendorf, to Serbia over the assassination of Franz Ferdinand that set Europe on the road to war. Franz Josef, who was revered within the empire, died in 1916, an event that hastened its breakup.

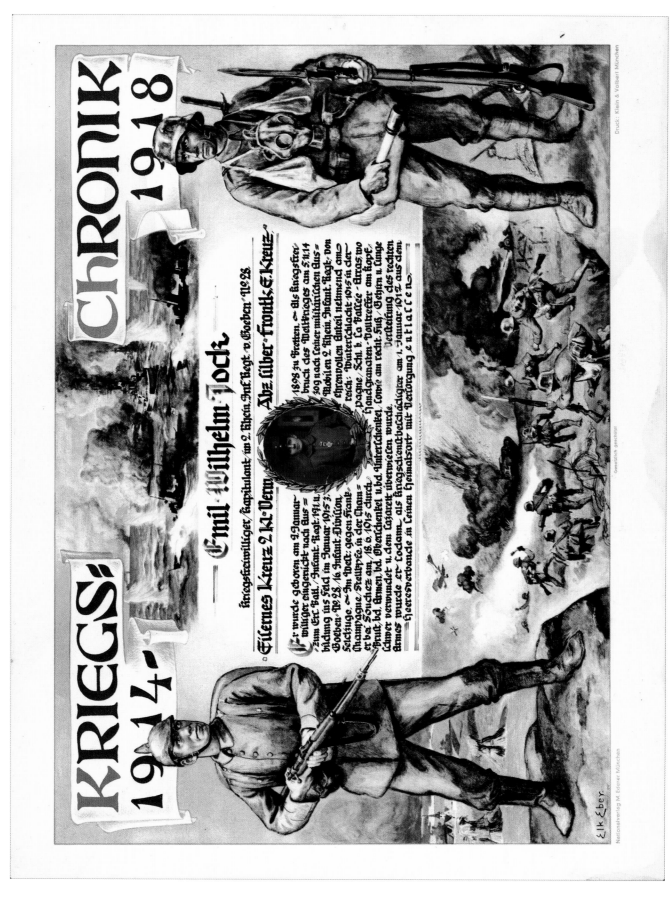

PRINT NO. 30 GERMANY, 1918. "WAR CHRONICLE 1914-1918, OF EMIL WILHELM JOCK." ELK EBER

LEADERSHIP DISASTERS

Hötzendorf was so focused on defeating the Serbs that he underestimated the challenges presented to the empire by the Russians, the terrain, and the weather. He divided his army into three parts (rarely a successful tactic), none of them strong enough to prevail in their campaigns. He also misjudged the fighting qualities of the Serbs who were well-armed, well-trained, and well-led. The outcomes of the initial fighting were disastrous for Austria-Hungary. Several of its armies invaded Serbia on August 1 and before the month was over were driven back over the border with heavy casualties. In Galicia, on the empire's eastern border, the Russians foiled the Austro-Hungarian attack and forceed a costly retreat. And in the rugged Carpathian Mountains, where transportation was medieval at best, Hötzendorf's blundering and reliance on a few obsolete strongpoint forts prolonged the campaign well into a winter for which the Austro-Hungarian army was not prepared. In less than a year, the emperor's army suffered over 2 million casualties and was all but destroyed.

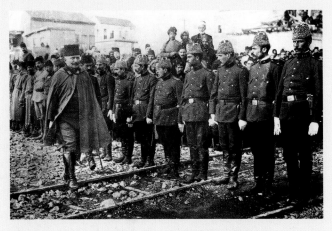

An officer reviews Turkish troops. The Ottoman Empire's alliance with Germany spread the war into the Middle East.

It was rebuilt in time, but repeatedly had to be reinforced by German army units.

Its special mountain infantry units, though, were well-trained, and in the mid-years of the war fought effectively in the Dolomite Alps alongside its German allies against an Italian army that was poorly trained and unimaginatively led. In 11 futile offensives along the Isonzo River over two years, the Italian army lost over 600,000 men; the cost to Austria of

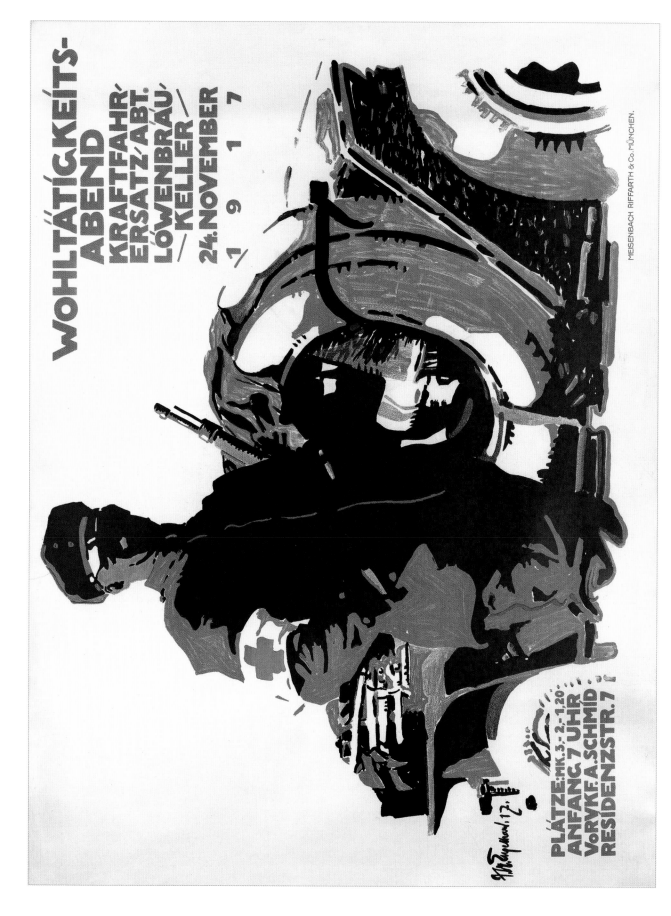

WOHLTÁTIGKEITS-ABEND

KRAFTFAHR-ERSATZ-ABT.
LÖWENBRÄU-
KELLER
24.NOVEMBER
1 9 1 7

PLÁTZE:MK.3.-2,-1,20·
ANFANG 7 UHR
VoRVKF.A.SCHMID
RESIDENZSTR.7

MEISENBACH RIFFARTH & Co. MÜNCHEN.

PRINT NO.31 GERMANY, 1917. "CHARITY EVENING: DRIVER REPLACEMENT DEPARTMENT." JULIUS USSY ENGELHARD

those battles was some 350,000 men. In the 12th such battle, in September 1917, a combined Austro-Hungarian and German force broke through at Caporetto and stampeded the Italian army.

That massive retreat was immortalized by novelist Ernest Hemingway in *A Farewell to Arms*.

Turkey and Russia had long circled each other in mutual diplomatic suspicion of the other's motives and ambitions for the greater Middle East. Tensions increased when the "Young Turks" took power in 1908 and sought to concentrate Ottoman power in a Eurocentric Turkish nation. Germany supported their modernization efforts, seeing them as a useful counter-weight to both Russia and Britain. Alarmed by Germany's initial successes on both Eastern and Western fronts, and its support for Turkey, Russia and Britain declared war on Turkey in response to that nation's surprise naval raid in the Black Sea. Thus the war was widened dramatically and the Central Powers strengthened.

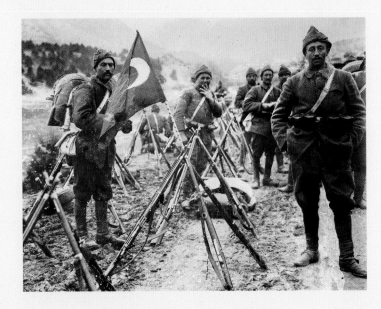

Serbian prisoners cross the Sava River, at Novi Sad. The Serbian capital of Belgrade fell to the Central Powers in October 1914.

THE WORLD CANNOT LIVE HALF SLAVE, HALF FREE

THE PRUSSIAN BLOT

100,000,000 PEOPLE ALREADY ENSLAVED BY GERMANY

President Wilson Says of the Germans:

"Their plan was to throw a broad belt of German military power and political control across the very center of Europe and beyond the Mediterranean Sea into the heart of Asia. They have actually carried the greater part of that amazing plan into execution."

THE KAISER PROCLAIMS:

"Woe and death unto those who oppose my will. Death to the infidel who denies my mission. Let all the enemies of the German nation perish. God demands their destruction."

WHILE GERMANY DREAMS OF DOMINATING THE WORLD BY FORCE
THERE CAN BE NO PEACE

By Authority of the State Council of Defense

PRINT NO. 32 AMERICA, 1917-1918. "THE PRUSSIAN BLOT." STATE COUNCIL OF DEFENSE

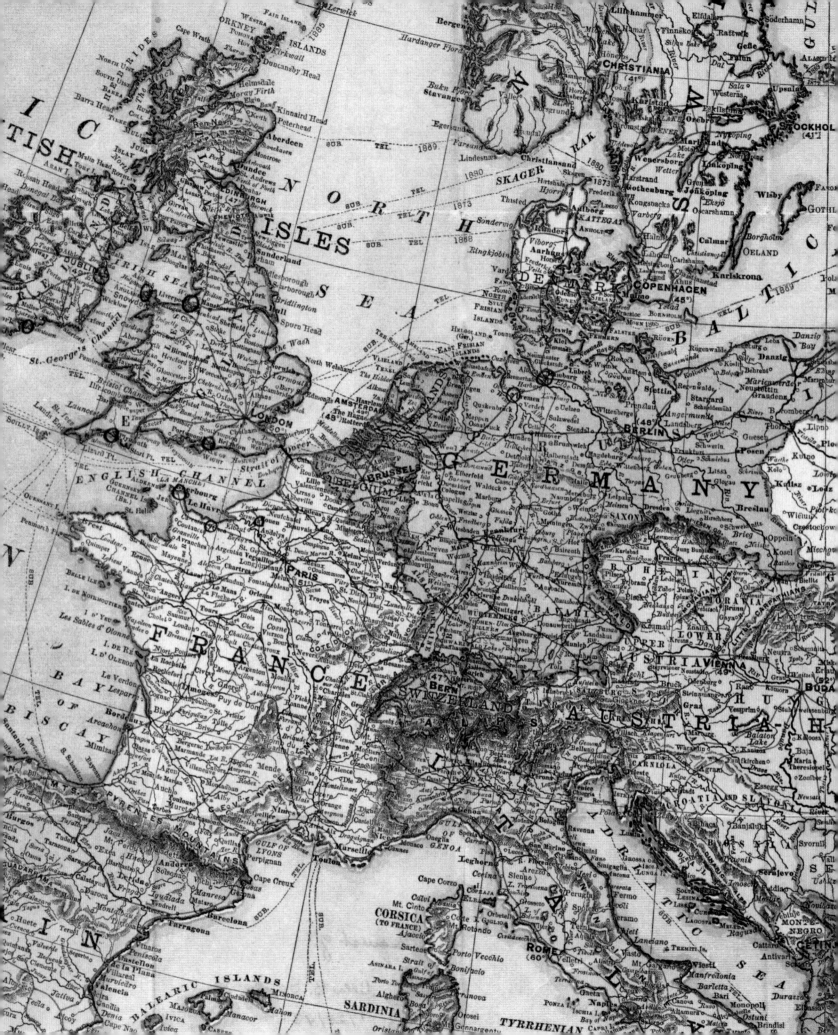

The ALLIES

What became known as the "Allied" nations were not exactly allies at the beginning of hostilities in 1914. When Austria-Hungary delivered its ultimatum to Serbia it expected its demands to be rejected, and as soon as the Austrians were rebuffed they declared war on Serbia on July 28. Germany supported Austria-Hungary of course. Then Russia was bound to mobilize to defend the Serbs as fellow Slavic peoples. Russia also had close diplomatic ties with France, the nation that most feared Germany, so France then mobilized in support of Russia. ❖ Britain was something of an enigma: It, too, was quite concerned about the rise and dominance of Germany in central Europe. It was cordial enough with France—though those two nations had clashed repeatedly over the past millenium. Britain had no formal treaty ties with France, but felt obligated to respond to Germany's overt armed violation of Belgium's sovereignty and neutrality.

Entente nations Britain and France were joined by Russia, Serbia, Italy, Belgium, Romania, then by many smaller nations and eventually by the United States.

During the first week of August 1914, Germany declared war on Russia and France; Britain declared war on Germany; Austria-Hungary declared war on Russia; and Serbia declared war on Germany. During the second week of August, France and Britain declared war on Austria-Hungary. And by the end of August, Japan had declared war on Germany and Austria-Hungary, and Austria-Hungary had declared war on Belgium. During November of that year Russia, Serbia, Montenegro, France, and Britain all declared war on the Ottoman Empire.

So essentially, in the first two full years of the war, the Allies consisted of Britain, France, Russia, Serbia, and Italy plus a few smaller nations. Italy entered the war on the Allies' side in an act of geopolitical opportunism: After flirting with the Central Powers before the shooting started and vowing neutrality at the outset, Italy signed a secret treaty in April 1915 under which it was promised substantial Austro-Hungarian territory in the event of an Allied victory. The United States entered the war with a declaration against Germany on April 6, 1917. But the abdication of the czar that spring and the Leninist coup in November forced Russia to drop out of the war, leaving Britain, France, and the United States as the major Allied powers in the war's final year.

General Joseph Joffre led French forces at the start of the war but suffered horrific battlefield losses in 1914 and 1915.

BRITAIN'S SLOW START

Britain had a national population of about 46 million and a peacetime army of some 250,000 soldiers. Plus it could call on the military strength of its Commonwealth including Canada, India, Australia, New Zealand, South Africa, and other colonies with a total population of some 400 million.

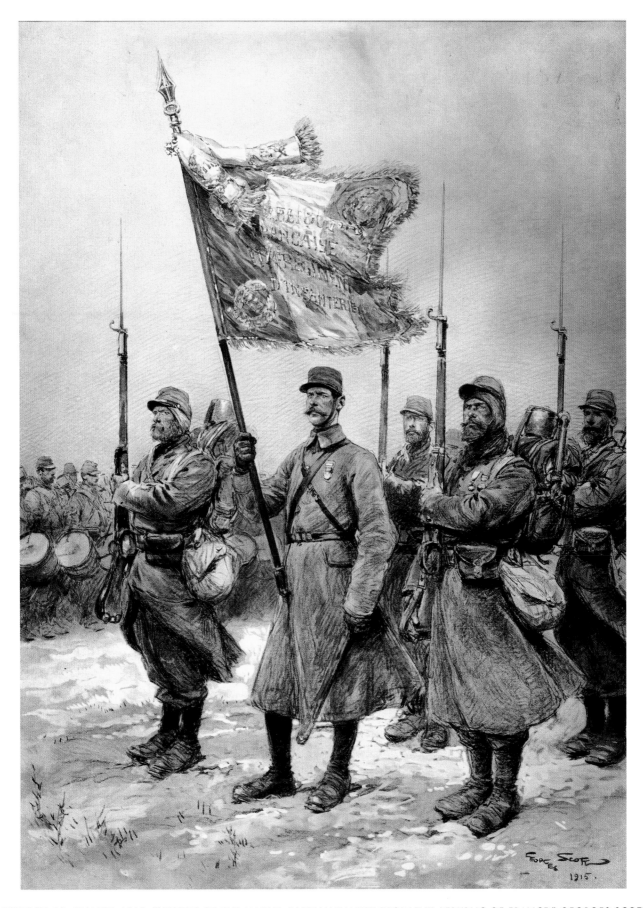

PRINT NO. 33 FRANCE, 1915. "HEROES OF THE MARNE: 117TH INFANTRY REGIMENT, REPUBLIC OF FRANCE." GEORGES SCOTT

Militarily, Britain boasted the world's largest and most powerful navy: It began the war with 22 dreadnoughts (heavy battleships), 34 armored cruisers, 9 battle cruisers, and 73 submarines. On land, Britain was far less powerful, with its volunteer army led by a professional officer class. In 1914, the British Expeditionary Force (BEF) that crossed the Channel to fight consisted of one cavalry division and four infantry divisions. Tanks were undreamed of at that time, and as for artillery, Britain had fewer than 500 fieldpieces (a number that would grow during the war to exceed 8,000). The leaders of its army at that time, including Sir John French, Sir Douglas Haig, and Sir Edmund Allenby, were convinced that a strong cavalry was the key to battlefield success and clung to that belief. At the beginning of the war, the British army was very much a junior partner to the French.

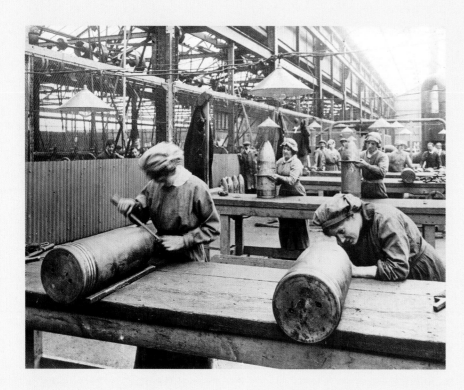

British "munitionettes" finish 9.2-inch artillery shells for heavy siege guns. Nearly 1 million British women worked in munitions factories.

THE WAR OF MUNITIONS

HOW GREAT BRITAIN HAS MOBILISED HER INDUSTRIES

WOMEN in INDUSTRY

Of the 500 different processes in munition work, upon which women are engaged, two-thirds had never been performed by a woman previously to a year ago.

NATIONAL ARSENALS

Before the War there were three National Arsenals working for the land service; to-day there are more than 100.

THE NAVY

To equip a naval man-o'-war takes nearly eight times as many workers as are required to provide a soldier with all he needs in the way of munitions. Since the outbreak of war the personnel of the British Navy has increased from 146,000 to 350,000.

HIGH EXPLOSIVES

In High Explosives the production is now more than 100 times what it was in January, 1915.

THE ARMY

In 1914 the British Army numbered the outbreak of war more 173,000 men have been enrolled million since than five in the forces of the Crown.

HEAVY GUNS

The monthly output of Heavy Guns during 1916 was more than ten times what it was during 1915.

SINCE the outbreak of war in August, 1914, Great Britain has grappled with the task of munitionment with astonishing success, and to-day she is one great Arsenal. Not only has she maintained her armies at the Front with ever-increasing supplies, but she has also materially assisted in the munitioning of her Allies. Despite the fact that more than five million men have been drafted to the Colours, she has raised a vast industrial army which is ceaselessly engaged upon the production of munitions. Her industries have been mobilised and placed upon a war footing, countless new factories have been erected, many old factories have been adapted for war purposes, and the output of munitions in the British Isles has been enormously increased. The workshops of Britain are at war, and they will know no truce till victory is secure.

MACHINE GUNS

The number of Machine Guns available for the British Army is now twenty times as great as it was at the end of the first year of the War.

TRAINING SCHOOLS

Up to December, 1916, over 16,000 students had passed through Munition Training Schools, and at least 21,000 had been placed in employment.

GUN AMMUNITION

The total amount of Shells produced during the first year of the War is now being produced in the above periods.

Field Gun and Howitzer Shell, about 5 days.

Medium Gun and Howitzer Shell, about 5 days.

Heavy Howitzer Shell, about 10 days.

WAR WORKERS

There are engaged on Government Munition work 4½ million persons of whom nearly half are women.

BOMBS

Between May, 1915, and December, 1916, the output of Bombs was increased 33-fold.

NATIONAL PROJECTILE FACTORIES

The New National Projectile Factories, which consist of buildings of an average breadth of 40 feet, and a total length of 3 miles, are equipped with more than 10,000 machine tools, driven by 17 miles of shafting with an output of 35,000 horse-power. The weekly output of this group of factories alone amounts to more than 10,000 tons weight of projectiles.

10,000 TONS

PRINT NO. 34 ENGLAND, 1917. "THE WAR OF MUNITIONS." G.K.

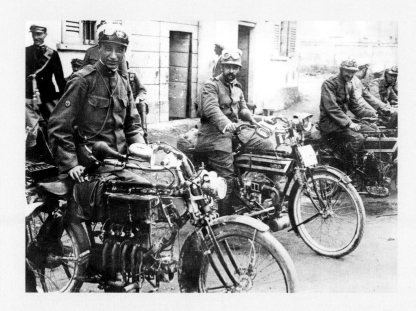

An Italian motorcycle squad awaits its next mission. Motorcycles were used to deliver messages and supplies.

France had a national population of about 40 million and a regular army of about 740,000. It could call on the military manpower of its colonies in North Africa: Algeria, Morocco, and Tunisia, plus other smaller colonies including Indochina—all with a total population approaching 100 million. Thanks to its familiarity with and proximity to Germany, France had a sizeable and ready army, a line of major fortresses on its borders for defense, and a war plan—Plan 17 developed by General Joseph J. Joffre, army commander in chief—for offense.

Joffre's strategy of seeking to expel the German invaders resulted in very high casualties. Major leaders including General Ferdinand Foch, who later became the Allies' supreme commander, and some who emerged during the war—General Robert Nivelle and General Philippe Pétain—adopted other strategies with mixed results. One notable French battlefield advantage was its artillery: The model 1897 75mm field gun, an accurate and rapid-fire (15 to 20 rounds per minute) weapon, proved invaluable and was widely used by the Allied armies.

PRINT NO. 35 ITALY, 1914-1918. "IL RE SOLDATO (THE SOLDIER KING), VICTOR EMMANUEL III, KING OF ITALY, WITH HIS TROOPS."

INEPT COMMANDERS

Russia had a national population that far exceeded that of any other combatant nation on either side—at an estimated 168 million—including the United States. But that population was widely scattered from Europe to the Pacific Ocean, in a nation that had only limited and primitive road and railroad networks and communication systems. Russia also initially had the largest standing army, at nearly 1.5 million, but much of it was ill-trained and inexperienced. And poorly led: A lesson of the early Russian debacle at Tannenberg in East Prussia was how inept its army leadership proved to be.

Russia's only military leader of note was General Alexei Brusilov. He masterminded the enormous 1916 summer offensive named for him in which he broke the Austrian line and routed its armies before his advance was countered by German reinforcements.

Italy, with a population of some 35 million, mobilized a military force that totaled nearly 6 million over the course of the war, of which about 1.4 million became casualties. It was an army of very uneven quality and it was led by an unimaginative martinet, General Luigi Cadorna. Nearly all the Italians' fighting was carried on in the rugged mountainous frontier with Austria, and the fact that those enemies fought no fewer than 12 battles along the Isonzo River in just over three years—as much of a bloody stalemate as the trench warfare on the Western Front—attests to

Russia, like the other major powers, dealt with the shortage of motorized transport by requisitioning private vehicles for military use.

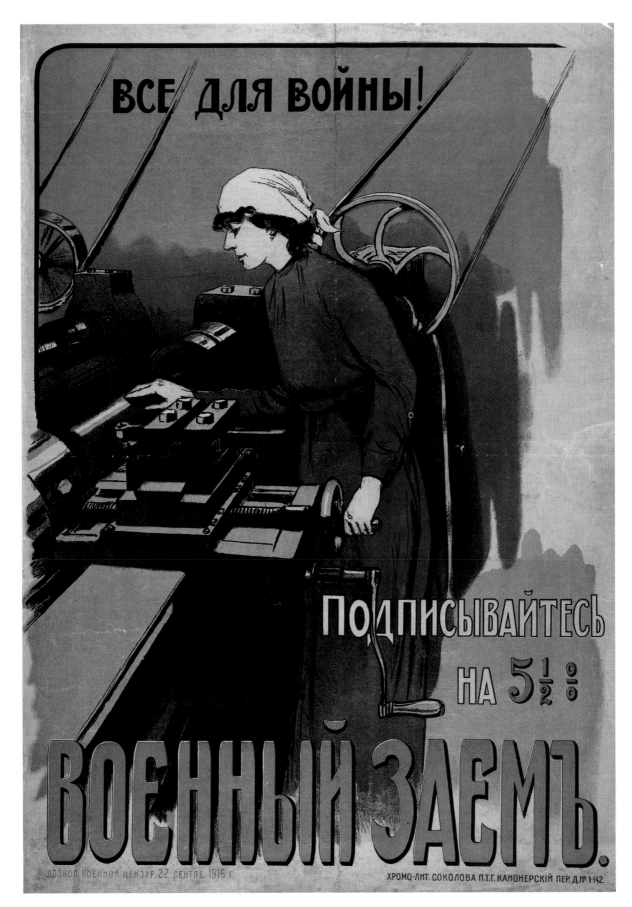

PRINT NO. 36 RUSSIA, 1916. "EVERYTHING FOR THE WAR!" SOKOLOVA

the futility of Cadorna's approach. The 12th and final battle, for which the German army supplied the Austrians with seven divisions of elite veteran mountain fighters, broke the Italian army, with surrenders and desertions numbering in the hundreds of thousands.

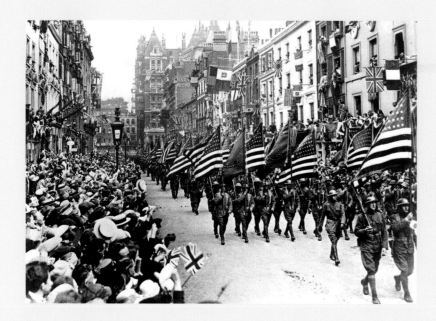

Perth, Scotland, gives American troops a hero's welcome in 1918.

AMERICA'S BUILD-UP

The United States, with a population of about 92 million, entered the war at a time when other nations had suffered years of debilitating casualties. Initially, the U.S. had a proportionately small regular army of just over 200,000, with combat experience limited to fighting Native Americans in the frontier West, the Spanish-American War, and quasi-police actions in Latin America. But the country had great potential strengths in manpower, capital, and industrial production, and once it entered the war in 1917, with just over 200,000 soldiers, plus a like number of National Guard and a small but well-trained Marine Corps, its forces grew rapidly. Under the

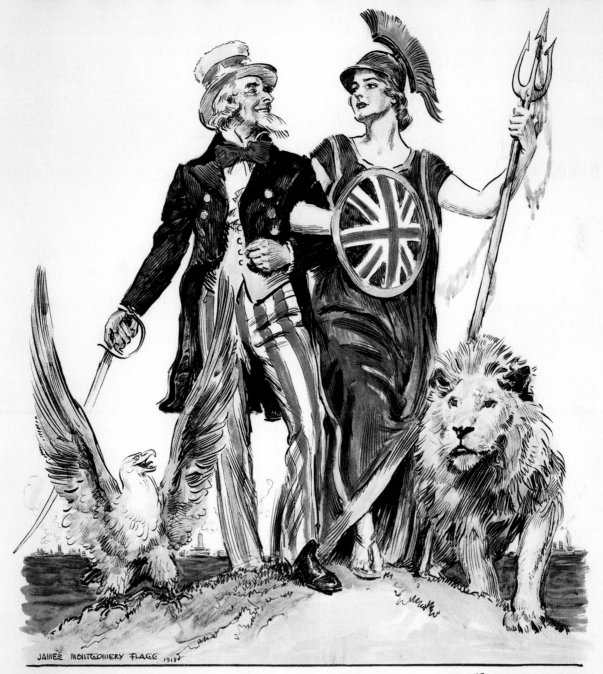

PRINT NO. 37 AMERICA, 1918. "SIDE BY SIDE — BRITANNIA!" JAMES MONTGOMERY FLAGG

command of General John J. Pershing, the new American Expeditionary Force (AEF) rushed an army division and two Marine brigades to France. The American navy joined the Allies with enough power to achieve dominance in surface warships.

Just a year later, in the spring of 1918, over 300,000 troops of the AEF had reached France and were engaged in Western Front combat before the end of the summer—the vanguard of the nearly 3 million draftees that would swell the total American armed forces to some 4 million by the time of the 1918 armistice.

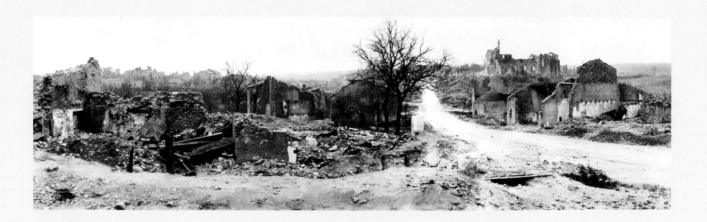

At the stubborn insistence of Pershing, they would join the battles as American units, not as piecemeal replacements fighting under foreign command, and though "green" they fought courageously at Belleau Wood, Château-Thierry, Soissons, and St. Mihiel.

The timing of the AEF arrival in Europe was fortuitous. The collapse of the Russian armies in late 1917 allowed the Germans to transfer more than 40 veteran divisions to the Western Front in preparation for what General Erich Ludendorff planned as knockout offensives. Those offensives, starting with Operation Michael in March 1918, were powerful thrusts that

The ruins of Limey, France, inside the St. Mihiel salient, 1918. The AEF fought at St. Mihiel in the war's closing months.

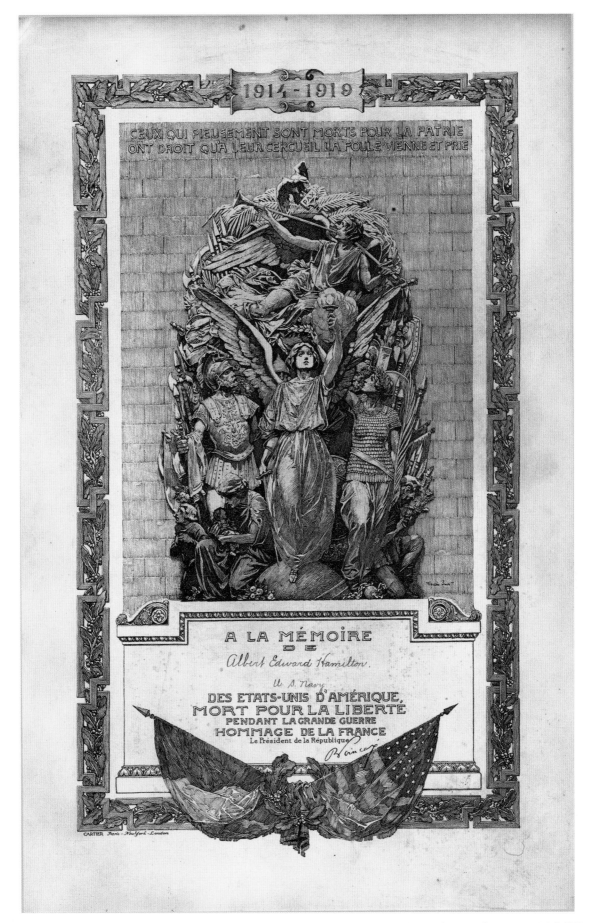

PRINT NO. 38 FRANCE, 1919. "TO THE MEMORY OF ALBERT EDWARD HAMILTON, U.S. NAVY." FRANKLIN BOOTH

broke front lines and gained territory. But one after another, they stalled and failed through the summer, costing the German army enormous—and irreplaceable—casualties. Facing Allied superiority in artillery, tanks, aircraft, supplies, and above all, manpower, the German leadership, including master tactician Ludendorff, realized that they had lost the race to win the war before the American army could tip the scales for good.

None of the Allied nations was prepared initially to fight a major and prolonged war. All were playing catch-up: They mobilized signifcant numbers of troops by calling up various types of reserves and conducting large-scale enlistment campaigns for volunteers. That was followed by massive conscription programs. The Allies needed to buy time for recruitment, for training officers and enlisted men, and for supplying the rapidly growing forces with everything from weapons and ammunition to boots, uniforms, and helmets. They had to produce trucks, ships, aircraft—and food. The logistical problems were solved by fits and starts as mass production got into gear and began accelerating.

POLITICS OF WAR

Attitudes and political policies toward the burgeoning war varied widely. For some nations, the war soon came to be seen as an existential threat: France had been conquered recently by Prussia and no citizen cared to repeat that experience. Britain, faced with the rapid build-up of Germany's High Seas Fleet and its advanced submarines, feared the strategic consequences of a challenge to its global maritime dominance, its essential overseas trade, and its very control of the English Channel and the North Sea. "Blockade" was a threat that struck home. The British began implementing its "distant" naval blockade of Germany at the outset of the fighting in August 1914.

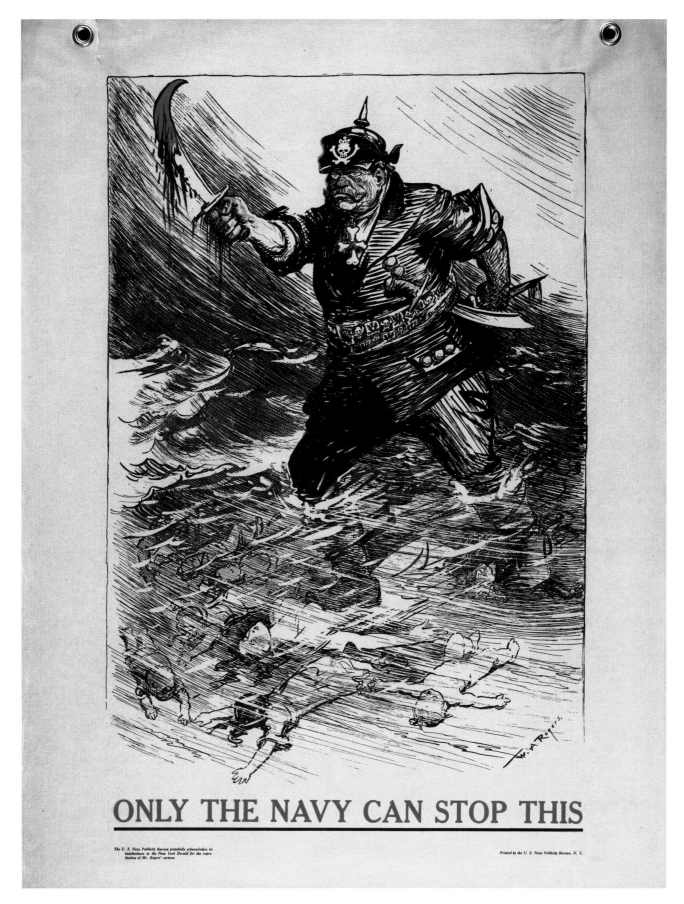

ONLY THE NAVY CAN STOP THIS

The U. S. Navy Publicity Bureau gratefully acknowledges its indebtedness to the New York Herald for the reproduction of Mr. Rogers' cartoon.

Printed by the U. S. Navy Publicity Bureau, N. Y.

PRINT NO. 39 AMERICA, 1917. "ONLY THE NAVY CAN STOP THIS." WILLIAM ALLEN ROGERS

Russia, which got an early ugly lesson in German modern mobile warfare in its thrashing at Tannenberg at the end of August 1914, feared getting overrun—as it was in Russian Poland and other border areas—before it could bring to bear its superiority in numbers.

Serbia, with an army of just 180,000, appeared to be the most vulnerable of the Allied nations. Indeed, Austria-Hungary in the first weeks of the war bombarded and then invaded Serbia and captured its capital, Belgrade. But the much larger Habsburg army underestimated the fighting qualities of the Serb defenders who twice fought the Austrians to a standstill and then drove them out of Serbia.

But Serbia could not long withstand the superior numbers of the Central Powers. A three-part invasion by Austro-Hungarians, Germans, and Bulgarians in late 1915 overpowered the country before other Allied nations could join that fight, and Serbia was finally and completely defeated.

The Serbian army, ravaged by typhus and hunger, retreats across the Albanian mountains in 1915.

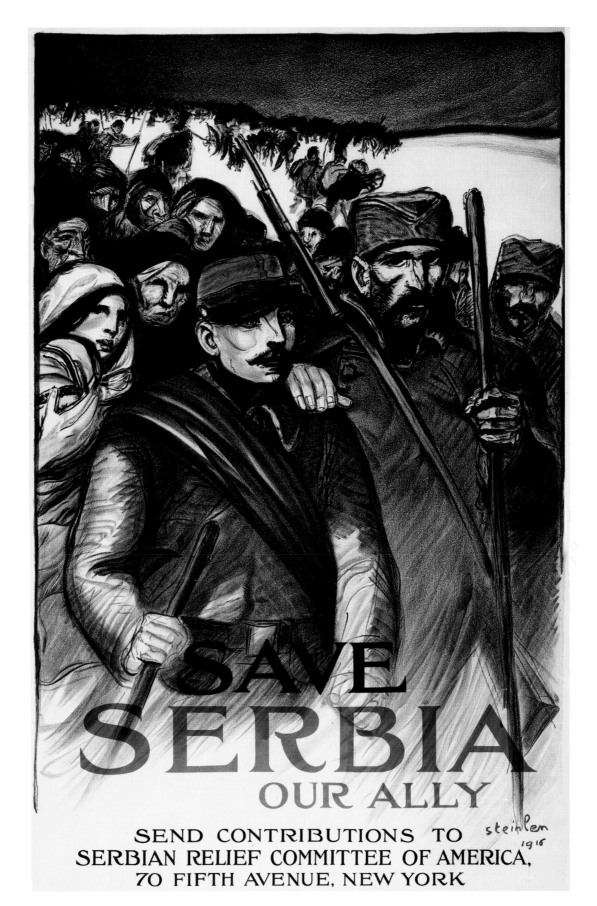

PRINT NO. 40 AMERICA, 1916. "SAVE SERBIA OUR ALLY." THEOPHILE ALEXANDRE STEINLEN

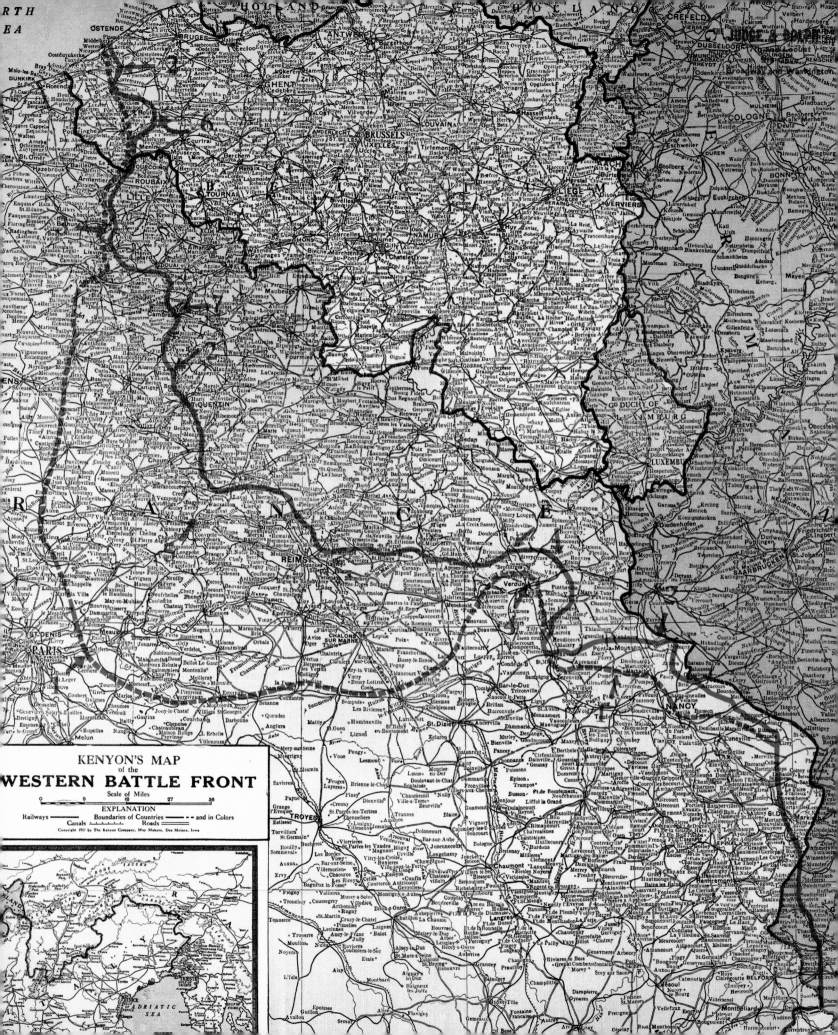

KENYON'S MAP
of the
WESTERN BATTLE FRONT

Scale of Miles

EXPLANATION
Railways ——— Boundaries of Countries ———
Canals ——— Roads ——— and in Colors

Copyright 1917 by The Kenyon Company, Map Makers, Des Moines, Iowa

The WESTERN FRONT

T he Western Front was the major and decisive theater of operations throughout World War I. It was fought in Belgium and France on the west and Germany on the east, most of it as the trench warfare that has come to be synonymous with "World War I." Most of it was fought on—or in—Belgian and French soil, and on a scale that was matched in history only by wars in the ancient world. ❖ The first major attack of the war occurred on the Western Front when the German army invaded Belgium on August 4, 1914. Major battles continued there until the November 11, 1918, armistice was declared. Then, as Erich Maria Remarque titled his great war novel, it was indeed *All Quiet on the Western Front*. ❖ While the war spread into a global conflict among many nations, the fighting on the Western Front remained the main event—the arena where the war would be won or lost.

The war's decisive battle zone extended from the English Channel some 440 miles to Switzerland.

France, anticipating a possible attack by Germany, had fortified its eastern border in the prewar years with major strongholds at Belfort, Épinal, Nancy, Toul, St. Mihiel, Verdun, and Reims. The German army had long decided, in its advance plan conceived by its former chief of staff, General Alfred von Schlieffen, to ignore those fortresses and outflank them with a rapid sweeping attack through Belgium to Paris, intending to defeat France in just six weeks. That plan soon went awry as events and military decisions in the field derailed it, while the initial fighting on both sides was characterized by maneuver and comparatively rapid movement of the large and newly mobilized armies.

France had its own advance plan (Plan 17) emphasizing the offensive. French commander in chief General Joseph Joffre quickly launched a counterattack in Alsace-Lorraine, which was just as quickly stalled against German fortification and thrown back with unprecedented casualties (nearly 300,000 in two weeks) by a powerful German force that French intelligence had underestimated.

A small British Expeditionary Force (BEF), two corps under the command of Sir John French, forming the vanguard of an eventual massive commitment, landed at Le Havre and Boulogne on August 9, 1914. Outnumbered by German General Alexander von Kluck's oncoming First Army, the British resisted for one day, then were forced into a two-week-long retreat. But von Kluck, by then overextended and lacking good intelligence, abandoned his planned sweep around Paris and moved back east, opening a gap in the German lines that was quickly exploited in a counterattack that, along with the now-strengthened BEF, drove the disorganized German forces into a retreat. They settled into positions along the Aisne

General Alexander von Kluck and the German First Army failed to deliver the knockout blow to France as envisioned in the Schlieffen Plan.

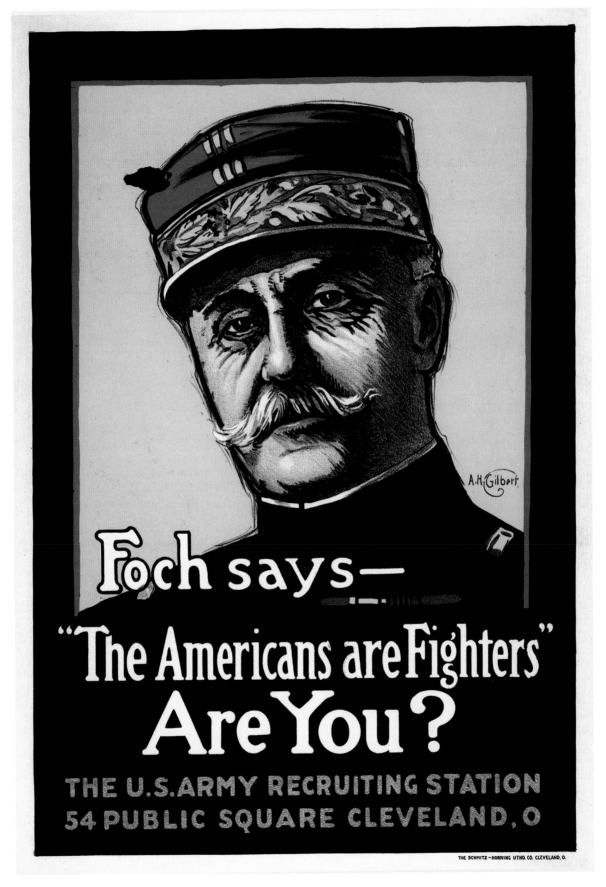

PRINT NO. 41 AMERICA, 1917-1918. "FOCH SAYS — 'THE AMERICANS ARE FIGHTERS' ARE YOU?" A.H. GILBERT

River and fought one last all-out battle at Ypres and lost. That was the end of maneuver warfare on the Western Front and the beginning of the trench system that would finally stretch from the Swiss border to the North Sea—and the beginning of the stalemate that would continue until the armistice.

The *Totenbrücke*—Bridge of the Dead—spans the Moselle River in Metz. The picture-postcard city was in the German-claimed Alsace-Lorraine.

STALEMATE AND CASUALTIES

The German command realized that their plan to conquer France swiftly had failed and they were in for a long war of attrition that—given the size of their opponents—they were unlikely to win. As the armies on both sides of that long trench line grew in numbers and firepower, a long series of major battles over the next four years would gain little territory and incur enormous casualties. Both sides would try various tactics in search of a war-ending strategic breakthrough—aerial bombardment, use of poison gases, innovative massing of artillery, tunneling and mining under enemy lines, flamethrowers, and the invention and deployment of self-propelled heavy weapons dubbed "tanks"—all essentially to no avail. The two sides were too evenly matched, too well-entrenched in strong defensive positions, and too wedded to unimaginative hammer-blow offensive tactics to achieve a strategic breakthrough.

On the continuously fought-over no-man's land between the trench lines, the essential futility of ever-more-massive frontal attacks was underscored by the frightful casualty lists of soldiers killed, wounded, and missing in the tens of thousands. The location names of those battles (some

PRINT NO. 42 FRANCE, 1916. "SAVE THE WINE FOR OUR INFANTRY SOLDIERS." SUZANNE FERRAND

numbered as the fighting was repeated on the same killing grounds) still resonate a century later as shorthand for mass horror: Ypres, Aisne, Arras, Belleau Wood, Cambrai, Cantigny, Château-Thierry, Loos, Marne, Mons, Passchendaele, Reims, St. Mihiel, Soisson, Somme, and Verdun.

The numbers of young men dead and maimed in these industrial-scale battles defy real comprehension (all numbers are approximate): 130,000 French at Aisne; nearly 60,000 British on July 1, 1916, the first day of the Somme battle; over 300,000 British/Canadians in three months at Passchendaele (aka Third Ypres) along with nearly 200,000 Germans; over 377,000 French and 337,000 Germans in the 10-month battle for the French fortress at Verdun. Attrition indeed: At Verdun, a memorial ossuary contains the bones of some 130,000 French and German soldiers who

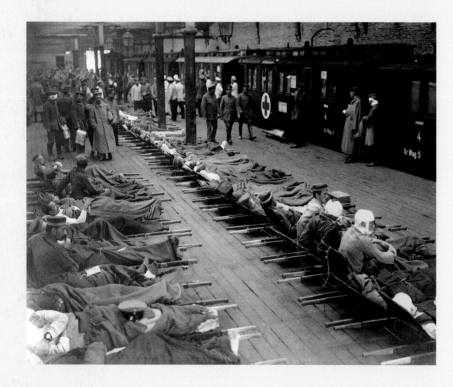

Soldiers wounded in the Battle of Cambrai are loaded onto a hospital train.

PRINT NO.43 FRANCE, 1917. "FRENCH VETERANS OF THE GREAT WAR." GEO DORIVAL & GEORGES CAPON

could not even be identified after the battle—a number that was about equal to the total population of Houston, Texas, at the time.

The fighting on the Western Front demonstrated some bedrock truths about modern industrial warfare: the destructive power of massed rapid-fire artillery, the futility of frontal attacks on fortified machine-gun positions, the obsolescence of horse cavalry and saber attacks, the importance of intelligence and rapid reliable communications.

ATTRITION AS POLICY

Battles in other theaters of the war also incurred massive numbers of casualties that in some cases were equal to those on the Western Front, some of those battles undertaken in efforts to break the stalemate there. But both sides came to accept that this was essentially a war of attrition, and the side that first ran out of manpower, materiel, money, food, fuel, and other resources would surely lose.

Germany deliberately locked into the 1916 fight over Verdun as a declared effort "to bleed the French Army white," on the assumption that while Verdun had scant strategic importance, it had so much emotional importance to France as the nation's strongest defensive position, that a loss there would be intolerable. Germany's assumption was correct but in the event, the strategy backfired when German losses there equaled those of France.

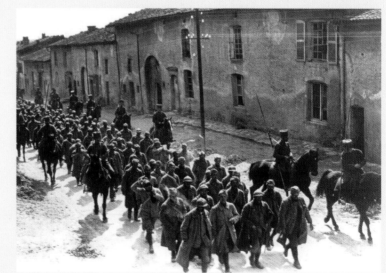

French soldiers report to Verdun in 1916. During the battle, some 12,000 soldiers a day traveled into the city.

aux petits réfugiés

Là fut notre maison...

PRINT NO. 44 FRANCE, 1915. "TO THE YOUNG REFUGEES — HERE USED TO BE OUR HOME." TANCREDE SYNAVE

Germany gained a reprieve from its own pathway to military exhaustion in 1917 when Russia was convulsed by riots and revolution, along with severe military setbacks—notably at the Baltic port of Riga, where a lightning German attack stampeded the Russian Twelfth Army. Russia finally collapsed out of the war as entire units began refusing to fight, and by autumn, Russian deserters totaled in the millions. The German army was then able to transfer dozens of divisions from the East to bolster its forces on the Western Front, a move it lost no time in making.

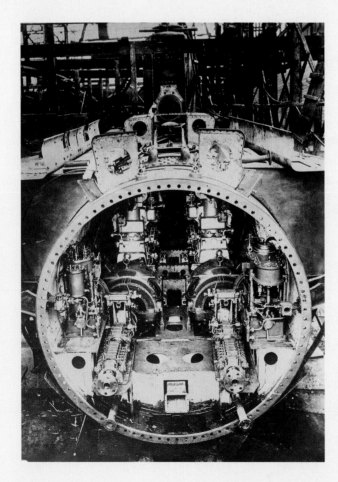

The engine compartment of a German *Unterseeboot;* U-boats crippled Britain's ability to import food and other supplies.

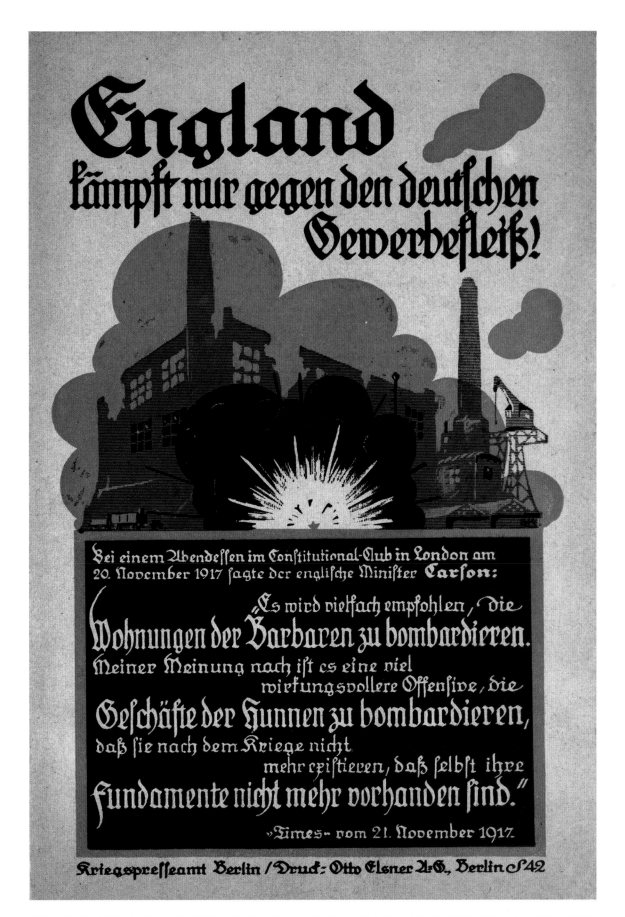

PRINT NO. 45 GERMANY, 1917. "ENGLAND FIGHTS ONLY AGAINST GERMAN INDUSTRIOUSNESS." OTTO EISNER

That reprieve came just in time for Germany, as its strategic decisions, especially the move in February 1917 to resume unrestricted submarine warfare, finally provoked America's entry into the war on the Allied side. From that day—April 6, 1917—forward, Germany was locked in a race to prevail on the Western Front before the resources of the United States could be brought to bear on the desperate struggle in Europe.

Germany came close to winning that race. Numbed and demoralized by the ruinous casualties suffered at Verdun in 1916, and in General Robert Nivelle's ill-considered and disastrous offensive at Chemin des Dames in April 1917, French soldiers and entire units went on a sort of military strike with many declining to return to the front lines and refusing to fight. With scant reserves to fall back on, the French army leaders were compelled to address the problem. Among other changes in plans, that meant a pause in large-scale offensives.

LUDENDORFF TAKES CHARGE

With Germany essentially under the political as well as military control of Generals Erich Ludendorff and Paul von Hindenburg by midsummer of 1917, Ludendorff judged that only the British could mount major actions. With German morale declining and political unrest rising, Ludendorff decided that a massive offensive against the British on the Western Front offered the best hope of victory—or at least of a breakthrough. Able to achieve numerical superiority in some sectors of the Western Front having retrained infantry units in what became known as "storm-trooper" tactics, and adopting the artillery innovations pioneered in the East by Colonel Georg Bruchmüller, Ludendorff launched the first of his major offensives, Operation Michael, in March 1918. Initially, the Germans did break through—in an unprecedented advance of some 40 miles on a broad front.

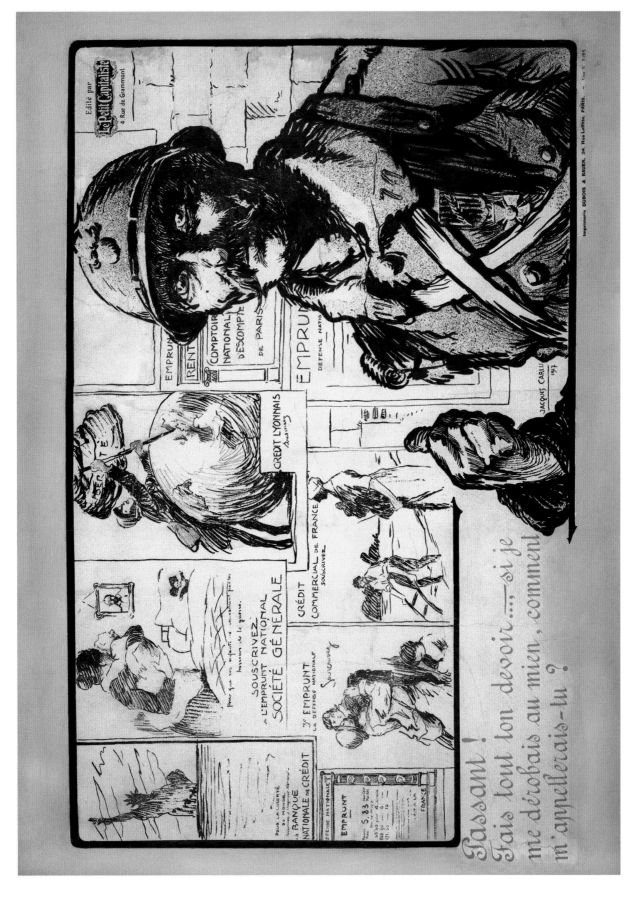

PRINT NO. 46 FRANCE, 1917. "HEY YOU! DO YOUR DUTY. IF I DIDN'T DO MINE WHAT WOULD YOU CALL ME?" JACQUES CARLU

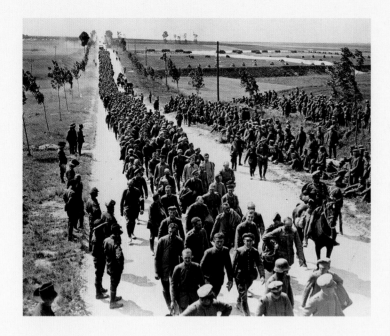

German prisoners of war arrive at a British camp on the Western Front.

But German casualties were high and irreplaceable, the British Third Army stood fast, and the exhausted German troops were finally unable to reach the key transportation junction at Amiens. Ludendorff's big tactical push did not achieve strategic breakthrough. Instead Michael proved to be the first in a pattern of increasingly costly and strategically futile lunges through the summer of 1918: Operation Georgette, Operation Blücher-Yorck, Operation Hagen, Operation Gneisenau, and Operation Marneshutz-Reims. The losses were unsustainable, supplies were dwindling. Ludendorff had failed.

On August 8, 1918, the British army, resupplied and reinforced, launched a furious surprise counterattack at Amiens. Time had run out. Germany lost its race against the Allies; American and Commonwealth soldiers had arrived and joined the fighting. Ludendorff himself dubbed that day, when thousands of German soldiers surrendered, the "Black Day for the German Army." The end, on the all-important Western Front, was near.

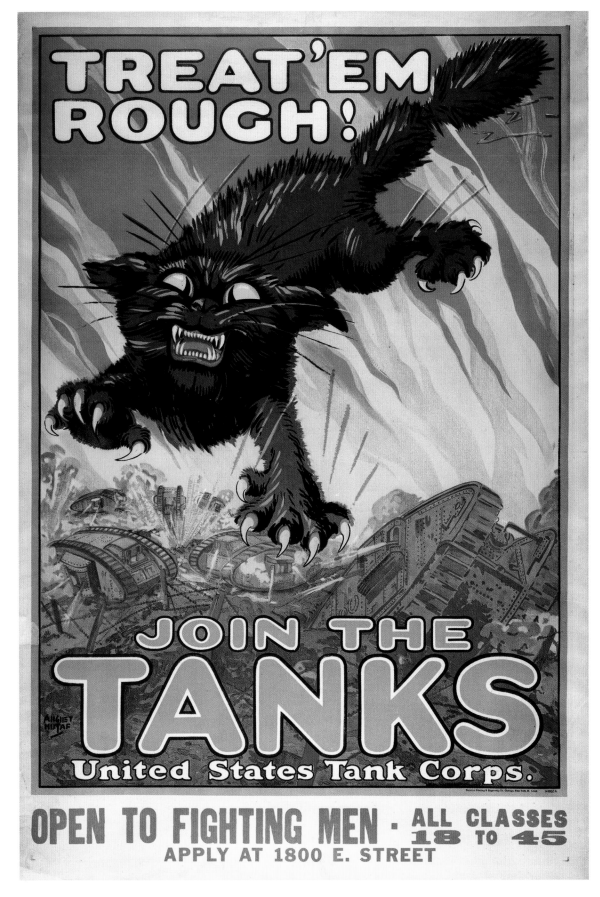

PRINT NO. 47 AMERICA, 1918. "TREAT 'EM ROUGH!" AUGUST WILLIAM HUTAF

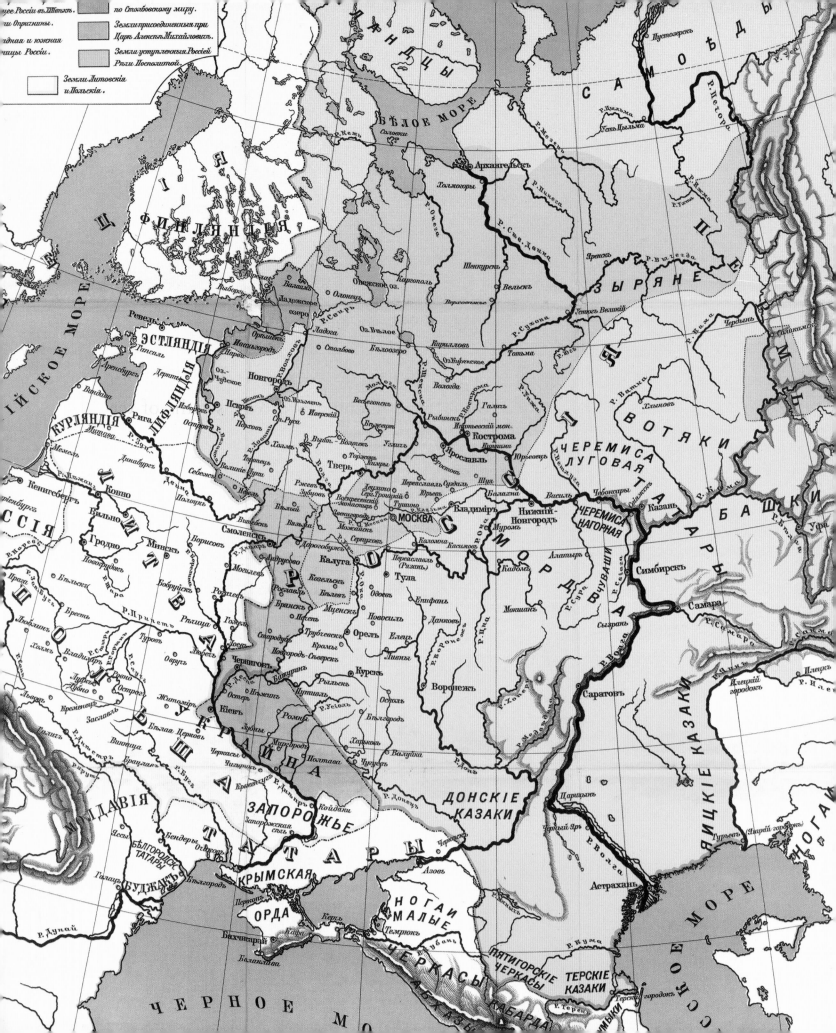

The EASTERN FRONT

From the start, the Great War on the Eastern Front was an undertaking of great size. ❖ Big numbers appear in nearly every category: There were enormous armies clashing on fronts stretching over vast swaths of territory, retreating record numbers of miles, suffering huge numbers of casualties, and capturing many thousands of prisoners. ❖ Yet, despite the large scale of the warfare, much of what occurred there has faded from collective memory in the West. Mention, for instance, the bitter winter campaign of 1914-1915 in the Carpathian Mountains, in present-day Romania, Ukraine, and Poland, and the response is likely to be a blank stare. But the horrific fighting there between the Russian army and the Austro-Hungarian—and some German—forces cost over a million men in just a few months. That is more than were lost at the much more familiar lengthy battles at Verdun or the Somme.

Eastern Europe's battle zone extended from the Baltic Sea to the Balkan states and the Black Sea.

Germany had long been concerned about the difficulties of fighting a two-front war, but planned to knock its traditional enemy France out of the war quickly and then turn its attention to Russia. It declared war on both nations in the first week of August 1914, and sent only a comparatively small force of a dozen divisions to the East, mostly to protect East Prussia. Germany's ally, the Austro-Hungarian Empire, however, actually sought a two-front fight. Its rashly aggressive chief of staff, Field Marshal Franz Conrad von Hötzendorf, had divided his army in two, first sending invaders into nearby Serbia (where they were soundly thrashed) and then sending nearly 30 divisions on an early offensive into Russian Poland in mid-August.

Russia, with its vast territory and poor networks of both roads and railroads, had major difficulties in bringing its large and disorganized army to bear. Nonetheless, pressured by its already beleaguered ally France, it managed to kick off an invasion of East Prussia in August 1914 with two

Looking more like peasant farmers than soldiers, Russian prisoners are allowed water by their East Prussian captors.

large armies: The First Army under General Pavel von Rennenkampf crossed into East Prussia from the north, planning to rendezvous with the Second Army under General Aleksandr Samsonov, which was advancing from the south. The Russians, with nearly half a million soldiers, planned to encircle and trap the smaller German force of about 175,000.

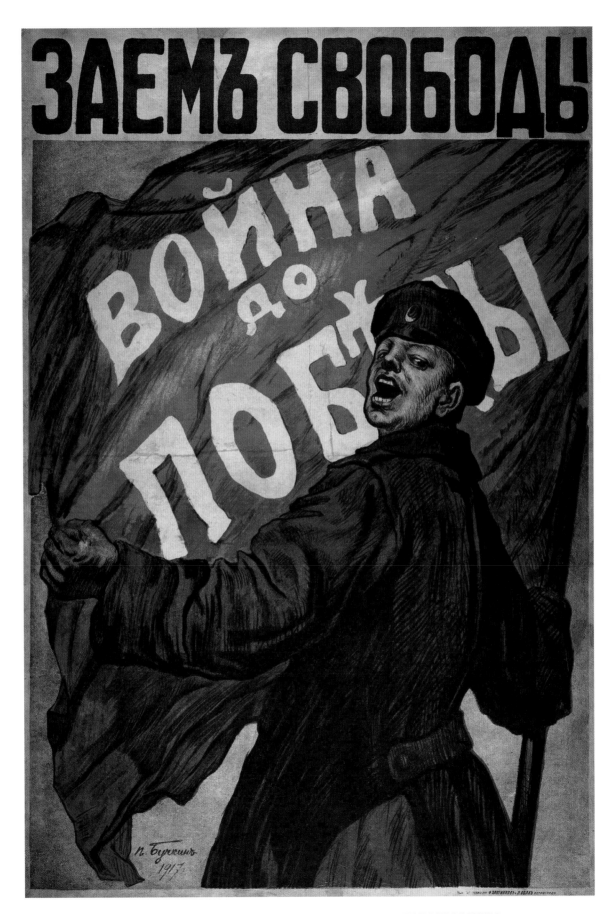

PRINT NO. 48 RUSSIA, 1917. "LIBERTY LOAN: WAR TO VICTORY." PETR DMITRIEVICH BUCHKIN

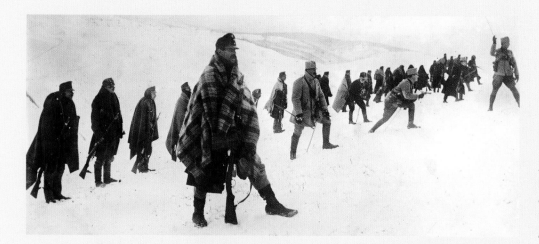

Austrian soldiers brave a fierce and often fatal winter in the Carpathian Mountains.

It was not to be. In the Battle of Tannenberg—named for a small village that was once the site of a 15th-century battle in which the powerful Teutonic Knights were destroyed by an inferior but larger Polish army—the poorly led Russians were out-generaled, outmaneuvered, outwitted, and out-fought by the Germans. The hapless Russian leaders moved uncertainly and seemed not to grasp where the Germans were or what was happening. Moreover, the Russian forces communicated openly without using coded messages, allowing the Germans to anticipate their every move. The result was a debacle at the end of August in which the Germans focused on the Russian Second Army, which they encircled and essentially destroyed, inflicting some 50,000 casualties and taking about 90,000 prisoners.

Tannenberg was the first big battle in the East and it set a pattern for much of what was to follow there. It also introduced and popularized the two officers who would prove to be Germany's best battlefield commanders and tacticians, General Paul von Hindenburg and Chief of Staff Erich Ludendorff, who would in the course of the war rise to the very top command of the German military—and de facto, of the German nation.

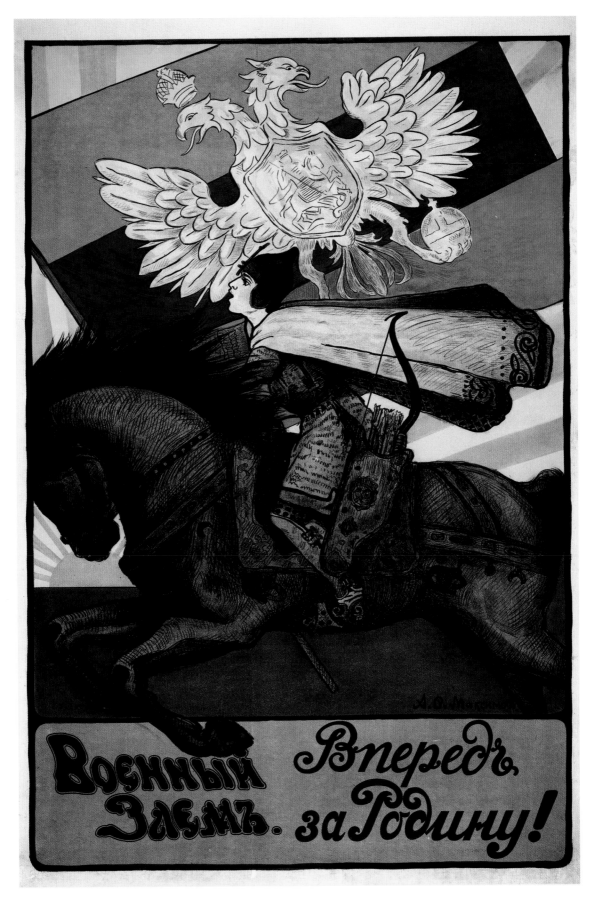

PRINT NO. 49 RUSSIA, 1914-1915. "WAR LOAN FOR THE COUNTRY!" ALEKSANDR O. MAKSIMOV

During that autumn and early winter of 1914, Hötzendorf's attacks against Russia met increasingly stiffening and costly resistance. The Austrians were driven backward into the Carpathians, resulting in the wintry disaster noted above and essentially the destruction of the prewar Austrian army. Germany, for its part, understood that it would have to come to the rescue of its only ally, Austria, and under German military leadership, launched the first of a pattern of joint offensives in the East. They succeeded in pushing the Russians out of Poland, inflicting many casualties, and taking many prisoners. Again, staggering numbers characterize the fighting in the East: With both Russia and Germany clashing mercilessly on Polish lands and showing no regard for the civilian inhabitants, the fighting in 1915 succeeded in generating over 3 million refugees. By then, it had become clear to all the combatant nations on all fronts that their initial ideas for a short, sharp, and decisive war was merely a grand illusion, and that they were facing a long slog of deadly attrition, with no end in sight.

German troops come to the aid of their Austrian allies in the Carpathians. They turned back the Russians in the spring of 1915.

RUSSIAN STRENGTHS

Another hard truth that emerged on the Eastern Front was the sheer overpowering scale of the theater of operations: The armies were big, but the landscape was far bigger, and the transportation and supply challenges were well nigh insurmountable. There were simply not enough roads or rail lines

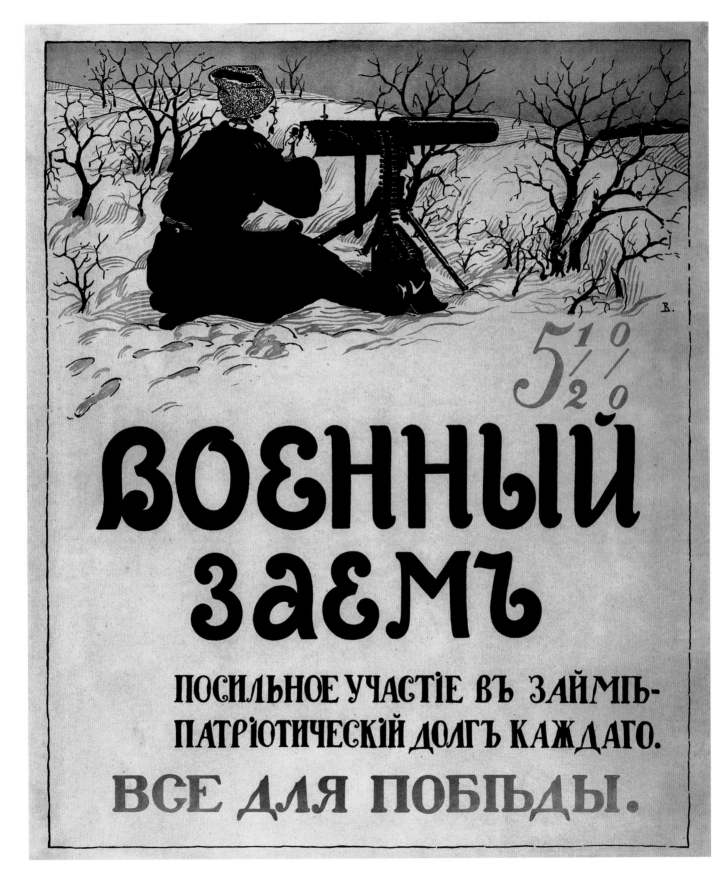

PRINT NO. 50 RUSSIA, 1914-1915. "WAR LOAN: EVERYTHING FOR VICTORY."

to move large military units quickly. Moreover, the vast scale of the lands ruled out any notion of the strong defensive—entrenched—positions that characterized the fighting on the Western Front. The sheer mileage and the harsh winters largely favored the Russians—as those factors had favored them in Napoleon's time and would again in World War II. The magnitude of the much larger Russian population also set some of the major conditions of combat on the Eastern Front. Russia could afford to lose large numbers on the Polish plains and in the Carpathian Mountains; Austria and Germany could not. Where Russia could bring those numbers to bear on the battlefield, they had something of an edge, despite their early deficiencies in transportation, weapons, communications, intelligence, and leadership.

Czar Nicholas II faced failures on the battlefield and deepening social and political strife at home.

In the early summer of 1915, the combined forces of Germany and Austria-Hungary launched an 18-division surprise attack through Galicia that broke the Russian line. In two weeks, the Russians were driven back nearly 100 miles. A second German army attacked in the north and quickly advanced to capture Warsaw. The German forces advanced some 300 miles and when it seemed that nothing could stop them, Russia itself stalled their advance. They outran their supply lines and wore out their soldiers. Still, the attack was a brilliant tactical success on the part of the Central Powers. The Russians suffered nearly a million casualties and nearly another million captured, but the attack failed to destroy the Russian army and failed to knock Russia out of the war. This was a pattern that the Germans were to

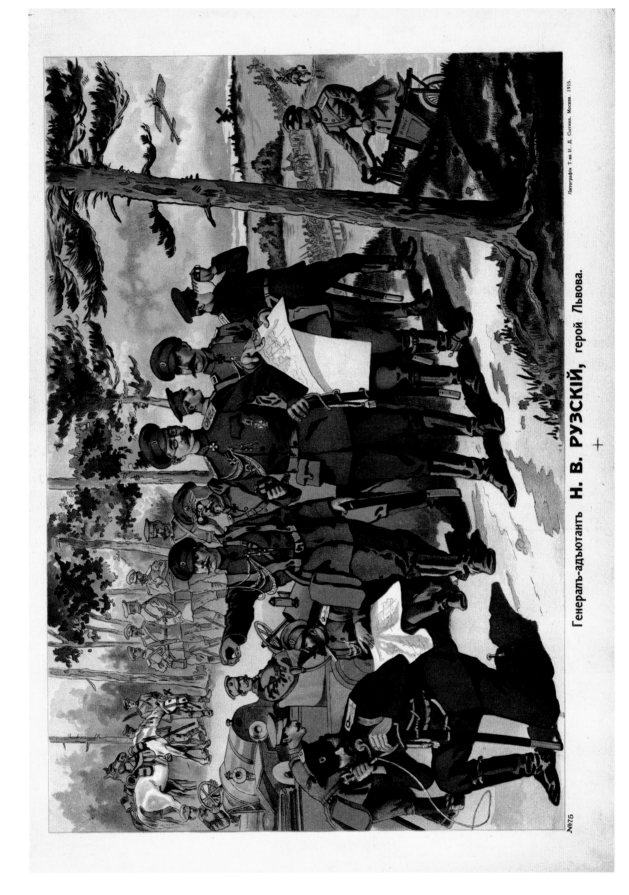

Генерал-адъютантъ **Н. В. РУЗСКİЙ**, герой Львова.

Литографія Т-ва И. Д. Сытина. Москва. 1915.

PRINT NO. 51 RUSSIA, 1915. "ADJUTANT GENERAL NIKOLAI RUZSKY, THE HERO OF LODZ." IVAN D. SYTIN

repeat again and again on the Western Front as well: brilliant tactical victories but no strategic triumph.

Such attacks had another consequence: They shook the Russian government to the extent that in late summer, Czar Nicholas II dismissed his uncle, Grand Duke Nicholas, and assumed command of the army himself—a responsibility for which he was manifestly unsuited, intellectually and temperamentally.

Several factors shed light on why the Russian army was able to withstand and recover from losses and setbacks that likely would have finished off any other military organization. One is that the ordinary soldiers, who were mostly illiterate peasants, were inured to hardships and setbacks, and were—in the field—tenacious fighters. A second is that due to its size, Russia was far more able to trade space for time and control than were any of its antagonists. And of course, there were those enormous reserves—millions of conscripts. There were also occasional flashes of aggression and risk-taking, if not tactical brilliance, among the Russian commanders.

General Alexei Brusilov led the 1916 summer offensive that cost both sides 3 million dead, wounded, or captured.

One such officer was General Alexei Brusilov, commander of the Russian Southern Front. By mid-1916, the Russians had retreated out of Russian Poland altogether and had thus shortened their front lines after withstanding costly attacks by the Germans and Austrians. At that time, in mid-May, the Austrians had shifted their main strength to their own southern border where they launched an offensive against a reeling Italian army

Kaiser-Geburtstags-Spende

für Deutsche Soldatenheime an der Front

PRINT NO. 52 GERMANY, 1916. "KAISER'S BIRTHDAY DONATION FOR GERMANY, SOLDIERS' HOUSES AT THE FRONT." MAX ANTLERS

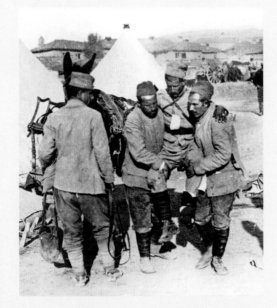

A wounded Serbian soldier is carried to a Red Cross station in the Balkans.

along the Isonzo River that threatened a major breakthrough. Italy sought a diversionary attack from its allies, and Brusilov, facing a reduced Austrian front, obliged by launching a large-scale assault that came to be known as the Brusilov Offensive. For a month or so, the Russian army stampeded the hapless Austrian defenders, who lost hundreds of thousands as casualties and to capture, but his offense, while causing concern among the Central Powers could not be sustained: Brusilov lacked the reinforcements and even the munitions to exploit his initial success, while strong German reinforcements stiffened the Austrian resistance.

That offensive was arguably the pinnacle achievement of the Russian army in World War I. Brusilov and some other commanders undertook additional offensives, but they were negated by the superior military effectiveness of the German army. By the end of 1916, the incompetent and corrupt Russian government, and indeed the civil order in Russia, was coming apart. Food shortages, transportation failures, and burgeoning strikes corroded the support for and authority of the czar's government. The continual high casualties and frustration at the army's inept conduct of the war led to increasing resistance to and evasion of military service. Desertions became rampant and uncontrollable.

Lest We Forget
LITHUANIA

United Lithuanian Relief Fund of America, Inc.
19 W. 44 St., New York 18, N. Y.
A Member Agency of the National War Fund

PRINT NO. 53 AMERICA, 1918. "LEST WE FORGET LITHUANIA." M. DOBUZINSKY

RUSSIA DROPS OUT

Early in 1917, food riots swelled into actual revolution, as the police and army in the capital, Petrograd, refused to act against the rioters and instead made common cause with them. Desertions and armed mutinies brought the military to a standstill. Czar Nicholas abdicated the Russian throne and his family was arrested.

A provisional government, led by Aleksandr Kerensky, sought to continue the war and indeed launched a Kerensky Offensive in June of that year against the Austrians at Lemberg in Poland. But by then the Russian army was increasingly unreliable and after a couple of days' advance, stopped fighting. German reinforcements had arrived to bolster the Austrians, and the Russians were again routed.

In August 1917, the German Eighth Army launched a lightning cross-river attack on the Baltic port city of Riga that featured innovative storm-trooper tactics and a complex and devastating artillery barrage orchestrated by Germany's artillery genius, Colonel Georg Bruchmüller—in what amounted to a dress-rehearsal for tactics that would soon prove very effective on the Western Front. In the event, the Germans took just three days to destroy the Russian Twelfth Army at Riga and send the remnants fleeing eastward. In the political chaos that ensued, Vladimir Lenin's Bolsheviks supplanted Kerensky. For the Russian army—and the Eastern Front—the Great War was over.

Provisional Minister of War Aleksandr Kerensky exhorted Russian soldiers in the summer of 1917 to continue the war.

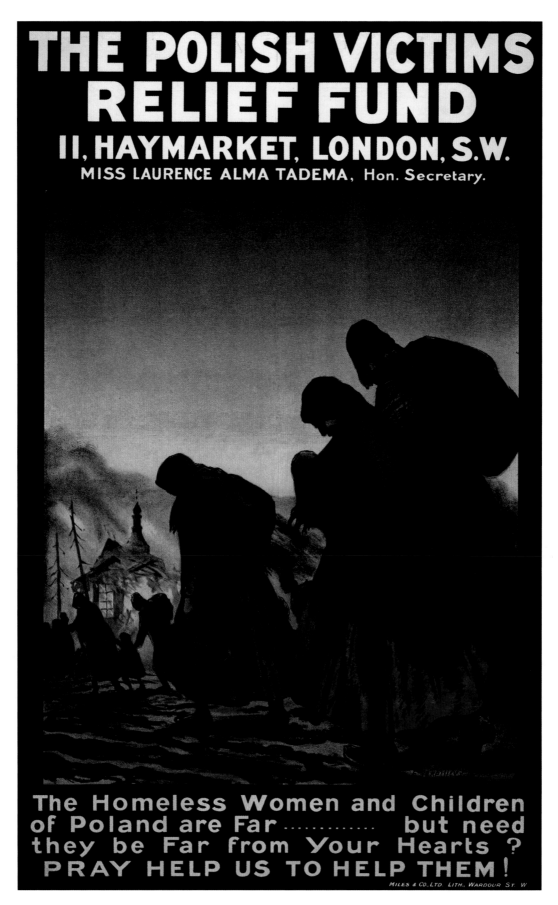

PRINT NO. 54 ENGLAND, 1915. "THE POLISH VICTIMS RELIEF FUND." EMILE ANTOINE VERPILLEUX

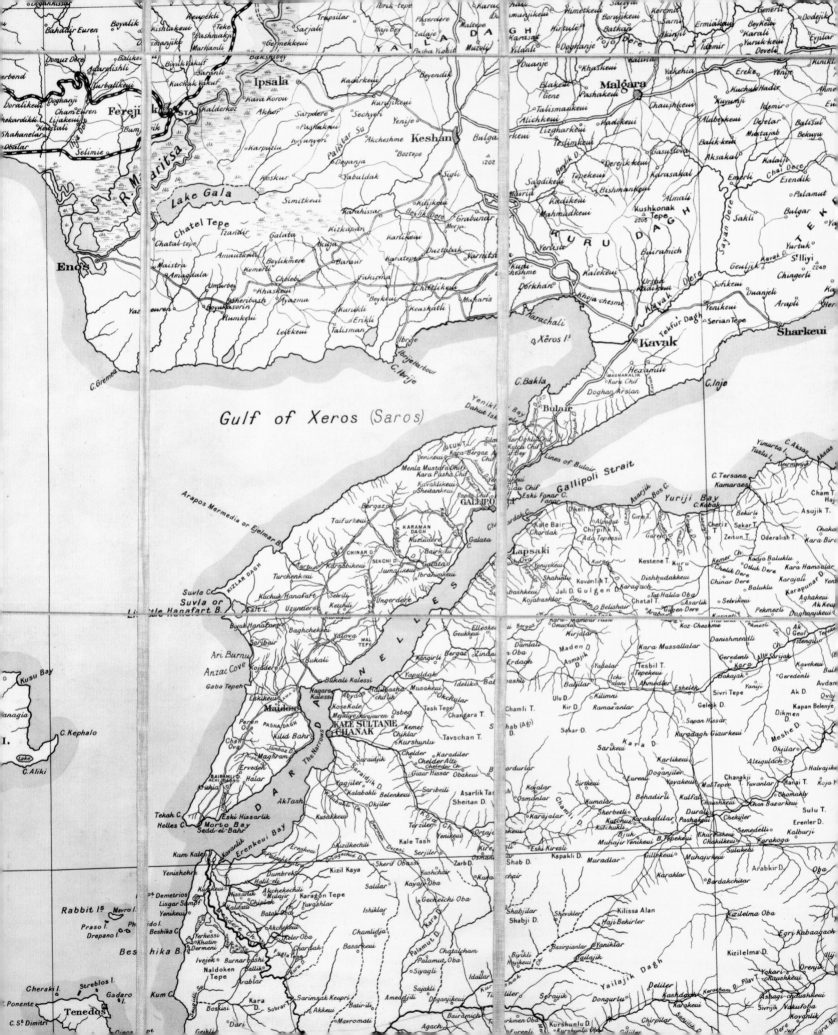

1915

As the Great War bled into 1915, the leaders of the combatant nations raised the stakes. The war was expanding, and not just because two new belligerents—Italy and Bulgaria—were preparing to take the battlefield. New strategic and tactical ideas were unveiled, new technologies employed, new fronts opened, new diplomatic initiatives undertaken—all in an effort to gain advantage in a conflict that, some six months since its start, was already becoming an attritional slog. ❖ Most of the new ventures would fail—some disastrously. The commanders marshaling troops were sometimes foolish and often callous. They put a cheap price on life as they chased victories, and by the end of the year the only tangible reality was that hundreds of thousands of soldiers would be dead without a significant shift in the fortunes of either side. It began to appear that no one had a good idea of how to win this war.

Britain and France attacked Turkey in the narrow Dardanelles linking the Aegean and the Black Sea, and on the Gallipoli Peninsula.

One example: Ottoman Minister of War Enver Pasha personally left Constantinople to take charge of his Third Army. He aimed to attack Russia in the Caucasus in middle of winter. The decision meant marching his men in light clothes through mountain passes in heavy snow and bitter cold. Nearly an entire army corp froze to death, followed by Pasha's abject defeat in the Battle of Sarikamis. He blamed his incompetence on Armenians—the Christian minority in the Ottoman Empire—setting the stage for the systematic killing of some 800,000 to 1.5 million Armenians, one of the first examples of modern genocide. Nineteen fifteen, then, would be a year of widespread horrors and bloody stalemate.

On the Western Front, British and French troops had launched a broad offensive in the Artois and Champagne regions of northwest France. By then the Germans were dug in defensively—mobile maneuver giving way to grinding trench warfare. It meant pounding enemy lines with artillery then rushing forward to seize a few miles of enemy territory, especially towns or high ground deemed significant. Problem was, nothing more than the small territorial gains was feasible—even with heavy numerical advantages—and came at a great cost in casualties. The Germans had established their tactic of "defense in depth," which involved placing a small number of troops in the front line and then concentrating manpower and materiel in second and third lines, farther back, which could be brought forward in counterattack. And so the Champagne offensive, which lasted for about four months and would be resumed in the autumn of 1915 with a second offensive and the Battle of Loos, fizzled out.

Field Marshal Sir Douglas Haig, the controversial commander of British forces on the Western Front, racked up huge casualty rates.

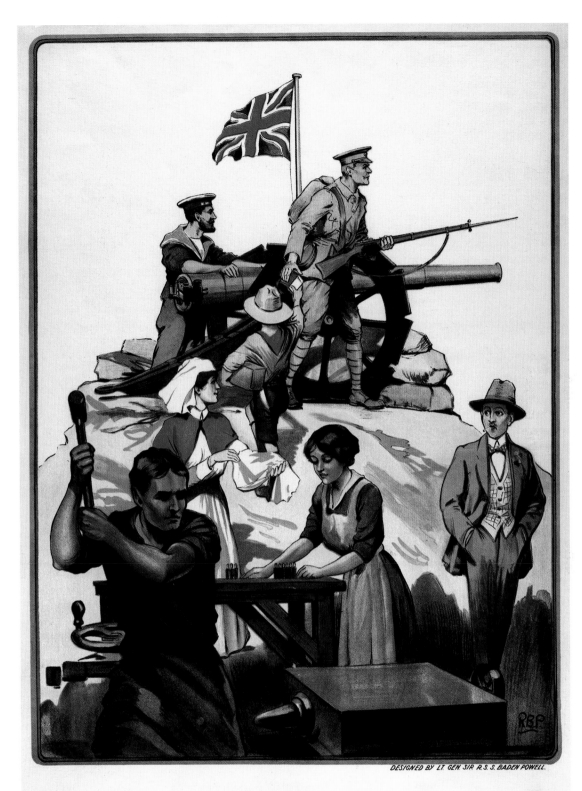

PUBLISHED BY THE PARLIAMENTARY RECRUITING COMMITTEE. LONDON. POSTER NO.112. PRINTED BY JOHNSON, RIDDLE & CO., LTD., LONDON. S.E.

PRINT NO. 55 ENGLAND, 1915. "ARE YOU IN THIS?" LT. GEN. R.S.S. BADEN-POWELL

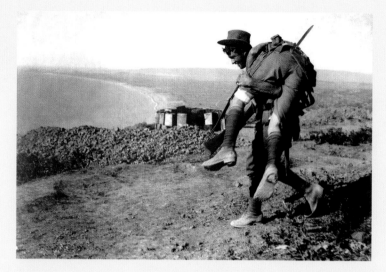

An Australian soldier rushes a wounded comrade to the hospital during the disastrous 1915 Dardanelles Campaign.

Germany, meanwhile, decided to devote most of its military might to the east, against Russia. Its Masurian Lakes offensive in East Prussia, in February, was successful, inflicting heavy casualties on the poorly equipped Russians, but the Austro-Hungarian Imperial Army's winter campaign against the same foe in the Carpathian Mountains failed miserably, marked by poor planning and leadership. In the first of two offensives under General Franz Conrad von Hötzendorf, chief of the Austro-Hungarian general staff, the losses from fighting, freezing, and starvation totaled 75 percent. Germany was forced to take over more of the Habsburg military command structure.

But Germany failed in its spring defense of the Carpathian stronghold of Przemysl and lost over 100,000 prisoners to the Russians. The Austro-German forces renewed their offensive drive and by autumn captured Warsaw. With the Russian armies in retreat, and total casualties topping 1.5 million, Czar Nicholas II made the fateful decision to take supreme command of his armies, leaving the capital, Petrograd, at a time of great uncertainty, suspicion, and unrest. Two years later, the Russian Revolution would force him to abdicate, ending the Romanov dynasty.

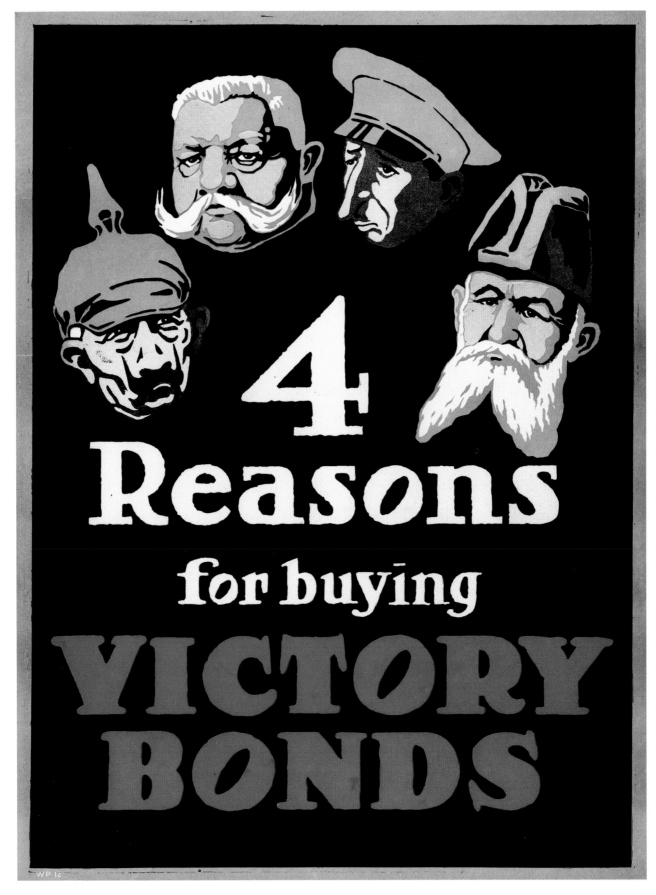

PRINT NO.56 CANADA, 1917. "4 REASONS FOR BUYING VICTORY BONDS."

Germany got more aggressive and innovative in a number of ways. It introduced new weaponry in the air, on the sea, and on land. In January it launched its first Zeppelin attack against Britain—dropping bombs on the east coast—and then later its airships targeted London. The attacks were meant to inflict as much psychological as physical damage on the Brits. It was a bold stroke that stoked fear for a time. What's more, during the summer the Germans grabbed air superiority with a new single-seat fighter plane developed by Anthony Fokker, a Dutchman. The Fokker-Eindecker plane was the first to feature synchronization gear that enabled the pilot to fire a machine gun through the propeller without damage. British and French pilots called the new German aerial campaign the "Fokker scourge," and began referring to themselves as "Fokker fodder."

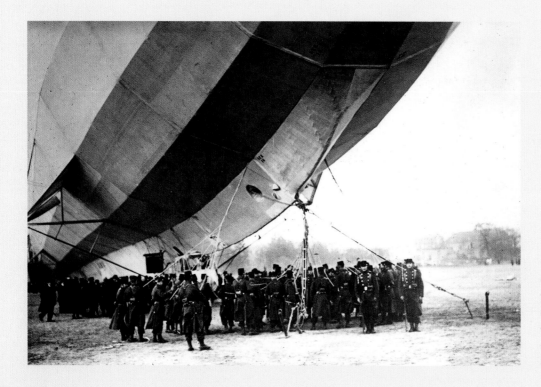

German Zeppelins, early in the war, could fly longer distances and carry heavier payloads than airplanes. Zeppelin raids caused some 1,500 casualties in Britain.

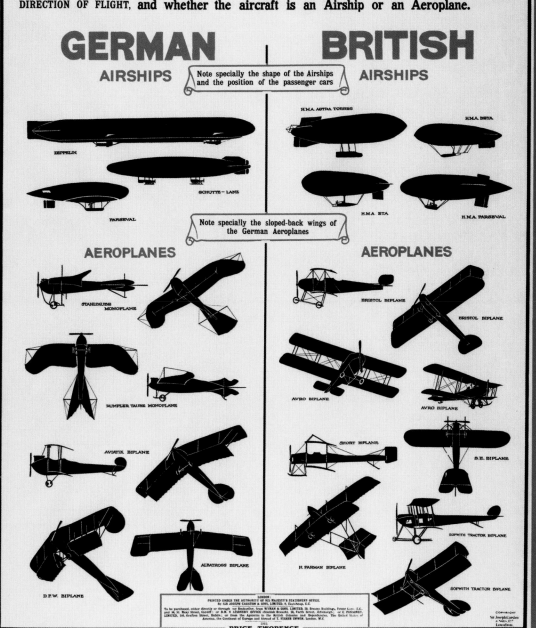

PUBLIC WARNING

The public are advised to familiarise themselves with the appearance of British and German Airships and Aeroplanes, so that they may not be alarmed by British aircraft, and may take shelter if German aircraft appear. **Should hostile aircraft be seen,** take shelter **immediately** in the nearest available house, preferably in the basement, and remain there until the aircraft have left the vicinity: do not stand about in crowds **and do not touch unexploded bombs.**

In the event of **HOSTILE** aircraft being seen in country districts, the nearest Naval, Military or Police Authorities should, if possible, be advised immediately by Telephone of the TIME OF APPEARANCE, the DIRECTION OF FLIGHT, **and whether the aircraft is an Airship or an Aeroplane.**

GERMAN ## BRITISH

AIRSHIPS — Note specially the shape of the Airships and the position of the passenger cars — AIRSHIPS

ZEPPELIN

SCHUTTE – LANZ

PARSEVAL

H.M.A. ASTRA TORRES

H.M.A. BETA

H.M.A. ETA

H.M.A. PARSEVAL

Note specially the sloped-back wings of the German Aeroplanes

AEROPLANES AEROPLANES

STAHLTAUBE MONOPLANE

RUMPLER TAUBE MONOPLANE

AVIATIK BIPLANE

ALBATROSS BIPLANE

D.F.W. BIPLANE

BRISTOL BIPLANE

BRISTOL BIPLANE

AVRO BIPLANE

AVRO BIPLANE

SHORT BIPLANE

B.E. BIPLANE

SOPWITH TRACTOR BIPLANE

H. FARMAN BIPLANE

SOPWITH TRACTOR BIPLANE

LONDON:
PRINTED UNDER THE AUTHORITY OF HIS MAJESTY'S STATIONERY OFFICE.
By SIR JOSEPH CAUSTON & SONS, LIMITED, 9, Eastcheap, E.C.

To be purchased, either directly or through any Bookseller, from WYMAN & SONS, LIMITED, 29, Breams Buildings, Fetter Lane, E.C. and 54, St. Mary Street, Cardiff ; or H.M.'S STATIONERY OFFICE (Scottish Branch), 23, Forth Street, Edinburgh ; or E. PONSONBY, LIMITED, 116, Grafton Street, Dublin ; or from the Agencies in the British Colonies and Dependencies, The United States of America, the Continent of Europe and Abroad of T. FISHER UNWIN, London, W.C.

PRICE TWOPENCE

COPYRIGHT
Sir Joseph Causton
& Sons, Ltd
London

PRINT NO.57 ENGLAND, 1915. "PUBLIC WARNING: GERMAN AIRSHIPS, BRITISH AIRSHIPS." PRINTED BY JOSEPH CAUSTON & SONS

NEW WEAPONS

On the sea, German submarines were deployed to blockade Britain and menace Allied shipping. The Germans warned that any vessels passing through war zones would be targeted. They made good on the threat, sinking the British steamship *Falaba* on March 1—the first passenger ship to be destroyed.

On May 7, a German submarine sank the British liner *Lusitania*, killing 1,198 people, including more than 100 Americans. The ship was carrying tons of military equipment to Britain, which the Germans had suspected. The sinking of the *Lusitania* was one of the war's signal events, as it irrevocably turned American opinion against Germany.

On land, the Germans also pushed the technological—and ethical—envelope. During their only significant offensive on the Western Front in 1915, the Second Battle of Ypres, the Germans were the first nation to use poison gas. At 5:00 p.m. on April 22, along a four-mile stretch of the front in the Flanders region of western Belgium, German soldiers opened by hand 5,700 canisters of chlorine gas and watched a greenish-yellow mist drift with the wind toward the Allied front

The *Lusitania* was making its 202nd Atlantic crossing between Liverpool and New York when it was sunk in 1915.

PRINT NO.58 ENGLAND, 1915. "COME ALONG, BOYS!" W.H. CAFFYN

line manned by the French Colonial Corps. Some 6,000 French soldiers, mainly Algerians, died of asphyxiation within 10 minutes; another 4,000 troops were incapacitated; many were captured by the Germans during their advance following the gas release. In a war memoir, a British soldier named Anthony R. Hossack, of Queen Victoria's Rifles, recalled what his unit saw as French colonial troops fled from the gas:

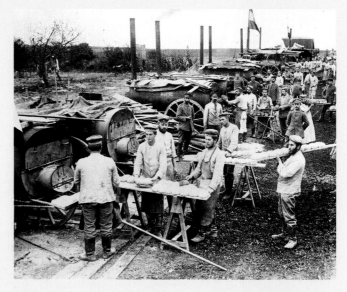

A German field bakery near Ypres, Belgium. The German army received over a billion kilos of flour between 1914 and 1916.

"Plainly something terrible was happening. What was it? Officers…stood gazing at the scene, awestruck and dumbfounded; for in the northerly breeze there came a pungent nauseating smell that tickled the throat and made our eyes smart. The horses and men were still pouring down the road, two and three men on horse. I saw, while over the fields streamed mobs of infantry, the dusky warriors of French Africa; away went their rifles, equipment, even their tunics that they might run the faster. One man came stumbling through our lines. An officer of ours held him up with a leveled revolver. 'What's the matter, you bloody coward?' says he. The Zouave was frothing at the mouth, his eyes started from their sockets, and he fell writhing at the officer's feet."

The German gas attack violated the Hague Convention of 1899, which outlawed the use of poison gas in war. Germany justified the move by claiming that the French had used asphyxiating gas in grenades and light artillery shells—and produced a French military memorandum to prove its point. Like most siege offensives, the German effort at Ypres failed. After their initial retreat from the gas, the Allies regrouped and kept the Germans from taking Ypres, though it was destroyed by artillery bombardment.

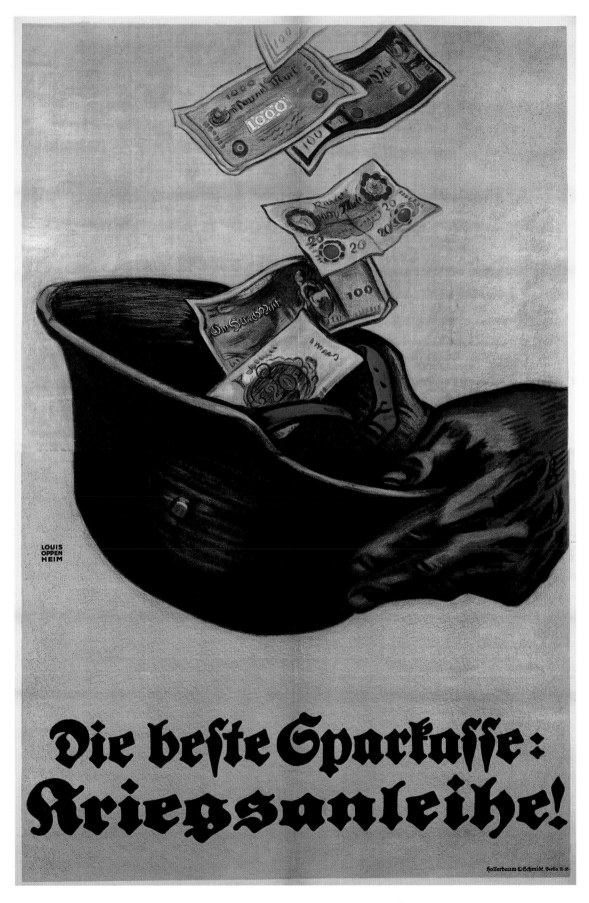

PRINT NO. 59 GERMANY, 1917. "THE BEST SAVINGS BANK: WAR LOANS." LOUIS OPPENHEIM

Later in the year, when launching their Loos offensive, the British deployed gas against the Germans for the first time, but with mixed success as shifting winds blew some of the gas back into British lines. Britain's Royal Flying Corps made a name for itself in this battle. It used new wireless transmitters to help artillery units with their targeting and engaged in the first-ever organized tactical bombing, blowing up German troops, trains, and railroad lines.

A seven-man team prepares to load a heavy-artillery shell for an Austro-Hungarian mortar on the Italian Front.

The Battle of Loos, which began in late September and featured two main clashes, was meant to reestablish mobile warfare. But the British could not achieve a breakthrough and suffered some 60,000 casualties, nearly twice the German total. Field Marshal Sir Douglas Haig blamed British Expeditionary Force commander in chief Sir John French for the failure—he was slow to dispatch reserves to support the attack's initial success. British leaders in London, including Secretary of State for War Horatio Kitchener, agreed: French was relieved of his command and replaced by Haig.

DARDANELLES DISASTER

French wasn't the only leader to suffer ignominy. Winston Churchill, who, as first lord of the admiralty, had pushed the idea of opening a third major front by attacking the Ottomans in the south, was replaced by Herbert Asquith. The British aimed to push destroyers through the Dardanelle Strait, land troops on the Gallipoli Peninsula, and whip Ottoman troops perceived

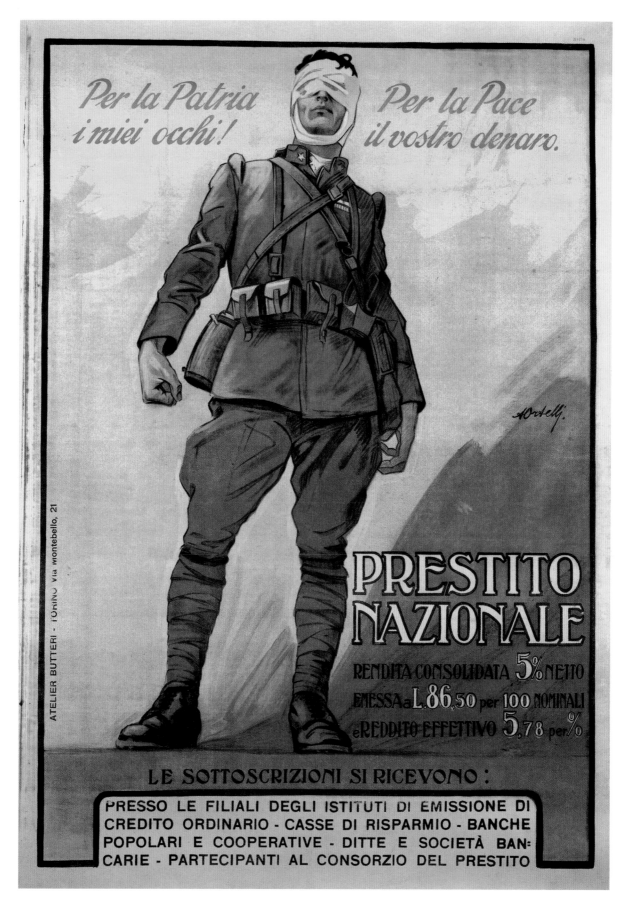

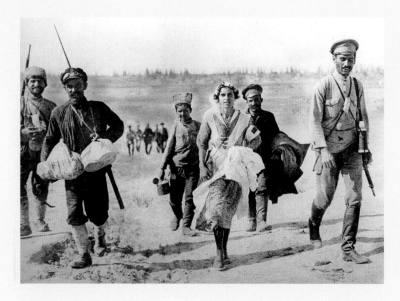

Many thousands of Armenians were forced into the Syrian desert by the Ottoman Empire.

to be inferior. Germany, the British thinking went, would have to assist the Turks and devote manpower to a third front, reducing its overall strength.

It was a clever strategy and the campaign started well, with British battleships destroying Turkish forts on the Dardanelles. But a month later, on March 18, a combined French and British battle fleet went on the attack in the Dardanelles. Six Royal Navy battleships hit mines; three sank and the other three were hobbled. The Admiralty lost its nerve and withdrew. The Brits then commenced a multi-force military landing. Some 70,000 British, French, and Australian and New Zealand Army Corps (ANZAC) forces landed at different locations on the peninsula and aimed to link up. But the Turks controlled the high ground and the Allies failed in two separate attempts to break out of their positions. By December, eight months after the first landings, the Allied troops were being withdrawn. Britain's Gallipoli Campaign had failed. It was one of the most humiliating military defeats in the nation's history. Churchill resigned and later heaped scorn on the British tendency to spare its proud navy but squander infantry lives.

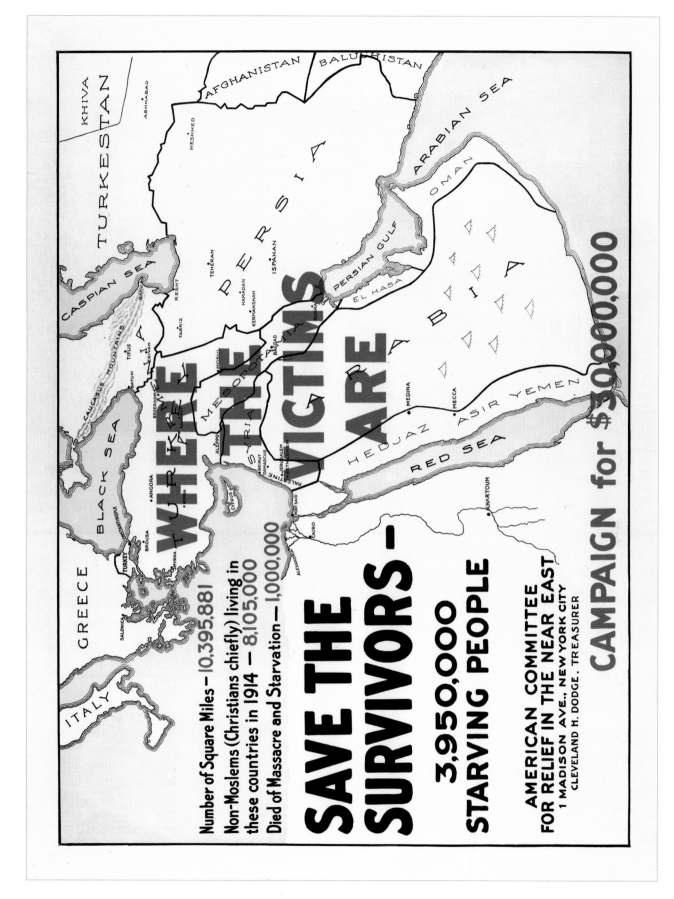

PRINT NO. 61 AMERICA, 1918. "WHERE THE VICTIMS ARE." AMERICAN COMMITTEE FOR RELIEF IN THE NEAR EAST

Both Italy and Bulgaria had geostrategic value and stayed neutral early on, waiting for overtures from each side. They got them. The Allies courted Italy because of its border with Austria-Hungary, and offered the Italians numerous postwar land concessions, including Trieste, southern Tyrol, and northern Dalmatia, in exchange for a pledge to join the war within a month. Italy agreed, signed the Treaty of London in April, and a month later declared war on Austria-Hungary. It began a series of futile battles against the Austrian Imperial Army on its northern frontier.

Germany, meanwhile, promised Bulgaria the Serbian province of Macedonia if it fought for the Central Powers. Bulgaria agreed, and in October 1915 it joined the invasion of Serbia by Germany and Austria-Hungary, declaring war on the Serbs on October 14.

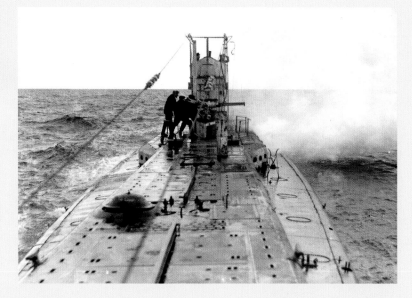

A U-boat fires at an Allied ship, April 1917. Deck guns were particularly effective against unarmed merchant vessels.

Both countries learned bitter lessons. Though the Italians had chosen the winning side, Italy would not get the territory promised to it. For its part, Bulgaria's decision would be ruinous: It fell out with the Turks, had problems with Germany—and was eventually beaten by Allied forces in Macedonia. All that, combined with serious economic and food problems, forced Bulgaria to sign an armistice with the Entente that, by war's end, left the country broke and battered, its dream of a greater Bulgaria gone. Every warring nation had grand plans in 1915, and most went bloody wrong.—R.E.

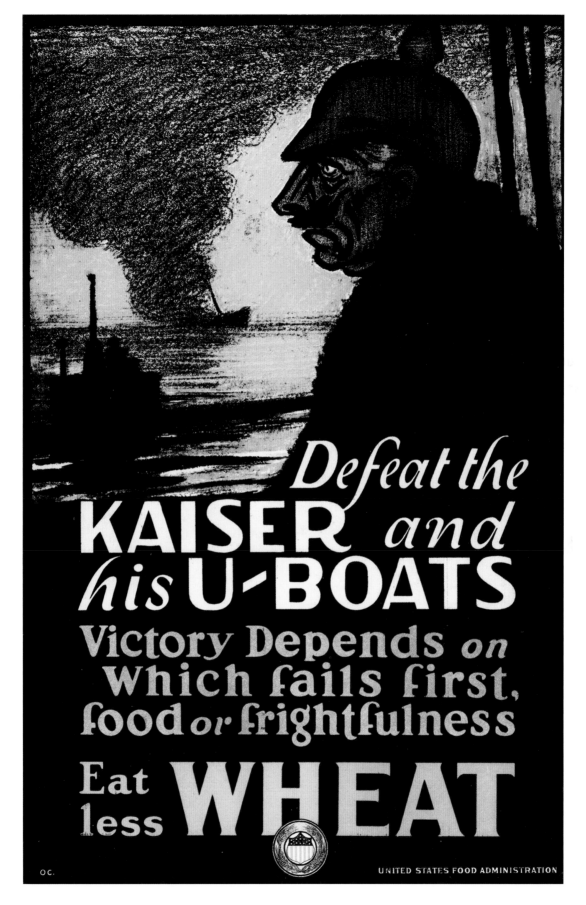

PRINT NO. 62 AMERICA, 1917-1918. "DEFEAT THE KAISER AND HIS U-BOATS." UNITED STATES FOOD ADMINISTRATION

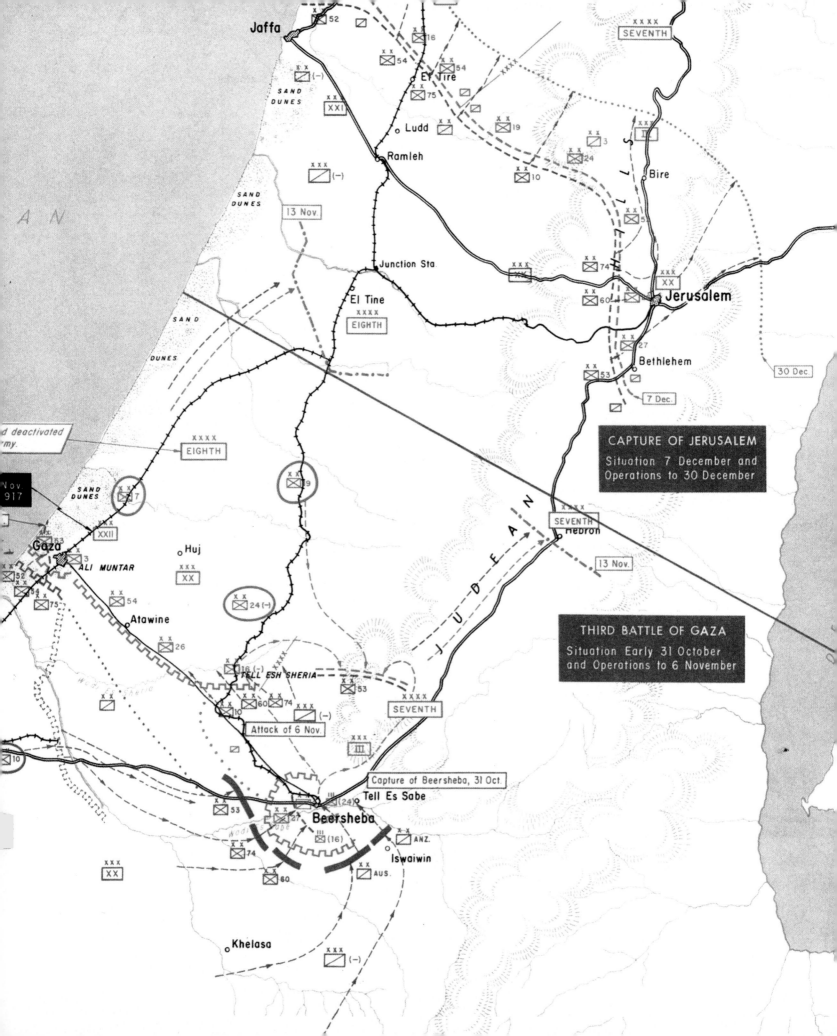

Jaffa

52

16

54

El Tire

SAND
DUNES

54

75

XXI

19

Ludd

3

24

I

Ramleh

Bire

SAND
DUNES

10

13 Nov.

A N

SAND
DUNES

Junction Sta.

74

Jerusalem

5

60

El Tine

XXXX
EIGHTH

27

Bethlehem

53

30 Dec.

7 Dec.

d deactivated
rmy.

XXXX
EIGHTH

CAPTURE OF JERUSALEM
Situation 7 December and
Operations to 30 December

Nov.
917

SAND
DUNES

7

19

XXXX
SEVENTH

Hebron

XXII

13 Nov.

Gaza

3

ALI MUNTAR

Huj

XXX
XX

52

24 (-)

THIRD BATTLE OF GAZA
Situation Early 31 October
and Operations to 6 November

54

75

Atawine

26

J U D E A N

16 (-)

TELL ESH SHERIA

53

10

60

74

(-)

SEVENTH

Attack of 6 Nov.

III

Capture of Beersheba, 31 Oct.

10

Tell Es Sabe

53

(24)

27

Beersheba

74

(16)

ANZ.

XXX
XX

60

Iswaiwin

AUS.

Khelasa

XXX
(-)

GLOBAL *Conflict*

I t's ironic, given its name, but World War I isn't typically perceived as a global conflict. That's because the war has largely been identified in the public mind with the brutal slugfest in northeastern France and Belgium, where many of the epic battles took place. ❖ But World War I truly was an international armed struggle. There was fighting in Euro-Asia—most notably the failed Gallipoli offensive by the British—but also in the Middle East (Persia, Mesopotamia, Palestine), China, and in the western Pacific. There were battles in Africa, where proxy armies for colonialist combatants Germany and Britain fought bitter territorial battles in the bush—ending all pretense of their "civilizing mission" on the "dark continent." Hundreds of thousands of people died in a prolonged East Africa campaign that was considered an insignificant sideshow during the war and that has since been largely forgotten.

In the Middle East, British and French forces battled Ottoman Empire forces in Palestine and Syria.

Once started in earnest, World War I promised a great geostrategic reshuffling in an age when strong nations routinely bullied weaker ones and when territorial conquest was accepted. There was opportunity for ambitious leaders with a powerful military—and an equal measure of risk for those who did nothing. To a certain extent, in certain places, the war was an extension of the so-called Great Game in the late 19th and early 20th centuries, when the big powers sought to expand their spheres of influence and, in doing so, to claim valuable new resources such as coal and oil.

Japan was one distant nation that played a supporting role in the war. It had been an ally of Britain since 1902, and when the war began London asked Tokyo for help pushing Germany out of its colonial possessions in China and the Pacific region. Japan, eager for more influence and possessing a stout military, agreed. On August 15, 1914, it sent Germany an ultimatum, ordering it to turn over Tsingtao, its colony in China's coastal Shandong Province, to Japan. Germany did not respond, and so Japan declared war on August 23. The Imperial Japanese Navy then began a blockade of Tsingtao, followed by a naval bombardment. During this campaign, Japan conducted the first-ever naval-launched air raids, against Austrian and German cruisers and gunboats along with targets on land. In early September

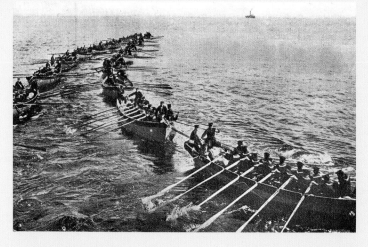

Japanese "blue-jackets" arrive to lay siege to Tsingtao in 1914. Japan's 60,000 troops included a British battalion.

Japanese troops landed in Shandong and started a siege of Tsingtao. On November 7, German and Austrian colonial forces in the city surrendered. Nearly 5,000 troops were taken prisoner. A month earlier, in October, the

PRINT NO. 63 JAPAN, 1904-1905. "JAPANESE BATALLION CHARGING AROUND TEISH , KOREA, RUSSO-JAPANESE WAR." KASAI TORAJIRO

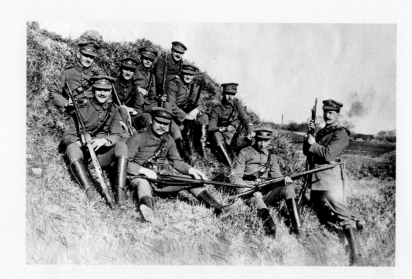

German defenders of Tsingtao. The Germans were out-numbered nearly 13 to 1 by the Japanese.

Japanese navy had seized several Germany island colonies in the South Pacific that had been part of the Imperial German Pacific Protectorates—among them the Marianas, the Marshall Islands, and the Carolines.

Australia also got involved in the effort to oust Germany from the region. In September 1914, troops from the Australian Naval and Military Expeditionary Force captured German New Guinea—in the northeast part of the island—along with the nearby Bismarck Archipelago and the North Solomon Islands. Australia suffered its first war casualties when six men were killed during an assault on the island of Neu-Pommern (now New Britain).

JAPAN'S OVERREACH

In 1915, Japan secretly presented China with its 21 Demands. Japan essentially insisted, under threat of war, that China grant it special privileges throughout the country—affirm its mining and railway concessions in Shandong, southern Manchuria, and central China, and give it access to various ports and bays along the coast. It also demanded that China stop leasing land to other foreign powers—and it wanted Japanese advisors to

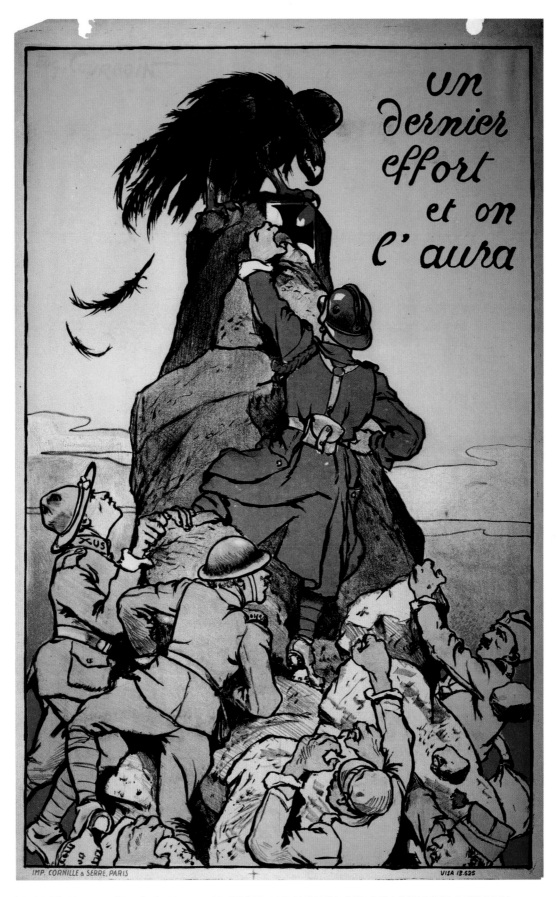

PRINT NO. 64 FRANCE, 1918. "ONE LAST EFFORT AND WE WILL GET THEM." EUGENE COURBOIN

take charge of political and economic affairs in China. That effectively would have turned China into a Japanese protectorate.

At that time China was in a period of turmoil following the collapse of the Qing Dynasty in 1912—the country's last imperial authority. Long the dominant power in East Asia, China had become weak and fallen under the yoke of European imperialists, losing two opium wars to Britain in the mid-1800s and being forced to grant concessions to other European nations. China's leaders stalled in responding to the Japanese demands, hoping for outside support, which came when the United States expressed strong opposition to the Japanese advisory stipulation. Japan retracted that demand, and China reluctantly capitulated on most of the others.

China had declared its neutrality when the war began. But, as author and archaeologist Matthew Leonard writes, by 1916 it too "had been sucked into the vortex of a global conflict, for the madness of Europe was creating a new world order, a geo-political tree, laden with the fruits of power and influence, and many wanted to sample its wares." Unless China could "regain influence on the world stage," notes Leonard, "she would find herself cut adrift" when the war ended. China essentially supported France and Britain, and declared war on Germany in 1917.

The German colonial government began evacuating "nonessential civilians" from Tsingtao in August 1914.

Problem was, China had little to offer the Allies, except labor. France and Britain needed workers, and so tens of thousands of Chinese men were crammed into transport ships and sent to France and Belgium. There they worked in camps close to the front, many in the town of Noyelles, France, near the Somme. "Straightaway," writes Leonard, "they were put to work on the railways and docks, as well as in tank workshops in northern France.

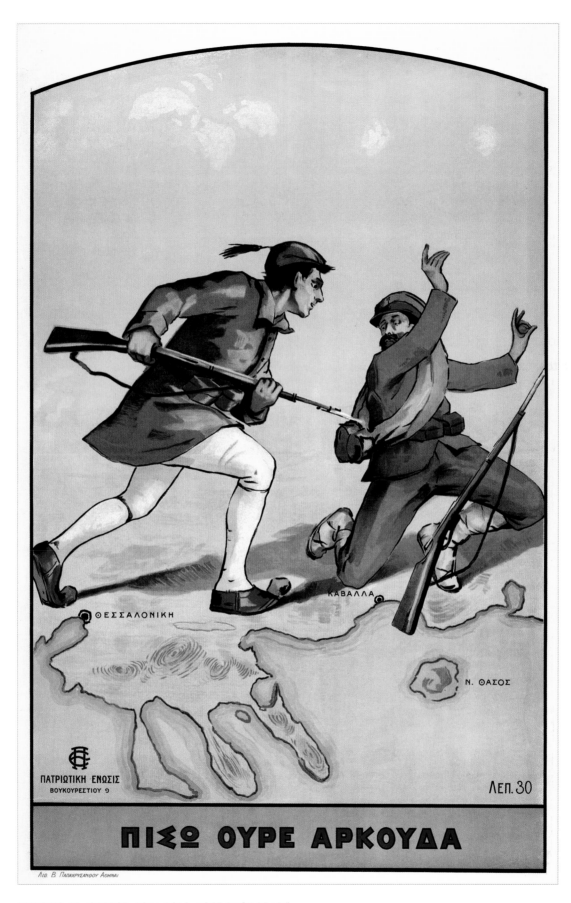

PRINT NO.65 GREECE, 1914–1918. "GET BACK BEAR."

They also toiled in factories, forests and mines. They would often have to carry out hazardous tasks such as carrying live ammunition. At the end of their shifts they would return to camps surrounded by barbed wire, whose proximity to the front meant that they would often be bombarded by German artillery." Conditions were harsh, but workers were paid and given decent food rations.

In the end, some 140,000 Chinese worked in France—and there are rough estimates that more than 2,500 Chinese workers were killed during the war, but nobody really knows. After the war, many of the Chinese stayed in France; others, according to Leonard, "were abandoned to their fate in the chaotic period after the grand finale."

Chinese officials hoped the Treaty of Versailles would end the embarrassing dominance of their country by outsiders, but they had little clout. Japan was a different story. In addition to ousting Germany from China and the Pacific islands, it had sent warships to the Mediterranean and elsewhere to escort Allied ships carrying troops to Africa, the Middle

Chinese Labour Corps workers with a basket of bread near Caëstre, France, July 14, 1917, just before the Third Battle of Ypres.

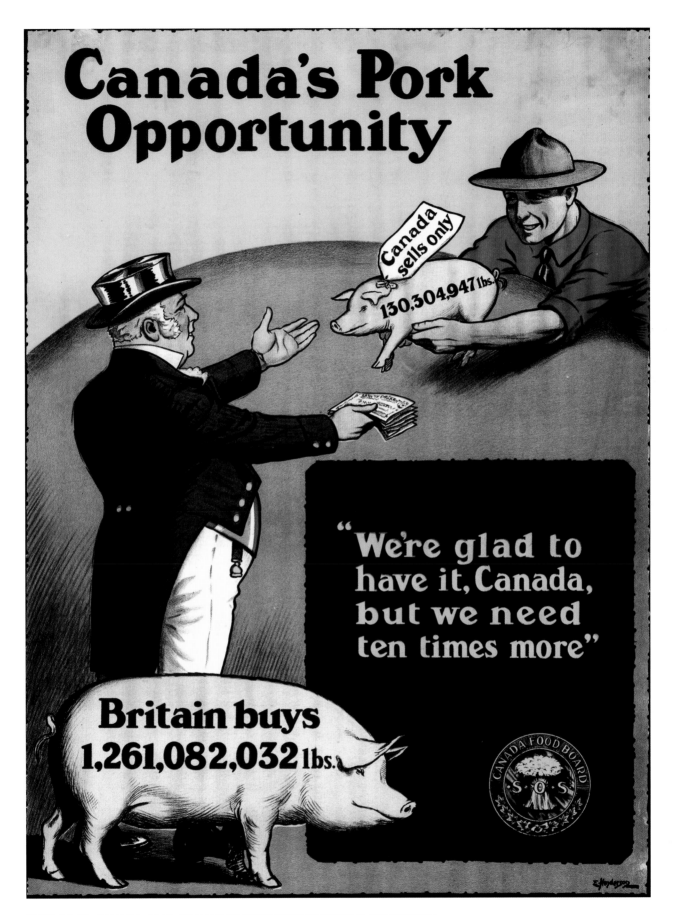

PRINT NO. 66 CANADA, 1918. "CANADA'S PORK OPPORTUNITY." E. HENDERSON

East, and to and from Europe. At the peace conference, Japan argued that it must maintain control of China's Shandong Province. American president Woodrow Wilson, breaking his own commitment to the principle of self-determination, agreed to Japan's request. Japan signed the Treaty of Versailles. China did not.

AFRICAN CAMPAIGNS

In Africa, imperialist European nations—Belgium, Britain, Germany, France, and Italy—had been rivals since the 1880s, when they'd all started dividing the continent among themselves. Few thought that the war in Europe would spill into Africa—"the inviolability of the white man would be besmirched by any unseemly squabbles between [the Europeans], in particular if the killing of white men by black men was sanctioned," writes African historian Peter Baxter. But there was no stopping the inevitable, and the war in Africa would be fought by colonial and, in particular, native troops, not white Europeans.

There were two main confrontations. The first was between what was then the British Union of South Africa and German South West Africa (now Namibia), and the second was between British East Africa (now Kenya) and German East Africa (now Tanzania). The military fight in South

An artillery unit of the *Schutztruppe*, the colonial army of German East Africa, with African soldiers and European officers.

West Africa was "a clean and quick campaign that exacted a minimal loss of life on either side, and was concluded in favor of the Allies," writes Baxter. "The Germans …were overwhelmed by a superior South African force. The Germans also tended to take the view that there was little to be gained in diverting resources to the

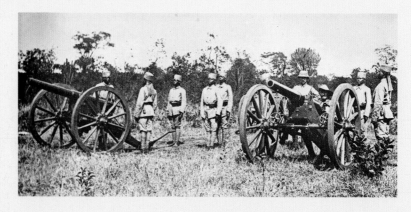

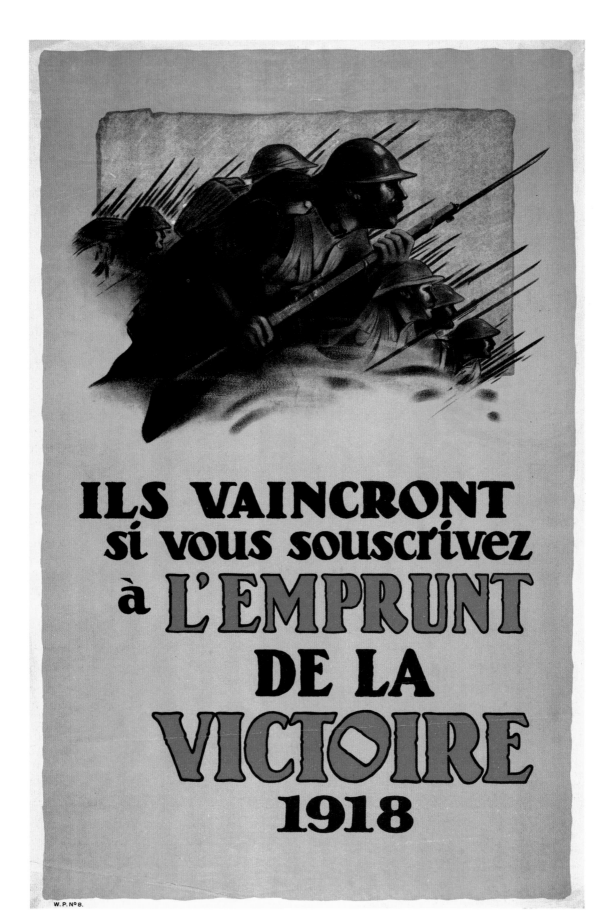

colonies in order to retain territory when an Axis victory in Europe was inevitable. Thereafter German's overseas territories would be returned along with the acquisition of all French, British and Belgian possessions."

In East Africa, neither the British nor German governors favored war, but the local settlers and military commanders did. In November 1914, a British expeditionary force, composed mostly of Indian troops, attempted to take the seaport town of Tanga in German East Africa. German troops, mostly local askari, repulsed the British colonial force. Still, the British had the superior military (including its own native force of Swahili, Sudanese, and Somalian troops, some of whom formed the King's African Rifles) and thereafter the Germans were on the defensive. The two sides fought along the border region, near Kilimanjaro, and by 1916 a large British and Allied force, comprising some 150,000 troops under General Jan Smuts, was pushing deep into German territory.

Colonel Paul von Lettow-Vorbeck, commander of German East Africa's colonial forces, was undefeated and hailed as a hero in Germany.

However, Smuts found it difficult to pin down the enemy. By then the much smaller German force, led by Colonel Paul von Lettow-Vorbeck and numbering only 25,000, was fighting a brilliant guerrilla campaign, harassing the British and attacking their rail lines. The war became a long, brutal chase across some 750,000 square miles. According to one source, upwards of 900,000 indigenous porters were used to carry supplies for troops on both sides. Conditions were harsh, especially when the "long rains" came. "What one wouldn't give for the food alone in France, for the clothing and equipment, for the climate..." said one officer in the Fortieth Pathans.

The biggest battle was fought at Mahiwa, in German East Africa, in October 1917. It was a Pyrrhic German victory. Nearly half of the British force of 5,000 men—including a Nigerian brigade, King's African Rifles, and (Indian) Bharatpur Infantry—was killed or wounded. The German casualty rate was an insupportable 25 percent. Soon after, von Lettow-

PRINT NO. 68 SOUTH AFRICA, 1918. "AFRICANDERS, YOUR PALS IN FLANDERS ARE IN DANGER."
GOVERNMENT PRINTING AND STATIONERY OFFICE, PRETORIA

Vorbeck and his men left German East Africa, and fought on through 1918 in Portuguese East Africa and Northern Rhodesia.

The British occupied the German colony, but the East Africa Campaign dragged on until a few weeks after the armistice was signed. In the end, some 400,000 people worked and fought for the British and Allies in the East Africa war. The Allied death toll topped 105,000—of which an estimated 90,000 were African porters. In total some 300,000 civilians,

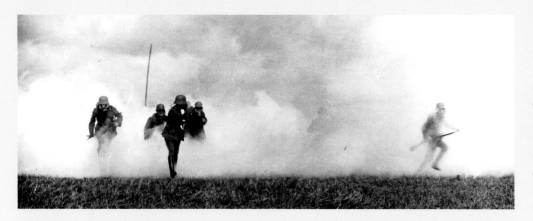

German soldiers flee a gas attack in Flanders, September 1917. Germany used 68,000 tons of gas during the war; Britain and France used 61,000 tons.

including the carriers, died during the conflict, most from disease or malnutrition. Just over 11,000 British imperial troops were killed. German colonial records do not list their casualties. After the war, German South West Africa became a South African protectorate, while East Africa became a British mandated territory.

China, meanwhile, disillusioned with the West, became more fractured. The Chinese Communist Party was established in 1921. Japan became more nationalistic and imperialistic, and tensions between it and the United States would grow. World War I was, then, a conflagration that spared almost nobody and left embers of instability in every corner of the world.—R.E.

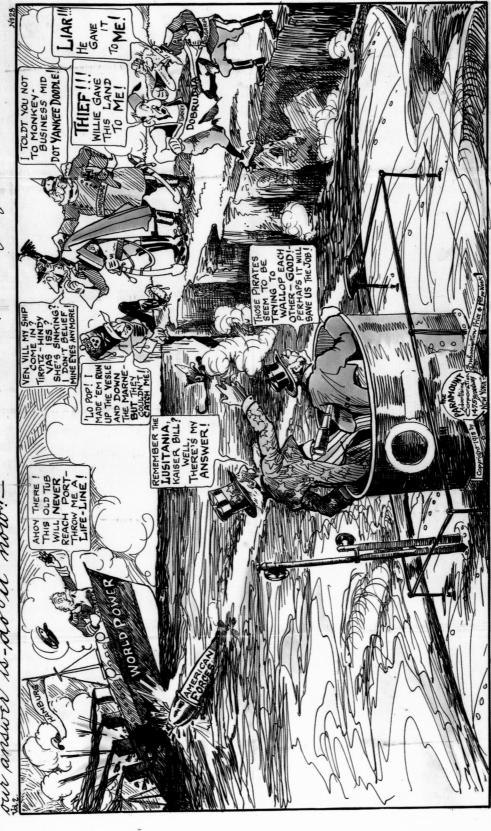

AMERICA'S ANSWER.

PRINT NO.69 AMERICA, 1918. "AMERICA'S ANSWER." PARAMOUNT ADVERTISING CORPORATION

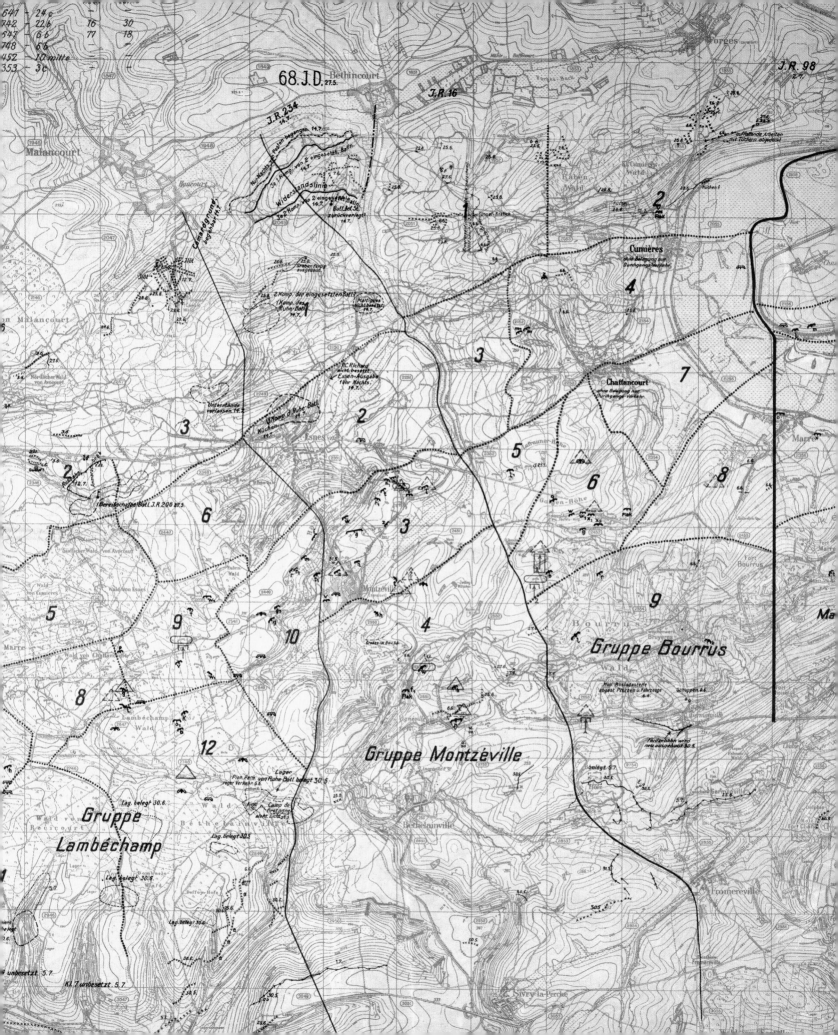

Modern WEAPONS

When World War I broke out in 1914, most of the major protagonist nations were already industrialized. Russia lagged behind initially, but Germany, Austria, Britain, France, and the United States were technologically advanced countries, with robust manufacturing, transportation, and communications infrastructures as well as experienced labor forces. Belgium and Italy, and smaller participants Serbia, Romania, and Bulgaria, had economies that were less well developed. ❖ Iron and steel manufacture was the key element of warfare at the time, and the major combatants possessed mature iron and steel industries with extensive experience in manufacturing railroads, ships, motor vehicles, machine tools, printing presses, and mining equipment (and soon, under pressure of the demands of the war, aircraft and heavy weapons). Their industries were experienced in the construction of bridges, dams, tunnels, docks, large buildings, and mills.

Use of artillery and machine guns on the dense battlefields of the Western Front relied upon detailed reconnaissance and mapping.

The economies of the nations that engaged in the heaviest fighting had already developed many mass-production capabilities—and given the size of the armies, those capabilities were soon spurred to extraordinary levels of product development and output.

The coincidence of mature technological capability and large-scale warfare created combat of unprecedented lethality. It produced, throughout World War I, destruction and death on a mass scale.

Among the weapons that wreaked record levels of destruction, consider the following:

ARTILLERY

Artillery was the deadliest weapon of the war, accounting for a majority of the combat deaths. During the 18th century and most of the 19th century, cannons were made of cast bronze or iron, used black powder explosive, and were muzzle-loaded, low-velocity, comparatively short-range, direct-fire weapons with a slow rate of fire. Their destructive power was limited. But in the last quarter of the 19th century, advances in metallurgy, manufacturing techniques, and the chemistry of explosives drastically improved the power, range, and speed of artillery.

American-built Mack trucks ready for service. Some 6,500 Mack trucks were supplied to U.S. and British forces during the war.

The standard-setting gun in World War I (and still in use decades afterward) was the French M1897 75mm fieldpiece—the most modern gun of its time. It was a breech-loaded, steel-tube, mobile, flat-trajectory weapon. What made it revolutionary was its recoil-control mechanism, essentially a hydraulic oil-and-air shock absorber that allowed repeated fire without moving the gun carriage. That meant the gun did not need to be reaimed after

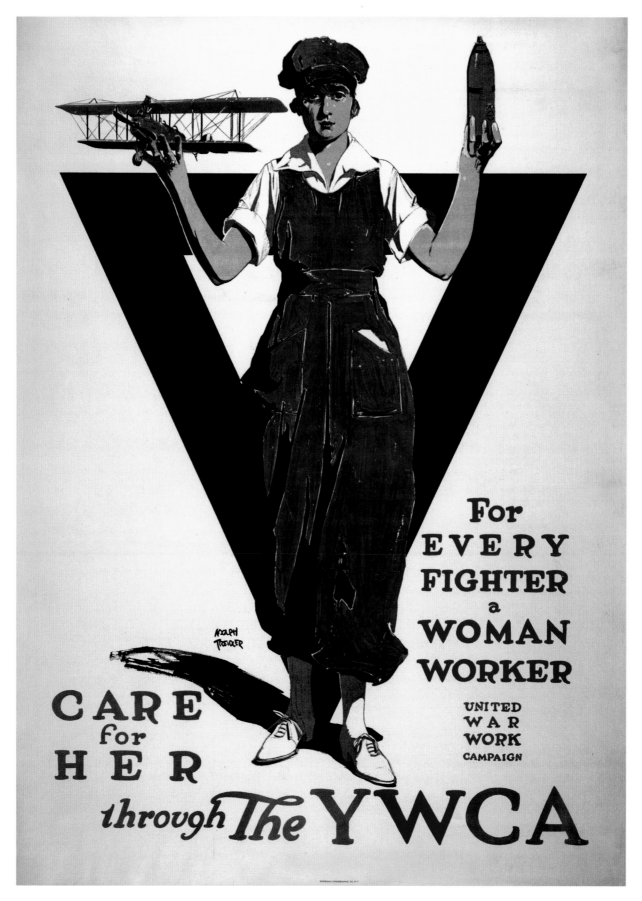

For
EVERY
FIGHTER
a
WOMAN
WORKER

UNITED
WAR
WORK
CAMPAIGN

CARE
for
HER
through The YWCA

PRINT NO. 70 AMERICA, 1917-1918. "FOR EVERY FIGHTER A WOMAN WORKER." ADOLPH TREIDLER

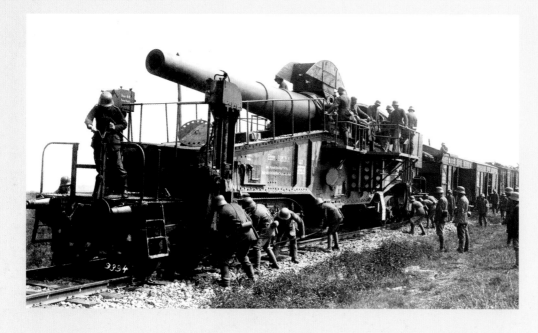

German soldiers position a Krupp 28cm railway gun, repurposed from the navy in 1916 for use on land.

every shot—which made it a rapid-fire weapon. A capable gun crew could fire the French 75 accurately as many as 15 times per minute.

Germany, Austria, Britain, France, Russia, and Italy all had or developed capable and competitive artillery during the war, especially in longer-range field guns, large-caliber howitzers, and mortars. Among the most effective: the German 77mm field gun and the Krupp-built 150mm heavy howitzer; the Russian M1900 76mm field gun; the Austrian Skoda 305mm siege mortar; the British 6-inch, 8-inch, and 12-inch howitzer and 18-pounder field gun; the Italian Modello 13 65mm mountain gun; and the French 155mm GPF long-range gun (late in the war, also used by the Americans). Britain and Germany also utilized very large-caliber, long-range, railway-mounted siege guns. Germany experimented with ultra-long-range weapons, notably the "Paris gun," which was able to fire 9-inch shells on Paris from a distance of 75 miles.

CHEMICAL WEAPONS

The modern era of gas warfare began on April 22, 1915, on the front line at Ypres, Belgium, when German soldiers released 170 tons of chlorine vapor into the air. A huge cloud of the green gas drifted into the lines manned by French and Algerian soldiers who immediately felt the effects: burning eyes and blindness, acute bronchial and lung damage, nausea, violent headaches, and coughing. The Allied soldiers fled in panic at this novel attack, with some 6,000 dying quickly and many more wounded.

A line had been crossed. While the idea, and the occasional use, of chemical weapons was not new, and many nations had sought to outlaw such "uncivilized," "unethical," and "unfair" weaponry, the German attack at Ypres caused widespread shock and horror, and brought the debates about such weapons front and center—debates that have continued to this day.

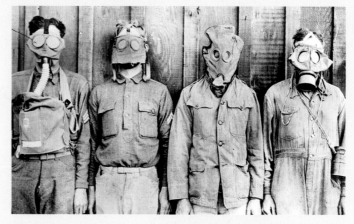

American, British, French, and German gas masks. Of the 3,000 chemical agents considered for use in the war, about 50 were deployed.

Countermeasures, chiefly gas masks and improved first-aid treatments, were quickly developed. And this being total war, other nations, first France, then Britian, and later the United States, developed and deployed their own chemical weapons. But gas weapons, including the deadlier phosgene and mustard gases, were imperfect weapons, dependent upon wind direction and difficult to control. To its victims gas remained a horror and a devastating weapon, but even with delivery by gas-filled artillery shells, it was never decisive. It was episodically effective as part of artillery barrages that delivered a mix of high explosives and various types of poison gas such as on the Eastern Front at Riga, on the Western Front at Loos, and on the Southern Front against the Italians in the 12th battle of the Isonzo River.

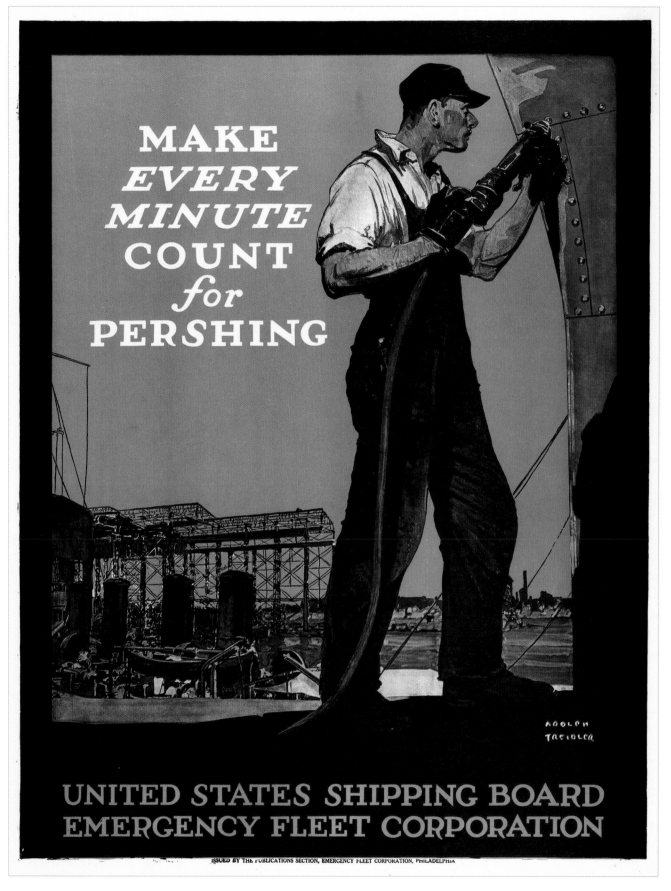

PRINT NO. 72 AMERICA, 1917. "MAKE EVERY MINUTE COUNT FOR PERSHING." ADOLPH TREIDLER

AIRCRAFT

The Great War in Europe broke out barely over a decade after Wilbur and Orville Wright proved the concept of powered, heavier-than-air flight. But in America, the birthplace of the airplane, the War Department, displaying both ignorance and bureaucratic inertia, flatly turned down the Wrights' offer to sell their aircraft to the U.S. government for military use. After some initial interest, the British government did the same, passing repeatedly on the opportunity to seize world leadership in aviation.

Only after the Wrights performed a successful 20-minute demonstration flight in Paris—generating a frenzy of acclamation—did governments come around. After some prodding by President Theodore Roosevelt, the U.S. Army entered into a development deal with the Wrights and thus in 1909 became the first nation to recognize the military implications of powered flight.

Development and improvements, from that point right on through the war, proceeded at a very rapid pace. By 1915, after one year of war, every combatant nation boasted some kind of "aero service," though only

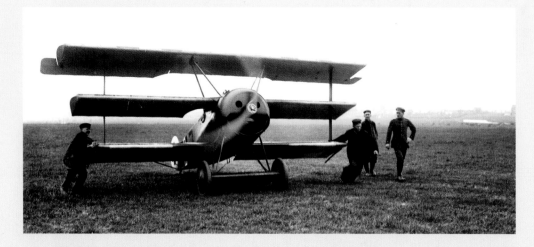

German pilots and ground crew with a Fokker triplane in Flanders. It was made famous by Manfred von Richthofen— the Red Baron.

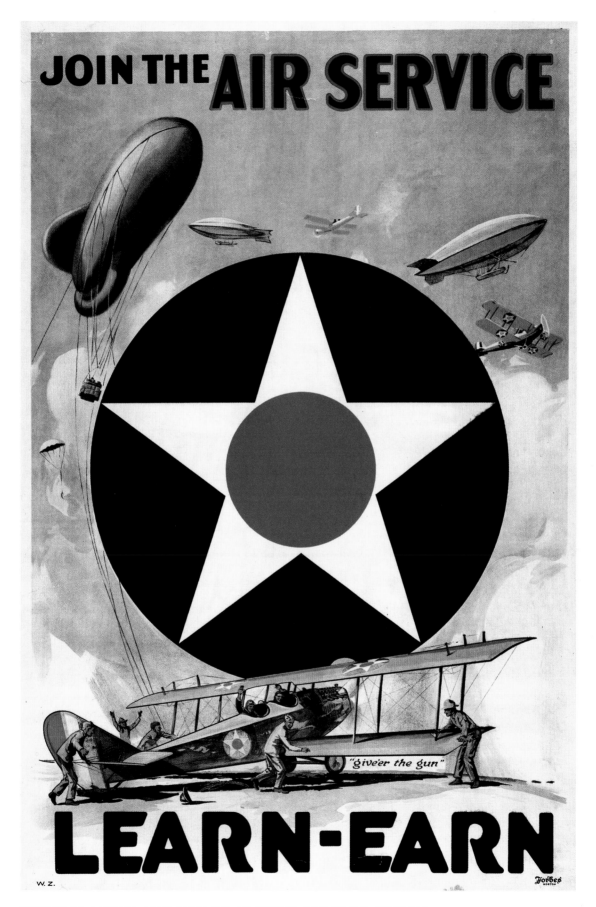

PRINT NO.73 AMERICA, 1917. "JOIN THE AIR SERVICE, GIVE 'ER THE GUN." W.Z.

the most industrialized nations, France, Britain, Germany, and the United States, manufactured the reconnaissance, fighter, and bomber aircraft that saw service. America's builders turned out some 7,000 aircraft during the war. Austria-Hungary, Italy, and Russia built a comparative hand- ful, mostly under license from the major producers. By the time of the armistice, thousands of dramatically improved aircraft—like the Fokker D-VII, the SPAD XIII, the Bristol F2B, the de Haviland DH-4, and the Sopwith Camel—armed with machine guns and toting bombs and torpedoes were flying sorties over the battle- fields and coastal waters of Europe.

Early in the war, bombs were dropped by hand from low- flying aircraft.

The major combatants prodigiously organized their aero ser- vices and trained air crews to operate the ever-evolving aircraft. From reconnaissance with aerial photography to dogfighting, and from ground attacks to early efforts at strategic bombing, this was a true revolution in warfare, unfolding daily before the eyes of partici- pants on the ground and in the skies. And in case anyone failed to notice the aerial warfare revolution, it was effectively championed by the likes of Colonel William "Billy" Mitchell, who became chief of the U.S. Air Service Army Group.

MACHINE GUNS

Machine guns, like many other weapons that proved decisive in World War I, developed rapidly from clumsy, overweight, early designs like Rich- ard Gatling's multibarrel weapon of the American Civil War. Such Ameri- can engineers as Hiram Maxim in the 1880s, John Browning in the 1890s, and Colonel Isaac Lewis in 1911 developed them into efficient, effective, and very deadly killing machines.

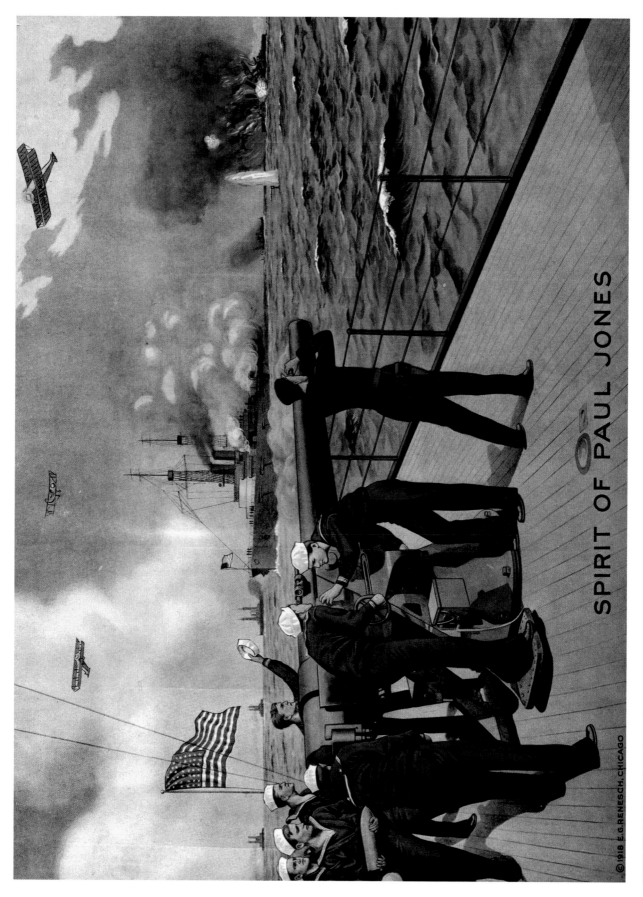

SPIRIT OF PAUL JONES

©1918 E.G.RENESCH.CHICAGO

PRINT NO.74 AMERICA, 1917-1918. "SPIRIT OF PAUL JONES." E.G. RENESCH

Second only to artillery in casualties inflicted in ground combat during the war, machine guns were also the essential weapon for aircraft and accordingly were improved rapidly during the war.

Whereas in the earliest days of the war, reconnaissance pilots shot at each other with revolvers and rifles, within a short time Allied fighter pilots were armed with twin 30-caliber Lewis guns capable of firing 500 rounds per minute.

Machine guns were at their deadliest on the ground in fixed defensive positions, often dubbed "machine-gun nests," that were largely responsible for the stalemated nature of the trench warfare on the Western Front. The Germans developed the tactic—utilizing the capabilities of the heavy machine gun (based on Maxim's design)—of defending their front lines with a long series of machine-gun emplacements situated so each gun commanded a cone-shaped field of fire that "interlocked" with that of adjacent guns. Thus able to sweep the field completely with 500 rounds-per-minute

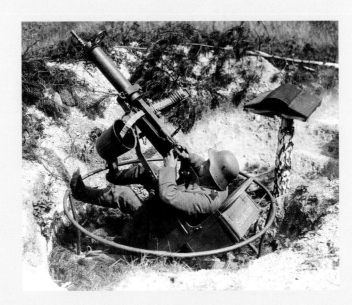

Germany's anti-aircraft (AA) weaponry claimed 1,588 Allied planes. The Allies' AA gunners combined for fewer than 1,000.

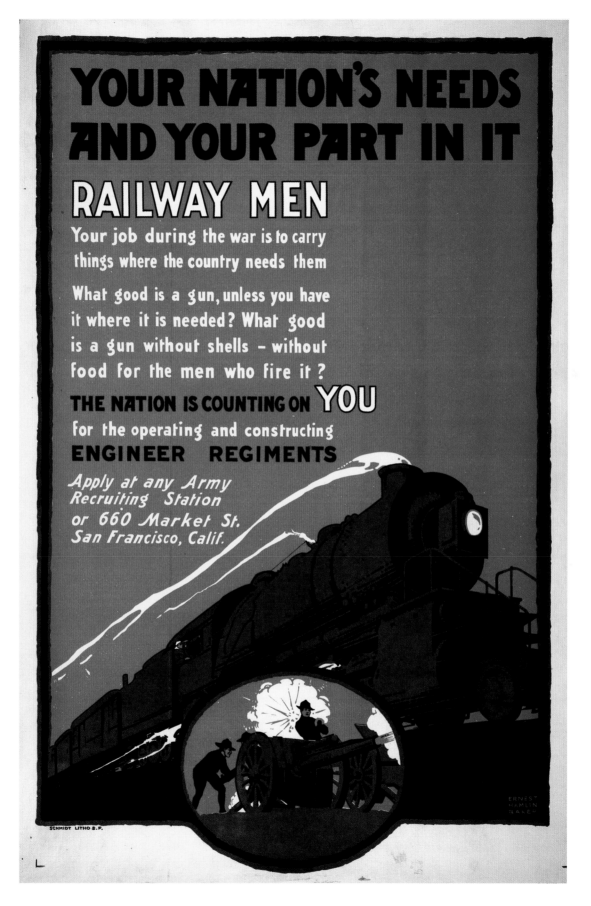

PRINT NO. 75 AMERICA, 1918. "RAILWAY MEN: YOUR NATION'S NEEDS AND YOUR PART IN IT." ERNEST HAMLIN BAKER

sprays of bullets (effective to a direct-fire range of 2,000 yards), machine guns transformed frontal infantry and cavalry charges—which inexplicably and tragically continued through the war—into acts of suicide.

TANKS

In early 1915, reacting to the already apparent stalemate of trench warfare and seeking a "breakthrough" weapon, the British Admiralty—at the behest of Winston Churchill, then first lord of the admiralty—established a committee to study the feasibility of what they called a "landship." It was to have some of the characteristics of a warship: self-propelled, armored, and armed with a variety of weapons. ("Tank" was a code name to disguise their true purpose.)

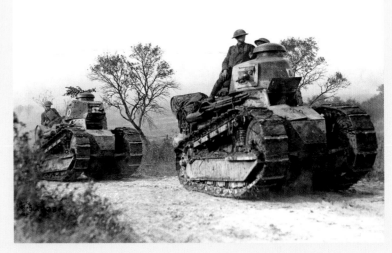

The initial prototype, a tracked vehicle powered by a gasoline engine and dubbed "Little Willie" Landship, was built in autumn 1915. It was capable of just two miles per hour and carried several machine guns. Development accelerated with a design by Lieutenant W.G. Wilson that featured a rhomboid steel hull with side sponsons that held six-pounder naval guns, improved

An American armored unit lumbers through the Argonne Forest in French-supplied Renault light tanks, 1918.

controls, and better mobility over rough terrain. Known as the MK I, it went into production by several British manufacturers, and some 150 were built in great secrecy during 1916.

First deployed in battle at the Somme on September 15, 1916, 49 of the tanks rumbled toward the German lines. Due to mechanical breakdowns and the inexperience of crews, only a few tanks reached the Germans. But

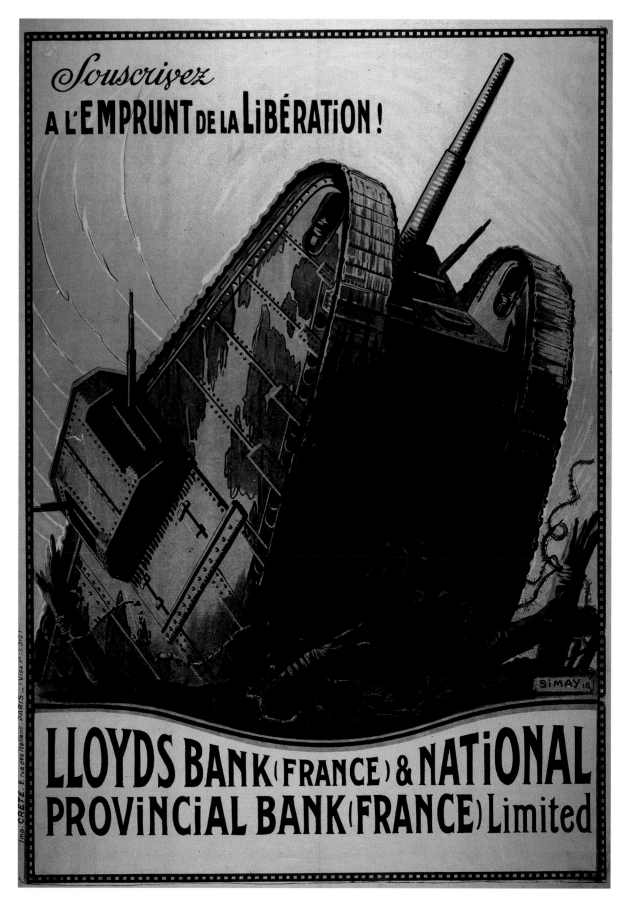

PRINT NO.76 FRANCE, 1918. "SUSBSCRIBE TO THE LIBERATION LOAN!" SIMAY

those few tanks stampeded the panicked German soldiers, who had never seen anything like them. These tanks were not decisive, but they proved the concept and a year of development followed. The MK I's flaws were many: Visibility and ventilation were very poor, the unshielded engine was deafening and made conversation impossible, steering was primitive, and top speed was about three miles per hour. Many improvements were made to the engine, drive gear, habitability, and armor of the resultant MK IV, of which some 1,000 were built. Even with the improvements, conditions inside were often described as "sheer hell for the crew," thanks to the noise, darkness (no lights), and gun smoke.

Final proof of the tank's utility in battle came in November 1917 at Cambrai, France, when a force of nearly 500 MK IVs broke through the barbed wire and other defenses blowing a nearly four-mile hole in the German lines—and suggesting a bright future for mobile armored warfare.

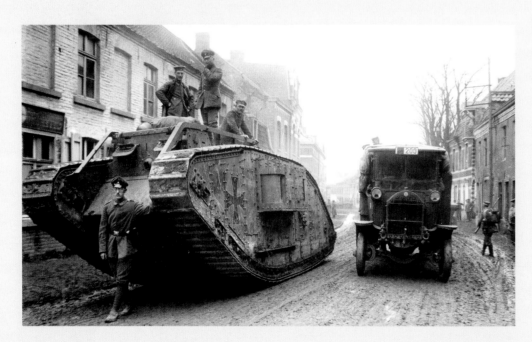

Germany produced very few tanks and instead relied on captured French and British tanks like this at Armentières, France.

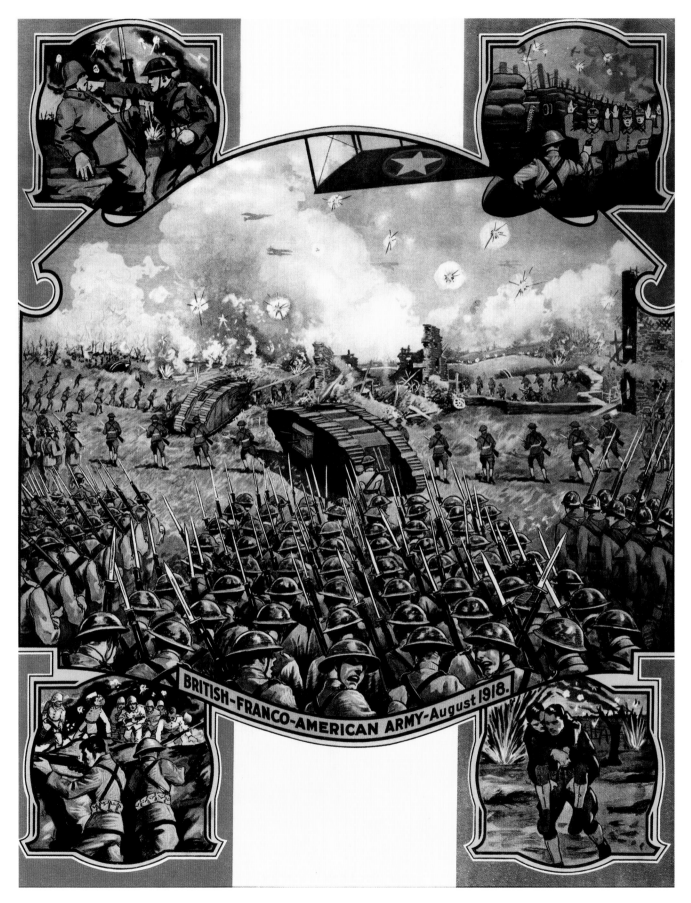

PRINT NO. 77 AMERICA, 1918. "BRITISH-FRANCO-AMERICAN ARMY—AUGUST 1918."

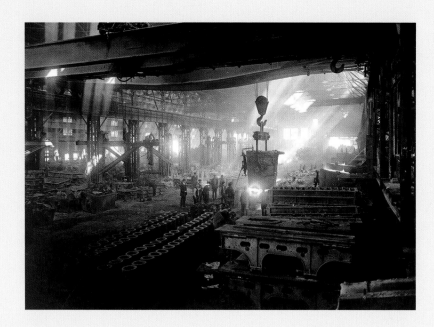

Scullin Steel in St. Louis landed a $4.6 million contract to produce shell casings for the war effort.

France had also begun studying ways to break through the trench lines, and in 1916 fielded a small number of Schneider assault tanks, an armored and weaponized version of the American Holt agricultural tractor. Renault got into the armor business with its FT-17 two-man light tank, launching a prototype in March 1917 followed by a production run of nearly 3,000 by war's end—though most were not in service until summer 1918. Lightly armored and lightly armed, the FT-17 included innovations soon to be found on later tanks, including a full-traversing turret and sprung suspension. The FT-17 was widely used by other nations during the interwar period, and hundreds were still in service in 1940, when many were captured and utilized by the German army.

Other weapons that were not revolutionary but nonetheless deadly effective were developed during the war: Britain's Mills bomb (the familiar pineapple-shaped fragmentation hand grenade) and Germany's dreaded *Flammenwerfer* or portable flamethrower, plus many varieties of small mortars.

ON THE JOB FOR VICTORY

UNITED STATES SHIPPING BOARD EMERGENCY FLEET CORPORATION

PRINT NO. 78 AMERICA, 1918. "ON THE JOB FOR VICTORY." JONAS LIE

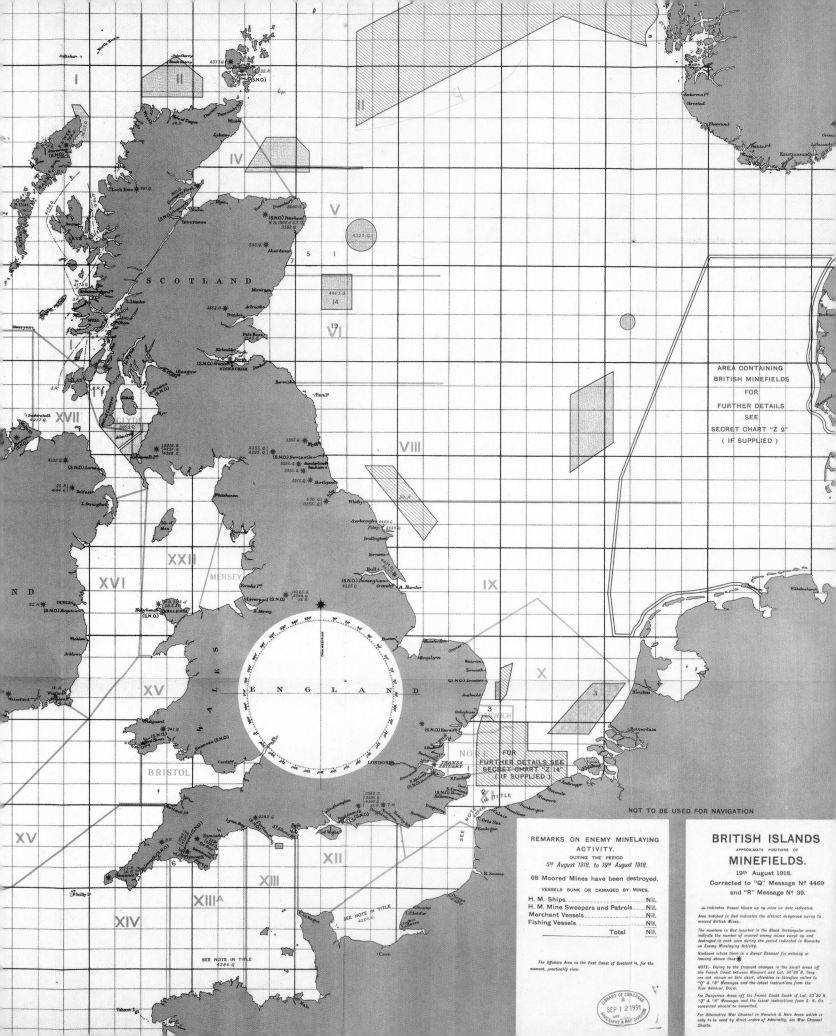

NOT TO BE USED FOR NAVIGATION

AREA CONTAINING
BRITISH MINEFIELDS
FOR
FURTHER DETAILS
SEE
SECRET CHART "Z 2"
(IF SUPPLIED)

NOTE FOR
FURTHER DETAILS SEE
SECRET CHART "Z 14"
(IF SUPPLIED)

REMARKS ON ENEMY MINELAYING ACTIVITY.

DURING THE PERIOD
5th August 1918. to 19th August 1918.

68 Moored Mines have been destroyed.

VESSELS SUNK OR DAMAGED BY MINES.

H. M. Ships	Nil.
H. M. Mine Sweepers and Patrols	Nil.
Merchant Vessels	Nil.
Fishing Vessels	Nil.
Total	Nil.

The Offshore Area on the East Coast of Scotland is, for the moment, practically clear.

BRITISH ISLANDS

APPROXIMATE POSITIONS OF

MINEFIELDS.

19th August 1918.
Corrected to "Q" Message No 4469
and "R" Message No 39.

⚓ Indicates Vessel blown up by mine on date indicated.

Area hatched in Red indicates the district dangerous owing to moored British Mines.

The numbers in Red inserted in the Black Rectangular areas indicate the number of moored enemy mines swept up and destroyed in each area during the period indicated in Remarks on Enemy Minelaying Activity.

Harbours where there is a Swept Channel for entering or leaving shown thus ✳

NOTE:- Owing to the frequent changes in the small areas off the French Coast between Nieuport and Lat. 50°50' N. they are not shown on this chart, attention is therefore called to "Q" & "R" Messages and the latest instructions from the Vice Admiral, Dover.

For Dangerous Areas off the French Coast South of Lat. 50°30' N. "Q" & "R" Messages and the latest instructions from S. N. O's concerned should be consulted.

For Alternative War Channel in Harwich & Nore Areas which is only to be used by direct orders of Admiralty, see War Channel Charts.

WAR *at* SEA

In World War I, there was fighting at sea as well as the far better known conflict on the land. Mighty navies were afloat, notably Britain's Royal Navy and Germany's High Seas Fleet in the English Channel and the North Sea. Other combatant nations had naval fleets as well, though many were smaller and strategically less consequential than the British and German fleets: France, Italy, Russia, the United States, Japan, Austria-Hungary, and Turkey. Sharp naval engagements did occur in the Black Sea, the Mediterranean, at the Dardanelles, and even in the South Atlantic and the Pacific. ❖ But with the exception of the Battle of Jutland in 1916, the anticipated war at sea was an anticlimax. Only the submarine warfare conducted by Germany (and Austria) had real impact on the conduct of the war, and it was nothing like the widely anticipated epic clashes between the surface fleets of dreadnoughts and battleships.

Most important naval actions occurred in the UK's "narrow seas" and the North Sea, though other engagements were global in scope.

Kaiser Wilhelm II believed that sea power was one of the keys to international dominance. He and other Central Powers leaders recognized that Britain's vast and far-flung colonial empire was enabled and protected by the might of the Royal Navy, and he sought to challenge that dominance by an ambitious program, beginning in the late 1890s, to build up Germany's own fleet. The effect of that program was to set in motion a naval arms race that accelerated with Britain's launching of its first dreadnought—a superbattleship—in 1906. HMS *Dreadnought* conceived by Admiral Sir John "Jackie" Fisher was a game changer, an "all-big-gun" ship armed with 10 powerful 12-inch guns in turrets, protected by 12 inches of armor, and capable of 21-knot speed. It rendered all other warships obsolete, and Germany, Italy, Russia, Austria, France, America, and Japan sought to match its speed and power. Smaller nations, like Turkey, Chile, Brazil, and others without the advanced industrial know-how of the majors, contracted to have powerful warships built, mostly in British or American shipyards.

The revolutionary HMS *Dreadnought* saw little combat apart from sinking a U-boat in 1915. It was decommissioned in 1919.

THE SHIPS ARE COMING

UNITED STATES SHIPPING BOARD EMERGENCY FLEET CORPORATION

Germany raced to match Britain's superiority in capital warships but was unable to catch up and by war's end had fewer than half the dreadnought superships that the Royal Navy's Grand Fleet could deploy. Moreover, Britain had an intelligence advantage right at the start of the war, when it captured several German code books and thereafter was able to read the High Seas Fleet's communications in real time.

The naval arms race before and during the war was essentially a mad exercise that in the end resulted in no strategic winner. In an age of rapidly improving sea mines and torpedoes—and the submarines and aircraft to deliver them—it eventually occurred to the great powers that those extremely costly dreadnoughts were too vulnerable to deploy for any but the most urgent engagement. So they largely remained in port. The kaiser most notably was reluctant to allow his beloved battleships to venture out into the North Sea, where the British fleet was sure to attack—not to mention the ever-present mines and enemy submarines. Except for the many deaths of sailors aboard those ships when the huge high-explosive shells did begin flying, there was something of a comic-opera finale to this era of the dreadnought.

Prince Henry of Prussia (with binoculars) and Admiral Reinhard Scheer on the submarine tender *Meteor*, October 1918.

The Battle of Jutland was the lone exception to the reluctance to engage in an all-out brawl between surface ships. In early January 1916, the German High Seas Fleet got a new commander, Admiral Reinhard Scheer, who was too aggressive and too impatient to abide the prevailing strategic timidity and passivity of the German leadership. In the spring, he began sending the fleet out for periodic raids along the English coast, always taking care to return to safe ports before the Grand Fleet could emerge from its anchorage at Scapa Flow, Scotland.

PRINT NO. 80 AMERICA, 1917. "JOIN THE NAVY, THE SERVICE FOR FIGHTING MEN." RICHARD FAYERWEATHER BABCOCK

The German battle cruiser SMS *Seydlitz*, its bow nearly underwater, limps back to port after the Battle of Jutland, June 1916.

In late May, both Scheer and the British admiral Sir John Jellicoe planned to send ships out into the North Sea to act as bait to lure the enemy's fleet into a submarine ambush to be followed by an all-out surface fleet engagement. Jellicoe, commander of the Grand Fleet, having been alerted by the Admiralty's Room 40 decoding operation that the High Seas Fleet would put to sea on May 31, sent Admiral Sir David Beatty's Battle Cruiser Fleet out first. Bad weather prevented aerial scouting, as both fleets headed for a central location between Dogger Bank and Jutland Bank west of the Danish coast—a certain collision course. A chance sighting on the afternoon of May 31 of a Danish merchantman near Jutland Bank by advance cruisers of both fleets brought the foes in sight and the battle was joined. Cruisers on both sides opened fire while the two main battle fleets were still groping their way forward. Heavy mist and dark battle smoke obscured many ships, especially on the German side, and the visibility only grew worse as the firing continued into the evening.

PRINT NO. 81 AMERICA, 1917. "FOLLOW THE FLAG." JAMES DAUGHERTY

The two sides were not evenly matched, the British having 24 dreadnoughts to the Germans' 16, plus outnumbering the Germans in cruisers and destroyers. The British held a major advantage in overall firepower, but the German fleet generally had the edge in speed. Between 6:00 p.m. and about 8:30, there was a heavy and costly exchange of fire, and then Scheer's fleet moved away in the growing darkness. Chance encounters continued until well after midnight as the ships maneuvered blindly, and the German fleet withdrew.

The British fleet lost 14 ships (four of them, *Indefatigable*, *Queen Mary*, *Invincible*, and *Black Prince*, blown up by direct hits to their magazines) to the Germans' 11. Over 6,000 British sailors were killed to the Germans' 2,550. Germany claimed victory, but many of its damaged ships were disabled and its fleet never returned to open-sea action. The British retained control of the North Sea and continued to blockade Germany. Strategically, the Battle of Jutland did not change the balance of power.

Heavy artillery inflicted serious damage on the battleship SMS *König*, which led the German line at Jutland.

Other naval engagements did occur in the Black Sea, the Baltic, and the Mediterranean and along the coasts of Africa and Asia, but these were largely raids and skirmishes, without overall strategic significance.

SUBMARINE WARFARE

The idea of a submarine, a fully submersible armed naval vessel, was long a subject of speculation and fantasy fiction, and during the 19th century, attempts were made to realize it.

The first submersible effective enough to sink an enemy ship in wartime was CSS *Hunley*, commissioned by the Confederacy in 1863 in an effort to

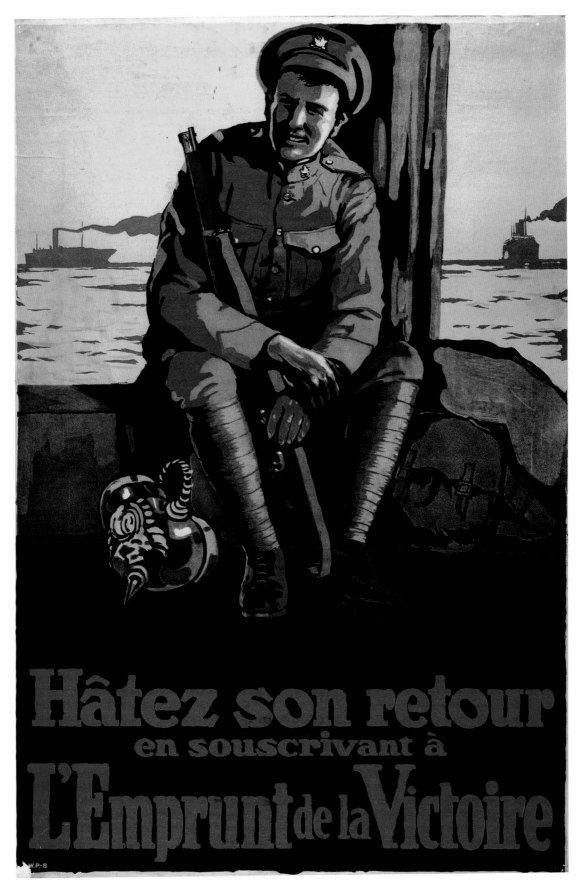

PRINT NO. 82 CANADA, 1918. "HURRY HIS RETURN: SUBSCRIBE TO THE VICTORY LOAN."

break the Union blockade of its major ports. *Hunley* was a crude design, essentially a 40-foot, seven-ton iron tube propelled by a hand-cranking crew. Its lone weapon was a 100-plus-pound black-powder charge mounted on a long forward spar. In its first operation, in Charleston Harbor in early 1864, it blew up and sank the Union sloop-of-war USS *Housatonic*—though *Hunley* itself sank with all hands immediately afterward.

During the latter part of the 19th century, marine designers in Britain, America, and Germany worked to solve the challenges in watertightness, navigation, propulsion, and weaponry. An American, John Holland, succeeded during the 1890s in launching *Holland VI*, a gasoline engine/electric motor propelled 75-foot submarine with diving planes for depth control. It was Germany's industrial powerhouse, Krupp, that first combined the many technological advances into one truly effective undersea weapon. Its prototype *U-1*, launched in 1906, was a stream-lined, steel, double-hulled, diesel-engine-powered, periscope-equipped vessel capable of 10 knots surface speed and five knots submerged speed. Armed with an effective torpedo, it was the first modern submarine.

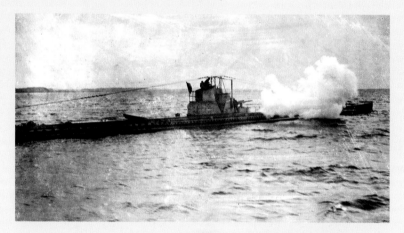

The Allies rightly feared torpedoes launched from German submarines, but U-boats were even more deadly when they attacked on the surface.

In the years leading to the outbreak of World War I, submarine development—especially in Germany—proceeded rapidly. How rapidly? In 1914, *U-9*, a 188-foot attack submarine launched in 1910, torpedoed and sank three aged British cruisers off Holland in the first month of the war, killing hundreds of sailors. Although they were hot, smelly, slow, and uncomfortable, German U-boats sank over 5,700 Allied ships—most of

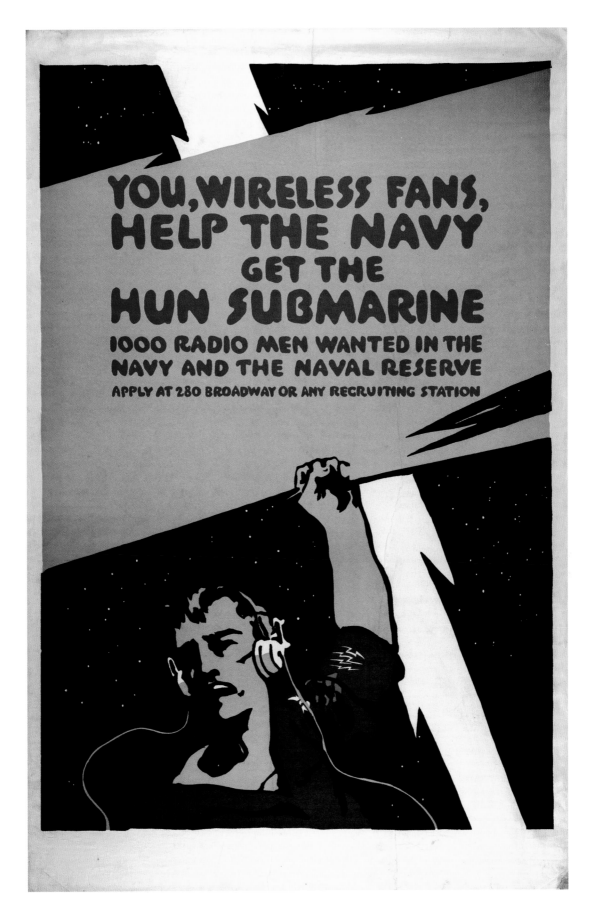

PRINT NO.83 AMERICA, 1914-1918. "YOU, WIRELESS FANS, HELP THE NAVY GET THE HUN SUBMARINE." CHARLES BUCKLES FALLS

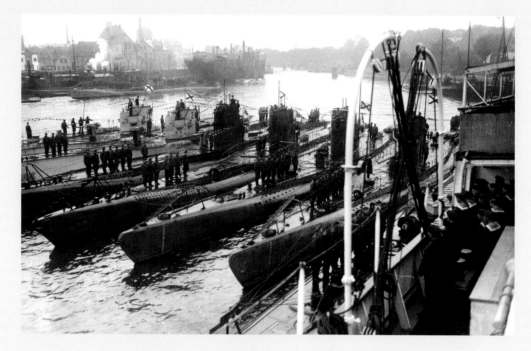

Eighty-four of Germany's 360 submarines were built at the shipyard in Kiel, a port city on the Baltic Sea.

them merchantmen—during the war. Most of that damage was inflicted not by torpedoes but by powerful deck guns during surface attacks. On the negative side for Germany, their U-boats were dangerous for their crews: Nearly half of the U-boats deployed by Germany were lost at sea.

Other combatant nations, including the United States, Russia, France, Britain, Austria, Italy, and Japan, developed and deployed submarines during the war but none was as effective—or feared—as the German U-boats.

As often as the German submarines did sink Allied ships, their success was largely confined to attacking unarmed merchant vessels in Europe's coastal waters.

Their limited range and low speed—especially when submerged—made them largely ineffective in the open Atlantic where vital supplies were crossing from America to the Allied nations. And that effectiveness dropped further when in mid-1917, the Allies agreed to adopt a convoy

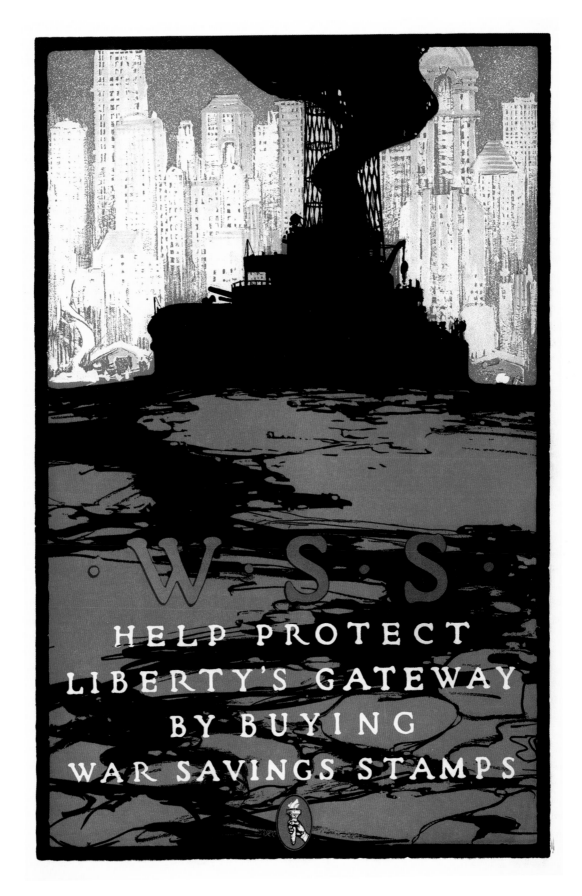

PRINT NO. 84 AMERICA, 1918. "HELP PROTECT LIBERTY'S GATEWAY."

system for Atlantic crossings. Intuitively, it might seem that convoys of up to 40 ships would present a more obvious target, but in the vastness of the ocean, they were no easier for U-boat captains—who lacked radar and speed—to find than lone ships. From the start of the convoy system to the end of the war in 1918, more than 80,000 ships made the crossing in convoys, with losses amounting to about 0.3 percent of that total.

Once the United States joined the war in April 1917, it began shipping troops across the Atlantic in an improvised fleet that included many converted luxury liners, as well as other kinds of ships from England and America, and ships confiscated from Austria and Germany. Despite initial fears in America that thousands of doughboys would be lost to a single German torpedo, that did not happen. By July 1918, American soldiers were arriving in Europe at a rate of 10,000 per day, and in the end, more than 2 million American soldiers had crossed the Atlantic in safety.

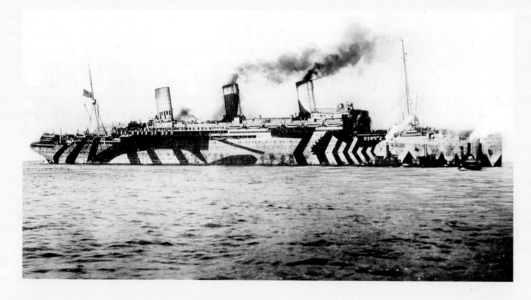

USS *Leviathan* sports British "dazzle" camouflage. The high-contrast paint scheme made it difficult for enemy ships to gauge the size and speed of oncoming vessels.

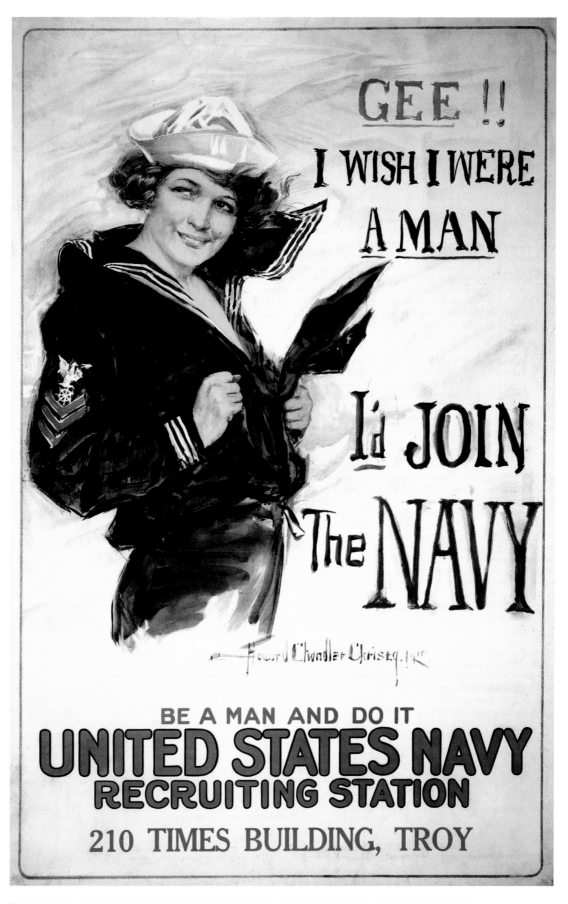

PRINT NO. 85 AMERICA, 1918. "GEE!! I WISH I WERE A MAN." HOWARD CHANDLER CHRISTY

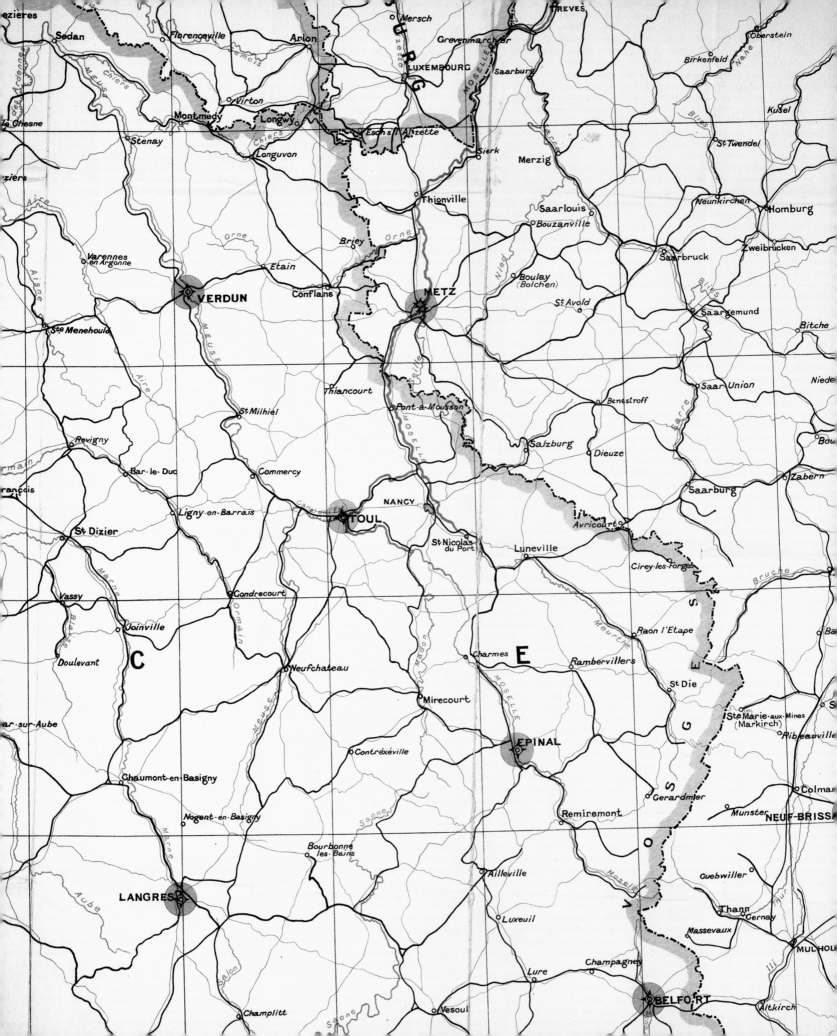

1916

The year 1916 might well be remembered as an apocalyptic year of death. The enormous numbers of casualties in the first years of war, which shocked and stunned governments, militaries, and civilian populations, continued to escalate through 1916. Casualties were numbering in the millions and climbing, and there seemed to be no end in sight. ❖ This was the year in which combatant nations on both sides tried to break the pattern of stalemate and attrition, but none of their ideas really worked and no breakthroughs were achieved. In retrospect, there was widespread failure of imagination: The commanders of both the German army and the British army seem to have taken the "get a bigger hammer" approach to bludgeoning their enemies into submission—the Germans at Verdun and the British at the Somme. Whatever the theories, this was a year of even bigger battles, greater losses, and more frustration all around.

On the stalemated Western Front trench lines, vast battles produced mass casualties.

The year opened with the bitter endgame at Gallipoli. The British/ Commonwealth/French invasion there failed both tactically and strategically. Instead of the diversionary campaign that would relieve the pressure on the Western Front that Winston Churchill had sought, the Allies suffered a catastrophic defeat. Their only real success was their final evacuation in early January, as they fooled the Turks, blew up their remaining supplies, and escaped with over 30,000 soldiers and their equipment, with nary a casualty. But the butcher bill for the Gallipoli fiasco was high: about a quarter of a million casualties on each side.

Collectively, the combatants realized they were now in for a long costly war, and their industries, for the most part, geared up with major increases in the production of arms, munitions, and other supplies and equipment needed for their expanding armies. Production of heavy weapons and high-explosive shells became a priority matter.

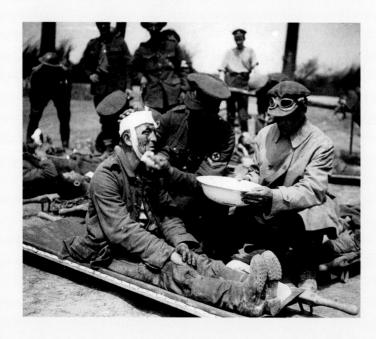

British medics treat a wounded German prisoner near Carnoy, France, during the Battle of the Somme, July 1916.

PRINT NO. 86 AMERICA, 1918. "HOLD UP YOUR END!" W.B. KING

Early in the year, it was the German chief of staff, Erich von Falkenhayn, who figured that a bigger and more focused hammer blow might crack the Western Front and lead to victory. He believed that the French army, which had suffered such high losses in 1914-15, might be nearing a breaking point, and it would be wise to hit them hard before the growing British army got any stronger. He also saw, like other generals on both sides, that artillery was emerging as the number one killer weapon of the war.

Falkenhayn reasoned that if the German army focused an overpowering combined-arms attack on a position that the French valued highly and would pay any price to defend, then the Germans could compel the French army to "bleed itself white" and collapse. The target he selected for this calculated bloodletting was the ancient French border fortress at Verdun. He was correct in that choice, as far as his thinking went: As a matter of national pride and honor, the French could not afford to lose Verdun. So early in 1916, Falkenhayn began gathering the forces and supplies for a *schwerpunkt* or "sharp point" assault on Verdun.

After Erich von Falkenhayn engineered the costly Battle of Verdun, he was sent to the Eastern Front.

That was the genesis of what, in the event, would prove to be the war's longest battle (over 10 months), and one of the costliest battles on the Western Front.

By early February, the German armies near the Verdun salient had assembled 1,000 guns, and after a long bad-weather delay (which the French, sensing that trouble was afoot at Verdun, used to rush in substantial reinforcements to augment their two divisions in place), the Germans opened fire. A nine-hour barrage destroyed the outer positions, but Verdun was surrounded by eight smaller formidable forts and the long battle was joined. French field marshal Joseph Joffre soon appointed General Philippe Pétain to take charge of the defense of the Verdun complex.

PRINT NO. 87 CANADA, 1918. "WE ARE SAVING YOU, YOU SAVE FOOD." E. HENDERSON

The Germans captured some of the outer forts, while the French continued to offer stubborn—nigh desperate—resistance. At first it seemed that the "bleed them white" approach was working, but the French held on and counterattacked, making the German assualts increasingly costly as fighting extended through March and April. By April, casualties numbered over 80,000 for each side, and it began to appear that Falkenhayn's approach had backfired: Both armies were being bled out.

The Germans did take Fort Douaumont, one of the toughest of the outlying forts, but paid a high price for it. They continued to advance and wrest control of other forts and some critical high ground, but the French continued to raise the ante with many fresh divisions thrown into the fight—which they were supplying via some 6,000 vehicles per day on the lone access road, now dubbed "the Sacred Way."

Falkenhayn reluctantly agreed to continue expanding the German effort with attacks across the Meuse River, but by early May, the battle—now widely referred to as a "meat-grinder"—had become another, larger trench warfare–style slugfest. The summer passed in a ghastly *pas de deux* of attack and counterattack, artillery slaughter, and deadly hand-to-hand grappling in the dark tunnels of the ruined forts around Verdun. The Germans gained some advantage when they deployed flamethrowers and phosgene gas, which kills every breathing creature it contacts, but the French quickly countered with an improved gas mask. Then, slowly, the Germans, having exhausted their reserves and with the huge British push at the Somme

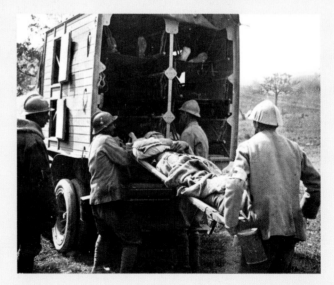

Increased artillery ranges pushed hospitals farther behind the front lines, making motorized ambulances indispensable.

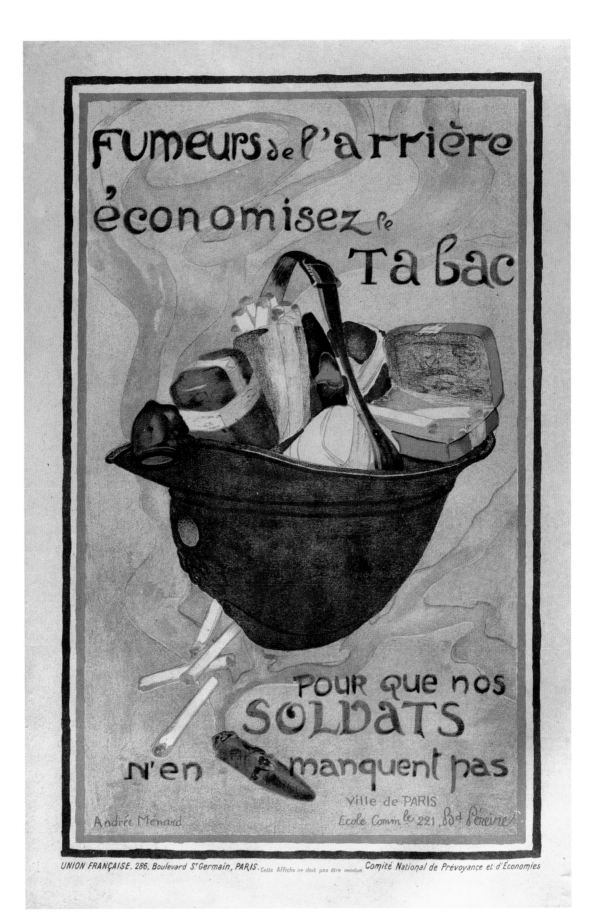

PRINT NO. 88 FRANCE, 1916. "CIVILIAN SMOKERS, SAVE TOBACCO FOR OUR SOLDIERS." ANDRÉE MENARD

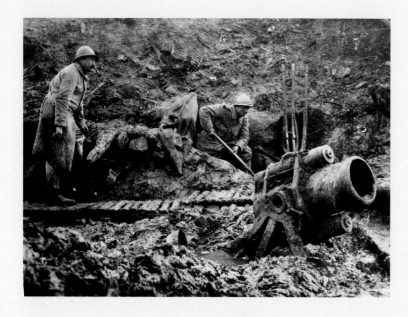

Trench mortars, like this large-caliber French model, were usually fired at a steep angle so the shells fell straight down on the target.

continuing, were pushed back to their starting lines. When the fighting finally wound down in early November, the French had regained the symbolic (now wrecked) Forts Douaumont and Vaux, and both sides, with casualties numbering in the hundreds of thousands, were right back where they started at the beginning of 1916.

Other major battles on land and sea unfoldeded during the same months of the seesaw fighting at Verdun, but failed to prove strategically decisive. At the end of May, the British Grand Fleet and Battle Cruiser Fleet came into nigh-accidental contact in the North Sea with the German High Seas Fleet. It seemed then that the two great naval powers would have their much anticipated "dreadnought showdown" (see Chapter 11). Their biggest guns exchanged fire, causing sinkings and casualties aplenty, but when the engagement broke off, both fleets were more or less intact. Britannia still ruled the waves and continued to blockade Germany.

DEADLOCK IN THE EAST

On the Eastern Front, it seemed clear that nothing decisive could happen. Despite its advantage in numbers of men under arms, Russia was so hamstrung by the sheer ineptitude of its leadership and the pervasive unrest among its citizenry that it could barely mount a sustained threat to German forces there. Germany was undercut in the East by the military weakness of its Austro-Hungarian ally and the many centrifugal internal pressures that threatened the dissolution and collapse of the Habsburg Empire. The Russians on their Northern Front did mount a series of attacks near the rail junction of Vilna but were repeatedly foiled by foul weather (thaws and freezes) and German defenses. On the Russian Southern Front, the ambitious commander General Alexei Brusilov—arguably the Russians' most capable and aggressive officer—kicked off the summer with a sweeping attack on the depleted Austro-Hungarian forces with astonishing success, penetrating scores of miles on a broad front and bagging hundreds of thousands of Habsburg prisoners. But the realities of Russian logistics doomed

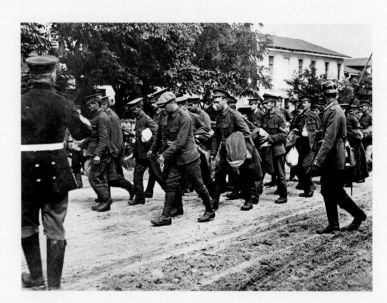

British prisoners captured at the Somme. Germany took nearly 4,300 prisoners during the long battle.

PRINT NO. 90 GERMANY, 1917. "WE NEED BOOKS, DONATE MONEY!" MAX ANTLERS

his effort. Brusilov's offensive could not be sustained, and once the German reinforcements joined the fray, his advances were negated—the campaign having cost the Russians over a million casualties for no strategic gain.

THE SOMME

The major Allied offensive at the Somme was masterminded and set in motion by the British Expeditionary Force commander Field Marshal Sir Douglas Haig. He was the epitome of the old-school British officer who evidently believed that there would always be a valuable place for cavalry and mass infantry charges (he appears to have considered machine guns a passing fad), who lacked the imagination to try anything other than a frontal infantry attack, and who apparently learned little as the war wore on. A case has been made that he was responsible for millions of British army casualties.

After a full week of artillery pounding the German lines, a large British and French assault went "over the top" early on the morning of July 1, with the French Sixth Army in the south and the British Fourth Army in the northern sector of a 25-mile front. Convinced that the preliminary barrage of some 1.7 million shells had likely destroyed the German lines, obliterated the barbed wire, and dazed the German troops, Haig expected a breakthrough against only scattered and disorganized resistance in his sector and sent wave after wave of unprotected and inexperienced infantrymen advancing slowly across a broad, empty no-man's land. For the British, that day was a military catastrophe of epic proportions: They took nearly 60,000 casualties including over 19,000 killed, the worst single day in British military history. To the south, the French divisions did better, taking far fewer casualties and advancing farther into the German defenses.

Field Marshal Douglas Haig was later called the "butcher of the Somme" for the 400,000 British casualties.

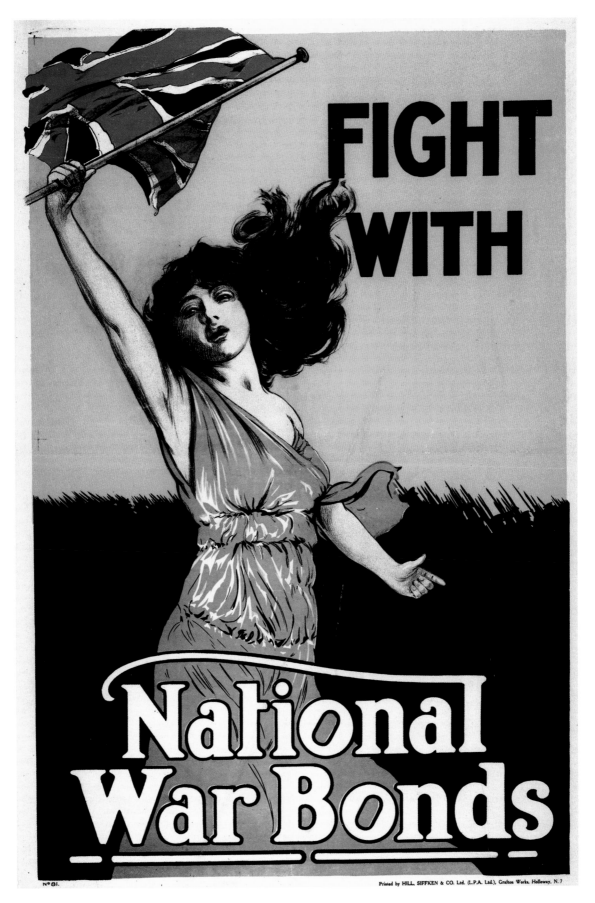

PRINT NO. 91 ENGLAND, 1914-1918. "FIGHT WITH NATIONAL WAR BONDS." PRINTED BY HILL, SIFFKEN, & CO.

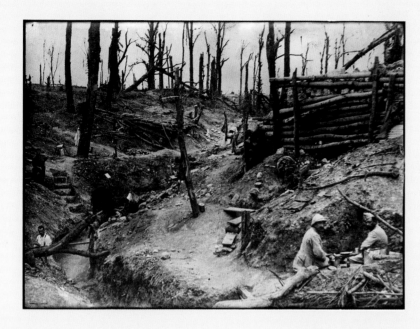

War turned the woods along the Somme River into a bleak, lifeless landscape.

That disastrous day was the opener for what became a long (four-plus months), costly advance. The Allies agreed to continue to attack in the Somme region and push the Germans back slowly in what became yet another battle of attrition that bid fair to wreck the German army, with lasting consequences. For the first time in history, tanks (British Mark I's) appeared in combat; only a few were operational, though they did surprise and panic the German defenders. Autumn rains turned the battle area into a bog, a nightmare landscape that made significant moves impossible. When the battle was halted in November, the Allies had penetrated the German positions for just six miles. The price for those gains: Over 400,000 British casualties, around 200,000 French casualties, and somewhere in the neighborhood of a half million German casualties.

There were other clashes in other theaters of the war in 1916: On the Southern Front, the Italian army under commander Luigi Cadorna fought an inferior Austro-Hungarian army along the border at Trentino, then

ILLION

L'ITALIA
HA BISOGNO
di
Carne - frumento - grasso & zucchero

Mangiate poco di questo cibo
perché deve andare al nostro
popolo, e le truppe
d'ITALIA

AMMINISTRAZIONE DEI CIBI STATI UNITI

PRINT NO. 92 AMERICA, 1917. "ITALY NEEDS MEAT, WHEAT, FAT AND SUGAR." GEORGE ILLIAN

launched the first of a long series of attritional and futile offensives in the rugged mountains along the Isonzo River, where the Austrian defenses hardened. In Mesopotamia, an overextended British expeditionary force under General Charles Townshend managed to get itself trapped and besieged by Turkish forces at Kut where they were starved into capitulating in yet another costly fiasco.

And so it went, in a year of inconclusive, deadly reversals and standoffs.

In long-term strategic consequences, the most important event of 1916 might well have been the conclusion in May of the negotiations of two men, Sir Mark Sykes of Britain and François Georges Picot. They had sat down in London with maps and proceeded in secret to draw up the partitioning of the Ottoman Empire into territories to be controlled in the postwar era by Britain and France—thus setting up the region's bitter nationalist/ethnic/religious conflicts that have persisted to this day.

British and Indian soldiers comprise a balloon observation team in Mesopotamia, 1916.

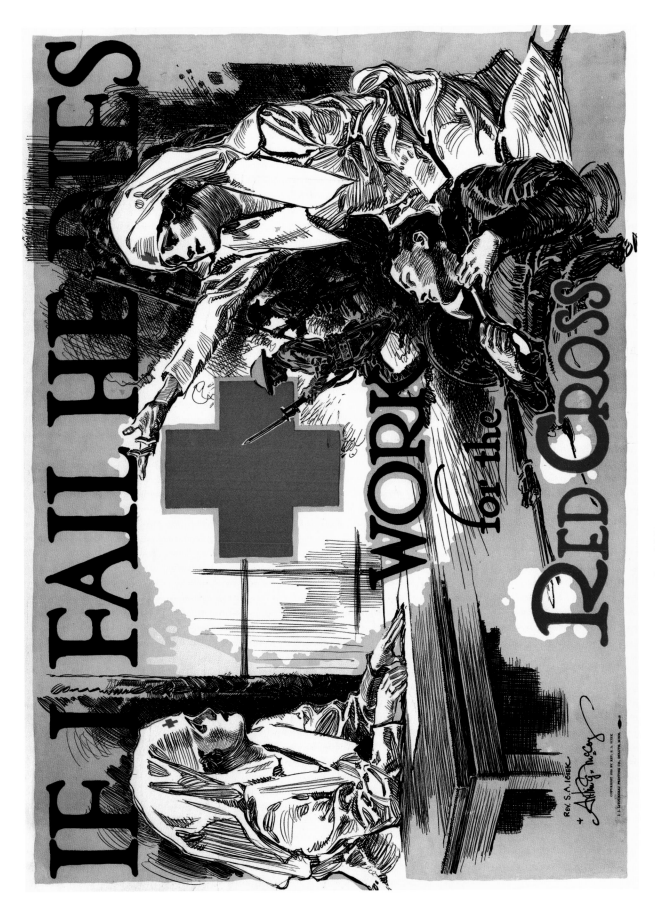

PRINT NO. 93 AMERICA, 1918. "IF I FAIL HE DIES." ARTHUR G. MCCOY

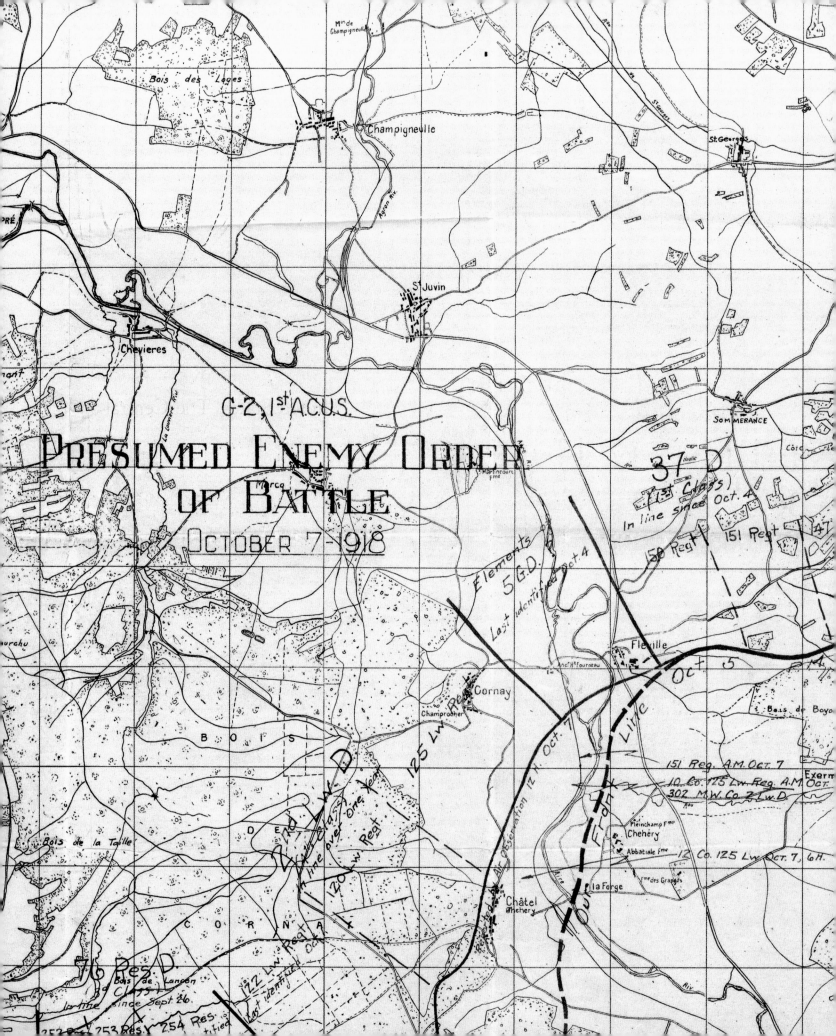

G-2, 1st A.C.U.S.

PRESUMED ENEMY ORDER OF BATTLE
OCTOBER 7-1918

Bois des Loges

Champigneulle

Mn de Champigneulle

St. Georges

St Juvin

Chevieres

La Lorraine Riv.

Agron Riv.

Sommerance

Martincourt Fme

37 D
(1st Class)
In line since Oct. 4

150 Regt 151 Regt

Elements
5 G.D.
Last identified Oct.4

Côte

Marcq

Fleville

Ancᵗ Hᵗ Fourneau

Cornay

Champrocher

151 Reg. A.M. Oct. 7

10. Co. 125 Lw. Reg. A.M. Oct.

302 M.W. Co. 2 Lw. D

Exerm

BOIS

125 Lw. Regt.

Air observation 12 H. Oct. 7

DE

Pleinchamp Fme
Chehéry

Abbatiale Fme

12. Co. 125 Lw. Oct. 7, 6 H.

D'ENFER

Reported

Bois de la Taille

120 Lw. Regt.

A line over one year

la Forge

Fme des Granges

Bois de Boyo

Châtel Chehéry

CORNAY

76 Res. D.

Bois de Lancon

in line since Sept. 26.

122 Lw. Regt.
Last identified Oct.

252 253 Res. 254 Res.

CALL *to* ARMS

More than 65 million soldiers were mobilized to fight in World War I. Of that total, 42 million men were from the Triple Entente (France, Britain, and Russia) and all its allies, including the United States. The Central Powers (Germany, Austria-Hungary, the Ottoman Empire, and Bulgaria, chiefly) mobilized about 23 million. Some individual country figures are staggering: Russia mobilized 12 million; Germany, 13 million; Britain, almost 9 million; France, 8.6 million; Austria-Hungary, nearly 7.8 million; Italy, 5.9 million; the United States, 4.4 million. ❖ There was a great need for manpower because the total casualty rate was so high—due to a combination of poor leadership, obsolete tactics, and increasingly deadly artillery. According to some sources, an astounding 57 percent of those mobilized were either killed (more than 5 million), wounded, or went missing during the course of the four-year conflict that some called the Great Mincing Machine.

The manpower needed for relentless fighting forced combatant nations to conscript millions of citizens.

Most of the troops were conscripted—that is, legally called up and obligated to fight for their countries as citizen-soldiers. But there were also a lot of volunteers, especially during the first year, 1914, when there was much patriotic fervor among all the combatants and many people thought that the war would be short.

Historians say that modern universal conscription got its start just after the French Revolution in the late 18th century. The country's so-called Jourdan Law stated that "any Frenchman is a soldier and owes himself to the defense of the nation." It was conscription that enabled Napoleon Bonaparte to form his Grande Armée.

According to Alex Watson, a history lecturer at Goldsmiths College, University of London, Prussia perfected the "short-service" conscript military model in the late 1800s—and most other Western nations, with the exception of Britain, emulated it. Prussian laws "obliged healthy male citizens to undergo a relatively brief period of military training in their youth and then made them subject for much of the rest of their adult lives to call up ... for service in an emergency." Men would be drafted at age 20, train and serve in the army for two years, then be released back to civilian life. But they could be called back to service at any time until age 45. Once past their formal military obligation, German men "passed through various reserve categories," writes Watson. "Those who had most recently completed their training belong to the first line reserve for five years, where they could be expected to be redrafted in the event of crisis."

YOUR COUNTRY
WANTS
YOU
AND
300,000
MORE MEN
LIKE YOU
DON'T WAIT
BUT JOIN NOW

British manpower needs were urgent in 1915 when this Parliamentary recruiting notice was posted in London.

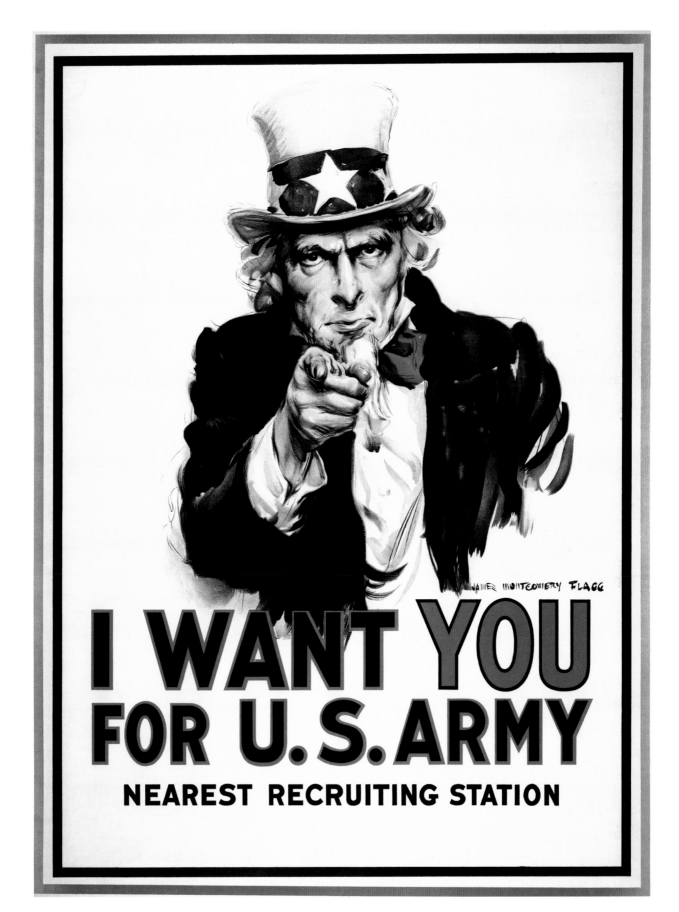

PRINT NO. 94 AMERICA, 1917. "I WANT YOU FOR U.S. ARMY." JAMES MONTGOMERY FLAGG

Women wave the German *Landsturm* off to war accompanied by a military band, circa 1914.

After those five years, the same men were designated over the next de-cade as *Landwehr*, or reservists, and then after that were moved to third-line *Landsturm* status for another several years. *Landsturm* was for the oldest re-servists (starting age 39); in the event of a major war, its men could see rear-line duties.

The short-service conscript system offered two advantages, explains Watson. "First, it created a large pool of trained manpower that could quickly augment the standing army in an emergency. Second, in a long conflict, the system offered an organizational framework capable of de-ploying nearly the entire manpower of a state as soldiers."

As it happened, every belligerent nation needed all the men it could find. More than 80 percent of the military-age men in France and Germany saw duty in the conflict. In Austria-Hungary the number was 78 percent; in Serbia, 63 percent; and in Italy and Bulgaria, more than half. And, of course, by 1918 Germany, Britain, and France were spent forces—all desperately short of men.

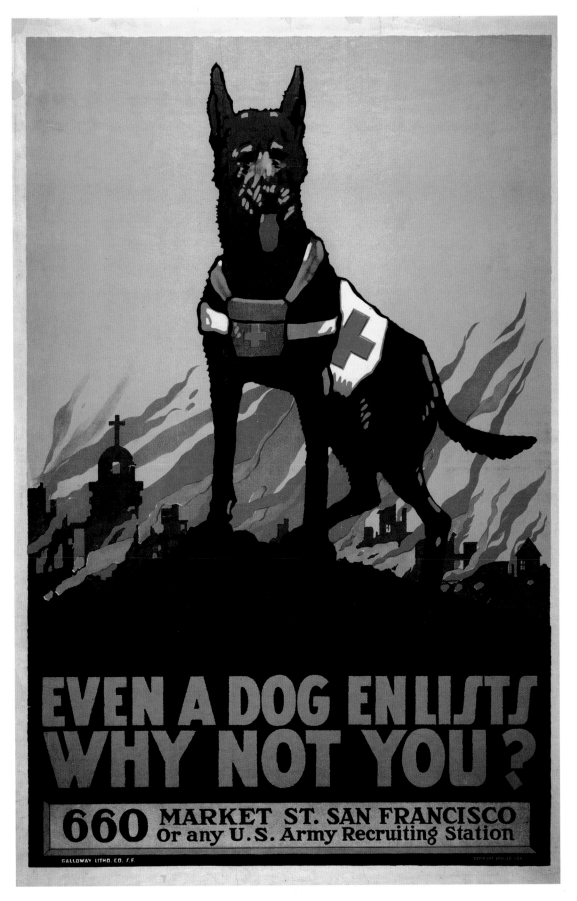

PRINT NO. 95 AMERICA, 1917-1918. "EVEN A DOG ENLISTS WHY NOT YOU?" MILDRED MOODY

BRITAIN

Britain was the only country that did not rely on compulsory service—at least for the first two years of the war. Conscription was an unpopular concept because, at that time, about 40 percent of men in Britain over age 21 could not vote, owing to discriminatory electoral and registration laws. The working class did not like the idea of dying for a government on which it had no influence. Many government officials and members of Parliament were sensitive to that viewpoint.

When the war began, Britain had a peacetime army of 250,000 men. Secretary of State for War Lord Horatio Kitchener appealed for volunteers to his so-called New Armies. Thanks partly to his famous "Your Country Needs You" posters, the response was robust: By January 1915, some 1 million Brits had volunteered to fight—and, in all, over the course of the war, 2.7 million volunteers were mobilized (roughly the same number as men conscripted to serve). Britain allowed local men to join and fight in "Pals Battalions"

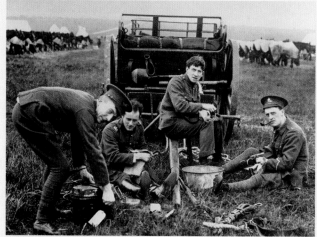

British recruits learn the ropes at Aldershot, the United Kingdom's first permanent military training camp established in 1854.

alongside their friends, family members, or work colleagues. Stockbrokers in London started the first Pals Battalion—1,600 men who became the Tenth Battalion, Royal Fusiliers. Some 250,000 of Britain's volunteers were boys under age 19, the legal requirement. Recruiting officers turned a blind eye to teenagers who wanted to fight.

By late 1915, as the war became a slaughterhouse and enlistments dwindled, it was apparent that volunteers could not meet the manpower needs. With passage of the Military Service Act of 1916, conscription was introduced. All single men ages 18 to 45 were compelled to serve. Teachers, clergymen, the medically unfit, conscientious objectors, and men with

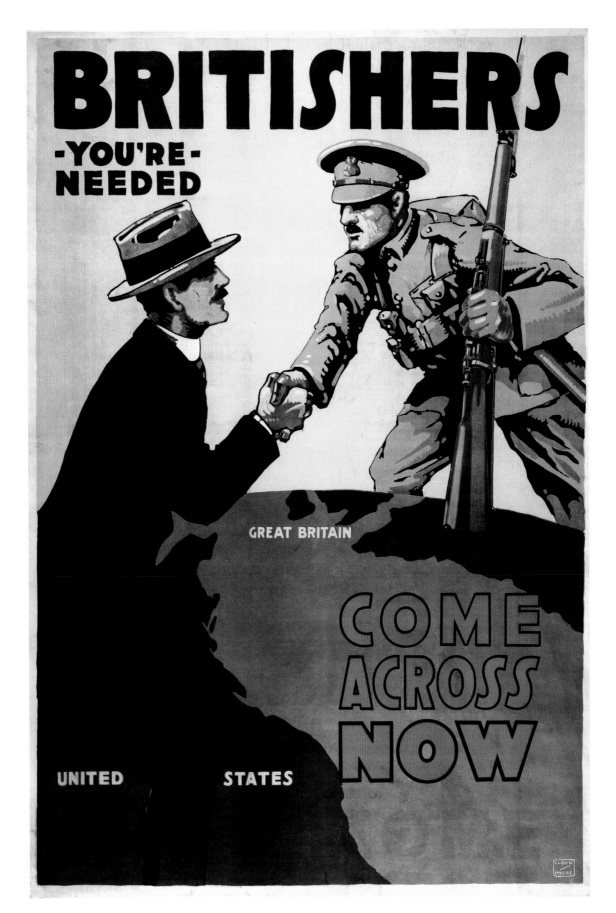

PRINT NO. 96 ENGLAND & CANADA, 1917. "BRITISHERS, YOU'RE NEEDED, COME ACROSS NOW." LLOYD MYERS

certain industrial jobs were exempted. There was a large anticonscription demonstration in Trafalgar Square, but compulsory service went ahead—and in May the law was tweaked to include married men. Over the next 12 months, 1.2 million men were drafted into the British army. In 1918 the manpower situation got so grave that the age limit was raised to 56.

More than 1 million from Britain's Dominions and Commonwealth nations—Australians, New Zealanders, Canadians, Indians, and South Africans—served as soldiers. Canada and New Zealand instituted conscription, while India had a professional, all-volunteer force, and some 1.3 million of its men fought in Turkey, Mesopotamia, and Egypt.

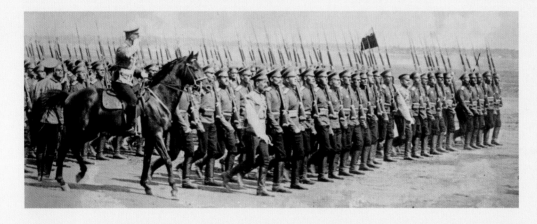

The Russian armed forces had some 1.5 million men in August 1914 and more than 6 million by December.

RUSSIA

Conscription in Russia goes back at least as far as Peter I. Every town and village had a quota system. Conscripts in the early 18th century served for life—at least until 1793, when the term of service was reduced to 25 years. Further reforms came in 1874, during the reign of Czar Alexander II: All men age 20 were compelled to serve in the Russian Imperial Army for six years, followed by nine years in the reserve.

PRINT NO. 97 AMERICA, 1918. " CZECHOSLOVAKS! JOIN OUR FREE COLORS!" VOJTECH PREISSIG

With its huge population, over 160 million in 1914, Russia had a de-
cided manpower advantage over Germany and Austria-Hungary. When war
broke out, Russia had the world's largest army, with nearly 1.4 million men.
More than half its soldiers were peasants from rural villages. After mobili-
zation, Russia's army grew to some 6 million. It suffered enormous losses,
especially in the first two years fighting Germany in East Prussia and in Rus-
sian Poland. Only Austria-Hungry had a higher casualty rate.

Then in 1917 a political revolution erupted. With Czar Nicholas II com-
manding the army, the government in Petrograd fell. The Bolsheviks, led by
Vladimir Lenin, soon took power, and by March 1918 Russia had signed the
Brest-Litovsk Treaty with the Central Powers and was out of the war.

FRANCE

France, with a population of 40 million people, could not match the man-
power of Germany, which had over 60 million. Thus the government in
1913 enacted the Three Year Law, which raised the length of compulsory
military service in an active regiment from two to three years for all men age
20 and older, up to age 45. The law aimed to keep French military manpower

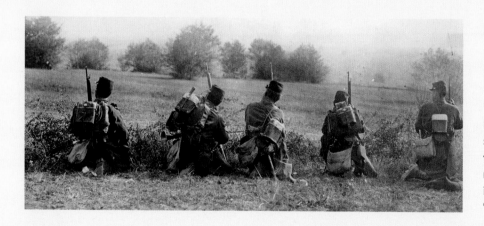

French front-line
soldiers or *poilus*,
which literally
means "hairy" but
is interpreted as
"virile" or "brave."

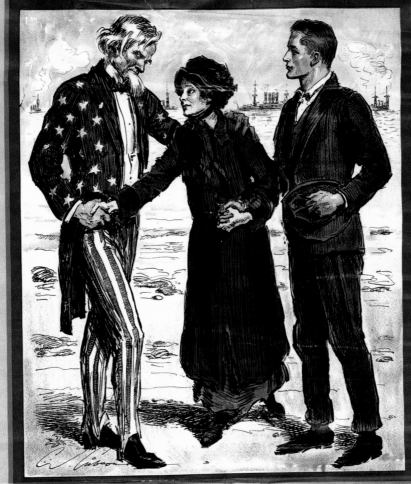

somewhat equivalent to that of the enemy. A man's total service requirement—including 11 years in the reserve followed by additional multi-year periods with the Territorial Army and Territorial Reserve—was raised to 28 years, meaning every French soldier could expect to be on a mobilization list for the duration of the war. Territorial reservists were not envisioned as being front-line soldiers—but French losses were so heavy that they experienced plenty of combat.

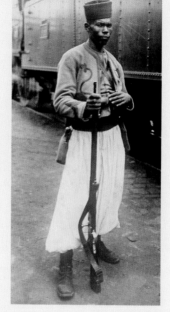

A *tirailleur* (rifleman) from the colonies of French Equatorial Africa. Some 450,000 Africans served in the French army, most of them in Europe.

About 260,000 Algerians fought for France and often led assaults. Algeria was the only North African colony in which France instituted conscription. According to historian Gilbert Meynier, a professor emeritus at the University of Nancy II, "Most Algerians had shown hostility to [compulsory] service, even while [the attitude] of a small group of young Algerians was favorable. They saw the measure as a way of attempting to obtain political rights in exchange for the blood-tax of the citizen. Many French officials made grand [economic and political] promises at the beginning of the war, sometimes sincerely." But most, in the end, were not kept.

UNITED STATES

The United States Army at the start of the war was small, with a little more than 200,000 men, including those in the National Guard. By 1916, when President Woodrow Wilson and others saw that America would likely have to join the conflict, Congress passed the National Defense Act, which stipulated that the federal army should grow to 165,000 men and the size of National Guard (the state militias) should rise to 450,000. Wilson hoped

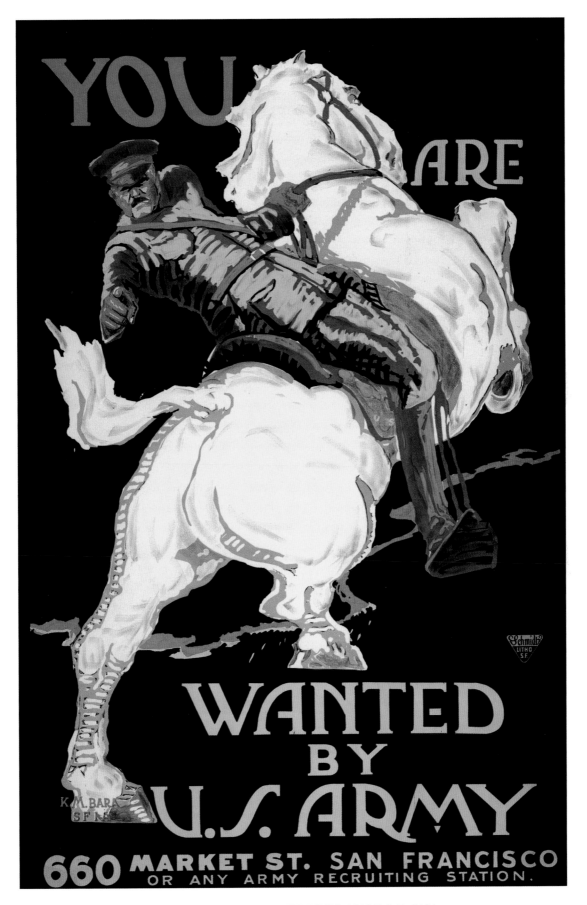

PRINT NO. 99 AMERICA, 1917-1918. "YOU ARE WANTED BY U.S. ARMY." K.M. BARA

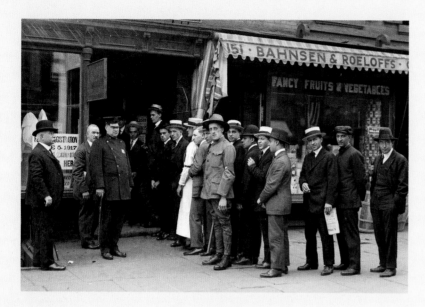

New Yorkers
queue for the
first of three draft
registrations,
June 5, 1917.

that volunteers would fill the ranks—but there were not nearly enough, and on May 18, 1917, barely a month after it had declared war on Germany, Congress passed the Selective Service Act, instituting compulsory service. All men ages 21 to 30 were required to register and enlist, and in August 1918 the age range was expanded to encompass men ages 18 to 45.

Ten million men registered for the draft on a single day—June 5, 1917—and over the next year and a half local draft boards across the country registered 25 million men. Within months about 10 percent would be called up and selected according to various categories of eligibility, "factoring medical, marital and occupational status along with the number of dependents one supported," according to A. Scott Berg's biography *Wilson*. By late 1918, the army had deployed some 2 million men in France, with about two-thirds of this number raised through conscription. According to a U.S. Army history of the war, "the Selective Service process proved so successful at satisfying the Army's needs while ensuring that essential civilian occupations remained filled that voluntary enlistments ended

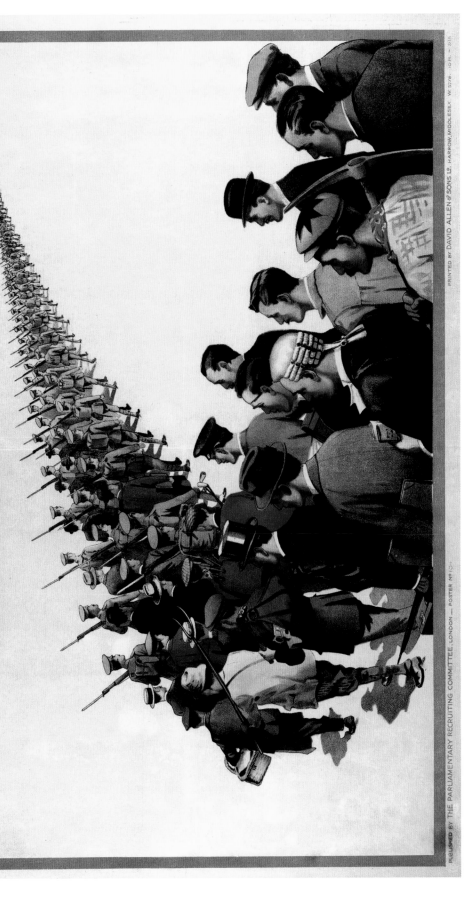

STEP INTO YOUR PLACE

PUBLISHED BY THE PARLIAMENTARY RECRUITING COMMITTEE, LONDON — POSTER Nº 101

PRINTED BY DAVID ALLEN & SONS LD. HARROW, MIDDLESEX. W. 5776. IGR. — 915.

PRINT NO.100 ENGLAND, 1915. "STEP INTO YOUR PLACE." PRINTED BY DAVID ALLEN & SONS LTD.

in August 1918. For the rest of the war, conscription remained the sole means of filling the Army's ranks."

There was opposition to the draft and the war. Some 350,000 Americans refused to register or serve—including many German-Americans, pacifists, and socialists. Socialist Party leader Eugene Debs, a four-time presidential candidate, spoke out against the war, and in June 1918 he was arrested for violating the Espionage Act of 1917. He was convicted and sentenced to 10 years in prison. The U.S. Supreme Court overlooked First Amendment arguments and upheld the conviction, stating that Debs had shown "the intention and effect of obstructing the draft and the recruitment for the war."

There were only 14,000 "doughboys" in France in the summer of 1917. By May 1918, just in time for the final push against Germany, there were more than 1 million—and half would be on the front lines. By the end of the war, 4.4 million American men had been mobilized for the conflict—nearly 3 million via conscription. The massive influx of American manpower, and the battles the Americans would fight, pushed Germany out of France and Belgium and helped to win the war for the Allies.—*R.E.*

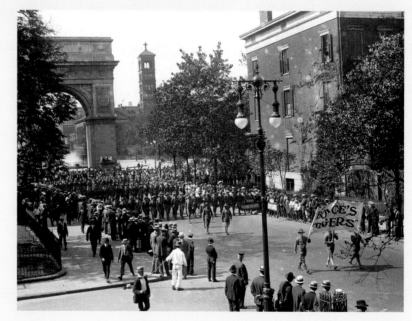

Draftees in Washington Square, New York, September 1917. As civilians, the men known as "Boyce's Tigers" trained under Major A.L. Boyce.

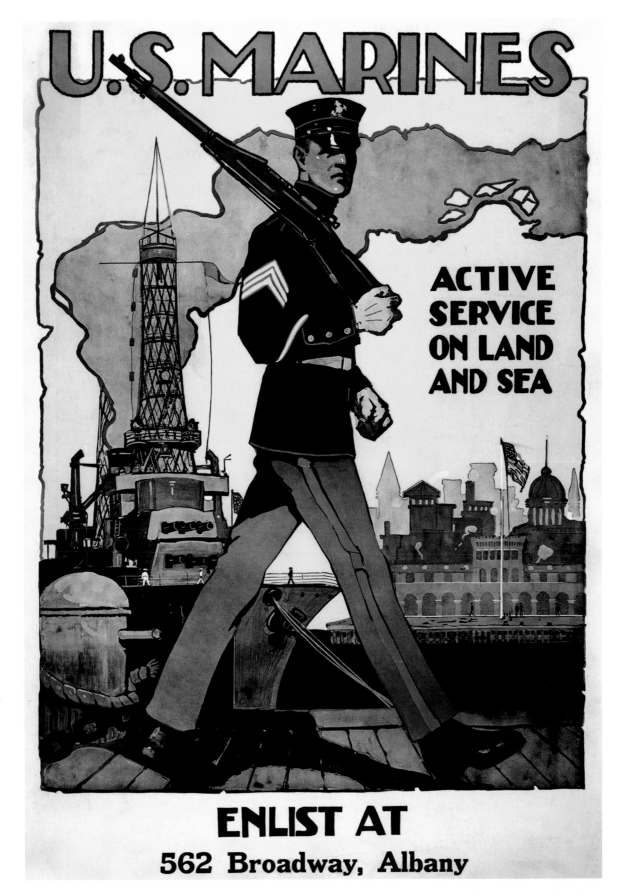

PRINT NO. 101 AMERICA, 1917. "U.S. MARINES: ACTIVE SERVICE ON LAND AND SEA." SIDNEY H. RIESENBERG

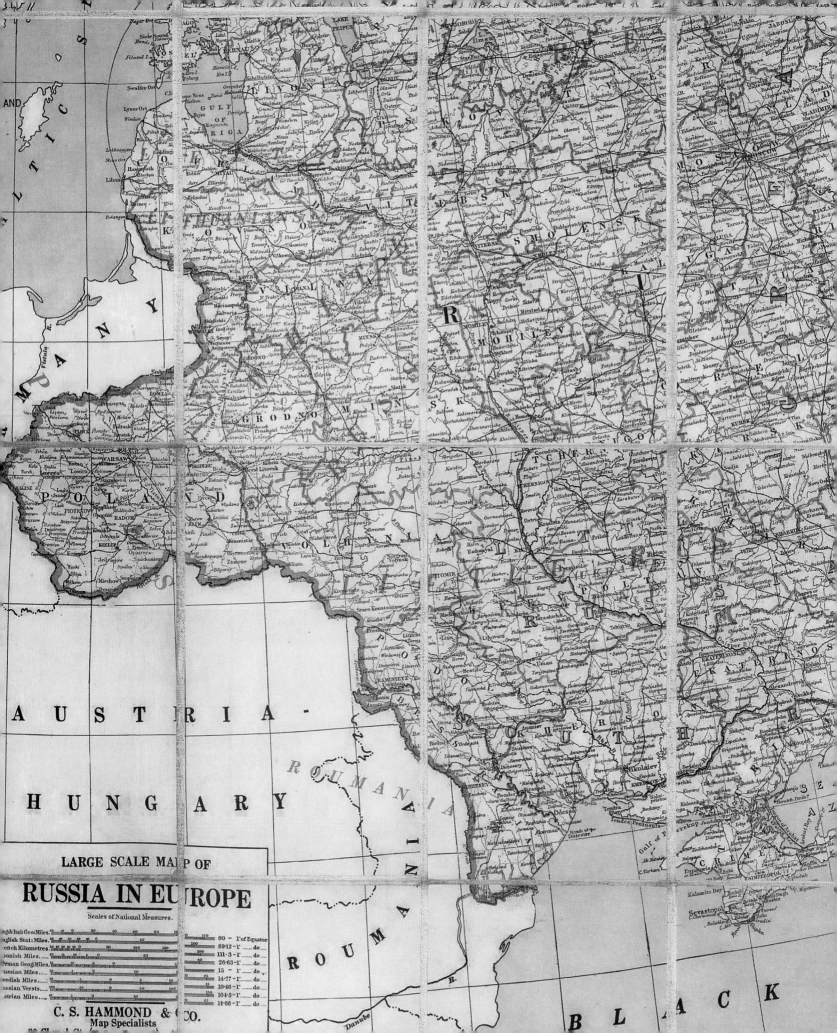

LARGE SCALE MAP OF

RUSSIA IN EUROPE

Scales of National Measures.

C. S. HAMMOND & CO.
Map Specialists

HOME FRONTS

On the home fronts, Russian, German, and Austrian civilians suffered major effects of combat, blockades, shortages, and political upheavals.

World War I was not the first "total war" in history, but for Europe it was surely the largest, with the most far-reaching consequences in the modern era. Civilian support and participation were extensive, most markedly in the empires and nations in Europe. During the early months, when the expectation of a short, decisive conflict was widespread, civilian morale ran high. But as the months, then the years, passed and the casualties mounted along with the economic and social impacts, disillusion and outright opposition to the war arose. One element of that total-war reality was the increasing government control over everyday life in all the nations. After the initial battles and fronts were established, the war settled into a long existential struggle. Among the challenges governments would face in the difficult years ahead were how to finance the high costs of waging war, how to find replacements for the armies' casualties, and how to feed their people.

Of course, in the fought-over regions of Belgium, France, Poland, Serbia, Russia, Austria-Hungary, Romania, and Italy, where the battle fronts and the home fronts often were one and the same, the impacts on civilian life were severe: terrible casualties along with destruction of property, resources, and local economies. Large numbers of civilians were displaced from their homes, farms, villages, and neighborhoods and became refugees. Even outside the areas where the bullets were flying, the changes wrought by four years of war touched the lives of everyone.

The rapid growth of the armies caused great disruption in all the combatant nations, as hundreds of thousands and eventually millions of young men were taken out of homes, shops, factories, farms, and communities—many of them never to return. One consequence was that women entered the workforce in unprecedented numbers, with predictable social and political changes to follow: In Britain, for instance, women gained the right to vote for the first time.

Germany, as a land power on the Continent facing England, the world's mightiest naval power, had good reason to be concerned about blockade of its North Sea and Baltic Sea ports. Indeed, the British had been planning ways to blockade Germany for 10 years before the war broke out. Kaiser Wilhelm, apart from his love for the idea of making Germany a sea power, launched his prewar shipbuilding program in part to counter a potentially ruinous British blockade.

A French woman sits in the ruins of her home in the Somme region, July 1917.

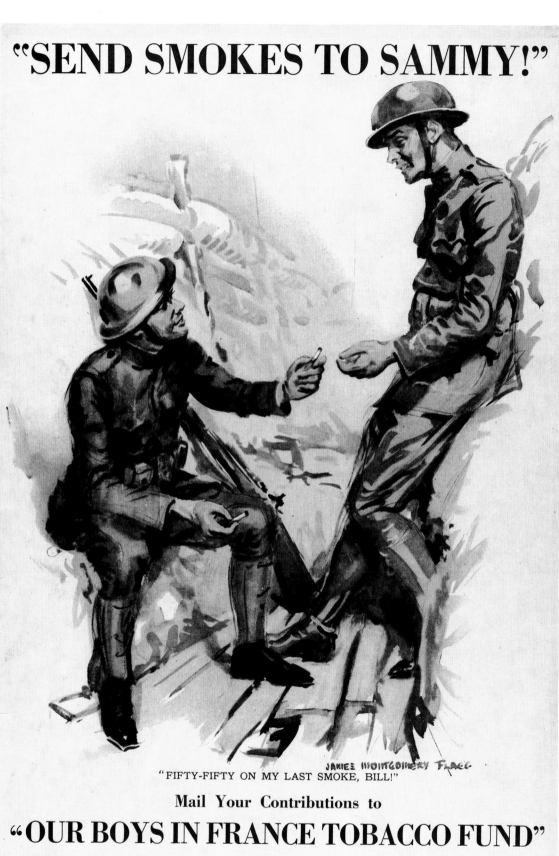

"SEND SMOKES TO SAMMY!"

"FIFTY-FIFTY ON MY LAST SMOKE, BILL!"

Mail Your Contributions to

"OUR BOYS IN FRANCE TOBACCO FUND"

25 West 44th Street Endorsed by
War Department New York City

PRINT NO. 102 AMERICA, 1914-1918. "SEND SMOKES TO SAMMY!" JAMES MONTGOMERY FLAGG

Germany, like many other European nations in the decades before the war, had developed a robust international trade in raw materials, manufactured goods, and food stocks and had long been aware that a naval blockade could cause calamitous economic disruption.

In the event, the British did institute a blockade of Germany on November 11, 1914, just a few months after the war began. The goals were to bottle up the German fleet in its home ports, to prevent strategic materials

A mobile soup kitchen feeds Berliners in 1916. The sign reads "Warm lunch. Supplied by the Association of the Berlin People's Kitchen."

from reaching the country, and to starve the population and the army into submission. With its powerful navy and worldwide intelligence network, Britain was able from the outset to curtail the flow of foods, fertilizer, fabrics, and strategic raw materials to Germany.

The effects began compromising the quality of life within the first year of the war, and by mid-1916, the impacts, especially on food supplies, were dire, and rationing became a signal reality. Combined with crop failures at the beginning of the war and the influenza epidemic in the last year of the

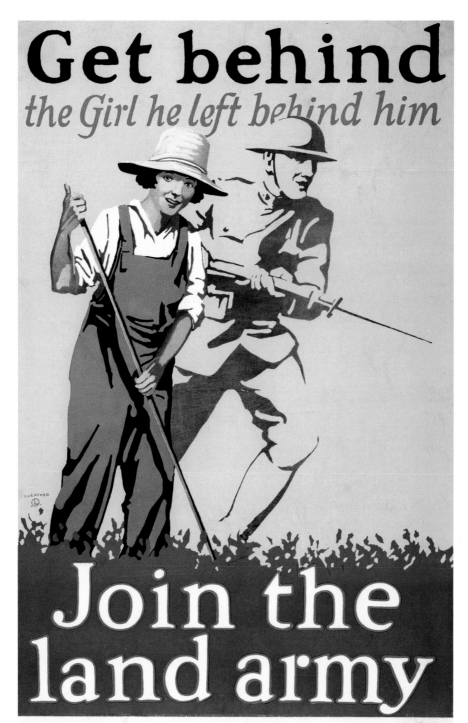

PRINT NO. 103 AMERICA, 1918. "JOIN THE LAND ARMY." LAMBERT GUENTHER

war—and the mounting effectiveness of the British blockade, which was also impeding the military effort—the German home front became a scene of considerable suffering due to malnutrition and concomitant disease, as well as declining morale. Germany proved ingenious at finding substitutes, *Ersatz*, for many unobtainable materials—chicory for coffee, turnips for potatoes, ash for pepper— but by 1917, even the ersatz items were in short supply, rationed, or nonexistent.

The privations due to war set the scene for growing social and political unrest, and with strikes, agitation, inflation, and the rise of black markets, riots spread. The strike of some 200,000 metal- workers in Berlin on April 16, 1917, was a watershed event. Desertions from the army and navy—previ- ously unheard of—began to grow. While Germany's resolve to continue the fight remained surprisingly strong, even after it was clear that victory was unlikely, by late 1917 revolution was in the air.

Tempelhofer Feld, a public park and military parade ground in Berlin, is plowed under and planted with potatoes in 1915.

Germany's home front situation became one of the worst among all nations as the war ground on. But while the burdens of civil privations and shortages fell unevenly on the combatant nations, life on the different home fronts took varying turns for the worse for complex social, econom- ic, and political reasons.

Austria-Hungary, Germany's chief Central Powers ally, suffered from shortages of food and key materials, but its home-front situation was ex- acerbated by the portmanteau character of its ethnic makeup. The death of its longtime popular monarch Franz Josef in November 1916 removed one of the props holding the fractious empire together at a time when its

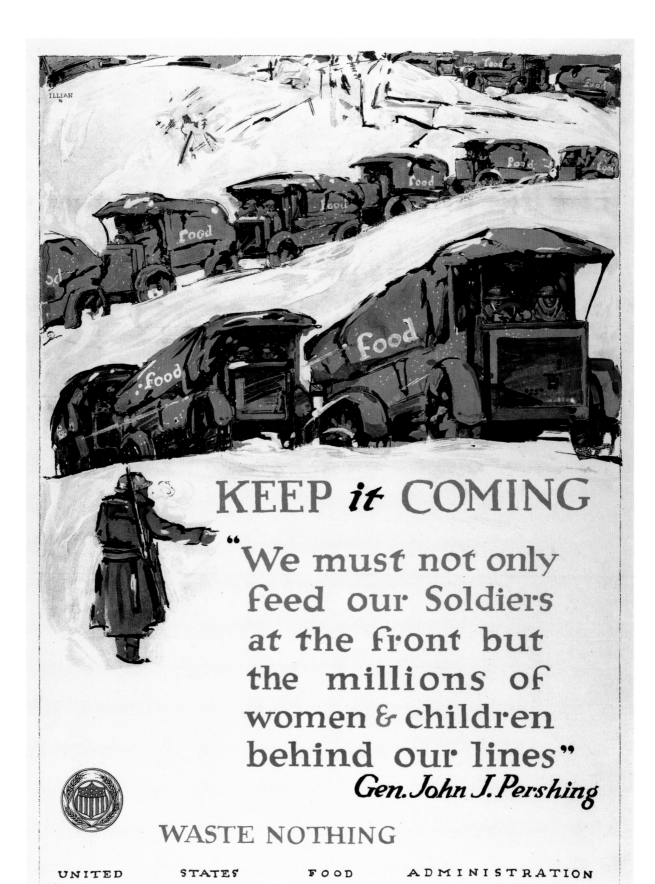

military setbacks, including its calamitous casualties in the first year of the war, were undermining civilian morale. In particular, Hungary, which was the breadbasket of the Habsburg Empire, grew less and less inclined to share its output with the Austrians, who were straitened by the British blockade. Austria was one of few combatant nations that openly sought a separate peace in advance of the 1918 armistice.

RUSSIAN HARDSHIPS

Russia's handicaps in mounting an effective military effort were the same ones that negatively impacted civilian life: poor transportation and communications facilities, a sclerotic government bureaucracy, the inept leadership of Czar Nicholas II, and the high army casualties in its early campaigns—as many as 4 million through 1915. The Turks, armed with cruisers supplied by Germany, controlled the Dardanelles and early on attacked Russia's important ports on the Black Sea.

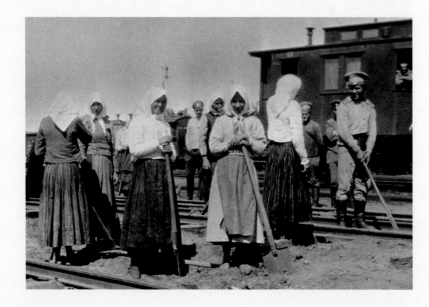

Russia drafted more than 5 million men in the last half of 1914 alone, leaving women to handle railroad work and other non-traditional jobs.

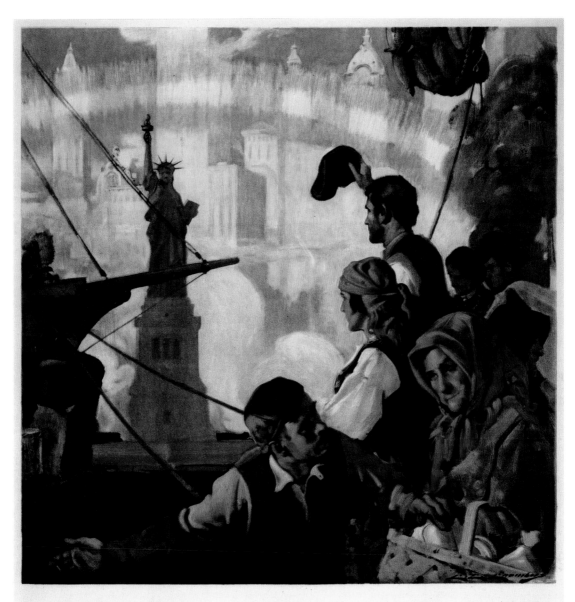

שפּייז וועט געווינען דיא קריעג!

אידר קומט אהער צו געפֿינען פֿרייהייט.

יעצט מוזט אידר העלפֿען זיא צו בעשיצען

מיר מוזען דיא עלליים פֿערזארגען מיט ווייץ.

לאזט קיין זאך ניט גיין אין ניווועץ

יוניטעד סטייטס שפּייז פֿערוואלטונג.

PRINT NO.105 AMERICA, 1917. "FOOD WILL WIN THE WAR." CHARLES EDWARD CHAMBERS

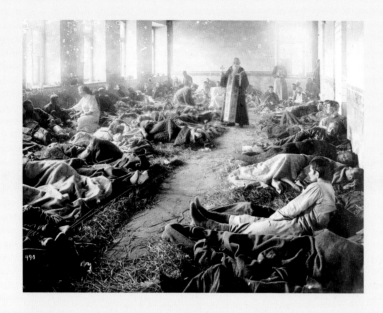

A Russian Orthodox priest leads a service for wounded soldiers in a makeshift hospital in Suwalki, Russian-claimed territory on the Polish-Lithuanian border.

Russia, even in the best of times without war, had been a seriously troubled country with an unwieldy economy and an autocratic, ineffective, and unresponsive government.

By 1917, the internal strains were visible and growing. Rapid industrialization brought a boom in jobs and wages, but also inflation, sudden migrations, and logistical dysfunction. Thus the stage was set for a social and governmental collapse.

No stranger to revolution (it had a prior brush with a populist uprising in 1905), Russia's inability to supply necessities simultaneously to its vast army and to its even more vast and increasingly restless civilian population resulted in food shortages, demonstrations, and strikes, which in Petrograd were joined by army units hitherto loyal to the czar. A complex swirl of political events led to the abdication of Nicholas II in March 1917, leaving the nation leaderless and in full revolt, and by November, the political power had been grasped by Vladimir Lenin and the Bolsheviks.

My Homing Pigeons–Birds of War

From a Painting
By
COLES PHILLIPS

Raising pigeons for war service is the unusual and very practical way in which Coles Phillips expresses his patriotism

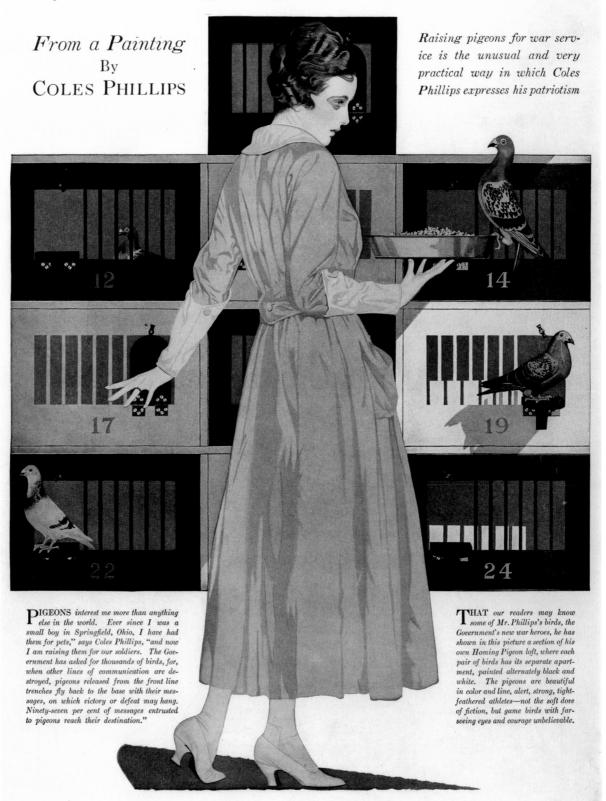

PIGEONS *interest me more than anything else in the world. Ever since I was a small boy in Springfield, Ohio, I have had them for pets,"* says Coles Phillips, *"and now I am raising them for our soldiers. The Government has asked for thousands of birds, for, when other lines of communication are destroyed, pigeons released from the front line trenches fly back to the base with their messages, on which victory or defeat may hang. Ninety-seven per cent of messages entrusted to pigeons reach their destination."*

THAT *our readers may know some of Mr. Phillips's birds, the Government's new war heroes, he has shown in this picture a section of his own Homing Pigeon loft, where each pair of birds has its separate apartment, painted alternately black and white. The pigeons are beautiful in color and line, alert, strong, tight-feathered athletes—not the soft dove of fiction, but game birds with far-seeing eyes and courage unbelievable.*

PRINT NO.106 AMERICA, 1917-1918. "MY HOMING PIGEONS — BIRDS OF WAR." COLES PHILLIPS

DISILLUSIONED FRANCE

France, with its own robust agricultural economy, at least had sufficient food throughout the war. But other shortages, plus the perceived ineptitude of many of its commanders and the enormous losses in such battles as Verdun, brought a wave of disillusionment with the war that crested with the military "mutinies" of 1917. Those breakdowns of military discipline came on the heels of commander in chief General Robert Nivelle's highly touted but high-casualty and ineffective offensives, especially at Chemin des Dames in April 1917. Nearly half of the 112 divisions in the French army engaged in some form of disobedience, mostly refusing when ordered to go into combat. The actions were met with a scattering of executions, but more wisely General Philippe Pétain, who had replaced Nivelle, promised and delivered a series of military reforms, including more leaves, more rotations out of the front lines, and better food, which restored a measure of the morale and spirit of the army. But the lesson was clear: France, although mindful of the existential consequences of the war, was perforce nearing the end of its support for the fight.

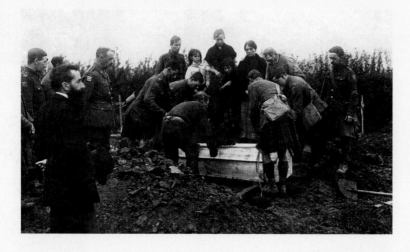

Scottish soldiers bury a French woman killed by a German shell in Denain, France. Canadian troops liberated the town in October 1918.

HUNGER

For three years America has fought starvation *in* Belgium

Will you *Eat less* – wheat meat – fats *and* sugar that *we* may still send food *in* ship loads?

UNITED STATES FOOD ADMINISTRATION

PRINT NO.107 AMERICA, 1918. "HUNGER." HENRY RALEIGH

Britain was in some respects the least prepared of the major nations for a ground war; its navy was famously powerful, but its army was small, lightly armed, and led by tradition-bound officers. Nevertheless, the British nation was among the best prepared economically, socially, and even politically to conduct a long war. Its industries and labor force were well organized, and it had the political foresight to plan for many of the eventualities that took other nations by surprise. Morale and support for the war—which was widely viewed as a just and necessary struggle against a nefarious enemy—was positive: Its army was initially inadequate, but volunteers swelled the ranks to over a million men in less than a year. And in mid-1916 a comprehensive draft was able to meet its personnel needs through the end of the war.

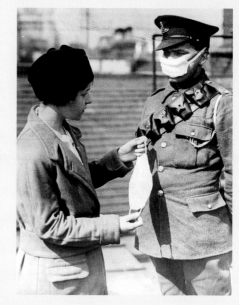

A British nurse and soldier show how to use a face mask during the deadly influenza outbreak that swept the front lines and the home front.

The interruptions in seaborne commerce affected the food supply, and there were shortages and rationing of food and other civilian goods, but morale and support for the war continued at a high level, seriously compromised only by the continued appalling casualty rates and the dissatisfaction with the military leadership.

AMERICAN STRENGTHS

America entered the war on the side of the Allies with a declaration of war on April 6, 1917. The Atlantic Ocean had long been a psychological and political defensive bulwark against invasion and participation in Europe's many conflicts over the years. But despite a significant German émigré population in America, the atrocious behavior of the German army at the war's outset began eroding support for the Central Powers. Moreover, with its neutral status, America had engaged in highly lucrative commerce with

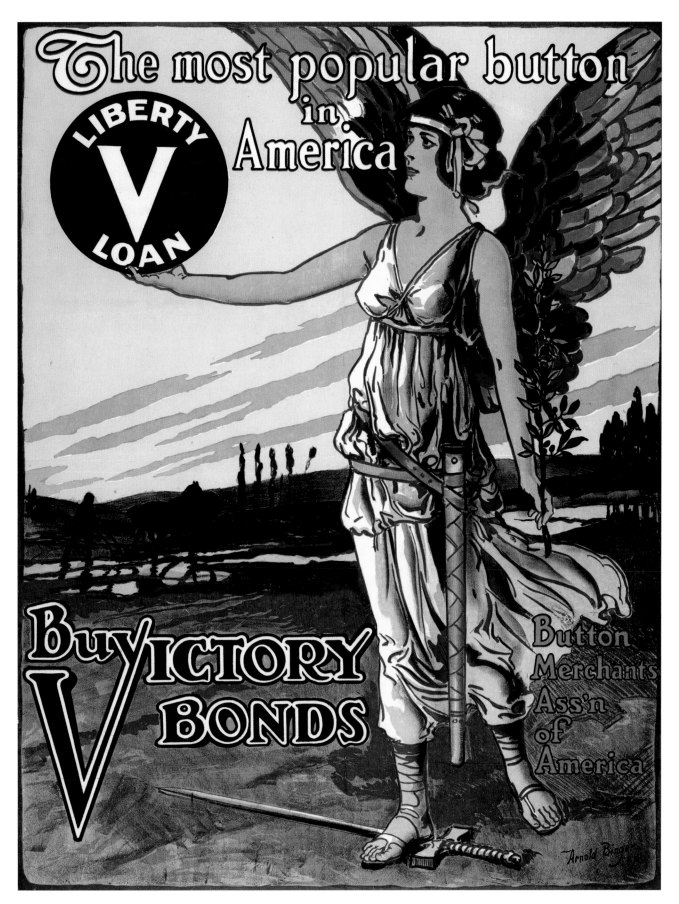

PRINT NO.108 AMERICA, 1917-1918. "THE MOST POPULAR BUTTON IN AMERICA." ARNOLD BINGER

the Allied nations, which, along with the revulsion to such U-boat attacks as the sinking of *Lusitania* in 1915 (and later to Germany's adoption of unrestricted submarine warfare), contributed to a shift away from the country's traditional isolationist attitudes. President Woodrow Wilson, after two years of trying to mediate the conflict between European belligerents, shaped America's entry as a far more idealistic enterprise than was the norm for the Allies, pointing as he did toward the creation of a new world order as a major motive. The word "crusade" appears on more than one American propaganda poster.

The armies of Britain and France were by early 1917 approaching exhaustion, and what they wanted from America was more soldiers. But trained manpower—the U.S. Army totaled just over 130,000 when war was declared—was only one of many assets the American military lacked, including heavy weapons and nearly every other kind of equipment. Conscription began about a month after the declaration of war, and the army's vast expansion was underway. Hundreds of thousands of young American

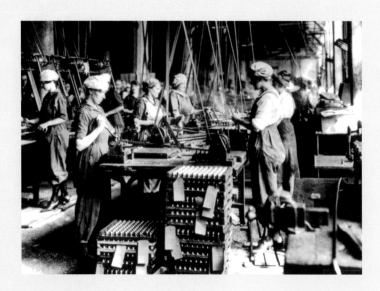

American women do their bit for the war effort, manufacturing ordnance at Gray & Davis, Cambridge, Mass.

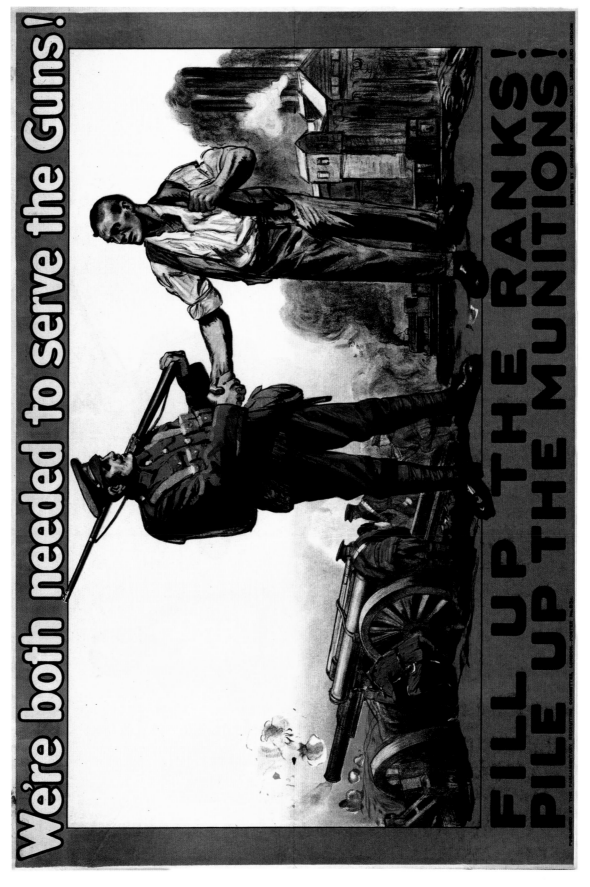

PRINT NO.109 ENGLAND, 1915. "WE'RE BOTH NEEDED TO SERVE THE GUNS!" PRINTED BY CHORLEY & PICKERSGILL LTD.

men volunteered, and many hundreds of thousands more were drafted, moving toward a final total of over 4 million by war's end. One indication of the attitudes toward the Great War in Europe is that many young American men volunteered to serve, prior to America's entry, with Canadian, British, and French military organizations, most notably with the French Foreign Legion and as flyers with the Lafayette Escadrille.

Propaganda in America, both domestic and produced by the Allies, mainly the British, relied on themes of service, selflessness, and even adventure and glamour to encourage volunteers and succor draftees. America's robust economy, especially its industrial and agricultural production, was already engaged in supplying war materiel to the Allies (the U.S. economy grew by 10 percent during the war), and it expanded to meet the challenge of equipping the fast-growing army, navy, and air services. Materiel of all kinds, from bullets to boots, was needed, and the switch from civilian to military production did dislocate the economy to the detriment of civilian consumer goods. But the shortages and frustrations on this side of the Atlantic paled in comparison with the effects on home-front life in Europe.

The youngest victims of war: the children of German soldiers at the front on an outing in Berlin.

The combat experience of the U.S. military lasted less than six months, and while the rate of casualties was comparable to that of Britain and France, the costs in blood were not seen on the American home front as they were in Europe. Moreover, the combat death toll of just over 50,000 Americans was substantially eclipsed by the deaths due to the influenza epidemic that struck during the World War I years.

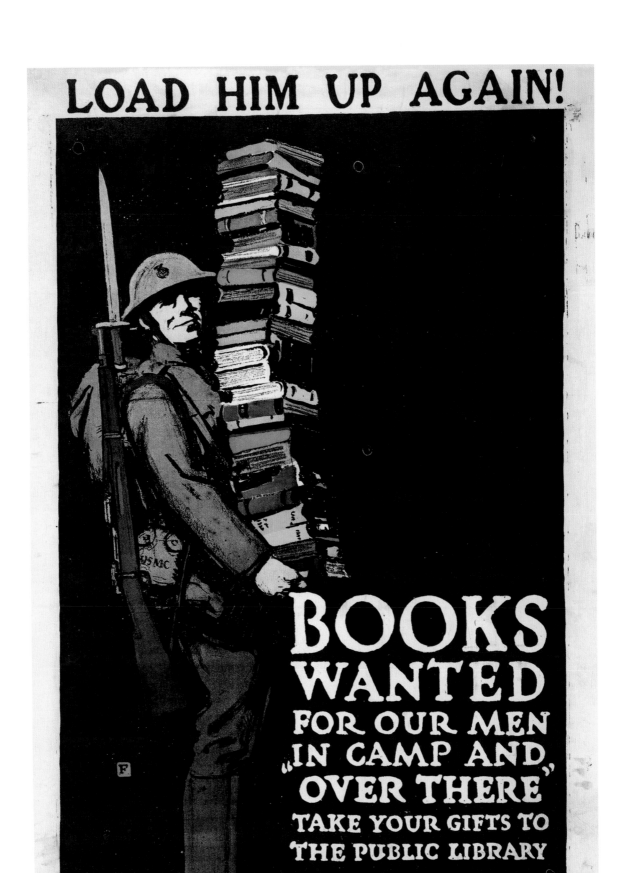

PRINT NO. 110 AMERICA, 1918-1919. "LOAD HIM UP AGAIN!" CHARLES BUCKLES FALLS

C.Kater
Home Bay
Disko I.
Godhavn
Jakobshavn
Disko Bay
Holstenborg
Angmagsalik
Kioge Bay
ICELAND
Reykjavik
Hekla 5107
King Christian IX Land
Denmark Strait

BATTLE OF JUTLAND MAY 31ST 1916

Fox Channel
Fox Land
Godthaab
Lichtenfels
Frederikshaab
C.Adelær

BATTLE OF THE BIGHT AUG. 28TH 1914

Faröe Is (Dan.)
Shetland Is.

Cumberland Sound
C.Chidley
C.Desolation
Julianehaab
Frederiksdal
C.Farewell

LORD KITCHENER LOST JUNE 5TH 1916

BRITISH

Hudson Strait
Frobisher Bay
Ungava Bay
Hebron
Nain
Hopedale

Churchill to Liverpool 2926 Miles

Glasgow
ISLES
Ed

LABRADOR
Big R.
East Main R.
James Bay
Kiksoak R.
Hamilton R.
Hamilton Inlet

Quebec to Liverpool 2625 Miles

LUSITANIA TORPEDOED MAY 7TH 1915

Belfast
Dublin
Cork
Liverpool
London
Southampton

Mistassini L.
C.Charles
Belle Isle Strait
NEWFOUNDLAND
Anticosti
Gulf of St.Lawrence
Trinity Bay
St. John's

Halifax to Liverpool 2485 Miles

English Chan
Brest
Nantes

Quebec
Montreal
Sault Ste Marie
Ottawa
St.Lawrence
Fredericton
Pr.Edward
Cabot Strait
Miquelon I. (Fr.)
C.Race

Quebec to Liverpool 2872 Miles

New York to Liverpool 3140 Miles

Bay of Biscay
Bordeaux

Buffalo
Albany
St.John
Portland
Sydney
Cape Breton I.
Sable I.

New York to Southampton 3120 Miles

Corunna
C.Finisterre
Bilbao

New York
Boston
C.Cod
Providence
Halifax
C.Sable

Oporto
Coimbra
MADRID
SPAIN

Baltimore
Philadelphia
Washington
Richmond
Norfolk
Plymouth
C.Hatteras

New York to Gibraltar 3180 Miles

Flores I.
Azores (Port.)
Lisbon
R.Tagus
C.St.Vincent
Cadiz
Strait of Gibraltar
Gibraltar (Br.)
Valencia
Seville

Wilmington
Charleston
Savannah
St.Augustine

N.Y. to B. 690

Kingston to Southampton 4075 Miles

Tangier
Rabat
Fez
Marakesh
MOROCCO

Bermuda Is (Br.)

St. Thomas to Southampton 3580 Miles
Colon to London 4775 Miles
Barbados to Liverpool 3650 Miles

Madeira I. (Port.)
Mogador

N.Y. to St. Thomas 1432 M

Nassau
Bahama Is (Br.)

N.Y. to K. 1485

Canary Is (Span.)
Ifni
C.Juby

CUBA
Santiago
WEST INDIES

Georgetown to London 4030 Miles

ATLANTIC

C.Bojador
RIO DE ORO

JAMAICA (Br.)
Kingston
HAITI
Port au Prince
St.Domingo
Porto Rico
Virgin Is (U.S.A.)
Anguilla I. (Br.)
Barbuda I. (Br.)
Antigua I. (Br.)
Guadeloupe I. (Fr.)
Dominica I. (Br.)
Martinique I. (Fr.)
Sta.Lucia I. (Br.)
Barbados I. (Br.)

New York to Cape Town 6600 Miles
London 6340 Miles
London 5205 Miles
C.Blanco

St. Louis
FRENCH W

Caribbean Sea
Curaçao
Valencia
La Guaira
St.Vincent
Grenada I. (Br.)
Tobago I. (Br.)
Trinidad I. (Br.)

Buenos Aires to London
Rio de Janeiro to

Cape Verde Is (Port.)
C.Verde
Dakar
Bathurst
GAMBIA
PORT.
GUINEA
Bammako

Barranquilla
Cartagena
Maracaibo
Caracas
Orinoco R.
Georgetown
New Amsterdam
Paramaribo
Cayenne

New York to Pernambuco 3690 Miles

Bissagos Is
Bolama
Konakry
Freetown
Kongo

VENEZUELA
Bogota
COLOMBIA
Medellin
Socorro
Popayan
Pasto
Mt.Roraima
BRIT. DUT. FR.
GUIANA

SIERRA LEONE
Monrovia
LIBERIA
C.Palmas
Bingerville
GOLD
COAST

Quito
Cotopaxi
R.Negro
R.Japura
R.Putumayo
Marajo I.
Luiz

St.Paul I. (Brazil)

London to Ascension
Gulf of

1917

During 1916 and 1917, Germany commissioned over 200 U-boats, many of them with ocean-going capability. There was a parallel development on the Allied side in land warfare: Although the very idea of a tank—a tracked, armored, self-propelled gun carrier—was still in its infancy, the French during those same years produced over 800 tanks, while Britain produced about 1,300 tanks. Production and deployment of such mechanized weapons was a sign that the combatant nations were seeking new ways to prevail over their enemies. ❖ The year 1917 was a time of reassessment. None of the war-weary nations had found a way to break through to a victory. Some, like Russia and Austria-Hungary, had suffered catastrophic casualties and were nearing the breaking point. In this third year of constant and costly fighting, all were desperately seeking a tactical edge and a fresh, winning strategy.

By 1917, both sides sought ways to avoid disaster and achieve a win. For the Allies, American manpower promised a path to victory.

In Germany, the military leaders Paul von Hindenburg and Erich Ludendorff had essentially taken command of the nation and moved to harness its industrial production almost wholly to the defeat of Britain, which by then had emerged as their strongest enemy. Russia in the east had all but collapsed, while France in the west was recoiling into a defensive posture after its years of crippling losses. Germany too had suffered enormous losses in the battles of 1916 on the Western Front, and it passed the early months of 1917 pulling back to a tighter defensive line, the Hindenburg position. At the same time, it held back from major land offensives and instead decided to adopt the very strategy that Britain had used on Germany: a sea blockade aimed at starving the population into submission. Lacking the surface ships to match the British navy, Germany fatefully decided, after temporizing for months, to resume unrestricted submarine warfare in February 1917, with the goal of targeting the merchant shipping upon which the British economy depended.

Generals Hindenburg and Ludendorff managed the German war effort like military dictators.

The German chancellor Theobald von Bethmann Hollweg had long cautioned that in the wake of the sinkings of *Lusitania, Arabic,* and other passenger liners, further submarine depredations threatened to bring the United States into the war on the Allied side. Germany's secretary of the navy, Admiral Eduard von Capelle, scoffed that America's military potential meant nothing: "They will not even come because our submarines will sink them." But the reality was that Germany, by following the urging of its chief of naval staff, Admiral Henning von

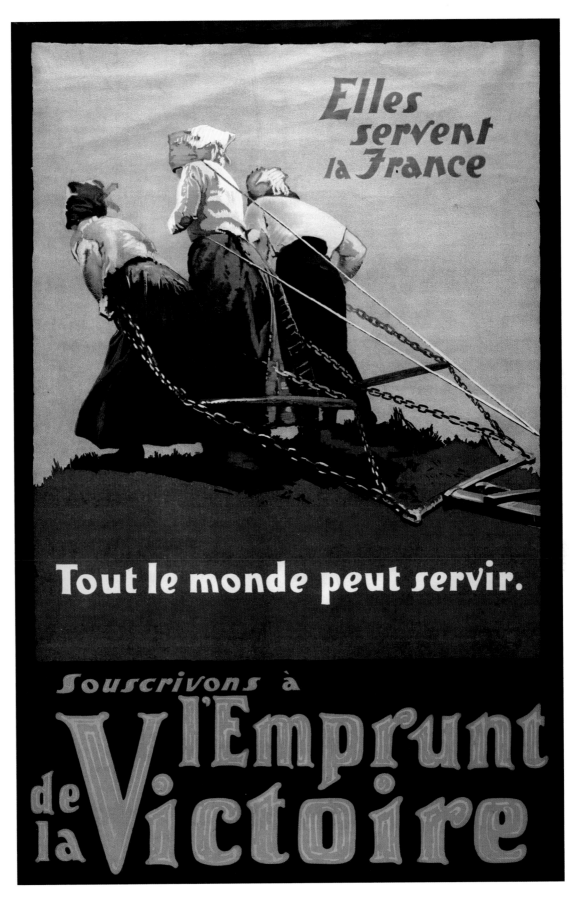

PRINT NO.111 CANADA, 1918. "THEY SERVE IN FRANCE, EVERYONE CAN SERVE." BASED ON A PHOTOGRAPH BY BROWN BROTHERS

Holtzendorff, to institute a U-boat blockade of Britain, was embarking on a race against time and America's mobilization. Holtzendorff had argued that if Germany could sink at least 600,000 tons of merchant shipping per month, it would take only about six such months to bring Britain to terms, if not to its knees.

The U-boats went about their deadly business immediately and in the first month sank more than 600,000 tons of shipping. In the weeks that followed, U-boats proceeded to torpedo even more, including the Cunard liner RMS *Laconia*, which sank off Fastnet, Ireland; three Americans were among those killed. A fortnight later, the German boats sank three U.S. merchantmen in a single day—an act that President Woodrow Wilson could not ignore.

As events played out during 1917, the German campaign came close to achieving its goal by sinking higher tonnages every month. Many countermeasures were tried without much effect, until the British Admiralty was finally per-suaded to adopt a convoy system for shipping on the Atlantic and the Medi-terranean, a measure that slowly but surely reduced the losses.

German submarine *U-36* passes before a Dutch packet steamer, *Batavier V*, that had been seized as a war prize.

Strategically, the U-boat campaign was one of several factors that brought the United States into the war. Another was the so-called Zim-mermann Telegram. Germany's foreign minister, Arthur Zimmermann, evi-dently believed that the Mexican government at the time was pro-German and wired a preposterous offer that in return for Mexico's support in the war, Germany would—if victorious—"return" Arizona, New Mexico, and Texas to Mexico. British intelligence intercepted the telegram and passed it to Wilson. One result was the arming of American merchant ships, an-other step toward entering the war (see Chapter 16).

Polacy! Kościuszko i Pułaski walczyli za wolność Polski i innych narodów! Idźmy w ich ślady! Hej na bój z wrogiem odwiecznym Polski i wolności!

POLES! KOSCIUSZKO AND PULASKI FOUGHT FOR THE LIBERTY OF POLAND AND OTHER NATIONS. FOLLOW THEIR EXAMPLE. ENLIST IN THE POLISH ARMY!

PRINT NO.112 AMERICA, 1917. "POLES! KOSCIUSZKO AND PULASKI FOUGHT FOR LIBERTY AND OTHER NATIONS."
WLADYSLAW TEODOR BENDA

Zeppelin *L-64* was part of a fleet that dropped 6,600 pounds of high explosives on England in April 1918.

AERIAL WARFARE

Another innovative effort to undercut Britain's growing strength and shorten the war occurred with Germany's strategic bombing campaign. Initial efforts at aerial bombing of targets in England had begun in 1915 with raids by Zeppelins, the rigid-frame, hydrogen-filled airships. But, while they had some impact on British morale, they were slow, vulnerable to antiaircraft fire, inaccurate, and could carry only limited bomb loads. By 1917, Germany had improved its aircraft designs and produced a twin-engined bomber, the Gotha, with a 400-mile range and 800-pound payload. Its advent surprised the Brits, and on its first mass raid on London killed some 160 people, including children in a school. Public reaction ranged from alarm to panic and outrage, and countermeasures were quickly put in place, including beefed-up squadrons of interceptor aircraft and more antiaircraft guns. The Germans then switched to night raids on coastal cities and towns. While there were casualties and damage, the major impact was psychological. The bombing was another instance of an advanced weapons system that foreshadowed the far deadlier and more widespread practice that would emerge 25 years later in World War II.

PRINT NO. 113 GERMANY, 1917. "EXHIBITION OF WAR LOOT." H. WÖBBEKING

Back on the ground, the war on the Western Front had become more defensive, with all sides initially disinclined to commit their dwindling manpower to ambitious frontal offensives. But as the year unfolded, events—several of them political changes—overtook the military plans. America joined the war in April, and Germany had to consider how to win the war before the doughboys could arrive in numbers sufficient to tip the balance on the Western Front. Germany caught a major break with the rising tide of chaos in Russia that culminated in the collapse of the army and the war effort, the abdication of Czar Nicholas, and the Bolshevik ascent to power. Those events freed Germany, toward the end of the year, to transfer some 40 to 50 army divisions from the Eastern Front to the west, giving the Germans a new manpower advantage there.

Those developments prompted both Britain and France to renew offensive operations midway through the year at a time when both nations were

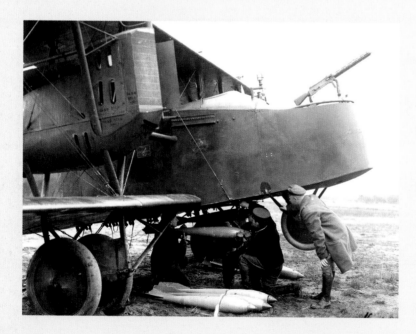

A crew loads 110-pound bombs onto a German Gotha heavy bomber.

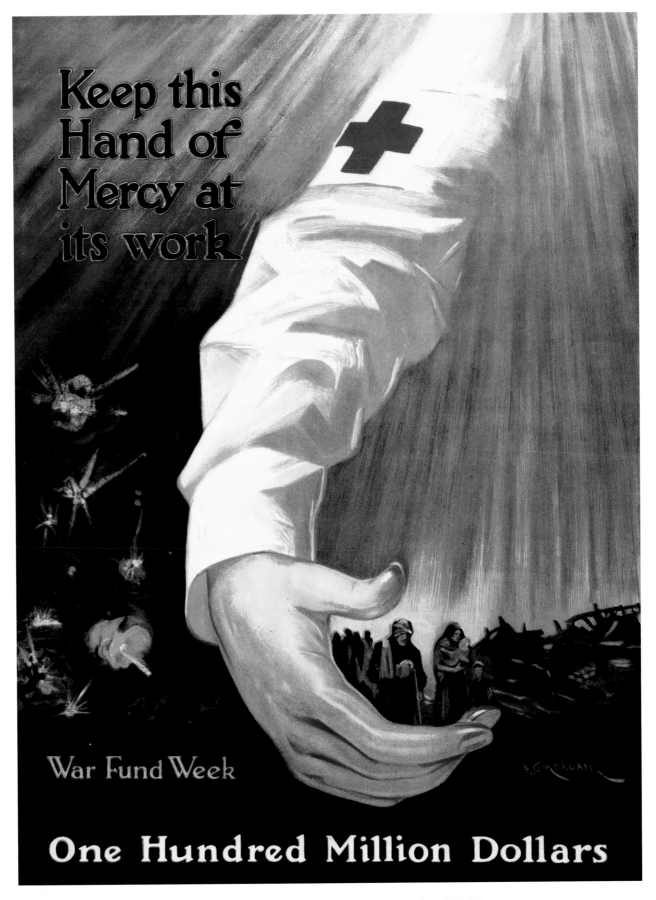

PRINT NO. 114 AMERICA, 1918. "KEEP THIS HAND OF MERCY AT ITS WORK." P.G. MORGAN

disillusioned with their leadership. In Britain, David Lloyd George became the prime minister and took a more active role in directing the war effort. He clearly lacked confidence in Field Marshal Sir Douglas Haig as commander and began seeking to reduce his role. In France, General Joseph Joffre was replaced as commander in chief by Robert Nivelle—who had never stopped believing in the efficacy of frontal assault offensives; at about the same time the French premier Aristide Briand resigned under political pressure and was succeeded by Alexandre Ribot.

The upshot was that Britain and France realized that the collapse of the Eastern Front and the loss of Russia as an effective ally were game changers. Both nations saw that the United States would need many months to raise and train its army and get it to the European battlefields—and to ramp

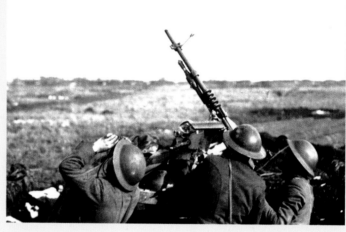

Allied antiaircraft gunners fire on a German observation plane at Chemin des Dames, France.

up production of everything an effective military force would need. Reluctantly, both nations also agreed that they could not wait and would have to resume offensive operations on the Western Front. What followed that fateful decision were two of the most catastrophic and futile major battles of the war: Third Ypres, also known as Passchendaele, and Chemin des Dames.

The first of two joint offensives, under the direction of French commander Nivelle (who claimed to have a plan for a breakthrough victory in 48 hours), opened on April 9 with an attack at Arras by predominantly British forces—three armies—under Haig. Like the Germans, the Allies had come to believe that artillery was the key to winning, and both sides had made improvements in targeting and fire control. The British

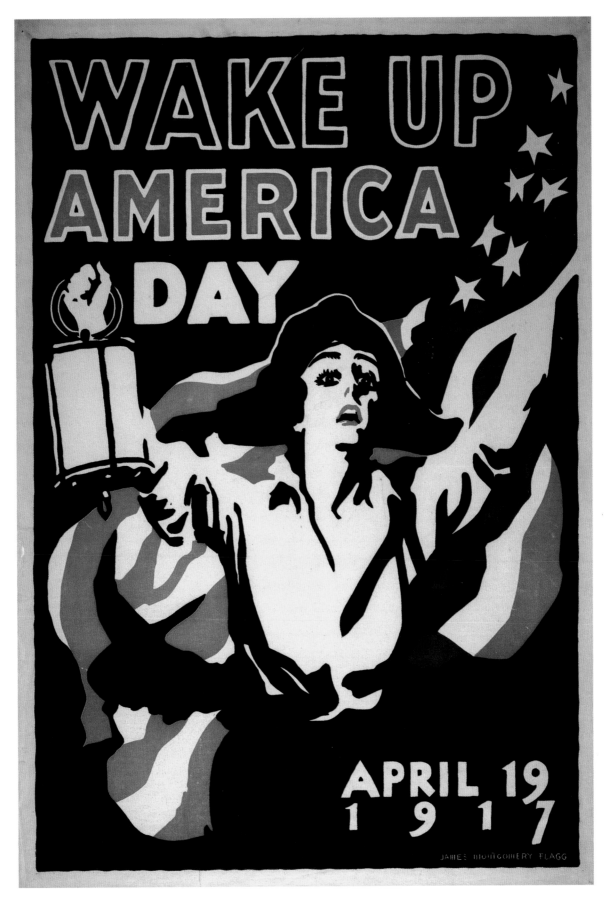

PRINT NO.115 AMERICA, 1917. "WAKE UP AMERICA DAY, APRIL 19, 1917." JAMES MONTGOMERY FLAGG

were optimistic in part because they now could field more guns with more ammunition than ever before. Nivelle's plan was first a frontal assault on Vimy Ridge near Arras to fix the Germans in place, followed by a powerful attack on the large German salient by a French army group of over 50 divisions at Chemin des Dames on the Aisne River.

In the event, the Allies' wheels came off early as the Germans foiled Nivelle's plan. Their fortifications near Arras were among the strongest on the Western Front, their intelligence knew about the British attack well in advance, and they moved their infantry back out of the range of the Allies' four-day bombardment. The main attack across the Aisne by the French had some success at first but the Germans had largely withdrawn from the salient. Nivelle's plan for a breakthrough failed, but he persisted with

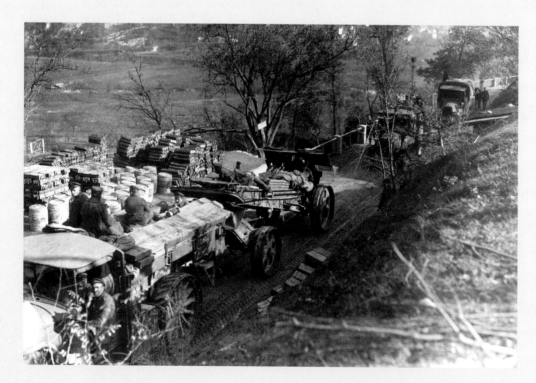

German troops advance into the Isonzo Valley, October 1917. The 12th Battle of the Isonzo (Caporetto) routed the Italian army.

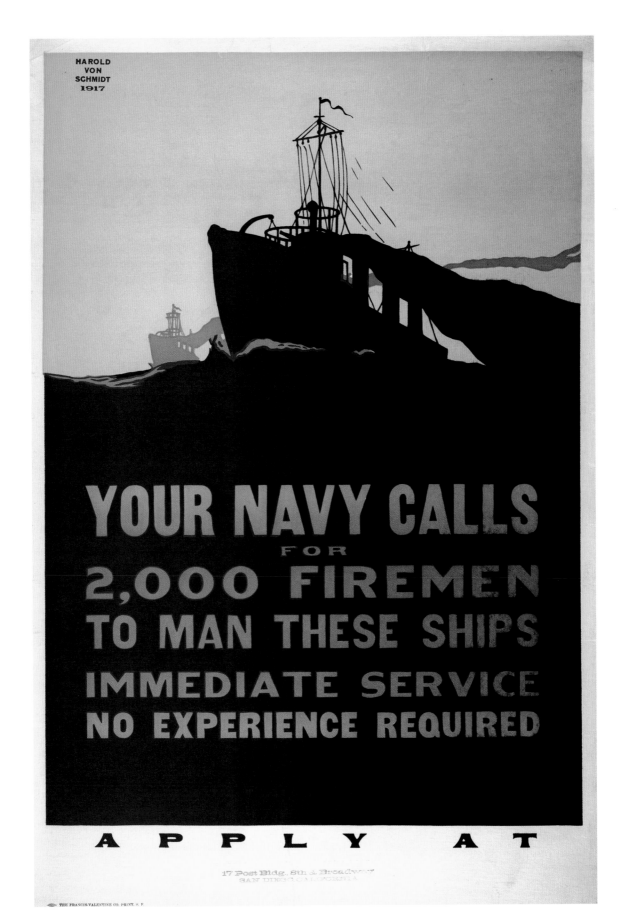

PRINT NO. 116 AMERICA, 1917. "YOUR NAVY CALLS FOR 2,000 FIREMEN." HAROLD VON SCHMIDT

costly—and all too familiar—frontal attacks that gained no ground and exhausted the French army. Nivelle's offensive devolved into the same old attritional stalemate, and its major effect was to spark crippling mutinies in the French army, which got the commander sacked.

BRITAIN'S OFFENSIVES

The French army was nearly *hors de combat* while dealing with its mutinies in the summer and fall of 1917. The British felt the need for an offensive to take some pressure off the French and also to undercut the German submarine bases at Zeebrugge and Ostend. Again, this was supposed to be a joint operation, this time under the command of Haig, on ground bitterly fought over twice, in 1914 and 1915. A preliminary attack by the British Second Army was kicked off by the early morning detonation on June 7 of a million pounds of high explosives in 19 100-foot-deep tunnels that had been secretly excavated by British, Canadian, and Australian miners under the German lines at Messines Ridge. The enormous blast was heard in London, instantly killed some 10,000 German troops, and opened an eight-mile gap in their front line. The British follow-up advance, however, was stopped by German counterattacks from their echeloned defense lines.

An antiaircraft battery is positioned during the advance on the Isonzo Valley, October 1917.

Haig's main battle for Passchendaele got underway on July 31, delayed for a week by wet weather; the terrain around Passchendaele was boggy at best, and as the fighting there continued through a month of rain, it became a true nightmare landscape of mud and blood—and a lasting symbol of the horrors of a World War I battlefield. Some Allied progress was made

Śladami Ojców Naszych
w Szeregach Armii Polskiej
za Ojczyznę i Wolność

FOLLOWING THE PATHS OF OUR FATHERS IN THE RANKS
OF THE POLISH ARMY FOR MOTHERLAND AND FREEDOM

PRINT NO.117 AMERICA, 1917. "FOLLOWING THE PATHS OF OUR FATHERS IN THE RANKS OF THE POLISH ARMY."
WLADYSLAW TEODOR BENDA

with small victories in early autumn, and near the end of October, the Canadian Corps took the ruins of Passchendaele, signaling the end of what had turned out to be yet another incredibly costly slog (over 300,000 Allied casualties; nearly 300,000 German casualties) for a net Allied advance of about five miles.

Beyond the confines of the Western Front, other actions were nearly as bloody but perhaps more nearly decisive: After a number of demoralizing setbacks in the Middle East, General Sir Edmund Allenby took command of British forces there. With a mixed bag of Commonwealth troops, including Australian cavalry, he began pushing back the Turks, first out of Gaza in the fall and then out of Jerusalem in December.

On the Southern Front, the Italian army, under the command of deeply unpopular and deeply unimaginative chief of staff General Luigi Cadorna, fought a long series of bloody battles (11 all told from 1915 to late 1917)

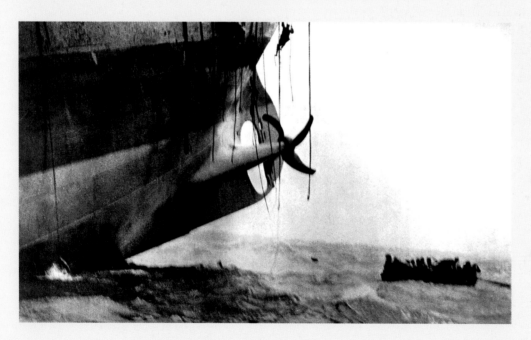

Survivors of a German torpedo attack escape their sinking ship in a lifeboat.

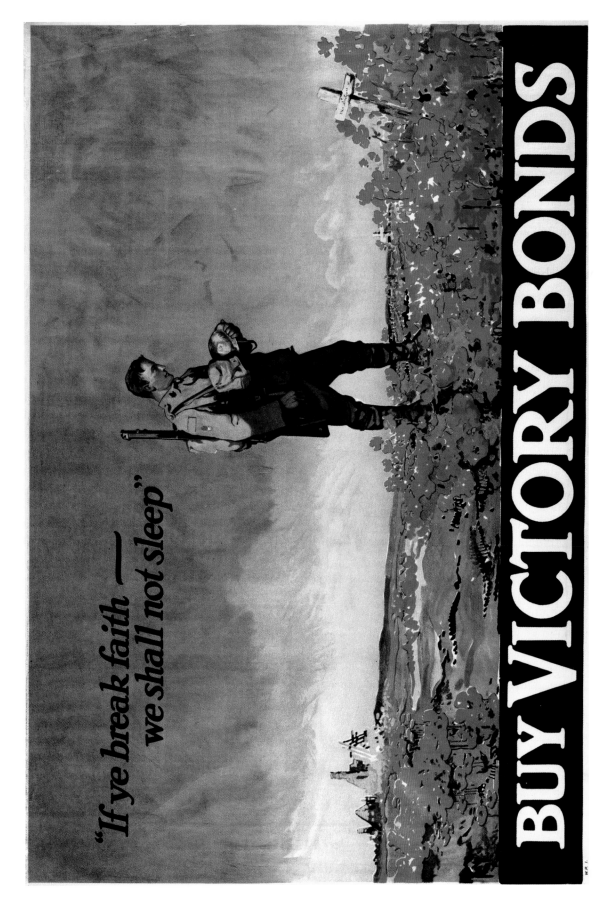

"If ye break faith —
we shall not sleep"

BUY VICTORY BONDS

PRINT NO. 118 CANADA, 1918. "IF YE BREAK FAITH — WE SHALL NOT SLEEP." FRANK LUCIEN NICOLET

with the Austrians along the Isonzo River in the rugged mountainous border country north of Trieste. Fearing the outnumbered Austrians would collapse, Germany sent reinforcements in early autumn amounting to six divisions, including specially trained Alpine units (and a young lieutenant, Erwin Rommel, who led a brilliant raid that won him a coveted *Pour le Mérite*). A powerful combined-force surprise attack hit a weakly defended Italian line at Caporetto, broke through in just a few days, and triggered a 100-mile retreat that became an epic rout. Over half a million demoralized Italian soldiers surrendered or deserted before their line was stabilized along the Piave River. In the first week of November, the French and British—responding to urgent pleas for help—dispatched a half-dozen divisions to help hold the Italian line. On November 9, Cadorna was relieved of command.

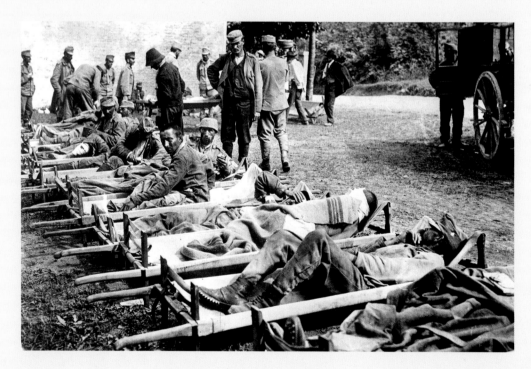

Italy lost 30,000 wounded or killed at Caporetto. The combined Austro-German forces lost 50,000.

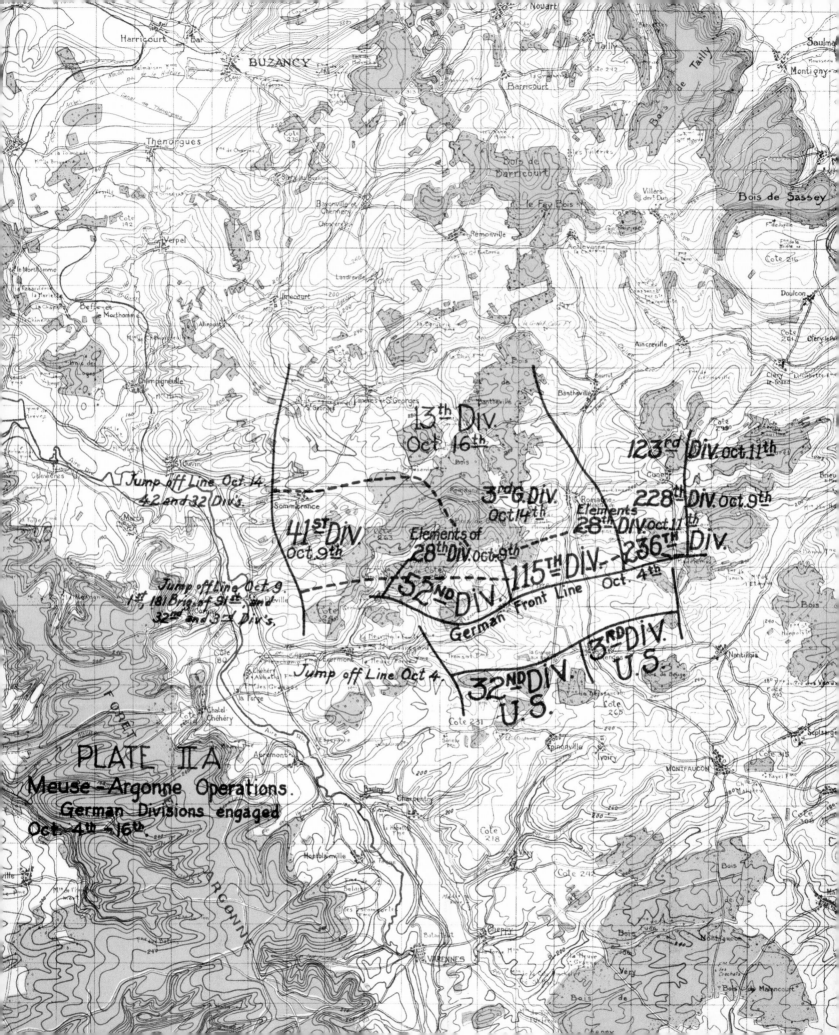

PLATE IIA
Meuse-Argonne Operations.
German Divisions engaged
Oct. 4th - 16th

AMERICA FIGHTS

American president Woodrow Wilson was a pacifist and an idealist who, in his words, "loved peace." At the start of the war, in August 1914, the United States issued a formal declaration of neutrality. Neither Wilson nor the country wished to become engaged in Europe's conflict. Indeed, Wilson's chief aim as the war progressed was to mediate a peace accord and then to put in place a new world order centered on the self-determination of nations, not military conquest. Neither goal would be realized. ❖ America's isolationist stance was tested in early 1915 when Germany declared the waters around the British Isles a war zone and threatened to sink any vessels passing through them. Attacks on merchant and passenger ships, including some U.S. vessels, followed. Then on May 7 a German submarine sank the British liner *Lusitania*, killing 1,198 passengers, including 128 Americans.

Late in the war at the Meuse-Argonne, 10 AEF divisions fought through three German defense lines.

The public outcry that followed the *Lusitania* attack pressured President Wilson to declare war on Germany. He demurred. At a speech in Philadelphia on May 10, Wilson stated that America "must be a special example" and that "there is such a thing as a man being too proud to fight." The president was criticized for his flaccid response. He urged the Imperial German government to "disavow its unjust acts... and take immediate steps to prevent the recurrence of further subversion of the principles of warfare."

Germany vowed to spare U.S. and other neutral vessels, but in early 1916 more maritime provocations followed. U.S. militarists chafed at Wilson's reluctance to fight. Former president Theodore Roosevelt called Wilson an "abject coward." Congress was split, as was Wilson's Cabinet. Both Secretary of State William Jennings Bryan, a pacifist, and Secretary of War Lindley Garrison, who felt America should be more aggressive, resigned. Wilson held his ground, and in 1916 narrowly won reelection on the theme "He kept us out of war."

On January 22, 1917, Wilson addressed the Congress and promoted his concept of a world without territorial aggression, of "government by consent of the governed." He wanted the United States to create a League for Peace that would "keep the future safe from war." There must be, he went on, "peace without victory."

Germany felt differently. On January 31, its government announced a new policy of unrestricted submarine warfare. All ships in the war zone around Britain, France, Italy, and the eastern Mediterranean, whether belligerent or neutral, would be attacked.

President Woodrow Wilson and first lady Edith Wilson, 1920.

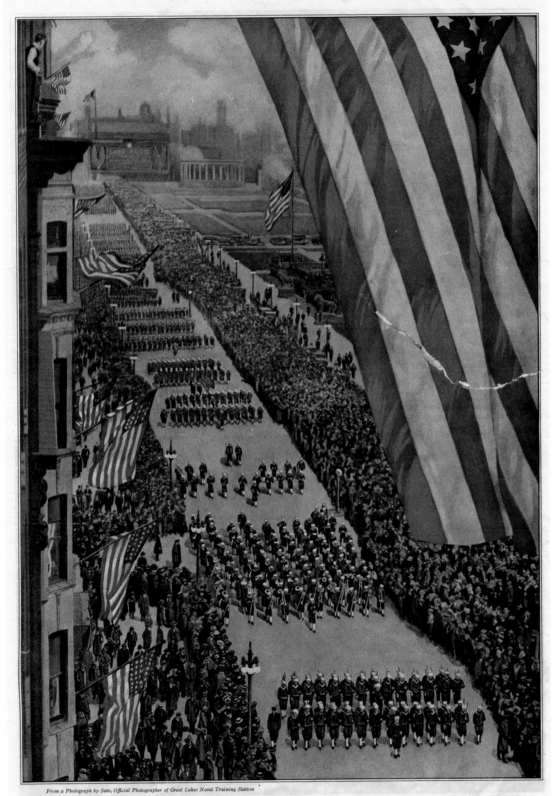

From a Photograph by Sato, Official Photographer of Great Lakes Naval Training Station

THEY FLASH THE LIGHT OF FREEDOM ACROSS THE SEAS

DOWN Chicago's wonderful Michigan Boulévard they came, thousands of boys from the Great Lakes Training Station, the heart under the blouse of every one of them beating in perfect accord with the greater heart of America. As they swung into view a great cheer went up from the masses that lined the roadway, but as they came on, the cheering subsided and the deeper tribute of silence was theirs.

PRINT NO.120 AMERICA, 1918. "THEY FLASH THE LIGHT OF FREEDOM ACROSS THE SEAS." WILLIAM SATO, OFFICIAL PHOTOGRAPHER OF GREAT LAKES NAVAL TRAINING STATION

Then, in late February, it was learned that German foreign minister Arthur Zimmermann had asked Mexico and Japan to become allies; in return, he promised Mexico that it could reclaim Texas, New Mexico, and Arizona from America. Wilson knew the time had come, and speaking again to Congress in April he laid out the case for war. Germany was a menace whose government must be toppled. "The world," he said, "must be made safe for democracy."

America officially declared war on Germany on April 6, 1917. Problem was, the country wasn't ready for war. Wilson promoted the idea of national unity and patriotic sacrifice by all citizens. Congress passed the Army Appropriations Act, which substantially boosted defense spending and gave the president emergency war powers, which he used to put the nation's railroads under federal control. A Food and Fuel Control Bill "granted power to the administration to fix prices and exert other controls over the production and distribution of living essentials," according to A. Scott Berg in his biography *Wilson*. The government established a War Defense Council, a mix of Cabinet secretaries and business leaders, to coordinate resource production for the war effort—dry goods and clothing for soldiers, oil, medical supplies, and more. A War Industries Board was created to centralize all military purchasing. To pay for the war, taxes were raised and Treasury Secretary William McAdoo, Wilson's son-in-law, organized four successful campaigns to sell war

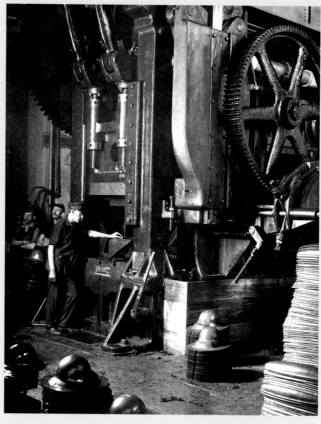

Workers man the power press at Hale & Kilburn Company, Philadelphia. The steel firm manufactured helmets for the American forces.

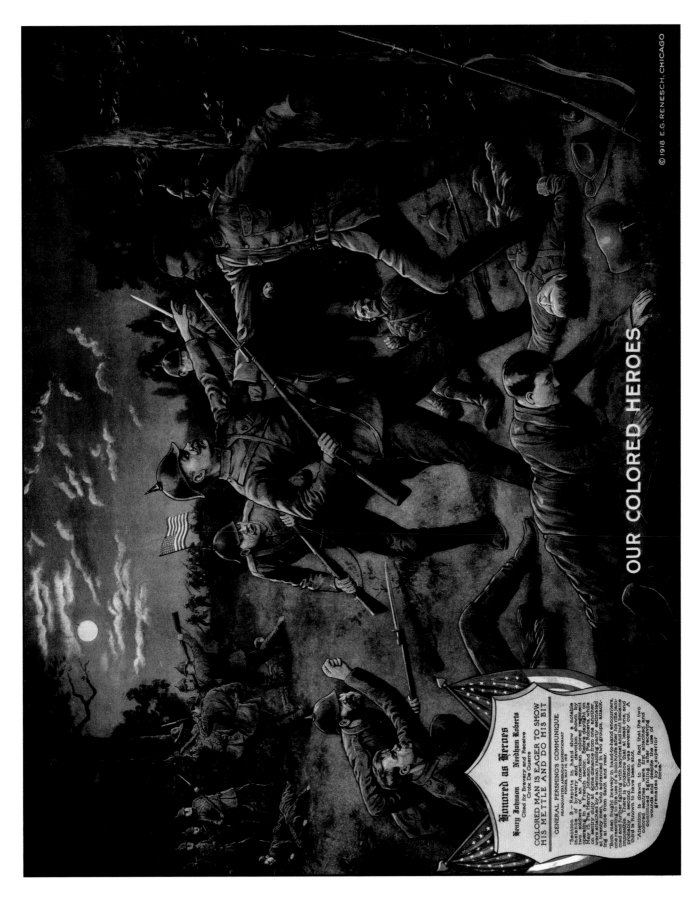

OUR COLORED HEROES

PRINT NO. 121 AMERICA, 1918. "OUR COLORED HEROES." E.G. RENESCH

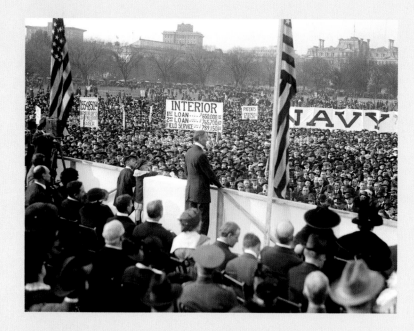

A Liberty Loan rally in Washington, D.C., 1917. Massive crowds turned out for similar events across the country to raise money for the war effort.

bonds ("liberty loans") to the American people. They raised $17 billion. Mining consultant Herbert Hoover took charge of agricultural production and conservation as head of the newly created Food Administration, and under his leadership wheat exports to the Allies rose dramatically.

Wilson named General John J. Pershing to lead the American Expeditionary Force (AEF). A tall, square-jawed West Point graduate, Pershing was a no-nonsense officer. After serving two stints in the Philippines, Pershing led a cavalry unit that put down a Mexican border rebellion and chased Pancho Villa along the border, the so-called Punitive Expedition. He led the Tenth Cavalry Regiment—a black unit better known as the Buffalo Soldiers—in the Spanish-American War (earning him the nickname "Black Jack"). Pershing and his men distinguished themselves fighting alongside Teddy Roosevelt's Rough Riders in Cuba. When Roosevelt became president, he championed Pershing's promotion from captain to brigadier general—a jump of three ranks.

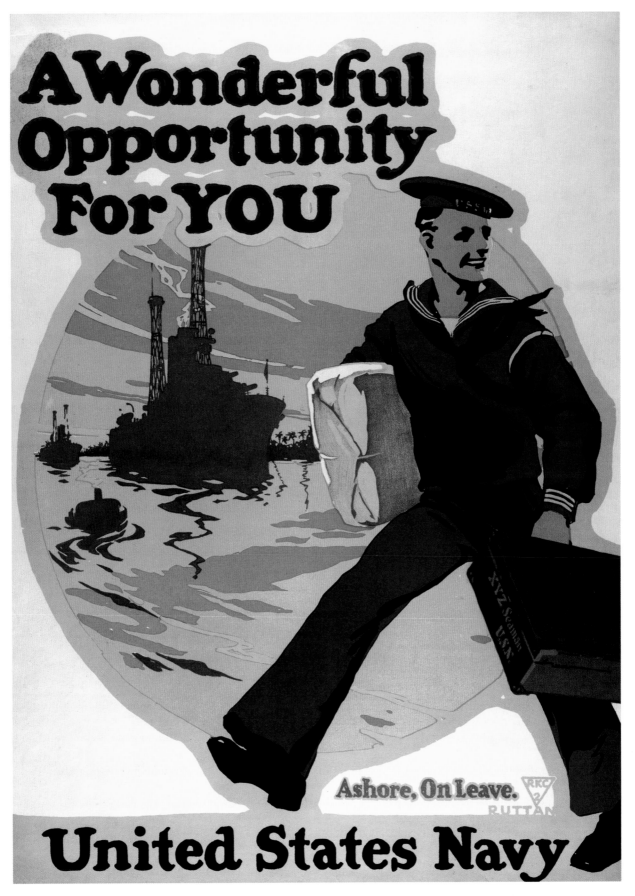

PRINT NO. 122 AMERICA, 1917. "A WONDERFUL OPPORTUNITY FOR YOU." CHARLES E. RUTTAN

RACE AGAINST TIME

In spring of 1918, hoping to win the war before U.S. forces could be fully deployed, Germany launched four offensives and drove within 40 miles of Paris. "The Allies are very weak," noted Pershing, "and we must come to their relief this year. Next year may be too late. The war is up to America to win or lose." War Secretary Newton Baker had been shipping troops and a vast quantity of materiel across the Atlantic Ocean—lumber, oil and gas, locomotives, rail cars and track, trucks, food, wool clothes, horses and mules, steel, medical equipment, and ammunition. Thousands of engineers and laborers were sent to France to build ports, warehouses, ordnance depots, train lines, hospitals, and training schools. The massive buildup took a year and a half.

Pershing, with Wilson's support, aimed to form a stand-alone U.S. army under American command. He was eager to show America's military partners—and the Germans—that he commanded a superior fighting force. French prime minister Georges Clemenceau and British prime minister David Lloyd George, desperate for

General John J. "Black Jack" Pershing molded the modern American army, incorporating new technologies such as tanks and airplanes.

manpower, wanted U.S. troops to "amalgamate" with French and British troops and serve under their commands. Pershing staunchly resisted that idea, and the debate over amalgamation caused serious tensions between him and his Allied counterparts.

PRINT NO. 123 AMERICA, 1917. "YOU DRIVE A CAR HERE — WHY NOT A TRANSPORT IN FRANCE?" H. BLYLEVEN ESSELEN

By the summer of 1918 about 1.5 million doughboys were in France. Most had received scant training before boarding their ships, but they were fresh. What the U.S. Army lacked in experience it made up in size, valor, and an eagerness to fight. The Americans got their first real test on May 27, when Pershing sent elements of his First Army to help stop the German offensive while regiments from the U.S. First Division, backed by French tanks, attacked the German-held village of Cantigny. U.S. troops quickly took the village and then over the next two days held it against German counterattacks—at a cost of 1,067 U.S. casualties. As a First Division history puts it, the battle was "America's first commitment in blood to democracy in Europe."

A much bigger fight occurred over the next 41 days, as part of the Second Battle of the Marne. The U.S. Second and Third Divisions rushed to plug the French defensive line in the Aisne-Marne sector five miles northwest of the town of Château-Thierry. The divisions, which included the Fifth and Sixth Marine regiments, held off the Germans and then attacked Belleau Wood, followed by Château-Thierry, taking both but suffering nearly 10,000 casualties, including 1,811 killed. The fierce fighting demonstrated the American will to fight, and Belleau Wood would become part of Marine Corps lore.

American recruits learn the "short point stab," a bayonet tactic, from British combat veterans of the Western Front.

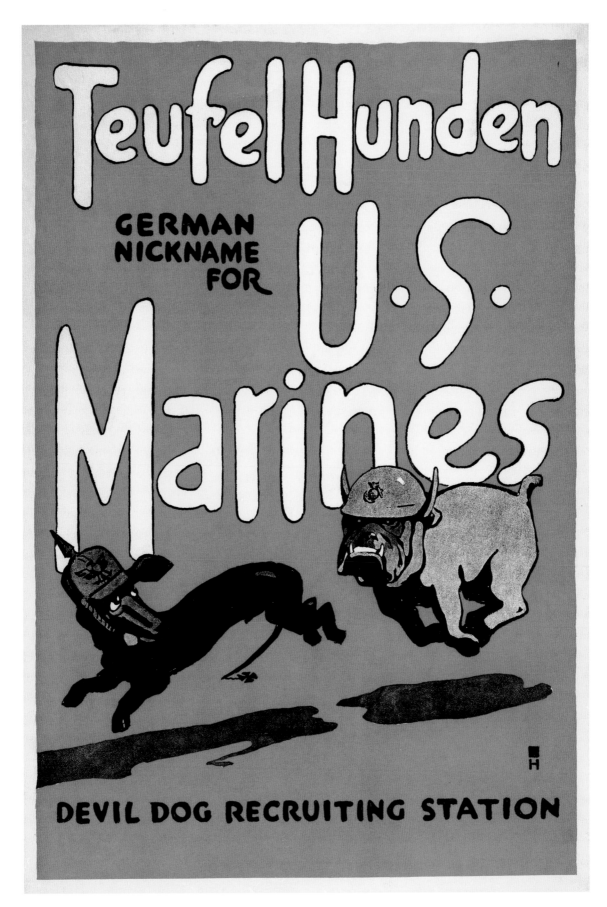

PRINT NO. 124 AMERICAN, 1917. *"TEUFEL HUNDEN, GERMAN NICKNAME FOR U.S MARINES."* CHARLES BUCKLES FALLS

AMERICA ON OFFENSE

On August 30, 1918, Pershing and the First Army took control of their own 90-mile-long sector along the front. On September 10, the First Army attacked the German salient at St. Mihiel and routed a relatively thin German defense. "The striking victory demonstrated the wisdom of building up a distinct American army," Pershing later wrote. "This result...gave [the American people] a tangible reason to believe that our contribution to the war would be the deciding factor. It inspired our troops with unlimited confidence."

There was no time for self-congratulation. The First Army had to immediately reorganize for its next and much larger offensive at Meuse-Argonne, scheduled to begin in two weeks. Some 600,000 troops and nearly 3,000 pieces of artillery, plus 1 million tons of supplies, had to be moved 60 miles to the Meuse-Argonne line of departure. And it all had to be transported on three roads—at night, so as not to alert the Germans.

American pilots got into the war early as volunteers for the Lafayette Escadrille, a unit of the French air service authorized in 1916.

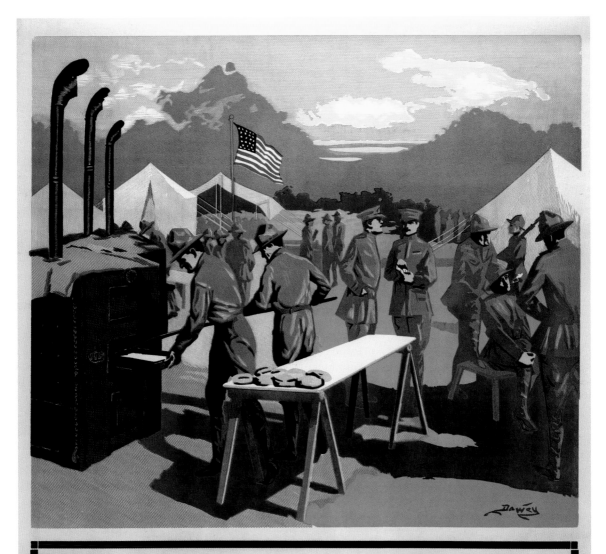

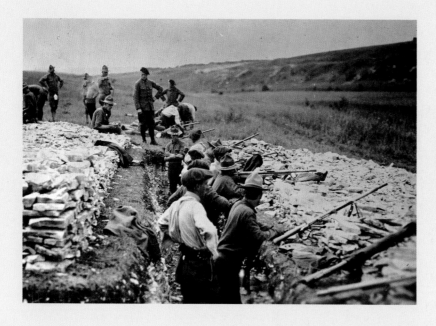

U.S. troops get a taste of the trenches while training with grenade launchers in France, 1917.

Colonel George C. Marshall, a First Division planner who would go on to become U.S. Army Chief of Staff in World War II and then secretary of state, masterminded the operation.

The Meuse-Argonne attack, the largest in U.S. history, commenced in heavy rain on September 26. It did not go well at first. The sector, directly opposite a crucial supply artery, was the most heavily fortified German defensive sector on the entire front. What's more, Pershing's best divisions had fought at St. Mihiel and so weren't available at the start of the new offensive. Four of the 10 U.S. divisions that launched the fight at Meuse-Argonne were green—and the offensive nearly became a disaster. The Americans charged into the heart of the enemy defense; progress was slow and there were heavy casualties. A worried Pershing relieved some of his commanders. Halfway through the battle he named veteran general Hunter Liggett to head the First Army. Liggett stopped the advance so that congestion in the supply lines could be sorted out. Once the second

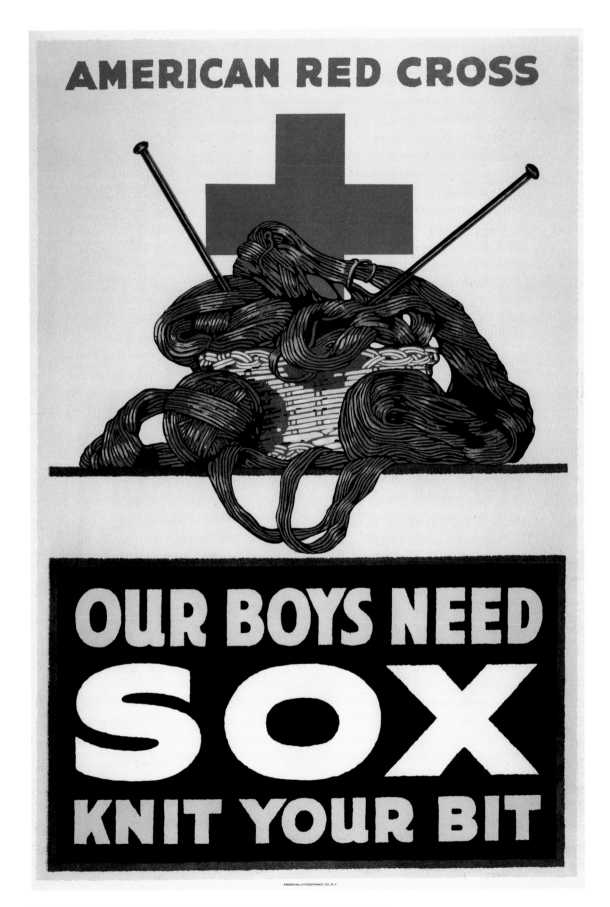

PRINT NO. 126 AMERICA, 1918. "OUR BOYS NEED SOX." L.N. BRITTON

phase began, the U.S. Army fought more efficiently and more effectively. Even so, its greatest advantage was the ability to throw more and more men at the outnumbered enemy—"smothering German machine gun fire with their flesh," as one historian put it. Sergeant Alvin York, Captain Harry Truman, and tank brigade commander George S. Patton all fought and distinguished themselves in this battle.

American persistence paid off. After 47 days, U.S. troops had advanced more than 30 miles to the north and 14 miles to the northeast, slogging past three German defensive lines, including the Hindenburg Line. By the time they reached Sedan, the target of the offensive, the Germans were ready to quit the war. Pershing had lost 26,277 men but was bursting with warrior pride. "All difficulties were overridden in one tremendous sustained effort to terminate the war then and there in a victorious manner," he recalled. "Once started, the battle was maintained continuously, aggressively and relentlessly to the end."

Aviators study the mechanics of automatic weapons in machine-gun school, 1917.

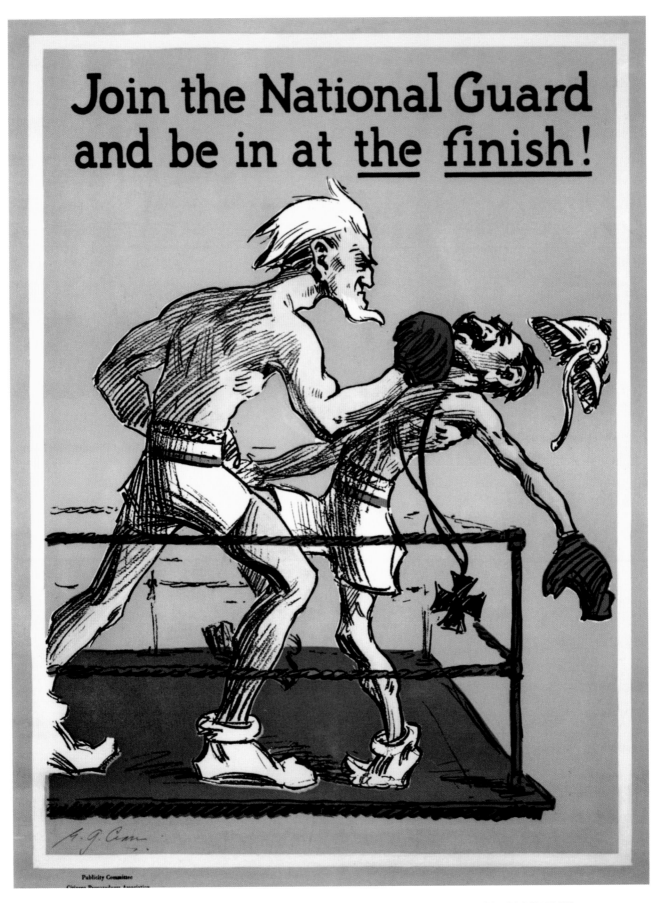

PRINT NO. 127 AMERICA, 1917-1918. "JOIN THE NATIONAL GUARD." CITIZENS PREPAREDNESS ASSOCIATION

While the Meuse-Argonne battle was part of a broad and simultaneous Allied offensive along most of the Western Front, Pershing had no doubt that the American effort was the catalyst for Germany's call for an armistice. "The enemy had been struck a blow so powerful that the extreme gravity of his situation in France was obvious to him," he wrote in his memoir. "From the North Sea to the Meuse, his tired divisions had been battered, and nowhere with more dogged resolution than the front of the American First Army, his most sensitive point. The initial moves of the government to stop the fighting occurred at this time and without a doubt because of the results of these first days of battle."

In 150 days of climactic fighting, 116,516 AEF troops lost their lives. Nearly half were killed in combat, while most of the rest succumbed to influenza. There were more than 200,000 wounded U.S. troops. It was a heavy price, but America had helped to win a terrible war. Wilson called the victory a "supreme historical moment."—*R.E.*

The Women's Liberty Loan Committee coordinated the selling of war bonds, which introduced countless American women to investing.

FIRST DIVISION

First - Last - and All the Time.

PRINT NO. 128 AMERICA, 1917-1918. "FIRST DIVISION: FIRST — LAST — AND ALL THE TIME."

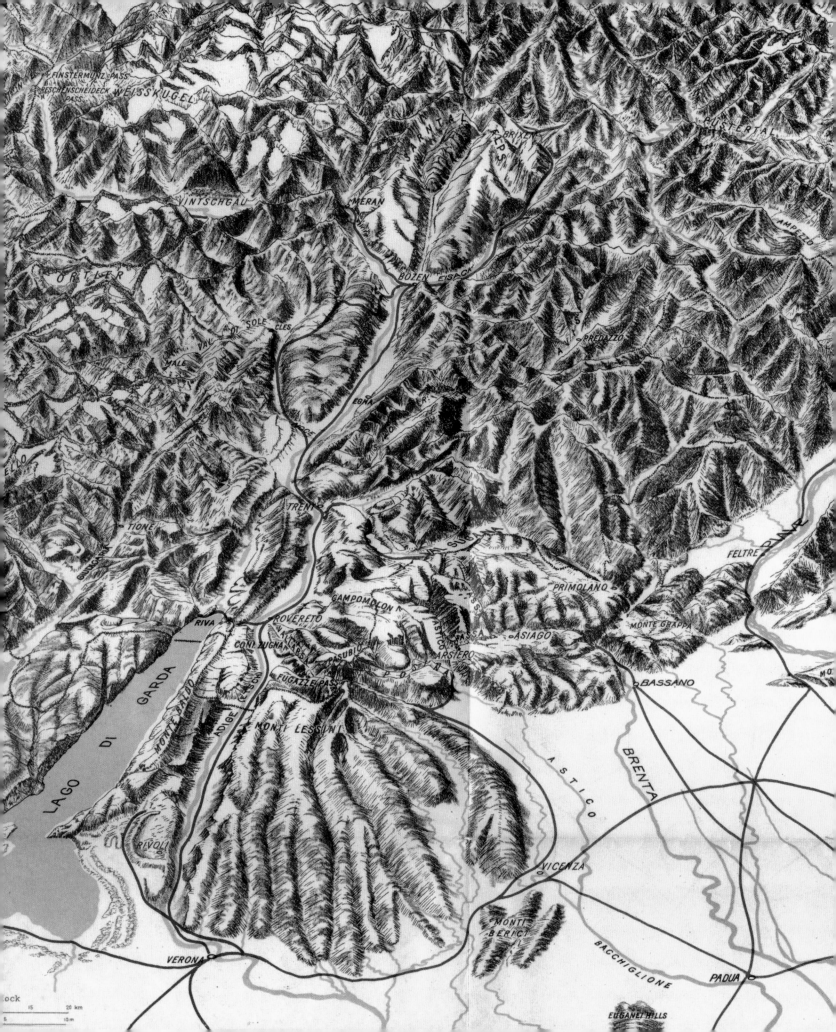

FINSTERMUNZ PASS
RESCHENSCHEIDECK WEISSKUGEL
PASS

VINTSCHGAU

ORTLER

VAL DI SOLE CLES

MALE

TIONE

GIUDICARIA

LAGO DI GARDA

RIVA

CONDUGNA

ROVERETO
VALLARSA
PASUBIO
FUGAZZE PASS

MONTE BALDO

ADIGE

MONTI LESSINI

RIVOLI

VERONA

MERAN

BOZEN EISACK

BRIXEN
ALPS

EGNA

PREDAZZO

TRENT

CAMPOMOLON

ARSIERO

POSINA

ASIAGO

PRIMOLANO

MONTE GRAPPA

BASSANO

ASTICO

BRENTA

VICENZA

MONTI BERICI

BACCHIGLIONE

PADUA

EUGANET HILLS

FELTRE
PIAVE

CISTERTAL
AMPEZZO

15 20 km

5 10 m

1918

During the first week of 1918, when no one could have known this was the final year of the Great War, two Allied leaders delivered speeches outlining their war aims. First, David Lloyd George, Britain's prime minister, spoke to a labor union gathering. Days later, America's President Woodrow Wilson spoke to a joint session of the United States Congress introducing his Fourteen Points. The two had not coordinated their messages, but their aims had much in common: disarmament; political settlements based on self-determination; reparations to the invaded nations; return of conquered lands; establishment of a global organization to mediate international disputes. Wilson's call for "freedom of the seas" caused heartburn in Britain. These were political frameworks to be erected on the blood-soaked battlegrounds, attempts to create something positive out of the years of personal and national losses, to bring peace and light out of the horror and darkness.

On the Southern Front, Italy and Austria fought bitter climactic battles in impossibly rugged mountain terrain.

But there was an ongoing war still to be won, and in that first week of the new year the path to an Allied victory had not been found.

Indeed, "over there" beyond the miles of long-contested no-man's land of the Western Front, the commander of the German forces, Erich Ludendorff, was shaping his tactical plan to defeat the combined armies of Britain, France, and the United States. At a November 1917 meeting of the German High Command in Mons, an ancient Belgian city near the French border, Ludendorff explained that the right moment to break the Allied armies was fast approaching. Submarine warfare was not proving fatal to Britain; Russia had all but collapsed; Italy was devastated by its defeat at Caporetto; Britain and France were shaken by the failure of their summer offensives at Ypres and Chemin des Dames; and American forces had not yet arrived in significant numbers. Ludendorff believed that the coming spring and summer of 1918 was a window of opportunity for a sharply focused offensive that could finally penetrate the Western Front, divide and defeat the British and French defenders, and win the war. Drawing on German divisions transferred from Russia, and draining remaining reserves, he planned to concentrate nearly 200 veteran and retrained divisions for a series of offensives in the Somme sector. Ludendorff was supremely confident in the combined-arms (infantry, artillery, aircraft) force he would bring to bear on the outnumbered Allies.

General Clarence Ransom Edwards (center), 26th (Yankee) Division, reviews battle plans at field headquarters in Château-Thierry, 1918.

AND THEY
THOUGHT WE
COULDN'T
FIGHT

VICTORY LIBERTY LOAN

PRINT NO. 129 AMERICA, 1917. "AND THEY THOUGHT WE COULDN'T FIGHT." VICTOR CLYDE FORSYTHE

But this plan was an all-or-nothing roll of the dice. Ludendorff had proved to be a first-rate tactician, but he was no strategist and his plan contained the seeds of its failure: Ludendorff famously revealed the limits of his thinking when he declared, "We will punch a great hole. For the rest, we shall see..."

In the last days of February, the rapidly advancing German forces on the Eastern Front were approaching Petrograd, the capital, when the Russian government surrendered. The Treaty of Brest-Litovsk, which had been in negotiations since November, was signed—very reluctantly by the Bolsheviks who had taken power—on March 3. Russia's concessions were massive, as it lost control of territories including Poland, Finland, Ukraine, and the Baltic countries with their huge agricultural and industrial assets. Russia also faced billions in reparations.

March was the month when Ludendorff launched the first of his planned five "decisive" attacks on the Western Front, code-named Operation Michael. British intelligence had learned that the assault was imminent, and

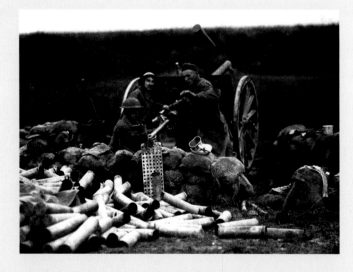

Battery C, U.S. 6th Field Artillery, in action on the Lorraine Front, September 1918.

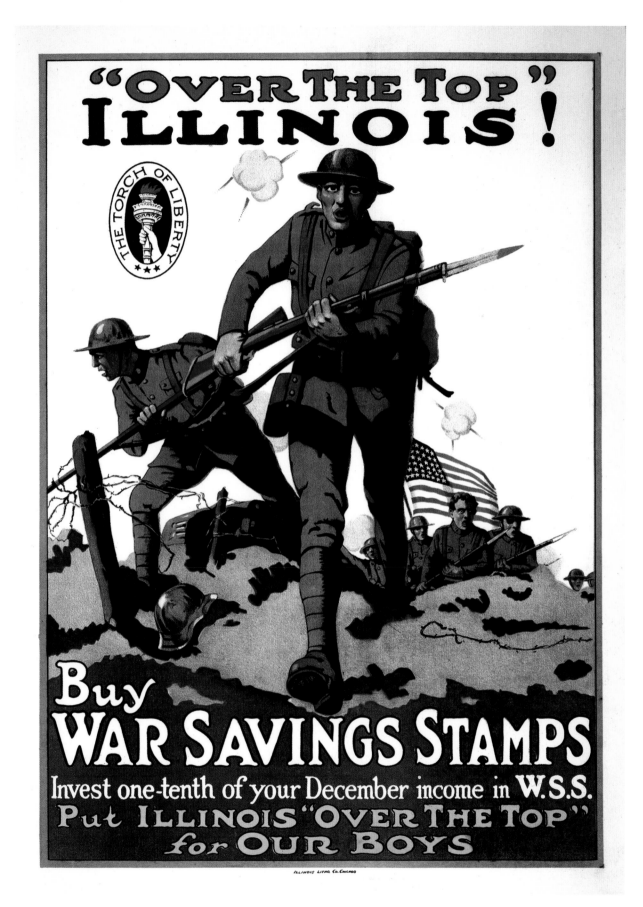

PRINT NO. 130 AMERICA, 1917-1918. "OVER THE TOP ILLINOIS!" ILLINOIS LITHO. CO.

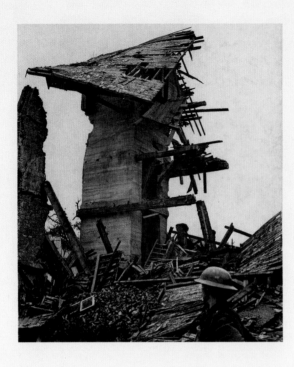

Using ruins as camouflage, Germans defending La Bassée, near Lille, disguised their concrete observation post, October 1918.

it opened on March 21 (see Chapter 18). Michael lasted only a few weeks, then stalled, and was followed by Operation Georgette in April, Operation Blücher-Yorck in May, Operation Gnisenau in June, and finally by Operation Marneschutz-Reims in mid-July. Those powerful attacks were blunted by the Allies and the Americans, and ended as expensive failures. From then on the German army was on the defensive.

PANDEMIC

At the same time that spring, an outbreak of a surprisingly deadly strain of influenza occurred in rural Kansas. It spread to the U.S. Army's nearby Fort Riley, where thousands of young men were training for the war in Europe, and thence quickly to other military bases at home and abroad. Marked by the rapid onset of high fevers, headaches, coughing spells, weakness, and often pneumonia, it struck and killed otherwise healthy young people.

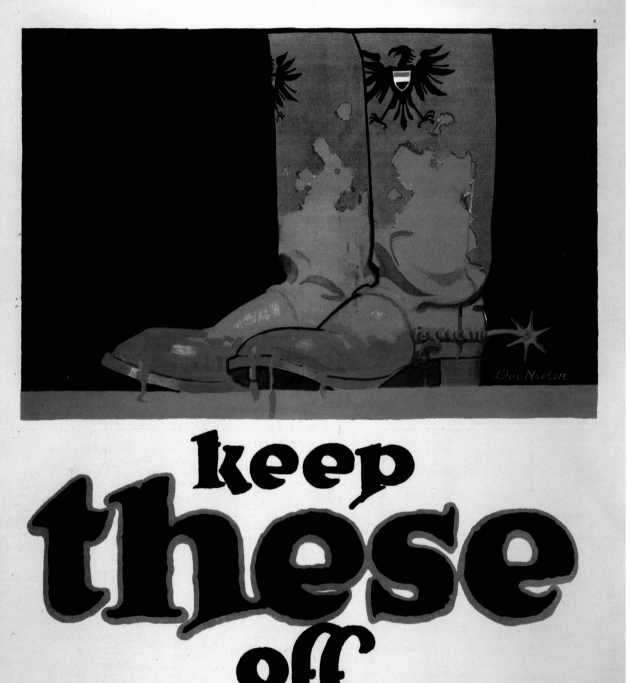

PRINT NO. 131 AMERICA, 1917. "KEEP THESE OFF THE U.S.A." STROBRIDGE LITHO. CO.

The outbreak spread rapidly through the armies on the Western Front—there was no cure for it—and into the civilian populations to become a worldwide pandemic that would ultimately kill an estimated 30 million people. The 1918 influenza outbreak had real impacts on the armies and on the conduct of the war. When it hit a concentration of soldiers, it hit hard: In September 1918, a busy

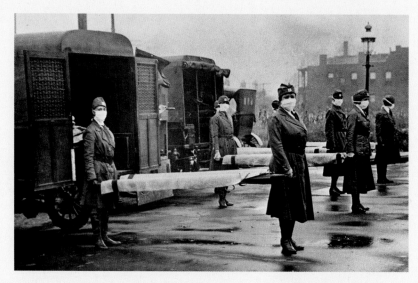

St. Louis Red Cross Motor Corps nurses at the height of the flu pandemic, October 1918. Some 675,000 Americans died of the flu.

U.S. Army training base, Camp Devens, near Boston, was losing 100 soldiers a day to the flu. In total, the disease cost the American army the lives of over 45,000 soldiers. The flu devastated the German army, which had been weakened by poor diet and difficult living conditions. Nearly a million German soldiers caught the disease, and Ludendorff called it a factor in the failure of his 1918 offensives.

While it was widely acknowledged that the war would be lost or won on the Western Front in Europe, there was significant fighting in other theaters that would have consequences that were felt long after the war and are influential even today.

On the Southern Front in Europe, the Italian army—all but destroyed at Caporetto in the fall of 1917—regrouped under new leadership and with substantial reinforcement by British and French divisions. In mid-June, the Austrian army launched what it hoped would be a decisive assault against the Italian line along the Piave River, an attack that soon stalled. It was a classic case of military overreach, as the Austrians lacked the transport, supplies, equipment, and effective manpower sufficient to

"HELP THE HORSE
TO
SAVE THE SOLDIER"

"GOOD-BYE, OLD MAN"
DRAWN BY F. MATANIA © FROM THE LONDON SPHERE
IN U.S.A. BY N.Y. HERALD CO.

PLEASE JOIN
THE AMERICAN RED STAR ANIMAL RELIEF
National Headquarters, Albany, N.Y.

THE W.F. POWERS CO. LITHO, N.Y.

PRINT NO. 132 AMERICA, 1918. "HELP THE HORSE TO SAVE THE SOLDIER." FORTUNINO MATANIA

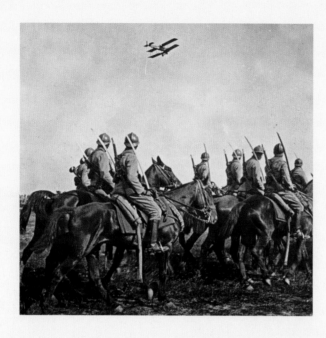

By war's end, airplanes had largely replaced traditional cavalry scouts as the "eyes of the army."

sustain the offensive and they were driven back across the Piave. After a summer of stalemate, during which the Habsburg Empire began to break into ethnic states—Yugoslavia, Czechoslovakia, and a separate Hungary— the Italians launched an offensive in October, again on the Piave. While the attack went badly and was costly, it succeeded: The Austrian army, shedding manpower to desertion and capture, surrendered on October 29. Austria began ceasefire and armistice negotiations and was out of the war within a week.

The Turks, who had nearly exhausted their army fighting the Russians in the Caucasus, were increasingly pressured on all sides in the Middle East by several British forces and an Arab uprising led in part by legendary British advisor Colonel T.E. Lawrence. General Edmund Allenby's army, the Egyptian Expeditionary Force, after staging only sporadic raids on Turkish forces around Syria, was reinforced by Commonwealth cavalry, and working with Arab cavalry, undertook a major fall offensive in the Jordan Valley.

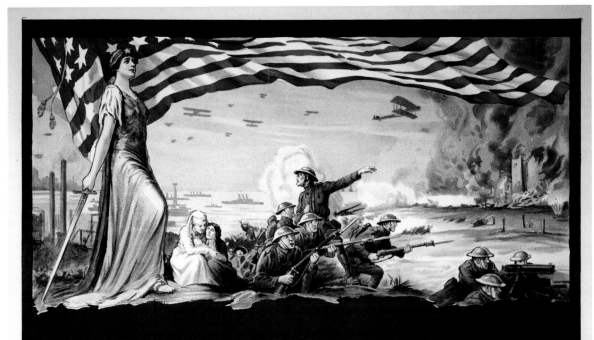

SECOND UNITED STATES
OFFICIAL WAR PICTURE

AMERICA'S ANSWER

Presented by
THE DIVISION of FILMS
COMMITTEE on PUBLIC INFORMATION
GEORGE CREEL, *Chairman*

PHOTOGRAPHED BY THE
U.S. SIGNAL CORPS A.E.F.

J·H·TOOKER LITHO. CO. N.Y.

PRINT NO. 133 AMERICA, 1917. "AMERICA'S ANSWER, PHOTOGRAPHED BY THE U.S. SIGNAL CORPS A.E.F." J.H. TOOKER LITHO.

They overwhelmed the Turks in battle after costly battle, from Megiddo to Damascus, where Allenby's cavalry and Lawrence's Arabs converged on October 1. The Arab Revolt ended bitterly there with the news that by agreement with the British, the French would henceforth control Syria. Turkish resistance in the region came to a halt, which effectively meant the death of the Ottoman Empire. Fighting in the region concluded with an armistice accepted by the Turks on the last day of October.

TURNING POINT

Late in July 1918, the trajectories in the fortunes of the Central Powers and the Allies on the Western Front appeared to cross. Since March, the Germans had been ascendant and the Allies struggled to contain them. Then as the last of the German offensives petered out, the Allies began to counterattack and push the Germans back from their earlier gains. The latter army, its manpower reserves nearly exhausted, had suffered casualties it could not replace, while the Americans were rapidly reinforcing the Allies;

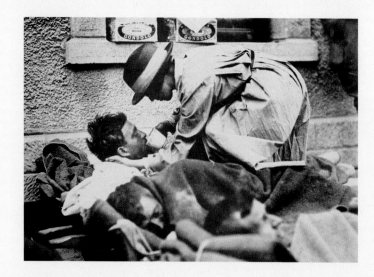

An American Red Cross worker cares for wounded British soldiers at Montmirail, France, during the German Spring Offensive, in 1918.

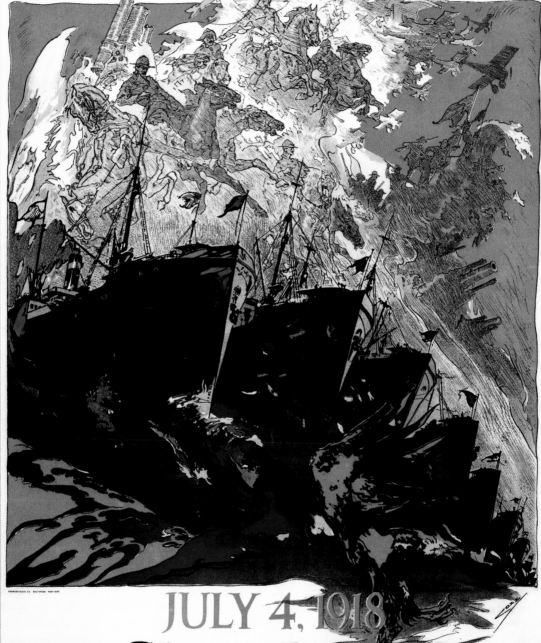

THE TIDAL WAVE

JULY 4, 1918
95 Ships Launched
UNITED STATES SHIPPING BOARD EMERGENCY FLEET CORPORATION

ISSUED BY PUBLICATIONS SECTION, EMERGENCY FLEET CORPORATION, PHILADELPHIA

PRINT NO. 134 AMERICA, 1918. "THE TIDAL WAVE." JOSEPH CLEMENT COLL

by the time they launched their major counterattacks at the end of July, the AEF had 42 large divisions on French soil. Moreover, time was now on the Allied side on the Western Front in another important way: The war industries of Britain and the United States had geared up production to the point where the Allies could field much better equipment and more supplies than the Germans, whose industries were hampered by growing shortages of materials and manpower.

One notable milestone occurred on August 8, when the British army attacked eastward from Amiens, the rail junction city that had been the objective of Ludendorff's first major offensive in March. By then, the British had all the assets they needed for combined-arms operations, with more effective artillery, many more and better tanks, and improved ground-attack aircraft. The outcome was predictable: The British sent the Germans reeling back nearly seven miles on the first day, and soon captured more than

First Lieutenant Eddie Rickenbacker, American fighter ace, aboard his Spad XIII at Rembercourt, France, October 1918.

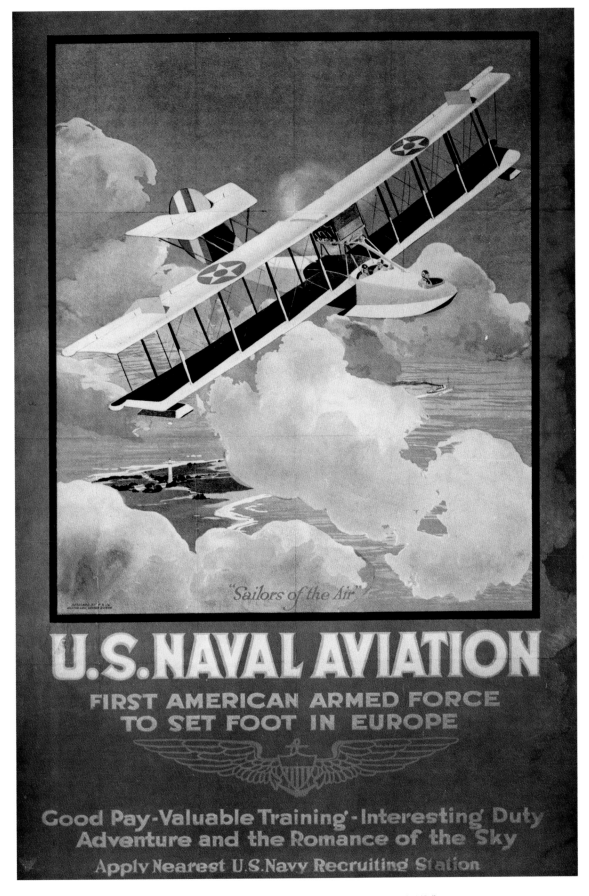

PRINT NO. 135 AMERICA, 1917-1918. "U.S. NAVAL AVIATION, SAILORS OF THE AIR."

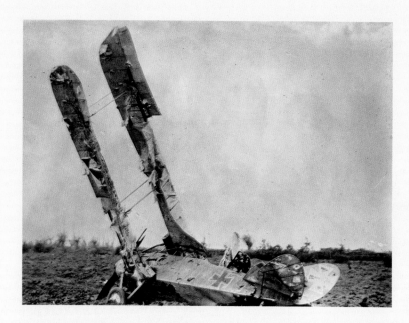

The wreckage of a German biplane in Flanders.

30,000 German soldiers. Ludendorff called it "the Black Day for the German Army," and a few days later told Kaiser Wilhelm there was no possibility of a German victory on the Western Front. What followed was a fighting retreat back to their strongest defensive position, the Hindenburg Line—which was breached by the oncoming Allies in the last days of September.

At that point, Ludendorff and Hindenburg agreed that the war was lost and peace negotiations must begin.

Still, with the Germans on the defensive, bitterly hard fighting continued through October in the Meuse-Argonne, in Flanders, in Italy, and in other lands as the Central Powers' war efforts gradually collapsed, and political turmoil wracked Germany. Prince Maximilian of Baden was appointed Germany's chancellor and conducted peace negotiations with President Wilson based on Wilson's Fourteen Points. The German navy staged a widespread mutiny, and Kaiser Wilhelm abdicated on November 9. The armistice agreement was signed on November 11, and the guns fell silent at last.

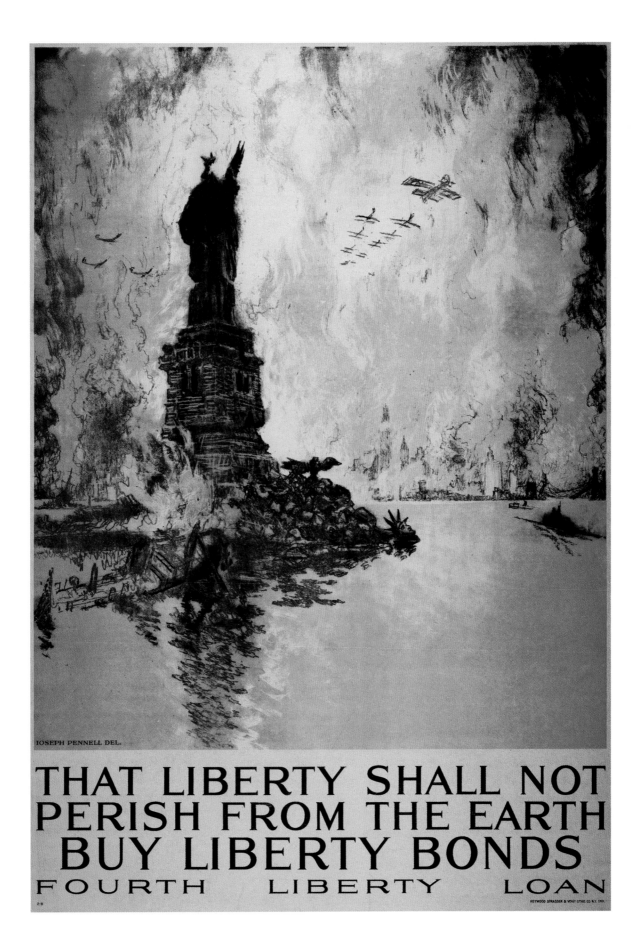

THAT LIBERTY SHALL NOT
PERISH FROM THE EARTH
BUY LIBERTY BONDS
FOURTH LIBERTY LOAN

PRINT NO. 136 AMERICA, 1918. "THAT LIBERTY SHALL NOT PERISH FROM THE EARTH." JOSEPH PENNELL

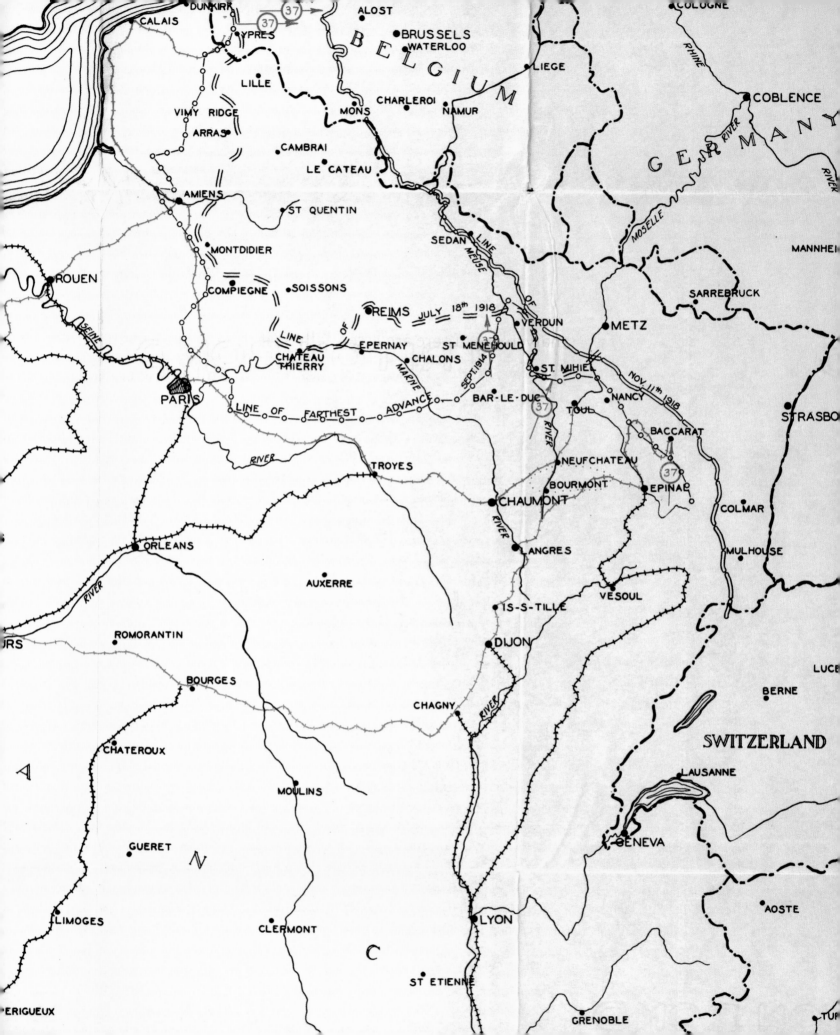

Germany's LAST CHANCE

I t is a longstanding truism among military historians and analysts that there are essentially just three ways to win a war: Conquer the enemy's territory. Annihilate the enemy's armed forces. Destroy the enemy's will to resist. In the Great War that began in 1914, the first of these options guided the most serious campaigns undertaken by all sides, but the stalemate that settled over the Western Front by the end of the war's first year forecast the enduring futility of that idea: Real estate was won and lost, but only inconclusively in increments of meters rather than miles. Emphasis then shifted to the second option, with both the Central Powers and the Allies waging campaigns of overt attrition. "Bleeding their army white" emerged as a de facto slogan. But the fallacy built into that idea was that the battlefield victories mostly proved to be Pyrrhic ones, in which the "winners" lost nearly as many soldiers as the "losers."

Fighting over the same grounds they'd initially invaded, German troops stormed through the Allied lines in 1918 but were finally stopped and driven back for good.

Crushing the enemy will to resist is perhaps the most complex, subtle, challenging, and certainly least quantifiable of strategies, compared to acreage and body counts. It may depend upon victories over territory and grinding down the enemy forces, but it also involves economic sanctions and blockades, attenuation of supplies, propaganda and psychological warfare, and other means of attacking the morale of the enemy military and civil political institutions. By the beginning of 1918, this last pathway to victory was beginning to look most promising on both sides; the phrase "sue for peace" came into common use.

To the casual observer, the war appears to have been one long attritional slog, fought in the most unimaginative and frightfully costly ways. While there is some accuracy in that observation, a closer look at how the war was fought as the years passed reveals that the tactics did evolve. Those changes came about in part because weapons new to the battlefield challenged the old tactical thinking and offered new opportunities for success, and in part because large improvements in industrial production, e.g., in improved munitions, changed

the scale of operations on the ground, at sea, and in the air. Such weapons as vastly improved aircraft, machine guns, aerial bombs, mines, torpedoes, tanks, mortars, chemical shells, and flamethrowers made it possible—nay, imperative—to think differently about tactics for their best use.

A camouflaged British gun is ready for action in Arras, France, during the German Spring Offensive, 1918.

Tactical changes also emerged in the last year of the war, in the ideas of a handful of brilliant military officers. Case in point: Tactics conceived by German army officers impatient with the clumsy and costly uses of

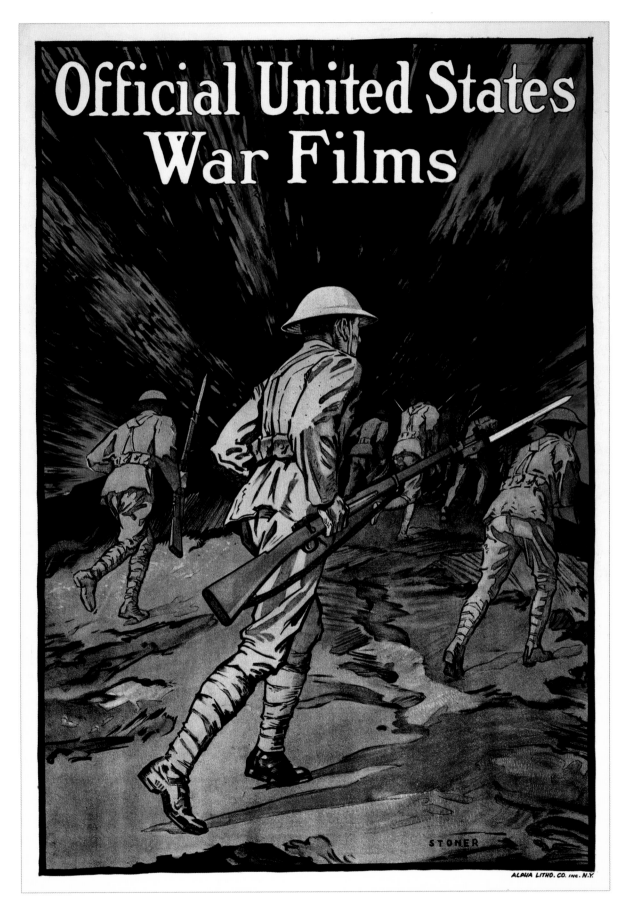

PRINT NO. 137 AMERICA, 1917. "OFFICIAL UNITED STATES WAR FILMS." HARRY STONER

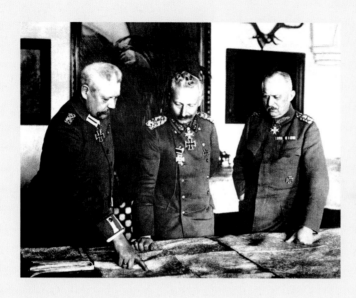

General Hindenburg, Kaiser Wilhelm, and General Ludendorff confer at German General Headquarters, January 1917.

infantry led to the innovative battle plans at the heart of Germany's final series of offensives on the Western Front in 1918.

By late 1917, the German military was locked into a race against time. If it were to win, it had to strike a decisive blow in the West against the armies of France and Britain before the Americans arrived in Europe in game-changing numbers, before the Allies' industrial production got even more overwhelming, and before Germany's declining home-front morale terminally sapped the nation's will to resist. And the signs of that decline were growing ever more ominous. Starvation and disease were spreading and increasing, as was civil disorder, labor unrest, and military mutiny; Russia's collapse had freed many veteran army divisions for service on the Western Front, but the troop-carrying trains were losing many deserters as they traversed Germany from east to west. It was no surprise when the German High Command agreed to Ludendorff's plans to deliver a crushing and decisive blow against the Allies as soon as possible in the spring of 1918—an attack utilizing tactics tried and tested in Russia and Italy.

PRINT NO. 138 AMERICA, 1918. "TAG YOUR SHOVEL DAY." UNITED STATES FUEL ADMINISTRATION

In its difficult cross-river attack on the important Baltic port city of Riga in September 1917, the German Eighth Army under General Oskar von Hutier was facing the larger Russian Twelfth Army. But the Eighth Army divisions had been specially trained and equipped to attack in small, fast-moving, powerfully armed units that penetrated the Russian line quickly and deeply, bypassing strong points to create chaos in rear areas. This was the first use of what came to be called storm-trooper tactics. This

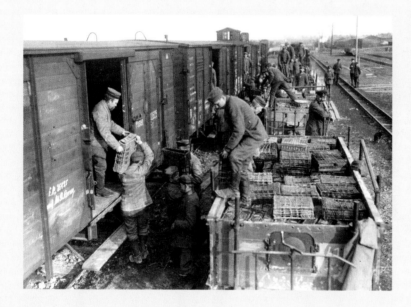

Soldiers unload German ammunition trains on the Western Front during Operation Michael, March 1918.

special style of infantry assault was preceded by an innovative, carefully orchestrated, five-hour artillery barrage by over 600 fieldpieces firing hundreds of thousands of mixed gas- and high-explosive rounds on an attack zone just 3,000 meters wide—the brainchild of Lt. Col. Georg Bruchmüller, already known as Germany's "artillery genius." The Russian front line at Riga was devastated, with resistance collapsing in a matter of hours. By the second day of the attack, Riga was taken and the beaten Twelfth Army

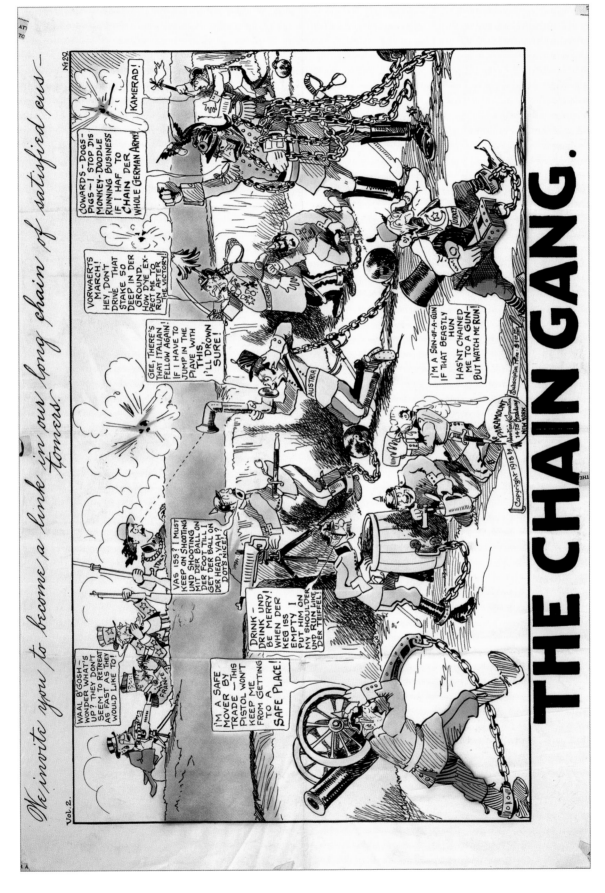

PRINT NO. 139 AMERICA, 1918. "THE CHAIN GANG." PARAMOUNT ADVERTISING CORPORATION

was in full retreat. This was clear proof of concept for the new German combined-arms tactics. That combination of Bruchmüller's artillery and storm-trooper assault formed the basis of the five German offensives on the Western Front, March through July, 1918.

THE LUDENDORFF OFFENSIVES

Operation Michael, the first and largest of those German attacks was aimed at the important rail junction at Amiens. Its objective was to drive a wedge between the British and French portions of the Western Front. If successful, it could force a British retreat northward to the English Channel and drive the French back toward Paris. Bruchmüller again was in charge of artillery and he directed the fire of over 6,000 guns on one portion of the line weakly defended by the undermanned British Fifth Army. The Germans hit them with over 50 divisions spearheaded by storm-trooper units on the foggy morning of March 21. Their success was unprecedented: For the first

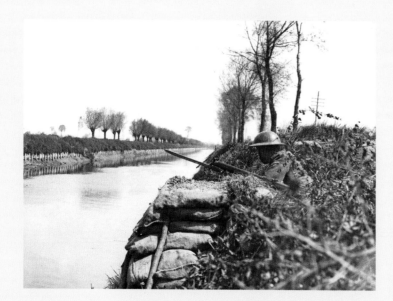

A British outpost on a Lys River canal, St. Floris, France. Fighting raged along the Lys during Operation Georgette in April 1918.

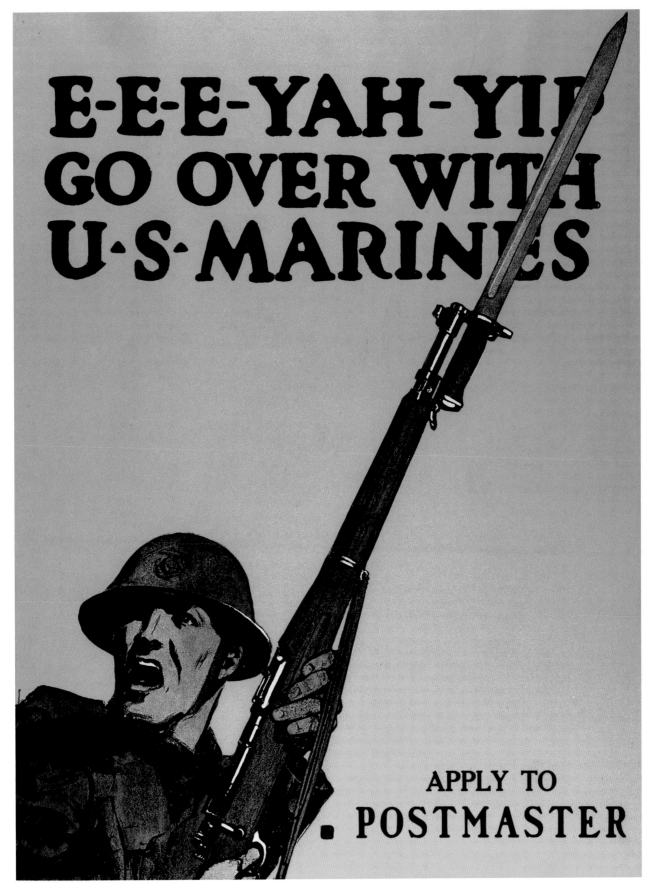

PRINT NO. 140 AMERICA, 1917. "E-E-E-YAH-YIP." CHARLES BUCKLES FALLS

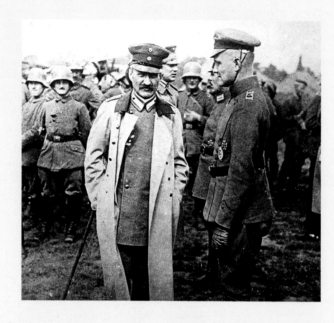

General Ludendorff and German ace Baron von Richtofen meet in July 1917, three days after the Red Baron had suffered a serious head wound.

time in the war, there was a true breakthrough on the Western Front. In just a few days, the Germans drove in some 40 miles on a wide front, their progress surprising even Ludendorff himself.

But Allied resistance stiffened and held, and logistically the Germans were unable to sustain their drive. They outdistanced their powerful artillery and outran their supply lines; two weeks of hard fighting reduced and exhausted their best attack divisions. On April 5, Ludendorff called a halt to Operation Michael, which had failed in its objective to take Amiens.

Determined not to allow the Allies any breathing space, Ludendorff quickly launched a second combined-arms thrust, Operation Georgette, to the north against the British line in Flanders between Arras and Ypres on April 9, seeking to break through to the Channel coast. Again, the Germans hit a weak portion of the front, defended by a Portuguese corps along the Lys River, and broke through, overrunning the Portuguese and driving the British Second Army into full retreat.

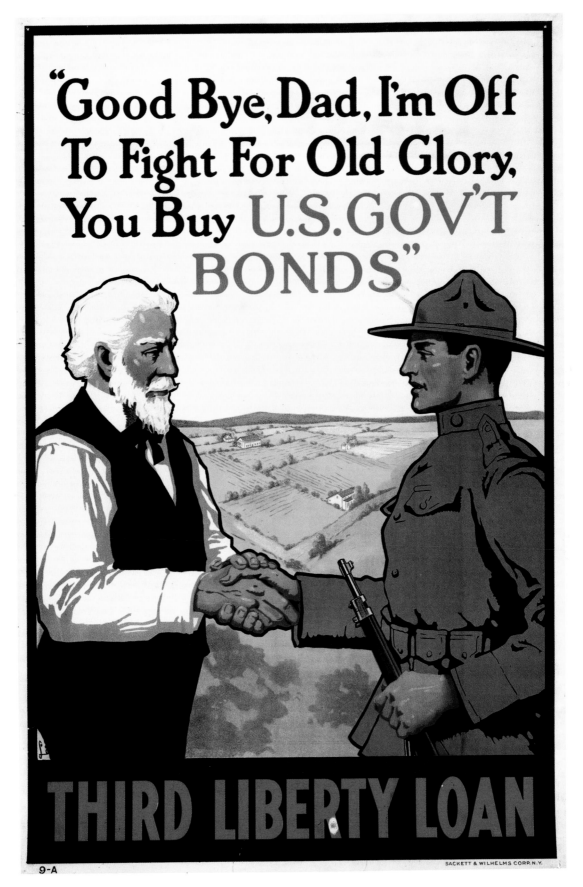

PRINT NO. 141 AMERICA, 1917. "GOOD BYE, DAD, I'M OFF TO FIGHT FOR OLD GLORY." LAWRENCE HARRIS

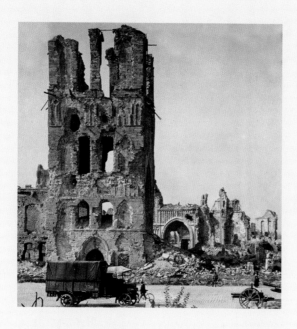

St. Martin's, a magnificent 13th-century cathedral in Ypres, Belgium, was reduced to rubble by four years of German shelling.

At this point on April 11, fearing a German complete breakthrough to the Channel, Field Marshal Sir Douglas Haig issued his epic order: "With our backs to the wall and believing in the justice of our cause, each one of us must fight on to the end. The safety of our homes and the freedom of mankind alike depend upon the conduct of each one of us at this critical moment. Every position must be held to the last man. There must be no retirement."

Urgent speeches notwithstanding, the British continued to retreat until they fought the Germans to a standstill by mid-April. Several French divisions joined in the battle along the Lys River, and though the Germans staged smaller attacks along the line with limited gains, Operation Georgette was over by the end of April. Again, it was a German strategic failure paid for with high casualties.

With that, Ludendorff elected in May to continue his offensives but shifted his focus south to the French lines along the Aisne River. He

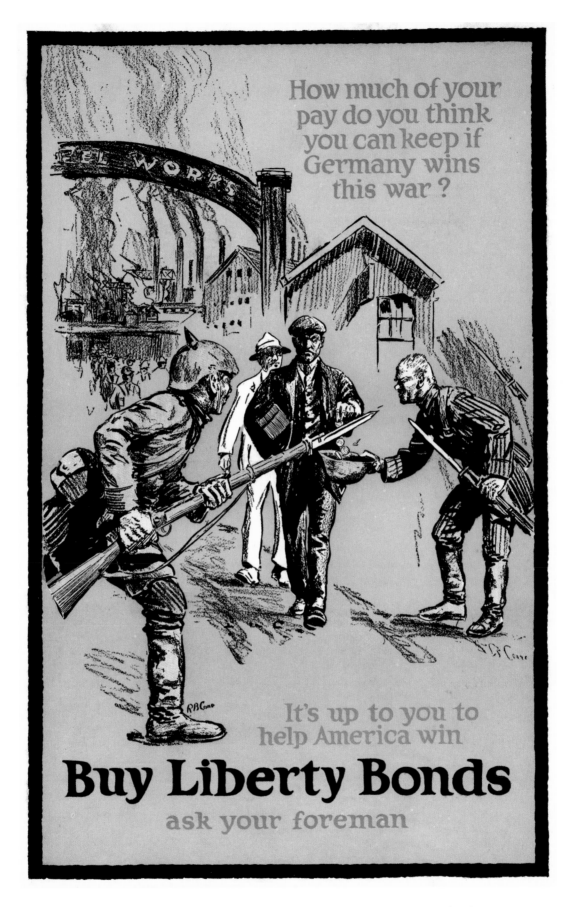

PRINT NO. 142 AMERICA, 1917-1918. "HOW MUCH OF YOUR PAY DO YOU THINK YOU CAN KEEP IF GERMANY WINS THIS WAR?" R.B. CANE

launched Operation Blücher-Yorck in the direction of Paris on May 27, but by then it was less clear what he hoped to accomplish and how these offensives might lead to a German victory. Ludendorff was no closer to destroying the Allied armies, which were now expanding as the American forces arrived, and the Germans were losing at least as many effectives as the Allies. In the West, there was now no talk of suing for peace. The German army had indeed punched holes in the Western Front but the gains in territory were strategically worthless and increasingly difficult for the Germans to defend and hold.

Blücher was a powerful attack by over 40 divisions in the Chemin des Dames area between Soissons and Reims, preceded by another ferocious Bruchmüller artillery barrage. The assault expanded into a 25-mile-deep salient that brought the Germans back to the Marne River—but still no closer to Paris and victory—and that was impossible to hold against powerful Allied flank attacks.

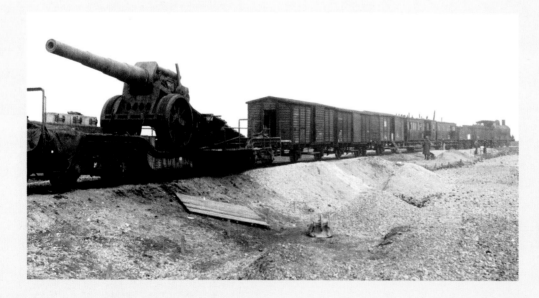

A German 17cm long-range cannon is moved by rail during Operation Michael, April 1918. The gun had a range of about 10 miles.

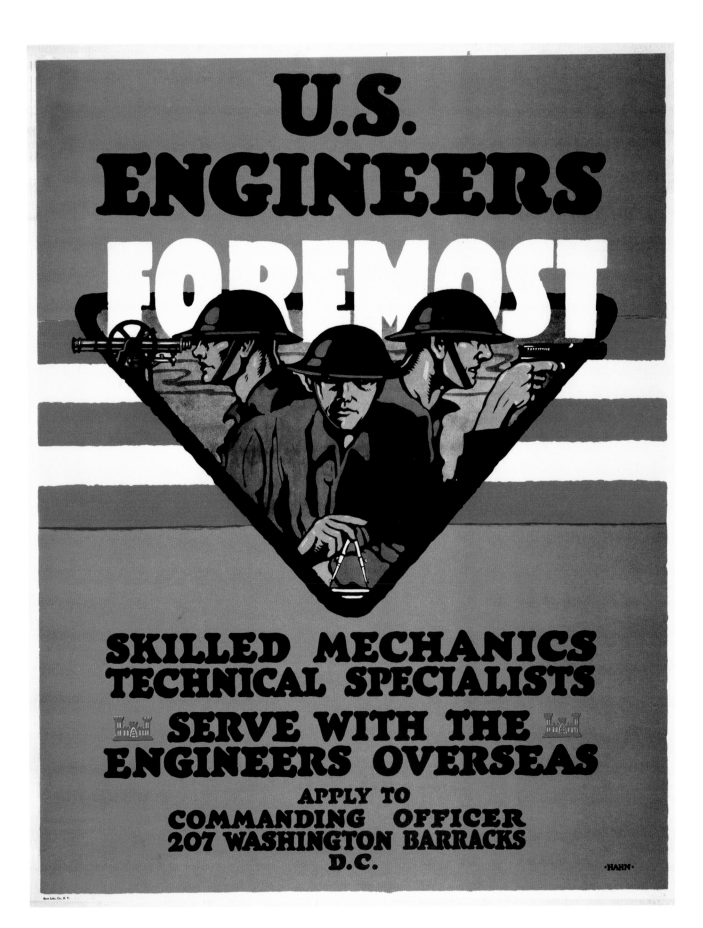

PRINT NO. 143 AMERICA, 1917. "U.S. ENGINEERS: FOREMOST." CHARLES BUCKLES FALLS

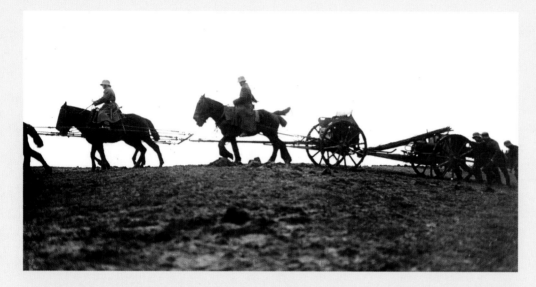

Horse-drawn German artillery advances to the front lines in the early days of Operation Michael, March 1918.

LUDENDORFF'S FAILURE

With diminishing resources and having no strategic gains to show for their enormous losses, and with Ludendorff becoming increasingly desperate—and some thought delusional—the Germans had fallen back into the early pattern of the war in trading high casualties for minor territorial gains. They launched two more smaller offensives, Operation Gneisenau in early June and Operation Marneschutz-Reims in mid-July, to no avail; both lasted only a few days before the Allies—and the American soldiers and Marines who were now fully engaged—stopped the attacks. Offensively, the German army had reached the end of the line.

The five offensives, for all their tactical brilliance and short-lived advances, had cost the Germans about 1,000,000 casualties, which they could not replace. They could not overcome the stubborn Allied resistance, nor sufficiently reduce their growing armies. As far as affecting the will to resist, that too was a failure as the Allies were about to demonstrate with a massive counterattack on the Marne on July 18.

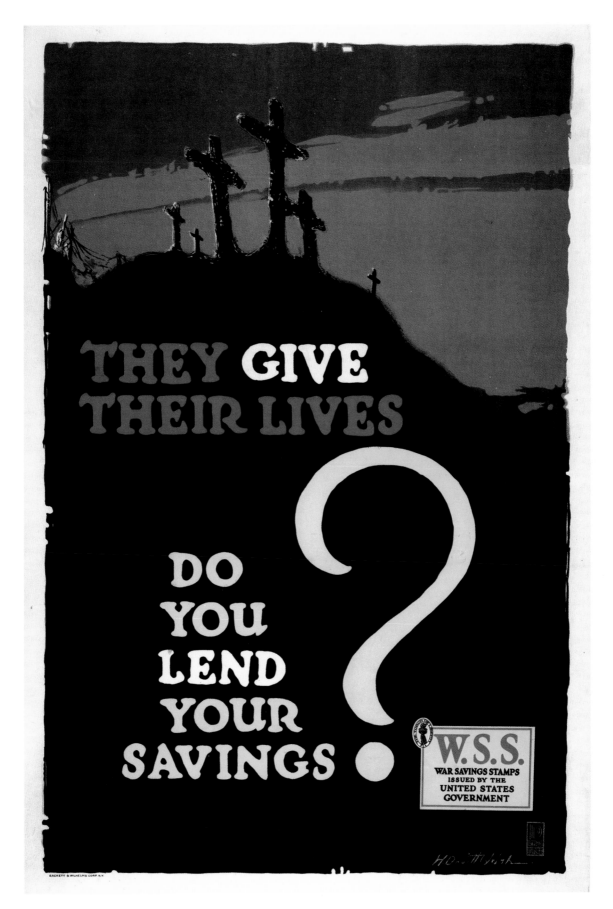

PRINT NO. 144 AMERICA, 1918. "THEY GIVE THEIR LIVES, DO YOU LEND YOUR SAVINGS?" HORACE DEVITT WELSH

PLATE III A
Meuse-Argonne Operations
German Divisions
Engaged Nov.1st - 6th 1918.

COUNTERATTACKS

I f it can be said that there was a "moment" when the tides of war and fortune reversed, when the momentum of battle shifted from the German side to the Allied side, that great turnaround occurred in France on the Western Front in the 48 hours of July 17 and 18, 1918. On the 17th, the fifth and final German offensive ground to a halt, and Ludendorff cancelled the operation. At dawn on the next morning, French general Philippe Pétain launched a powerful surprise counterattack on the Aisne River with two French armies that incorporated several British and American divisions. Their -goal was to reduce the long-held Marne salient; the hard fighting was costly on both sides, but they drove the German Seventh Army back over 20 miles. ❖ This was the first Allied offensive of 1918 in a series that in the next 100 days would push the Germans out of France into Belgium and bring the fighting to a close on November 11.

The final phase of the war began with relentless Allied attacks along the entire length of the Western Front, which the Germans finally could not stop.

A week after that tide-turning moment, Allied commander Ferdinand Foch—ever in favor of taking the offensive—met with Generals Haig, Pershing, and Pétain to decide how to seize the initiative, which they finally had the manpower and the firepower to do. Instead of concentrating forces to punch a hole in the enemy line, as the Germans had done for the last four months, Foch favored launching multiple attacks—surprises wherever possible—along nearly the entire Western Front, to keep the German army off balance and in retreat. Haig initially took charge of the combined armies in an action on the Amiens sector.

Bolstering the Allies' manpower on the ground in these offensives, Australian, Canadian, and American soldiers carried out some of the most challenging front-line fighting. In these early battles where the American units were fully engaged in combat, the First and Second Divisions of the American Expeditionary Force endured a major pounding in the Aisne sector, as did the Forty-Second, the so-called Rainbow Division.

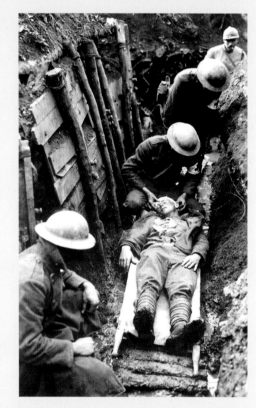

A wounded U.S. Marine is treated in the trenches of the Toulon sector near Verdun, March 1918.

But Foch's offensive approach of broad front attacks succeeded in the first week in August in forcing the Germans all the way back to the positions from which they had launched Operation Michael, the first of their major offensives, on March 21.

WAR GARDENS
OVER THE TOP

The Seeds of Victory
Insure *the* Fruits of Peace

FOR FREE BOOKS WRITE TO NATIONAL WAR GARDEN COMMISSION
WASHINGTON, D.C.

Charles Lathrop Pack, President Percival S. Ridsdale, Secretary

PRINT NO. 160 AMERICA, 1919. "WAR GARDENS OVER THE TOP." MAGINEL WRIGHT BARNEY

The United States and Britain had signed an addendum to the treaty vowing to protect France's security—but the Republican-controlled U.S. Senate did not ratify the Treaty of Versailles. That was a bitter pill for Wilson, by then incapacitated by strokes. He blamed "puny" politicians "who preferred personal partisan motives to the honor of their country and the peace of the world." He died in 1924. His League of Nations became a reality with 42 initial members—but the United States was not one of them, and the League could not stop Hitler's aggression. Fifteen years later, Europe was again at war.—*R.E.*

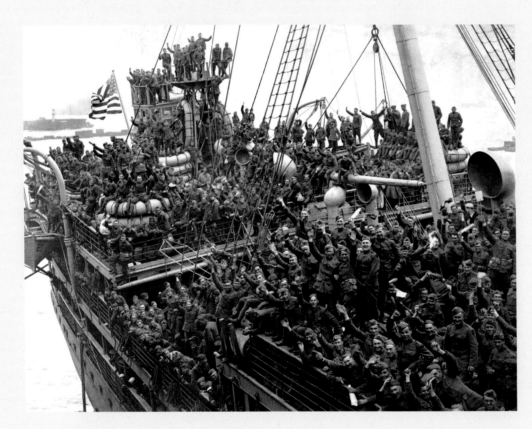

The transport ship *Agamemnon* delivered jubilant American troops to Hoboken, N.J., 1919.

PRINT NO. 161 AMERICA, 1918. "U.S. GOVERNMENT WAR EXPOSITION." MAGINEL WRIGHT BARNEY

AUTHOR'S SELECTED SOURCES

BOOKS

Banks, Arthur. *A Military Atlas of the First World War.* Barnsley, UK: Pen & Sword Books, 2001.

Berg, A. Scott. *Wilson.* New York: G.P. Putnam's Sons, 2013.

Burg, David F., and L. Edward Purcell. *Almanac of World War I.* Lexington, KY: University Press of Kentucky, 1998.

Chambers, John Whiteclay II, ed. *The Oxford Companion to American Military History,* New York: Oxford University Press, 1999.

Clark, George B. *The American Expeditionary Force in World War I: A Statistical History, 1917–1919.* Jefferson, NC: McFarland, 2013.

Ellis, John, and Michael Cox. *The World War I Data Book: The Essential Facts and Figures for all the Combatants.* London: Aurum Press, 2004.

Evans, Martin Marix. *Battles of World War I.* Wiltshire, UK: Crowood Press, 2004.

Fussell, Paul. *The Great War and Modern Memory.* New York: Oxford University Press, 2013.

Gilbert, Adrian. *World War I in Photographs.* New York: Military Press, 1986.

Haythornthwaite, Philip. *Gallipoli 1915: Frontal Assault on Turkey.* Westport, CT: Praeger, 2004.

Holmes, Richard, ed. *The Oxford Companion to Military History.* New York: Oxford University Press, 2001.

Howard, Michael. *The First World War.* Oxford, UK: Oxford University Press, 2002.

Hughes, Matthew, and William J. Philpott. *The Palgrave Concise Historical Atlas of the First World War.* New York: Palgrave Macmillan, 2005.

Jankowski, Paul. *Verdun: The Longest Battle of the Great War.* New York: Oxford University Press, 2014.

Jones, Simon. *World War I Gas Warfare Tactics and Equipment.* Oxford, UK: Osprey, 2007.

Keegan, John. *An Illustrated History of the First World War.* New York: Alfred A. Knopf, 2001.

———. *The Face of Battle.* New York: Penguin Books, 1978.

———. *The First World War.* New York: Alfred A. Knopf, 1999.

Kirchberger, Joe H. *The First World War: An Eyewitness History.* New York: Facts on File, 1992.

Lengel, Edward G. *Thunder and Flames: Americans in the Crucible of Combat, 1917–1918.* Lawrence, KS: University Press of Kansas, 2015.

———. *To Conquer Hell: The Meuse-Argonne, 1918.* New York: Henry Holt and Company, 2008.

———. *World War I Memories.* Lanham, MD: Scarecrow Press, 2004.

Lettow-Vorbeck, Paul von. *My Reminiscences of East Africa.* London: Forgotten Books Classic Reprint, n.d.

Macdonald, Lyn. *1914–1918: Voices & Images of the Great War.* London: Penguin Books, 1988.

MacMillan, Margaret. *Paris 1919.* New York: Random House, 2001.

Mayhew, Emily. *Wounded: A New History of the Western Front in World War I.* New York: Oxford University Press, 2014.

Monger, David. *Patriotism and Propaganda in First World War Britain.* Liverpool, UK: Liverpool University Press, 2014.

Murray, Williamson. *Military Adaptation in War.* New York: Cambridge University Press, 2011.

Myer, G.J. *A World Undone: The Story of the Great War.* New York: Delacorte Press, 2006.

Neiberg, Michael S., ed. *The World War I Reader.* New York: New York University Press, 2007.

Prior, Robin, and Trevor Wilson. *The First World War.* London: Cassell & Co., 2001.

Reynolds, David. *The Long Shadow: The Legacies of the Great War in the Twentieth Century.* New York: W.W. Norton, 2014.

Rommel, Erwin. *Infantry Attacks.* Minneapolis: Zenith Press, 2009.

Sheffield, Gary, ed. *War on the Western Front: In the Trenches of World War I.* Oxford, UK: Osprey, 2007.

Strachan, Hew, ed. *The Oxford Illustrated History of the First World War.* New York: Oxford University Press, 2014.

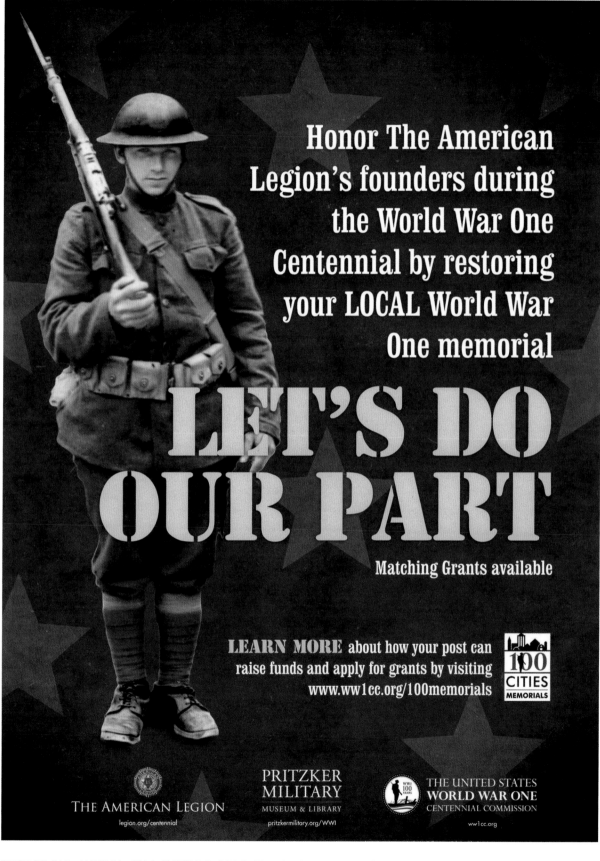

Honor The American
Legion's founders during
the World War One
Centennial by restoring
your LOCAL World War
One memorial

LET'S DO OUR PART

Matching Grants available

LEARN MORE about how your post can
raise funds and apply for grants by visiting
www.ww1cc.org/100memorials

100 CITIES MEMORIALS

THE AMERICAN LEGION
legion.org/centennial

PRITZKER MILITARY
MUSEUM & LIBRARY
pritzkermilitary.org/WWI

THE UNITED STATES
WORLD WAR ONE
CENTENNIAL COMMISSION
ww1cc.org

PRINT NO.162 AMERICA, 2016. "LET'S DO OUR PART: HONOR THE AMERICAN LEGION'S FOUNDERS."
PRITZKER MILITARY MUSEUM & LIBRARY

Strohn, Matthias, ed. *World War I Companion.* Oxford, UK: Osprey, 2013.

Tuchman, Barbara W. *The Guns of August.* New York: Random House, 2014.

Tunstall, Graydon A. *Blood on the Snow: The Carpathian Winter War of 1915.* Lawrence, KS: University Press of Kansas, 2010.

Warner, Philip. *World War One: A Chronological Narrative.* London: Arms and Armour Press, 1995.

Weale, Putnam. *An Indiscreet Chronicle from the Pacific.* New York: Dodd, Mead, 1922.

Wilks, John, and Eileen Wilks. *Rommel and Caporetto.* South Yorkshire, UK: Pen & Sword Books, 2001.

Zabecki, David T. *Steel Wind: Colonel Georg Bruchmüller and the Birth of Modern Artillery.* Westport, CT: Praeger, 1994.

PERIODICALS

Bruce, Robert B. "Victor of Verdun." *Military History* (July/August 2008): 52-61.

Corum, James S. "Riga 1917: How to Prepare for a Battle." *MHQ: The Quarterly Journal of Military History* 27, no. 1 (Autumn 2014): 52-63.

Mockenhaupt, Brian. "The Most Treacherous Battle of World War I Took Place in the Italian Mountains." *Smithsonian Magazine* (June 2016): 44-57.

Murray, Williamson. "Tactical Genius, Strategic Fool: Erich Ludendorff's Obsessive Militarism Left Germany in Ruins." *Military History* (September/October 2008): 42-49.

Neiberg, Michael S. "Pale Horse: The Influenza Pandemic and the Apocalyptic Climax of the Great War." *MHQ: The Quarterly Journal of Military History* 28, no. 1 (Autumn 2015): 44-51.

Thompson, Mark. "Isonzo 1915: Do You Want Everyone to Die?" *Military History* (August/September 2009): 46-53.

Warren, Christopher A. "An International Red Line: Why Chemical Weapons are Taboo." *MHQ: The Quarterly Journal of Military History* 26, no. 2 (Winter 2014): 40-43.

Zabecki, David T. "Georg Bruchmüller: The Father of Modern Artillery Tactics." *MHQ: The Quarterly Journal of Military History* 28, no. 3 (Spring 2016): 62-69.

———. "Hope is Not a Strategy: The Promise and Failure of Germany's Last Best Shot at Victory in 1918." *MHQ: The Quarterly Journal of Military History* 27, no. 2 (Winter 2015): 72-79.

WEBSITES

Boehler, Patrick, et al. "The Forgotten Army of the First World War: How Chinese Labourers Helped Shape Europe." South China Morning Post—China's WWI. http://multimedia.scmp.com/ww1-china/.

Keller, R.H. "The German Soldier in World War I: Organization and Service in the German Army." Great War Militaria. www.greatwar.com/scripts/openExtra.asp?extra=10.

Brosnan, Matt. "The Pals Battalions of the First World War." Imperial War Museums. www.iwm.org.uk/history/the-pals-battalions-of-the-first-world-war.

Watson, Alexander. "Recruitment: Conscripts and Volunteers During World War One." British Libray. www.bl.uk/world-war-one/articles/recruitment-conscripts-and-volunteers.

Ath, Altay. "Turkey in the First World War: Gallipoli." TurkeysWar.com, last updated January 6, 2015. www.turkeyswar.com/campaigns/gallipoli.html.

AFTERWORD

This profusely illustrated volume reminds us of a generation of Americans who are sadly often forgotten, overshadowed by the struggles of their children in a later war.

Anniversary periods in history are important as they allow us to reflect on the service, achievements, and sacrifices of America's citizen-soldiers. As the Founding Sponsor of the World War One Centennial Commission, the Pritzker Military Museum & Library has devoted significant energy to remembering the role of Americans who willingly served their nation in times of peace and war.

As the Chair of the United States World War One Centennial Commission, I know the many reasons why books like this one are important. Created by an act of the United States Congress, the World War One Centennial Commission is charged with ensuring that the United States of America remembers its harrowing journey through the War to End All Wars, and that we as citizens remember those who fought for the ideals of liberty and lasting world peace.

When Congress created the commission, it stipulated that funding for commemorating WWI should come from the private sector, and that is where the Museum & Library committed to a nation-leading grant to start the commission's work. This book will stand as a lasting testament to the partnership between the World War One Centennial Commission and the Pritzker Military Museum & Library as it meets the very spirit of the charter that Congress gave the commission to remember those Americans who served during WWI and to celebrate our nation's victory in that war.

The Museum & Library's commitment is fully in concert with the words of the Commanding General of the American Expeditionary Force, General John J. Pershing, who desired that the service of American soldiers, sailors, airmen, marines, and coast guardsmen never be forgotten. He stated, "Time must not dim the glory of their deeds."

Understanding the necessity to acknowledge America's contribution during World War I through commemorative cemeteries and memorials overseas, Congress created the American Battle Monuments Commission. The commission was responsible for honoring American armed forces where they had served and for overseeing military cemeteries, monuments, and markers on foreign soil. General of the Armies John J. Pershing was appointed to the commission in 1923, and was elected chairman. He served in that capacity until his death in 1948.

The government also recognized a need for a burial and repatriation policy for America's war dead. Over the course of the conflict, more than 116,000 Americans lost their lives in Europe. Legislation was enacted that entitled families to select permanent interment of a loved one's remains in an American military cemetery on foreign soil, or repatriation of the remains to the U.S. for interment in a national or private cemetery. The majority of families chose repatriation; approximately 30 percent chose permanent interment in an American Battle Monuments Commission cemetery.

THE AMERICAN BATTLE MONUMENTS COMMISSION began an aggressive commemorative program that resulted in eight permanent American cemeteries in Europe and 13 separate memorials and markers. Each cemetery would include nonsectarian chapels, sculptures, and battle maps depicting the course of the war in the region, and visitor reception facilities.

The gravesites were marked by a Latin cross headstone of pristine white marble; headstones for those of the Jewish faith were marked by Stars of David. "Here Rests in Honored Glory an American Soldier Known but to God" was inscribed on the headstones of servicemen who could not be identified. Individuals recorded as missing in action or lost or buried at sea were memorialized by including their names on Walls of the Missing.

As cemeteries and memorials took shape, the American Battle Monuments Commission endeavored to document America's efforts in World War I by compiling divisional operational summaries and publishing *American Armies and Battlefields in Europe*, a guidebook that pro-

vides detailed descriptions of and directions to the European battlefields where Americans fought. Serving as part of this documentation process was a young U.S. Army major, Dwight D. Eisenhower.

In January 2017, the American Battle Monuments Commission acquired its ninth World War I cemetery, the Lafayette Escadrille Memorial Cemetery near Paris.

As we mark the WWI centennial, it is especially fitting that the Pritzker Military Museum & Library, in collaboration with the United States World War One Centennial Commission, provides us with this evocative publication, which causes us to pause and remember a generation of Americans that served to bridge the 19th and 20th centuries.

World War I transformed America dramatically. The service in our armed forces of African-Americans and immigrants—and women, working in the military, in industry at home, and providing humanitarian service abroad—furnished the kindling that sparked a wildfire in American society. Every aspect of our society was touched by World War I: how we viewed gender, how we viewed race, how we viewed the loyalty of new immigrants to America. Though it would be a long road, many prejudices and beliefs were shaken to the core—and the world was changed forever.

Colonel Robert J. Dalessandro, U.S. Army (Retired)
Chair, United States World War One Centennial Commission,
October 2013–September 2017
Acting Secretary, American Battle Monuments Commission

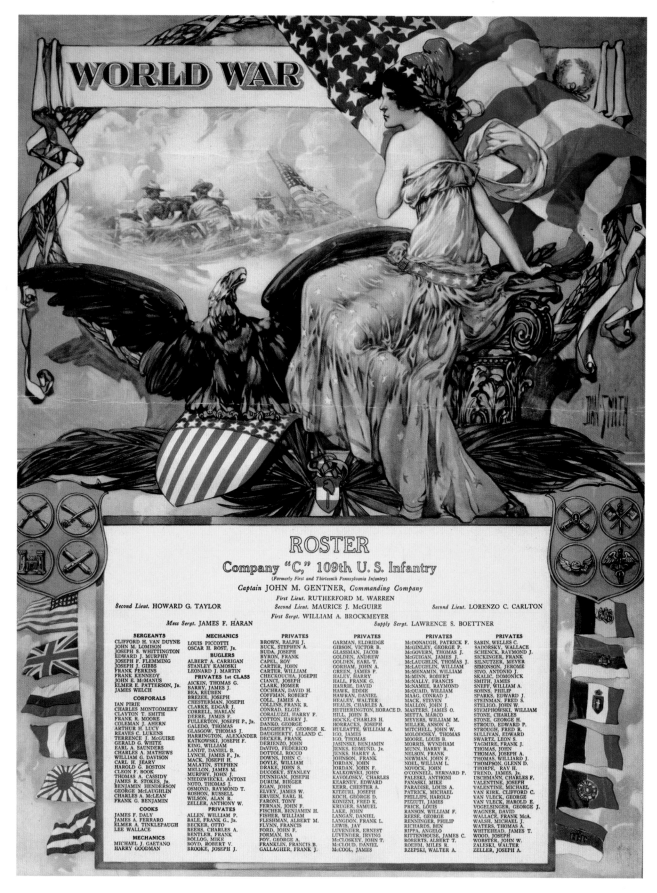

PRINT NO. 163 AMERICA, CA. 1919. "ROSTER OF COMPANY C, 109TH U.S. INFANTRY." DAN SMITH

PRINT NOTES

THE 166 WWI PRINTS in this book are from scans of the original posters in the collections of the Pritzker Military Museum & Library. More information about each print in this book can be obtained at www.pritz kermiltary.org by using the PMML catalog number in the search function. 🔍 Additionally, there are more than 900 WWI posters in the Museum & Library's collections, along with tens of thousands of other artifacts, books, and items related to military history and affairs that can be viewed online.

Print No. 1 America, 1917-1918. *Are You Idle To-Day?* U.S. Department of Labor
PMML Catalog #329640
Print Topic Category: Production
Copyright: Public Domain

Print No. 2 America, ca. 1918. *Over the Top: Doughboys, Tanks, and Airplanes.*
PMML Catalog #329566
Print Topic Category: Documentary
Copyright: Public Domain

Print No. 3 France, 1917. *Army of Africa and Colonial Troops Day.* Lucien Jonas
PMML Catalog #321979
Print Topic Category: Recruiting
Copyright: Public Domain

Print No. 4 ca. 1895.
European Royalty ca. 1895.
PMML Catalog #329014
Print Topic Category: Documentary
Copyright: Public Domain

Print No. 5 France, 1918. *The Exhibition of the Allies.* Robert de Coninck
PMML Catalog #321846
Print Topic Category: Documentary
Translation: "Exhibit organized for the benefit of exhibitors." Poster within the

poster reads "Communicated: Visit all the exhibition of the Allies. Organized for the benefit of exhibitors and the fraternity of artists."
Copyright: Public Domain

Print No. 6 Germany, 1914.
The Secret of Lüttich: Our Bombing Success. Knackstedt & Co.
PMML Catalog #321553
Print Topic Category: Production
Translation: "The secret of Lüttich. Our bombing success. Original size. 42cm Projectile."
Copyright: Public Domain

Print No. 7 Russia, 1915-1916.
War Loan 5½%.
PMML Catalog #320634
Print Topic Category: War Loans
Copyright: Public Domain

Print No. 8 Italy, 1914-1918. *We Are Taking Your Father to Make More Munitions.* Louis Raemaekers
PMML Catalog #320660
Print Topic Category: Documentary
Translation: "Exhibit of Raemaekers' 100 drawings of a neutral [country]. The deportations in Belgium: We're taking your father to make more munitions."
Copyright: ©2017 Used by permission of the Stitching Louis Raemaekers Foundation

Print No. 9 Russia, 1915-1916.
War Bonds for Victory. T. Kibbel
PMML Catalog #321813
Print Topic Category: War Loans
Translation: "Buy 5½% bonds: War bonds for victory."
Copyright: Public Domain

Print No. 10 America, 1918.
Remember Belgium. Ellsworth Young
PMML Catalog #321746

Print Topic Category: War Loans
Copyright: Public Domain

Print No. 11 America, 1918. *The Kaiser: The Beast of Berlin.* Morgan Litho.
PMML Catalog #320964
Print Topic Category: Film
Copyright: Public Domain

Print No. 12 Austria, 1917. *Subscribe to the 7th War Loan.* Alfred Offner
PMML Catalog #321444
Print Topic Category: War Loans
Copyright: Public Domain

Print No. 13 England, 1915. *Forward!* Lucy Kemp-Welch
PMML Catalog #320968
Print Topic Category: Recruiting
Copyright: Public Domain

Print No. 14 America, 1918. *J. Joffre, Marshal of France.* New York American
PMML Catalog #329204
Print Topic Category: Literary
Translation: Letter reads "I thank you on behalf of France, and its army which I represent here. I beg you to convey to your colleagues the expression of my gratitude for the sympathy with which they have shown me during my stay, and be assured of my respectful consideration."
Copyright: Public Domain

Print No. 15 America, 1917. *American Field Service.* Josef Pierre Nuyttens
PMML Catalog #320960
Print Topic Category: Recruiting
Copyright: Public Domain

Print No. 16 Russia, 1915-1916.
Everything for the War, Everything for Victory. M. Olkone
PMML Catalog #320970
Print Topic Category: War Loans

Translation: "Buy the 5½% war loan: everything for the war, everything for victory."
Copyright: Public Domain

Print No. 17 France, 1914.
The Imperial Thief. Eugene Courboin
PMML Catalog #329106
Print Topic Category: Documentary
Translation: "'The Imperial Thief': Episodes of the war, 1914. Popular Prints G.W.D.—No. 3. The Crown Prince takes advantage of his stay at the Castle of Baye to loot it. He chooses the most precious objects, has them packed in his presence, and ships them to Germany."
Copyright: Public Domain

Print No. 18 England, 1915.
Daddy, What Did You Do in the Great War? Savile Lumley
PMML Catalog #320260
Print Topic Category: Recruiting
Copyright: Public Domain

Print No. 19 England, 1915. *Men of London! Remember!* Andrew Reid & Co.
PMML Catalog #321992
Print Topic Category: Recruiting
Copyright: Public Domain

Print No. 20 England, 1915. *Every Fit Briton Should Join Our Brave Men at the Front.* ES&A Robinson Ltd.
PMML Catalog #321743
Print Topic Category: Recruiting
Copyright: Public Domain

Print No. 21 France, 1915. *The Destruction of Reims Cathedral, 1914.* Gustave Fraipont
PMML Catalog #329403
Print Topic Category: Documentary
Copyright: Public Domain

Print No. 22 Russia, 1917.
Year 1914 (Our Resurrection).
PMML Catalog #320969
Print Topic Category: Literary
Translation: "1917 annual subscriptions are now available (second year of publication). You can now subscribe to *Year 1914 (Our Resurrection)*, a print magazine of literature, art, politics, and economics. "Published by the 'Year 1914 Society'— the revival of Russia and struggle against the German influence/the dominance of Germanness.
"The great struggle of Mankind against Germanness is a turning point in European history. This struggle has (already) raised innumerable burning issues; it is opening up wide prospects for a better and brighter future; it has set the grandiose goals for the upcoming creative work. Our magazine *Year 1914 (Our Resurrection)* aims to facilitate the decisive struggle against Germanness through merging the scientific and artistic forces in order to revive our Glorious and Long-suffering Motherland.
"Subscription fees: 1st edition yearly subscription 5 rubles; Half-year subscription 3 rubles; 2nd edition (printed on heavy paper) 10 rubles. Editorial Board and Main Office: 32, Sadovaya Str., Petrograd."
Copyright: Public Domain

Print No. 23 America, 1915.
If You Want to Fight! Join the Marines. Howard Chandler Christy
PMML Catalog #321751
Print Topic Category: Recruiting
Copyright: Public Domain

Print No. 24 Ireland, 1915. *Irishmen Avenge the Lusitania.* John Shuley & Co.
PMML Catalog #321842
Print Topic Category: Recruiting
Copyright: Public Domain

Print No. 25 Germany, 1918. *9th Arrow: Subscribe to War Loans.* Fritz Erler
PMML Catalog #320552
Print Topic Category: War Loans
Copyright: Public Domain

Print No. 26 America, 1918.
Hearts of the World. Grant E. Hamilton
PMML Catalog #329612
Print Topic Category: Political
Copyright: Public Domain

Print No. 27 Germany, 1917.
That is How Your Money Helps You Fight! Lucian Bernhard
PMML Catalog #320318
Print Topic Category: War Loans
Translation: "That is how your money helps you fight! Transformed into submarines, it keeps enemy grenades from your body. Therefore, subscribe to war loans."
Copyright: © 2017 Artists Rights Society (ARS), New York/VG Bild-Kunst, Bonn

Print No. 28 America, 1917-1918. *Help Women Physicians Fight Disease and Death in Serbia.* American Women's Hospitals
PMML Catalog #321963
Print Topic Category: Relief Funds
Copyright: Public Domain

Print No. 29 America, 1917-1918.
It's Our War Chest Against His. William Addison Ireland
PMML Catalog #320865
Print Topic Category: War Loans
Copyright: Public Domain

Print No. 30 Germany, 1918. *War Chronicle 1914-1918, of Emil Wilhelm Jock.* Elk Eber
PMML Catalog #329227
Print Topic Category: Documentary
Translation: "War Volunteer/Enlistee/in 2nd Rheinische Infantry Regiment von Goeben No. 28.
"Iron Cross 2nd Class—Wounded Badge in Silver—Front Fighter Honor Cross.
"He was born on 7 January, 1898 in Bretten. Entered active-duty as a volunteer enlistee after the outbreak of The World War on 5.11.14. Assigned to 1st Battalion, 171st Infantry Regiment. After his military training transferred to the field in January, 1915. Assigned to the Mobile 2nd Rheinische Infantry Regiment von Goeben, No. 28, 16th Infantry Division. Served honorably

in military operations. In the West: Against France; Winter Battle Campaign 1915 in Champagne; various battles in Champagne; Battle at Ballee-Arras, where near Souchez on 18.6.1915 he was gravely wounded from a direct hit from a hand grenade, suffering serious wounds to his head, chest, thighs and calves, his right foot, brain and eyes. Evacuated to hospital gravely wounded. Due to stiffening of his right arm, he was discharged from military service on 1 January, 1917 as a pensioned War Service–Disabled Veteran and returned to his home of record."
Copyright: Public Domain

Print No. 31 Germany, 1917. *Charity Evening: Driver Replacement Department.* Julius Ussy Engelhard
PMML Catalog #320631
Print Topic Category: Recruiting
Translation: "Charity Evening: Driver replacement department. November 24, 1917 at Löwenbrau Cellar."
Copyright: Public Domain

Print No. 32 America, 1917-1918. *The Prussian Blot.* State Council of Defense
PMML Catalog #320364
Print Topic Category: Political
Copyright: Public Domain

Print No. 33 France, 1915. *Heroes of the Marne: 117th Infantry Regiment, Republic of France.* Georges Scott
PMML Catalog #321983
Print Topic Category: Documentary
Copyright: Public Domain

Print No. 34 England, 1917. *The War of Munitions.* G.K.
PMML Catalog #320734
Print Topic Category: Production
Copyright: Public Domain

Print No. 35 Italy, 1914-1918. *Il Re Soldato (The Soldier King), Victor Emmanuel III, King of Italy, with His Troops.*
PMML Catalog #329182

Print Topic Category: Documentary
Copyright: Public Domain

Print No. 36 Russia, 1916. *Everything for the War!* Sokolova
PMML Catalog #320377
Print Topic Category: War Loans
Translation: "Everything for the war! Subscribe to the 5½% war loan."
Copyright: Public Domain

Print No. 37 America, 1918. *Side by Side— Britannia!* James Montgomery Flagg
PMML Catalog #320681
Print Topic Category: Political
Copyright: Public Domain

Print No. 38 France, 1919. *To the Memory of Albert Edward Hamilton, U.S. Navy.* Franklin Booth
PMML Catalog #329190
Print Topic Category: Memorial
Translation: "Those who piously died for the country are entitled to their crowd come to their coffin and pray. To the memory of Albert Edward Hamilton, U.S. Navy of the United States of America, who died for liberty during the Great War. A tribute from France in the name of the President of the republic."
Copyright: Public Domain

Print No. 39 America, 1917. *Only the Navy Can Stop This.* William Allen Rogers
PMML Catalog #321929
Print Topic Category: Recruiting
Copyright: Public Domain

Print No. 40 America, 1916. *Save Serbia Our Ally.* Theophile Alexandre Steinlen
PMML Catalog #321725
Print Topic Category: Relief Funds
Copyright: Public Domain

Print No. 41 America, 1917-1918. *Foch Says—"The Americans Are Fighters" Are You?* A.H. Gilbert
PMML Catalog #320863
Print Topic Category: Recruiting
Copyright: Public Domain

Print No. 42 France, 1916. *Save the Wine for Our Infantry Soldiers.* Suzanne Ferrand
PMML Catalog #321544
Print Topic Category: Conservation
Copyright: Public Domain

Print No. 43 France, 1917. *French Veterans of the Great War.* Geo Dorival & Georges Capon
PMML Catalog #321741
Print Topic Category: Documentary
Copyright: © 2017 Artists Rights Society (ARS), New York/ADAGP, Paris

Print No. 44 France, 1915. *To the Young Refugees—Here Used To Be Our Home.* Tancrede Synave
PMML Catalog #321753
Print Topic Category: Documentary
Copyright: Public Domain

Print No. 45 Germany, 1917. *England Fights Only Against German Industriousness!* Otto Eisner
PMML Catalog #329196
Print Topic Category: Production
Translation: "England fights only against the German Industriousness! At a dinner at the Constitutional Club in London on 20 November 1917 the English Minister Carson said: 'It is frequently recommended to bomb the housing of the Barbarians. In my view it is a far more valuable offensive, to bomb the businesses of the Huns, so that after the War they do not exist, that even their foundations are no longer to be found.' Times—from 21 November 1917."
Copyright: Public Domain

Print No. 46 France, 1917. *Hey You! Do Your Duty. If I Didn't Do Mine What Would You Call Me?* Jacques Carlu
PMML Catalog #321298
Print Topic Category: Production
Copyright: Public Domain

Print No. 47 America, 1918. *Treat 'em Rough!* August William Hutaf
PMML Catalog #320257

Print Topic Category: Recruiting
Copyright: Public Domain

Print No. 48 Russia, 1917. *Liberty Loan: War to Victory.* Petr Dmitrievich Buchkin
PMML Catalog #320203
Print Topic Category: War Loans
Copyright: Public Domain

Print No. 49 Russia, 1914-1915. *War Loan for the Country!* Aleksandr O. Maksimov
PMML Catalog #320484
Print Topic Category: War Loans
Copyright: Public Domain

Print No. 50 Russia, 1914-1915. *War Loan: Everything for Victory.*
PMML Catalog #329793
Print Topic Category: War Loans
Translation: "War Loan: Participation in the loan is everyone's patriotic duty. All for victory."
Copyright: Public Domain

Print No. 51 Russia, 1915. *Adjutant General Nikolai Ruzsky, the Hero of Lodz.* Ivan D. Sytin
PMML Catalog #320199
Print Topic Category: Documentary
Copyright: Public Domain

Print No. 52 Germany, 1916. *Kaiser's Birthday Donation for Germany, Soldiers' Houses at the Front.* Max Antlers
PMML Catalog #320735
Print Topic Category: Political
Copyright: Public Domain

Print No. 53 America, 1918. *Lest We Forget Lithuania.* M. Dobuzinsky
PMML Catalog #321980
Print Topic Category: Relief Funds
Copyright: Public Domain

Print No. 54 England, 1915. *The Polish Victims Relief Fund.* Emile Antoine Verpilleux
PMML Catalog #320469
Print Topic Category: Relief Funds
Copyright: Public Domain

Print No. 55 England, 1915. *Are YOU in This?* Lt. General R.S.S. Baden-Powell
PMML Catalog #320553
Print Topic Category: Recruiting
Copyright: Public Domain

Print No. 56 Canada, 1917. *4 Reasons for Buying Victory Bonds.*
PMML Catalog #320502
Print Topic Category: War Loans
Copyright: Public Domain

Print No. 57 England, 1915. *Public Warning: German Airships, British Airships.* Joseph Causton & Sons
PMML Catalog #329336
Print Topic Category: Public Notice
Copyright: Public Domain

Print No. 58 England, 1915. *Come Along, Boys!* W.H. Caffyn
PMML Catalog #320529
Print Topic Category: Recruiting
Copyright: Public Domain

Print No. 59 Germany, 1917. *The Best Savings Bank: War Loans.* Louis Oppenheim
PMML Catalog #320603
Print Topic Category: War Loans
Copyright: Public Domain

Print No. 60 Italy, 1918. *For the Country My Eyes! For Peace Your Money.* Alfredo Ortelli
PMML Catalog #320630
Print Topic Category: War Loans
Translation: "For the country my eyes! For peace your money." National Loan annual 5% income. Subscriptions are received. Press branches of banks that normally issue credit—savings banks, credit unions and cooperatives, banking companies, participants of the loan consortium."
Copyright: Public Domain

Print No. 61 America, 1918. *Where the Victims Are.* American Committee for Relief in the Near East

PMML Catalog #320488
Print Topic Category: Relief Funds
Copyright: Public Domain

Print No. 62 America, 1917-1918. *Defeat the Kaiser and His U-Boats.* U.S. Food Administration
PMML Catalog #329015
Print Topic Category: Conservation
Copyright: Public Domain

Print No. 63 Japan, 1904-1905. *Japanese Battalion Charging Around Teish, Korea, Russo-Japanese War.* Tokyo Kandaku Minami Norimono Cho 15 banchi seiun-do, Kasai Torajiro
PMML Catalog #321415
Print Topic Category: Documentary
Translation: "This illustration of Japanese battalion charging around Teishu, Japan Russia Battle Illustrated Magazine Number 14, Meiji era 27th year April 7 Date of printing and issued in the same year on April 10. Drawn and printed by: Tokyo Kandaku Minami Norimono Cho 15 banchi seiun-do, Kasai Torajiro."
Copyright: Public Domain

Print No. 64 France, 1918. *One Last Effort and We Will Get Them.* Eugene Courboin
PMML Catalog #329614
Print Topic Category: Recruiting
Copyright: Public Domain

Print No. 65 Greece, 1914-1918. *Get Back Bear.*
PMML Catalog #320737
Print Topic Category: Recruiting
Copyright: Public Domain

Print No. 66 Canada, 1918. *Canada's Pork Opportunity.* E. Henderson
PMML Catalog #321783
Print Topic Category: Production
Copyright: Public Domain

Print No. 67 Canada, 1918. *They Shall Overcome.*
PMML Catalog #329455

Print Topic Category: War Loans
Translation: "They shall overcome if you subscribe to the victory loan, 1918."
Copyright: Public Domain

Print No. 68 South Africa, 1918. *Africanders, Your Pals in Flanders Are in Danger.* Government Printing and Stationery Office, Pretoria
PMML Catalog #321864
Print Topic Category: Recruiting
Copyright: Public Domain

Print No. 69 America, 1918. *America's Answer.*
Paramount Advertising Corporation
PMML Catalog #321937
Print Topic Category: Political
Copyright: Public Domain

Print No. 70 America, 1917-1918. *For Every Fighter a Woman Worker.*
Adolph Treidler
PMML Catalog #320556
Print Topic Category: Production
Copyright: Public Domain

Print No. 71 America, 1918. *United States Official War Films.* Kerr
PMML Catalog #320314
Print Topic Category: Film
Copyright: Public Domain

Print No. 72 America, 1917. *Make Every Minute Count for Pershing.* Adolph Treidler
PMML Catalog #329337
Print Topic Category: Production
Copyright: Public Domain

Print No. 73 America, 1917. *Join the Air Service, Give 'er the Gun.* W.Z.
PMML Catalog #320283
Print Topic Category: Recruiting
Copyright: Public Domain

Print No. 74 America, 1917-1918. *Spirit of Paul Jones.* E.G. Renesch
PMML Catalog #329061
Print Topic Category: Documentary
Copyright: Public Domain

Print No. 75 America, 1918. *Railway Men: Your Nation's Needs and Your Part in It.* Ernest Hamlin Baker
PMML Catalog #320723
Print Topic Category: Recruiting
Copyright: Public Domain

Print No. 76 France, 1918. *Subscribe to the Liberation Loan!* Simay
PMML Catalog #320509
Print Topic Category: War Loans
Translation: "Subscribe to the Liberation Loan! Lloyds Bank (France) and National Provincial Bank (France) Limited."
Copyright: Public Domain

Print No. 77 America, 1918. *British-Franco-American Army—August 1918.*
PMML Catalog #321870
Print Topic Category: Documentary
Copyright: Public Domain

Print No. 78 America, 1918. *On the Job for Victory.* Jonas Lie
PMML Catalog #329649
Print Topic Category: Production
Copyright: Public Domain

Print No. 79 America, 1917. *The Ships Are Coming.* James Daugherty
PMML Catalog #321701
Print Topic Category: Production
Copyright: Public Domain

Print No. 80 America, 1917. *Join the Navy, the Service for Fighting Men.* Richard Fayerweather Babcock
PMML Catalog #320196
Print Topic Category: Recruiting
Copyright: Public Domain

Print No. 81 America, 1917. *Follow the Flag.* James Daugherty
PMML Catalog #320348
Print Topic Category: Recruiting
Copyright: Public Domain

Print No. 82 Canada, 1918. *Hurry His Return: Subscribe to the Victory Loan.*
PMML Catalog #329454

Print Topic Category: War Loans
Copyright: Public Domain

Print No. 83 America, 1914-1918. *You, Wireless Fans, Help the Navy Get the Hun Submarine.* Charles Buckles Falls
PMML Catalog #321720
Print Topic Category: Recruiting
Copyright: Public Domain

Print No. 84 America, 1918. *Help Protect Liberty's Gateway.*
PMML Catalog #320733
Print Topic Category: War Loans
Copyright: Public Domain

Print No. 85 America, 1918. *Gee!! I Wish I Were a Man.* Howard Chandler Christy
PMML Catalog #329117
Print Topic Category: Recruiting
Copyright: Public Domain

Print No. 86 America, 1918. *Hold Up Your End!* W.B. King
PMML Catalog #321856
Print Topic Category: Relief Funds
Copyright: Public Domain

Print No. 87 Canada, 1918. *We Are Saving You, You Save Food.* E. Henderson
PMML Catalog #321739
Print Topic Category: Conservation
Copyright: Public Domain

Print No. 88 France, 1916. *Civilian Smokers, Save Tobacco for Our Soldiers.* Andrée Menard
PMML Catalog #321549
Print Topic Category: Conservation
Copyright: Public Domain

Print No. 89 America, 1918. *Down with the Murderers. Up with Democracy.* Vojtech Preissig
PMML Catalog #320455
Print Topic Category: Political
Copyright: © 2017 Artists Rights Society (ARS), New York/OOA-S, Prague

RETRIBUTION

When the guns fell silent to end World War I, in November 1918, many of the world's major countries were in a state of hardship. Some 9 million soldiers—a generation of young men from Europe to west Asia—were dead. Four empires—the German, the Austro-Hungarian (Habsburg dynasty), the Russian (the Romanovs), and the Ottoman—had been destroyed. Most of the combatant nations, having spent an estimated $185 billion during the four-year conflict, were in financial difficulty. There were widespread food shortages and, in many places, political unrest. The first step to calm "a world on fire," as U.S. president Woodrow Wilson put it, was for the victors to craft a comprehensive peace settlement—one that, the Allies agreed, should punish Germany for its aggression, reconstitute the fallen empires with new nations, and establish, if Wilson were to get his way, a new world order that would prevent the recurrence of another "world war."

World War I effectively redrew the map of Europe, as four empires had fallen and new nations took shape.

Delegates from the principal warring countries, plus scores of ethnic plaintiffs with nationalist ambitions, gathered in Paris in January 1919 for the peace conference. French prime minister Georges Clemenceau, British prime minister David Lloyd George, and Wilson dominated intense discussions and negotiations that went on for five months. Russia, in the throes of its revolutionary civil war, was absent; Italy, the last member of the diplomatic Big Four in Paris, was largely ignored.

Clemenceau, nicknamed "The Tiger," was determined to castrate Germany, while Wilson tried to mitigate the French desire for vengeance, emphasizing the need for a treaty "founded on justice." "Our greatest error would be to give [Germany] powerful reasons for one day wishing to take revenge," Wilson told Clemenceau, according to A. Scott Berg in his biography *Wilson*. The U.S. president added, presciently, "Excessive demands would most certainly sow the seeds of war."

U.S. president Woodrow Wilson, 1913-21.

Wilson's chief goal was the establishment of a League of Nations, which had been the centerpiece of his well-received Fourteen Points plan for global harmony. He envisioned the League as a "general association of nations" formed to mutually guarantee "political independence and territorial integrity to great and small states alike." It would arbitrate disputes, keep potential aggressors in line, and promote democracy and self-determination. Given Wilson's influence and the good will engendered by America's role in the war, the League was an easy sell in Europe. It was approved during the second plenary session and became the forerunner of the United Nations.

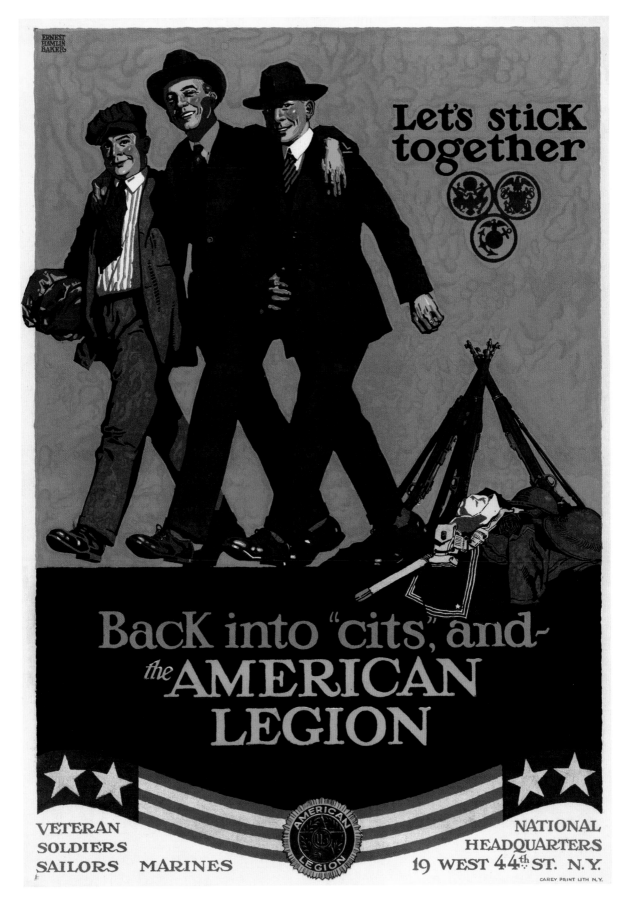

PRINT NO. 153 AMERICA, 1919. "BACK INTO 'CITS,' AND THE AMERICAN LEGION." ERNEST HAMLIN BAKER

There was also quick consensus in Paris on the creation of several new nations in, or close to, Europe, all to be carved from the erstwhile empires. Most had wasted no time declaring their independence either late in the war or soon after the November 11 armistice. The new countries were Poland, the Czechoslovak Republic, Ukraine, the Kingdom of Serbs, Croats and Slovenes (to become Yugoslavia), and the Baltic states of Finland, Estonia, Latvia, and Lithuania. (The Kingdom of Serbs, Croats and Slovenes and the Czechoslovak Republic would be formalized via the Treaty of Trianon in June 1920.)

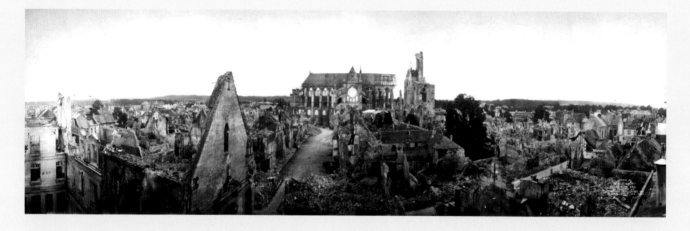

Poland was to be formed from the Grand Duchy of Warsaw (taken from Russia), from Polish lands in West Prussia (taken from Germany), and from Galicia (taken from Austria). The Czechoslovak Republic was sewn together from a swath of northern and western Austria (including ethnic Czech Bohemia and Moravia and German-speaking Sudetenland) and territory occupied by the Czech's Slovak "cousins" in defeated Hungary. The new Baltic states had been part of the Russian Empire at the start of the war—then all but Finland were occupied by the German army. Bolshevik Russia ceded all of them to Germany as part of the Treaty of Brest-Litovsk

Amiens, like thousands of cities, towns, and villages across France, lay in ruins in 1919.

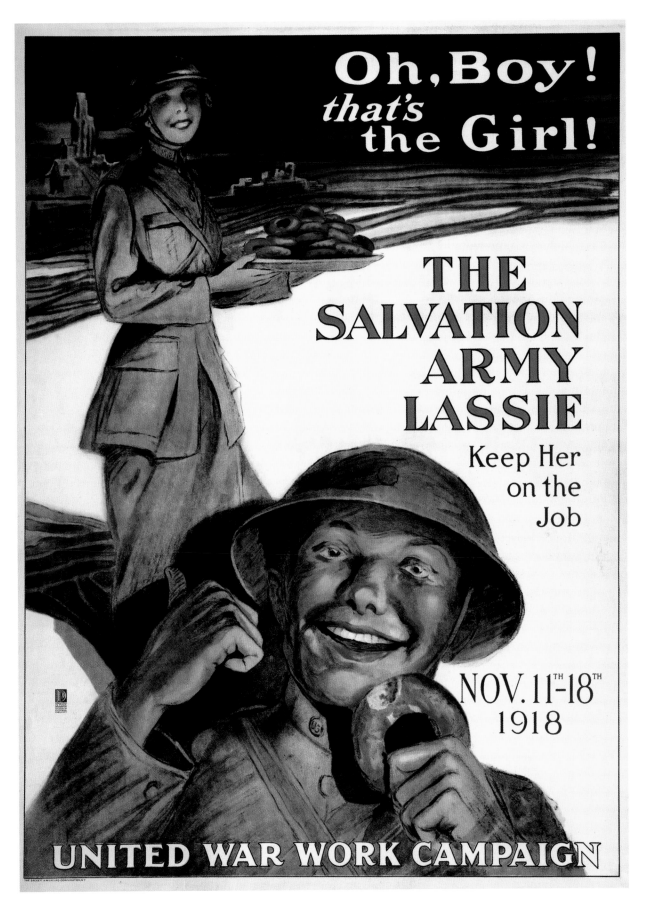

PRINT NO. 154 AMERICA, 1918. "OH, BOY! THAT'S THE GIRL." GEORGE MATHER RICHARDS

in March 1918, by which a battered Russia dropped out of the war. Germany intended to manage the Baltic territories as autonomous dependencies, but after its defeat they all sought—and won—independence.

Agreement on other issues came more slowly. British diplomat Harold Nicolson described an atmosphere of "discord and disorder" at the Paris talks. The cunning British premier, David Lloyd George, floated between the French and American leaders, often switching his views from one day to the next. Wilson lamented the lingering imperialistic worldview of the British and the French at a moment when nationalist movements were emerging all over the globe. Clemenceau, according to Berg, mumbled at one point that Wilson "thought himself another Jesus Christ come upon the Earth to redeem men."

British prime minister David Lloyd George, 1916-22.

Armenians, Albanians, Zionists, Arabs, Chinese, and Japanese all pressed grievances or aspirations on the popular Wilson and his counterparts. The Japanese aimed to keep Shandong Province, in China—and Wilson, going against his own principles, nodded his approval. Armenian delegates lobbied for independence from the genocidal Turks, and got their wish via the Treaty of Sévres in August 1920. Wilson came to the rescue of Albania. Diplomats decided to partition the country among Italy, Greece, and the Serbs, which had all occupied parts of Albania during the war. Wilson objected, and the League of Nations granted Albania its sovereignty in December 1920.

Treaties of convenience signed during the war, some secretly, were a complication. In the 1915 Treaty of London, Britain had promised Italy

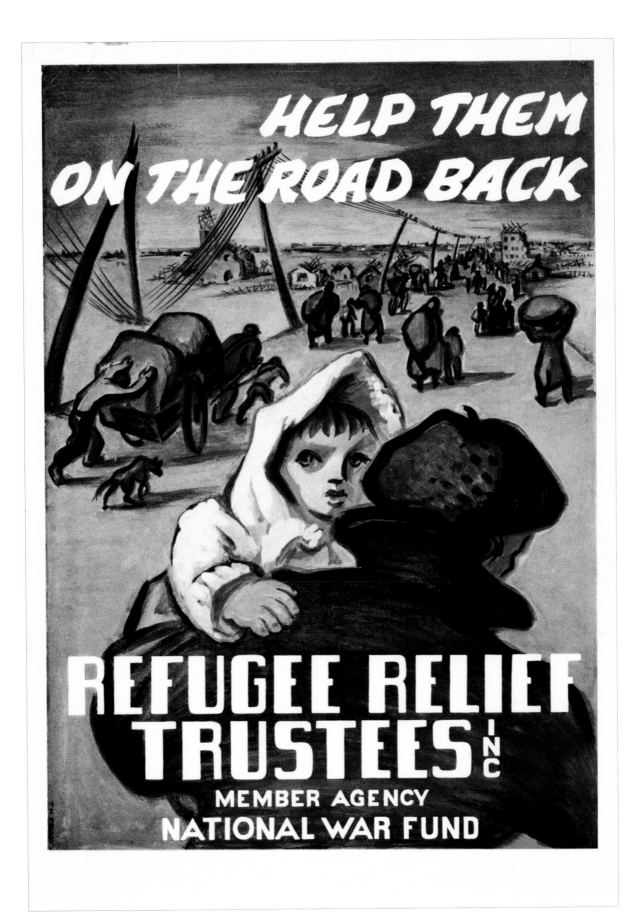

PRINT NO. 155 AMERICA, 1918-1919. "HELP THEM ON THE ROAD BACK." T.H. FRIDAY

substantial territory, including the Austrian Littoral and northern Dalmatia, if it joined the Allies. The 1916 Sykes-Picot Agreement, by which France and Britain agreed to divide much of the Ottoman Levant between them after the war, and the 1917 Balfour Declaration, which conflicted with Sykes-Picot by committing Britain to the idea of a Jewish homeland in Palestine, were also problematic. Wilson argued that the new peace treaty should supersede all wartime accords. Italy lost much of the territory it expected (though it did get the port city of Trieste), and Italian premier Vittorio Orlando stormed out of the conference.

Clemenceau and Lloyd George wrangled over Arab lands. France, a defender of Christians in the Mount Lebanon region going back to the Crusades, claimed Greater Syria, though it was occupied by British troops and British diplomats had led the Arabs to believe they could rule it themselves. France got its Syrian mandate, and from it would come the nations of Lebanon (with its volatile mix of Christians and Muslims) and Syria.

French prime minister Georges Clemenceau served two terms: 1906-09 and 1917-20.

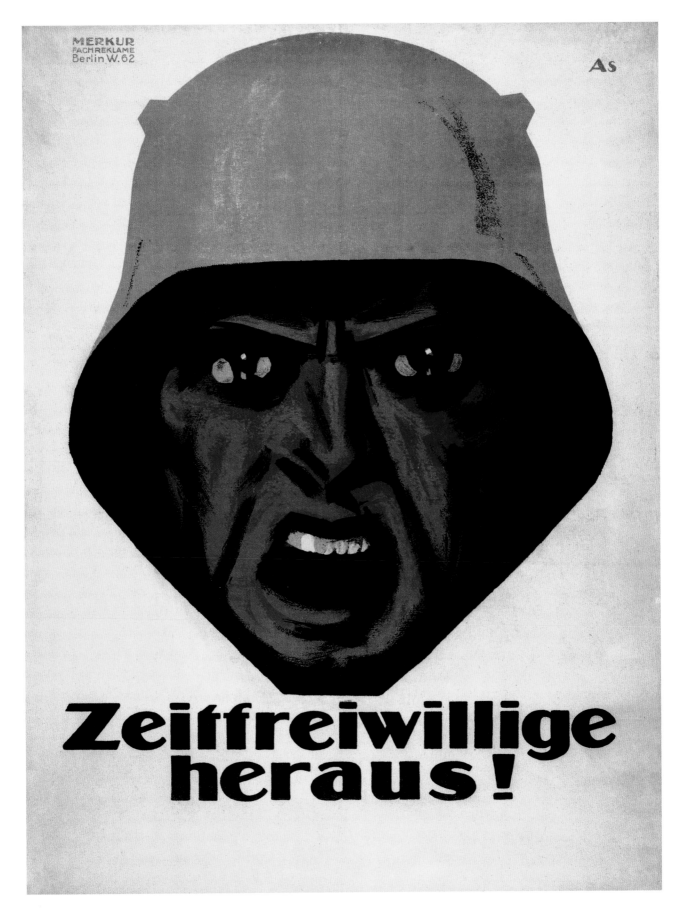

PRINT NO. 156 GERMANY, 1919. "TEMPORARY VOLUNTEERS, LET'S GO! (FREIKORPS)." A.S.

PALESTINE AT ISSUE

During the war, Britain enlisted the Arabs to help it drive the Turks out of the region, dangling the prospect of independence as an incentive. In Paris, that idea was conveniently forgotten. The Arabs were too weak to challenge the colonial powers. Britain got mandates for much of Mesopotamia (to become Iraq) and Palestine, the latter confirmed at the League of Nations San Remo Conference in 1920. Soon after, part of the original Palestine was hived off as Transjordan. No consideration was given to the views of the 700,000 people already living in Palestine—four-fifths of whom were Arabs not keen on sharing, or losing, their homeland.

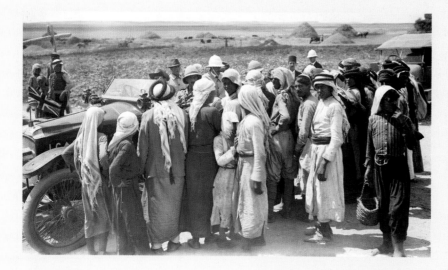

Sir Herbert Samuel, appointed high commissioner of the new British Mandate in Palestine, arrives at his post in 1920.

"When the Arabs pointed out that Palestine had not been exempted from the land to come under Arab rule," wrote Margaret MacMillan in her book *Paris 1919*, "the British accused them of ingratitude. 'I hope,' noted Foreign Minister Arthur Balfour, 'they will not begrudge that small notch, for it is no more geographically, whatever it may be historically—that

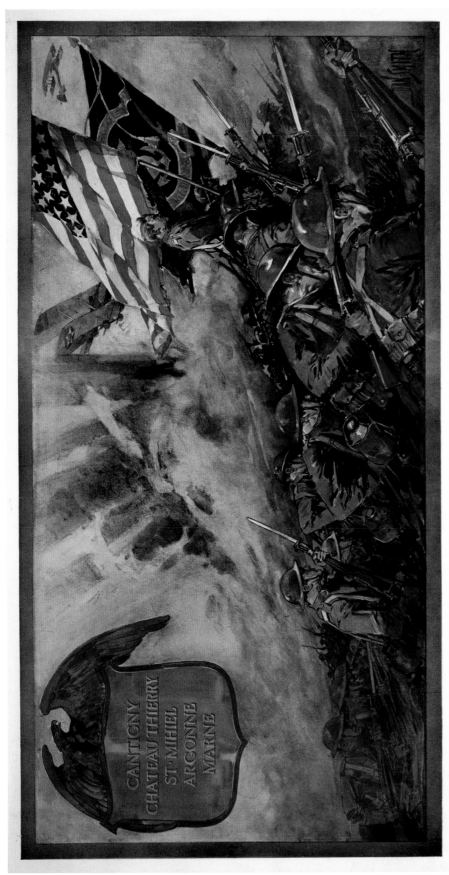

CANTIGNY
CHATEAU THIERRY
ST. MIHIEL
ARGONNE
MARNE

"PUT FIGHTING BLOOD IN YOUR BUSINESS · HERE'S HIS RECORD!
DOES HE GET A JOB?"

—Arthur Woods, Assistant to the Secretary of War

List Your Employment Needs With THE U. S. EMPLOYMENT SERVICE

✛ AMERICAN RED CROSS *CO-OPERATING WITH* THE DEPARTMENT OF WAR
THE DEPARTMENT OF LABOR ✛

DESIGNED AND PRINTED BY
Thomsen-Ellis Company :: Baltimore :: New York.

PRINT NO. 157 AMERICA, 1919-1920. "PUT FIGHTING BLOOD IN YOUR BUSINESS." DAN SMITH

small notch in what are now Arab territories being given to the people who for all these hundreds of years have been separated from it.' The Arabs did begrudge it." Meanwhile, the vast Arabian Peninsula was also made a British protectorate. Tribal strongman Ibn Saud went on to create the Kingdom of Saudi Arabia in 1932.

"The British, of course, created their own dilemma by making promises...they could not keep," MacMillan wrote. "On the one hand they supported a Jewish homeland on land largely inhabited by Arabs, and on the other they had encouraged the Arabs to revolt against their Ottoman rulers with the promise of Arab independence." Its frontier decisions thus sparked what has been nearly 100 years of Middle East turmoil.

On May 7, 1919, in the Hall of Mirrors at the magnificent Chateau de Versailles, Clemenceau, wearing yellow gloves, handed the German foreign minister the 413-page Treaty of Versailles and declared, "The time has come when we must settle our accounts." The document stipulated that Germany would restore Belgium's territory and cede Alsace-Lorraine to the French. France would occupy Germany's Saar Valley, with its valuable coalfields, for 15 years. Germany would recognize the independence of Austria and Czechoslovakia

Representatives from 27 nations gathered at the Palace of Versailles, Paris, to hammer out the terms of peace.

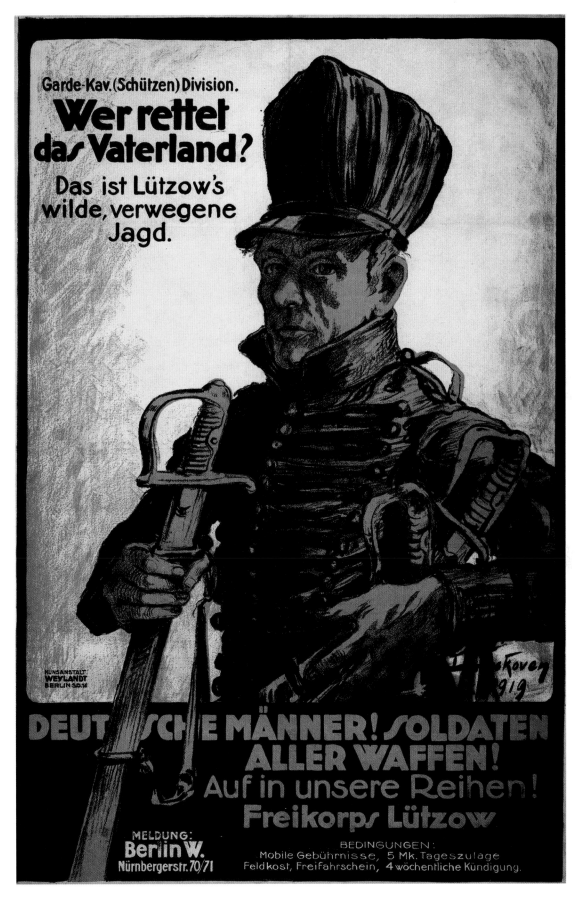

PRINT NO. 158 GERMANY, 1919. "WHO WILL SAVE THE FATHERLAND? (FREIKORPS)." LEO IMPEKOVEN

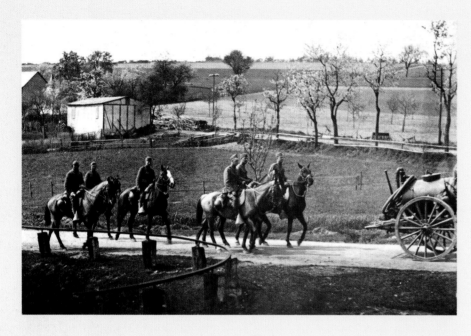

American occupation forces in the Rhineland town of Mayen, 1920. The U.S. left Germany in 1923.

and renounce its overseas possessions. It would mostly dismantle its military—reduce its army to 100,000 soldiers and maintain only a meager navy with a few merchant ships and no submarines. There could be no manufacture of weapons or munitions; no aircraft could be built for six months. In all, Germany would lose 10 percent of its land and 13 percent of its people. Germany would also pay reparations—a commission was still adding up the numbers; eventually, the bill came to $33 billion. The Allies would keep military forces along the Rhine to enforce payment.

BLAME AND PAYBACK

The Germans were outraged. They'd convinced themselves that the Allies would embrace Wilson's ideals and treat them with some leniency. Said Foreign Minister Ulrich von Brockdorff-Rantzau, "They could have expressed the whole thing more simply in one clause—'Germany surrenders all claims to its existence.'" Germany was especially appalled by the treaty's

V. F. W.

America's "Old Guard"

The Veterans of Foreign Wars

ORGANIZED 1899

An association of men who
have fought America's
foreign wars on land and sea

Edward
McCandlish

PRINT NO. 159 AMERICA, 1918. "V.F.W. AMERICA'S 'OLD GUARD.'" EDWARD MCCANDLISH

so-called guilt clauses, blaming it for the war. Its diplomats drafted a counterproposal that was largely ignored. The coalition government in Berlin refused to ratify the document and then fell. A new Weimar government was formed, and it sent two delegates to France who, on June 28, 1919, signed the Treaty of Versailles. Wilson called it "one of the greatest documents in human history." Paris rejoiced, and Germany seethed.

Critics have blamed the treaty for the subsequent economic and political ructions in Germany that led to World War II. Adolf Hitler certainly exploited German resentment and was bent on abrogating the settlement. But MacMillan and other historians have disputed this idea, noting that in the end the treaty's constraints on Germany were never consistently enforced and that Germany only paid some $6 billion of the reparations total.

MacMillan observed, "France was gravely depleted by the war, unwilling and, by the 1930s, increasingly unable to summon up the determination to oppose a [rearming] Germany." She added, "With different leadership in the Western democracies, with stronger democracy in Weimar Germany, without the damage done by the Depression, the story might have turned out differently. The Treaty of Versailles is not to blame."

Ticker tape and confetti rained down on Wall Street to celebrate news of the German surrender.

WAR GARDENS OVER THE TOP

The Seeds of Victory
Insure *the* Fruits of Peace

FOR FREE BOOKS WRITE TO NATIONAL WAR GARDEN COMMISSION
WASHINGTON, D.C.

Charles Lathrop Pack, President Percival S. Ridsdale, Secretary

PRINT NO. 160 AMERICA, 1919. "WAR GARDENS OVER THE TOP." MAGINEL WRIGHT BARNEY

The United States and Britain had signed an addendum to the treaty vowing to protect France's security—but the Republican-controlled U.S. Senate did not ratify the Treaty of Versailles. That was a bitter pill for Wilson, by then incapacitated by strokes. He blamed "puny" politicians "who preferred personal partisan motives to the honor of their country and the peace of the world." He died in 1924. His League of Nations became a reality with 42 initial members—but the United States was not one of them, and the League could not stop Hitler's aggression. Fifteen years later, Europe was again at war.—*R.E.*

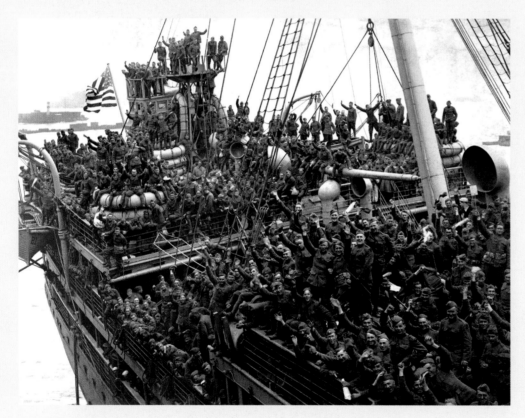

The transport ship *Agamemnon* delivered jubilant American troops to Hoboken, N.J., 1919.

NATIONAL PRINTING & ENGRAVING CO., CHICAGO.

PRINT NO. 161 AMERICA, 1918. "U.S. GOVERNMENT WAR EXPOSITION." MAGINEL WRIGHT BARNEY

AUTHOR'S SELECTED SOURCES

BOOKS

Banks, Arthur. *A Military Atlas of the First World War*. Barnsley, UK: Pen & Sword Books, 2001.

Berg, A. Scott. *Wilson*. New York: G.P. Putnam's Sons, 2013.

Burg, David F., and L. Edward Purcell. *Almanac of World War I*. Lexington, KY: University Press of Kentucky, 1998.

Chambers, John Whiteclay II, ed. *The Oxford Companion to American Military History*, New York: Oxford University Press, 1999.

Clark, George B. *The American Expeditionary Force in World War I: A Statistical History, 1917–1919*. Jefferson, NC: McFarland, 2013.

Ellis, John, and Michael Cox. *The World War I Data Book: The Essential Facts and Figures for all the Combatants*. London: Aurum Press, 2004.

Evans, Martin Marix. *Battles of World War I*. Wiltshire, UK: Crowood Press, 2004.

Fussell, Paul. *The Great War and Modern Memory*. New York: Oxford University Press, 2013.

Gilbert, Adrian. *World War I in Photographs*. New York: Military Press, 1986.

Haythornthwaite, Philip. *Gallipoli 1915: Frontal Assault on Turkey*. Westport, CT: Praeger, 2004.

Holmes, Richard, ed. *The Oxford Companion to Military History*. New York: Oxford University Press, 2001.

Howard, Michael. *The First World War*. Oxford, UK: Oxford University Press, 2002.

Hughes, Matthew, and William J. Philpott. *The Palgrave Concise Historical Atlas of the First World War*. New York: Palgrave Macmillan, 2005.

Jankowski, Paul. *Verdun: The Longest Battle of the Great War*. New York: Oxford University Press, 2014.

Jones, Simon. *World War I Gas Warfare Tactics and Equipment*. Oxford, UK: Osprey, 2007.

Keegan, John. *An Illustrated History of the First World War*. New York: Alfred A. Knopf, 2001.

———. *The Face of Battle*. New York: Penguin Books, 1978.

———. *The First World War*. New York: Alfred A. Knopf, 1999.

Kirchberger, Joe H. *The First World War: An Eyewitness History*. New York: Facts on File, 1992.

Lengel, Edward G. *Thunder and Flames: Americans in the Crucible of Combat, 1917–1918*. Lawrence, KS: University Press of Kansas, 2015.

———. *To Conquer Hell: The Meuse-Argonne, 1918*. New York: Henry Holt and Company, 2008.

———. *World War I Memories*. Lanham, MD: Scarecrow Press, 2004.

Lettow-Vorbeck, Paul von. *My Reminiscences of East Africa*. London: Forgotten Books Classic Reprint, n.d.

Macdonald, Lyn. *1914–1918: Voices & Images of the Great War*. London: Penguin Books, 1988.

MacMillan, Margaret. *Paris 1919*. New York: Random House, 2001.

Mayhew, Emily. *Wounded: A New History of the Western Front in World War I*. New York: Oxford University Press, 2014.

Monger, David. *Patriotism and Propaganda in First World War Britain*. Liverpool, UK: Liverpool University Press, 2014.

Murray, Williamson. *Military Adaptation in War*. New York: Cambridge University Press, 2011.

Myer, G.J. *A World Undone: The Story of the Great War*. New York: Delacorte Press, 2006.

Neiberg, Michael S., ed. *The World War I Reader*. New York: New York University Press, 2007.

Prior, Robin, and Trevor Wilson. *The First World War*. London: Cassell & Co., 2001.

Reynolds, David. *The Long Shadow: The Legacies of the Great War in the Twentieth Century*. New York: W.W. Norton, 2014.

Rommel, Erwin. *Infantry Attacks*. Minneapolis: Zenith Press, 2009.

Sheffield, Gary, ed. *War on the Western Front: In the Trenches of World War I*. Oxford, UK: Osprey, 2007.

Strachan, Hew, ed. *The Oxford Illustrated History of the First World War*. New York: Oxford University Press, 2014.

Honor The American Legion's founders during the World War One Centennial by restoring your LOCAL World War One memorial

LET'S DO OUR PART

Matching Grants available

LEARN MORE about how your post can raise funds and apply for grants by visiting www.ww1cc.org/100memorials

100 CITIES MEMORIALS

THE AMERICAN LEGION
legion.org/centennial

PRITZKER MILITARY MUSEUM & LIBRARY
pritzkermilitary.org/WWI

THE UNITED STATES WORLD WAR ONE CENTENNIAL COMMISSION
ww1cc.org

PRINT NO.162 AMERICA, 2016. "LET'S DO OUR PART: HONOR THE AMERICAN LEGION'S FOUNDERS."
PRITZKER MILITARY MUSEUM & LIBRARY

Strohn, Matthias, ed. *World War I Companion*. Oxford, UK: Osprey, 2013.

Tuchman, Barbara W. *The Guns of August*. New York: Random House, 2014.

Tunstall, Graydon A. *Blood on the Snow: The Carpathian Winter War of 1915*. Lawrence, KS: University Press of Kansas, 2010.

Warner, Philip. *World War One: A Chronological Narrative*. London: Arms and Armour Press, 1995.

Weale, Putnam. *An Indiscreet Chronicle from the Pacific*. New York: Dodd, Mead, 1922.

Wilks, John, and Eileen Wilks. *Rommel and Caporetto*. South Yorkshire, UK: Pen & Sword Books, 2001.

Zabecki, David T. *Steel Wind: Colonel Georg Bruchmüller and the Birth of Modern Artillery*. Westport, CT: Praeger, 1994.

PERIODICALS

Bruce, Robert B. "Victor of Verdun." *Military History* (July/August 2008): 52-61.

Corum, James S. "Riga 1917: How to Prepare for a Battle." *MHQ: The Quarterly Journal of Military History* 27, no. 1 (Autumn 2014): 52-63.

Mockenhaupt, Brian. "The Most Treacherous Battle of World War I Took Place in the Italian Mountains." *Smithsonian Magazine* (June 2016): 44-57.

Murray, Williamson. "Tactical Genius, Strategic Fool: Erich Ludendorff's Obsessive Militarism Left Germany in Ruins." *Military History* (September/October 2008): 42-49.

Neiberg, Michael S. "Pale Horse: The Influenza Pandemic and the Apocalyptic Climax of the Great War." *MHQ: The Quarterly Journal of Military History* 28, no. 1 (Autumn 2015): 44-51.

Thompson, Mark. "Isonzo 1915: Do You Want Everyone to Die?" *Military History* (August/September 2009): 46-53.

Warren, Christopher A. "An International Red Line: Why Chemical Weapons are Taboo." *MHQ: The Quarterly Journal of Military History* 26, no. 2 (Winter 2014): 40-43.

Zabecki, David T. "Georg Bruchmüller: The Father of Modern Artillery Tactics." *MHQ: The Quarterly Journal of Military History* 28, no. 3 (Spring 2016): 62-69.

———. "Hope is Not a Strategy: The Promise and Failure of Germany's Last Best Shot at Victory in 1918." *MHQ: The Quarterly Journal of Military History* 27, no. 2 (Winter 2015): 72-79.

WEBSITES

Boehler, Patrick, et al. "The Forgotten Army of the First World War: How Chinese Labourers Helped Shape Europe." South China Morning Post—China's WWI. http://multimedia.scmp.com/ww1-china/.

Keller, R.H. "The German Soldier in World War I: Organization and Service in the German Army." Great War Militaria. www.greatwar.com/scripts/openExtra.asp?extra=10.

Brosnan, Matt. "The Pals Battalions of the First World War." Imperial War Museums. www.iwm.org.uk/history/the-pals-battalions-of-the-first-world-war.

Watson, Alexander. "Recruitment: Conscripts and Volunteers During World War One." British Libray. www.bl.uk/world-war-one/articles/recruitment-conscripts-and-volunteers.

Ath, Altay. "Turkey in the First World War: Gallipoli." TurkeysWar.com, last updated January 6, 2015. www.turkeyswar.com/campaigns/gallipoli.html.

AFTERWORD

This profusely illustrated volume reminds us of a generation of Americans who are sadly often forgotten, overshadowed by the struggles of their children in a later war.

Anniversary periods in history are important as they allow us to reflect on the service, achievements, and sacrifices of America's citizen-soldiers. As the Founding Sponsor of the World War One Centennial Commission, the Pritzker Military Museum & Library has devoted significant energy to remembering the role of Americans who willingly served their nation in times of peace and war.

As the Chair of the United States World War One Centennial Commission, I know the many reasons why books like this one are important. Created by an act of the United States Congress, the World War One Centennial Commission is charged with ensuring that the United States of America remembers its harrowing journey through the War to End All Wars, and that we as citizens remember those who fought for the ideals of liberty and lasting world peace.

When Congress created the commission, it stipulated that funding for commemorating WWI should come from the private sector, and that is where the Museum & Library committed to a nation-leading grant to start the commission's work. This book will stand as a lasting testament to the partnership between the World War One Centennial Commission and the Pritzker Military Museum & Library as it meets the very spirit of the charter that Congress gave the commission to remember those Americans who served during WWI and to celebrate our nation's victory in that war.

The Museum & Library's commitment is fully in concert with the words of the Commanding General of the American Expeditionary Force, General John J. Pershing, who desired that the service of American soldiers, sailors, airmen, marines, and coast guardsmen never be forgotten. He stated, "Time must not dim the glory of their deeds."

Understanding the necessity to acknowledge America's contribution during World War I through commemorative cemeteries and memorials overseas, Congress created the American Battle Monuments Commission. The commission was responsible for honoring American armed forces where they had served and for overseeing military cemeteries, monuments, and markers on foreign soil. General of the Armies John J. Pershing was appointed to the commission in 1923, and was elected chairman. He served in that capacity until his death in 1948.

The government also recognized a need for a burial and repatriation policy for America's war dead. Over the course of the conflict, more than 116,000 Americans lost their lives in Europe. Legislation was enacted that entitled families to select permanent interment of a loved one's remains in an American military cemetery on foreign soil, or repatriation of the remains to the U.S. for interment in a national or private cemetery. The majority of families chose repatriation; approximately 30 percent chose permanent interment in an American Battle Monuments Commission cemetery.

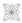

THE AMERICAN BATTLE MONUMENTS COMMISSION began an aggressive commemorative program that resulted in eight permanent American cemeteries in Europe and 13 separate memorials and markers. Each cemetery would include nonsectarian chapels, sculptures, and battle maps depicting the course of the war in the region, and visitor reception facilities.

The gravesites were marked by a Latin cross headstone of pristine white marble; headstones for those of the Jewish faith were marked by Stars of David. "Here Rests in Honored Glory an American Soldier Known but to God" was inscribed on the headstones of servicemen who could not be identified. Individuals recorded as missing in action or lost or buried at sea were memorialized by including their names on Walls of the Missing.

As cemeteries and memorials took shape, the American Battle Monuments Commission endeavored to document America's efforts in World War I by compiling divisional operational summaries and publishing *American Armies and Battlefields in Europe*, a guidebook that pro-

vides detailed descriptions of and directions to the European battlefields where Americans fought. Serving as part of this documentation process was a young U.S. Army major, Dwight D. Eisenhower.

In January 2017, the American Battle Monuments Commission acquired its ninth World War I cemetery, the Lafayette Escadrille Memorial Cemetery near Paris.

As we mark the WWI centennial, it is especially fitting that the Pritzker Military Museum & Library, in collaboration with the United States World War One Centennial Commission, provides us with this evocative publication, which causes us to pause and remember a generation of Americans that served to bridge the 19th and 20th centuries.

World War I transformed America dramatically. The service in our armed forces of African-Americans and immigrants—and women, working in the military, in industry at home, and providing humanitarian service abroad—furnished the kindling that sparked a wildfire in American society. Every aspect of our society was touched by World War I: how we viewed gender, how we viewed race, how we viewed the loyalty of new immigrants to America. Though it would be a long road, many prejudices and beliefs were shaken to the core—and the world was changed forever.

Colonel Robert J. Dalessandro, U.S. Army (Retired)
Chair, United States World War One Centennial Commission,
October 2013–September 2017
Acting Secretary, American Battle Monuments Commission

WORLD WAR

ROSTER

Company "C," 109th U. S. Infantry

(Formerly First and Thirteenth Pennsylvania Infantry)

Captain JOHN M. GENTNER, *Commanding Company*

First Lieut. RUTHERFORD M. WARREN

Second Lieut. HOWARD G. TAYLOR Second Lieut. MAURICE J. McGUIRE Second Lieut. LORENZO C. CARLTON

Mess Sergt. JAMES F. HARAN First Sergt. WILLIAM A. BROCKMEYER Supply Sergt. LAWRENCE S. BOETTNER

SERGEANTS
CLIFFORD H. VAN DUYNE
JOHN M. LOMISON
JOSEPH S. WHITTINGTON
EDWARD J. MURPHY
JOSEPH F. FLEMMING
JOSEPH J. GIBBS
FRANK PERKINS
FRANK KENNEDY
JOHN E. McMANUS
ELMER E. PATTERSON, Jr.
JAMES WELCH

CORPORALS
IAN PIRIE
CHARLES MONTGOMERY
CLAYTON T. SMITH
FRANK R. MOORE
COLEMAN J. AHERN
ARTHUR H. LUCY
REAVES C. LUKENS
TERRENCE J. McGUIRE
GERALD G. WHITE
EARL A. SAUNDERS
CHARLES A. MATHEWS
WILLIAM G. DAVISON
CARL H. JEARY
HAROLD G. BOSTON
CLEON F. BOOK
THOMAS A. CASSIDY
JAMES R. STOKES, Jr.
BENJAMIN HENDERSON
GEORGE McLAUGHLIN
CHARLES A. McLEAN
FRANK G. BENJAMIN

COOKS
JAMES F. DALY
JAMES A. FERRARO
ELMER A. TINKLEPAUGH
LEE WALLACE

MECHANICS
MICHAEL J. GAETANO
HARRY GOODMAN

MECHANICS
LOUIS PICCOTTI
OSCAR H. ROST, Jr.

BUGLERS
ALBERT A. CARRIGAN
STANLEY KAMOSKI
LEONARD J. MARTIN

PRIVATES 1st CLASS
AICKIN, THOMAS G.
BARRY, JAMES J.
BEA, REUBEN
BREZEE, JOSEPH
CHESTERMAN, JOSEPH
CLARKE, EDGAR J.
CORRELL, HARLAN
DEERE, JAMES F.
FULLERTON, JOSEPH P., Jr.
GALEDO, THOMAS
GLASGOW, THOMAS J.
HARRINGTON, ALEXANDER
KATKOWSKI, JOSEPH F.
KING, WILLIAM
LANDT, DANIEL B.
LYNCH, JAMES F., Jr.
MACK, JOSEPH H.
MALATIN, STEPHEN
MELLON, JAMES M.
MURPHY, JOHN J.
NIEDZWIECKI, ANTONI
NOTO, THOMAS J.
OSMOND, RAYMOND T.
ROSHON, RUSSELL
WILSON, ALAN B.
ZELLER, ANTHONY W.

PRIVATES
ALLEN, WILLIAM P.
BALE, FRANK G., Jr.
BECKER, OTTO
BEERS, CHARLES A.
BENTLER, FRANK
BOLLOG, MIKE
BOYD, ROBERT V.
BROOKE, JOSEPH J.

PRIVATES
BROWN, RALPH J.
BUCK, STEPHEN A.
BUDA, JOSEPH
BYRON, FRANK
CAPEL, ROY
CARTER, JOHN
CARTER, WILLIAM
CHECKOUCHA, JOSEPH
CIANCI, JOSEPH
CLARK, HOMER
COCHRAN, DAVID H.
COFFMAN, ROBERT
COLL, JAMES A.
COLLINS, FRANK R.
CONRAD, ELGIE
CORALUZZI, HARRY F.
COTTON, HARRY J.
DANKO, GEORGE
DAUGHERTY, GEORGE K.
DAUGHERTY, LELAND C.
DECKER, FRANK
DERIENZO, JOHN
DeVIVO, FEDERICO
DOTTOLI, ROCCO
DOWNS, JOHN C.
DOYLE, WILLIAM
DRAKE, JOHN S.
DUCOSKY, STANLEY
DUNNIGAN, JOSEPH
DURUM, BIRGER
EGAN, JOHN
ELVEY, JAMES W.
ERVIEN, EARL H.
FARONI, TONY
FERNAN, JOHN F.
FISCHER, BENJAMIN H.
FISHER, WILLIAM
FLESHMAN, ALBERT M.
FLYNN, FRANCIS
FORD, JOHN F.
FORMAN, ISA
FOY, GEORGE A.
FRANKLIN, FRANCIS B.
GALLAGHER, FRANK J.

PRIVATES
GARMAN, ELDRIDGE
GIBSON, VICTOR R.
GLASSMAN, JACOB
GOLDEN, ANDREW
GOLDEN, EARL T.
GORHAM, JOHN A.
GREEN, JAMES P.
HALEY, HARRY
HALL, FRANK G.
HARRIE, DAVID
HAWK, EDDIE
HAWRAN, DANIEL
HEALEY, WALTER
HEALIS, CHARLES A.
HETHERINGTON, HORACE D.
HILL, JOHN B.
HOCKE, CHARLES H.
HORRACKS, JOSEPH
HULEATTE, WILLIAM A.
IGO, JAMES
IGO, THOMAS
JASINSKI, BENJAMIN
JENKS, EDMUND, Jr.
JENKS, HARRY A.
JOHNSON, FRANK
JORDAN, JOHN
JORDAN, JOHN F.
KALKOWSKI, JOHN
KAVOLOSKY, CHARLES
KEARNEY, EDWARD
KERR, CHESTER A.
KITZURI, JOSEPH
KOCH, GEORGE D.
KONIZNI, FRED K.
KRUGER, SAMUEL
LAKE, JOHN
LANGAN, DANIEL
LANGDON, FRANK L.
LEWIS, JAY
LUVENDER, ERNEST
LUVENDER, IRVING
McCLOSKEY, JOHN T.
McCLOUD, DANIEL
McCOOL, JAMES

PRIVATES
McDONAUGH, PATRICK F.
McGINLEY, GEORGE P.
McGOVERN, THOMAS J.
McGUIGAN, JAMES J.
McLAUGHLIN, THOMAS J.
McLAUGHLIN, WILLIAM
McMENAMIN, WILLIAM
McMINN, ROBERT
McNALLY, FRANCIS
McNAMEE, RAYMOND
McQUAID, WILLIAM
MAAG, CONRAD J.
MACK, STEVEN
MALLON, JOHN J.
MASTERS, JAMES O.
METTA, MARCO
MEYERS, WILLIAM M.
MILLER, ANSON C.
MITCHELL, JOHN W.
MOLODOSKY, THOMAS
MOORE, LOUIS B.
MORRIS, WYNDHAM
MUNN, HARRY R.
NELSON, FRANK
NEWMAN, JOHN F.
NOIL, WILLIAM L.
NOVOCK, JOHN
O'CONNELL, BERNARD P.
PALESKI, ANTHONI
PANASKI, MIKE
PARADISE, LOUIS A.
PATRICK, MICHAEL
PHILLIPS, HAROLD
PIZZUTI, JAMES
PRICE, LOUIS
RANSON, WILLIAM F.
REESE, GEORGE
RENNINGER, PHILIP
RICHARDS, BEN
RIPPA, ANGELO
RITTENHOUSE, JAMES C.
ROBERTS, ALBERT T.
ROEHM, MILES R.
RZEPSKI, WALTER A.

PRIVATES
SABIN, WELLES C.
SADORSKY, WALLACE
SCHENCK, RAYMOND J.
SICKINGER, FRANK
SILNUTZER, MEYER
SIMONSON, JEROME
SIVO, ANTONIO J.
SKALIC, DOMONICK
SMITH, JAMES
SNEFF, WILLIAM A.
SOHNS, PHILIP
SPARKS, EDWARD J.
STEINMAN, FRED S.
STELIGO, JOHN W.
STEMPKOWSKI, WILLIAM
STONE, CHARLES
STONE, GEORGE H.
STROUD, EDWARD P.
STROUGH, FRED R.
SULLIVAN, EDWARD
SWARTZ, LEON S.
TAGMIRE, FRANK J.
THOMAS, JOHN
THOMAS, JOSEPH A.
THOMAS, WILLIARD J.
THOMPSON, GLENN D.
THORPE, RAY E.
TREND, JAMES, Jr.
USCHMANN, CHARLES F.
VALENTINE, JOSEPH
VALENTINE, MICHAEL
VAN KIRK, CLIFFORD C.
VAN VLECK, GEORGE
VAN VLECK, HAROLD E.
VOGELSINGER, GEORGE J.
WAGNER, DAVID
WALLACE, FRANK McA.
WALSH, MICHAEL J.
WATERS, THOMAS A.
WHITEHEAD, JAMES T.
WOOD, JOSEPH
WORSTER, JOHN W.
ZALESKI, WALTER
ZELLER, JOSEPH A.

PRINT NO.163 AMERICA, CA. 1919. "ROSTER OF COMPANY C, 109TH U.S. INFANTRY." DAN SMITH

PRINT NOTES

THE 166 WWI PRINTS in this book are from scans of the original posters in the collections of the Pritzker Military Museum & Library. More information about each print in this book can be obtained at www.pritzkermilitary.org by using the PMML catalog number in the search function. ⌕ Additionally, there are more than 900 WWI posters in the Museum & Library's collections, along with tens of thousands of other artifacts, books, and items related to military history and affairs that can be viewed online.

Print No. 1 America, 1917-1918. *Are You Idle To-Day?* U.S. Department of Labor
PMML Catalog #329640
Print Topic Category: Production
Copyright: Public Domain

Print No. 2 America, ca. 1918. *Over the Top: Doughboys, Tanks, and Airplanes.*
PMML Catalog #329566
Print Topic Category: Documentary
Copyright: Public Domain

Print No. 3 France, 1917. *Army of Africa and Colonial Troops Day.* Lucien Jonas
PMML Catalog #321979
Print Topic Category: Recruiting
Copyright: Public Domain

Print No. 4 ca. 1895.
European Royalty ca. 1895.
PMML Catalog #329014
Print Topic Category: Documentary
Copyright: Public Domain

Print No. 5 France, 1918. *The Exhibition of the Allies.* Robert de Coninck
PMML Catalog #321846
Print Topic Category: Documentary
Translation: "Exhibit organized for the benefit of exhibitors." Poster within the poster reads "Communicated: Visit all the exhibition of the Allies. Organized for the benefit of exhibitors and the fraternity of artists."
Copyright: Public Domain

Print No. 6 Germany, 1914.
The Secret of Lüttich: Our Bombing Success. Knackstedt & Co.
PMML Catalog #321553
Print Topic Category: Production
Translation: "The secret of Lüttich. Our bombing success. Original size. 42cm Projectile."
Copyright: Public Domain

Print No. 7 Russia, 1915-1916.
War Loan 5½%.
PMML Catalog #320634
Print Topic Category: War Loans
Copyright: Public Domain

Print No. 8 Italy, 1914-1918. *We Are Taking Your Father to Make More Munitions.* Louis Raemaekers
PMML Catalog #320660
Print Topic Category: Documentary
Translation: "Exhibit of Raemaekers' 100 drawings of a neutral [country]. The deportations in Belgium: We're taking your father to make more munitions."
Copyright: ©2017 Used by permission of the Stitching Louis Raemaekers Foundation

Print No. 9 Russia, 1915-1916.
War Bonds for Victory. T. Kibbel
PMML Catalog #321813
Print Topic Category: War Loans
Translation: "Buy 5½% bonds: War bonds for victory."
Copyright: Public Domain

Print No. 10 America, 1918.
Remember Belgium. Ellsworth Young
PMML Catalog #321746

Print Topic Category: War Loans
Copyright: Public Domain

Print No. 11 America, 1918. *The Kaiser: The Beast of Berlin.* Morgan Litho.
PMML Catalog #320964
Print Topic Category: Film
Copyright: Public Domain

Print No. 12 Austria, 1917. *Subscribe to the 7th War Loan.* Alfred Offner
PMML Catalog #321444
Print Topic Category: War Loans
Copyright: Public Domain

Print No. 13 England, 1915. *Forward!* Lucy Kemp-Welch
PMML Catalog #320968
Print Topic Category: Recruiting
Copyright: Public Domain

Print No. 14 America, 1918. *J. Joffre, Marshal of France.* New York American
PMML Catalog #329204
Print Topic Category: Literary
Translation: Letter reads "I thank you on behalf of France, and its army which I represent here. I beg you to convey to your colleagues the expression of my gratitude for the sympathy with which they have shown me during my stay, and be assured of my respectful consideration."
Copyright: Public Domain

Print No. 15 America, 1917. *American Field Service.* Josef Pierre Nuyttens
PMML Catalog #320960
Print Topic Category: Recruiting
Copyright: Public Domain

Print No. 16 Russia, 1915-1916.
Everything for the War, Everything for Victory. M. Olkone
PMML Catalog #320970
Print Topic Category: War Loans

Translation: "Buy the 5½% war loan: everything for the war, everything for victory."
Copyright: Public Domain

Print No. 17 France, 1914.
The Imperial Thief. Eugene Courboin
PMML Catalog #329106
Print Topic Category: Documentary
Translation: "'The Imperial Thief': Episodes of the war, 1914. Popular Prints G.W.D.—No. 3. The Crown Prince takes advantage of his stay at the Castle of Baye to loot it. He chooses the most precious objects, has them packed in his presence, and ships them to Germany."
Copyright: Public Domain

Print No. 18 England, 1915.
Daddy, What Did You Do in the Great War?
Savile Lumley
PMML Catalog #320260
Print Topic Category: Recruiting
Copyright: Public Domain

Print No. 19 England, 1915. *Men of London! Remember!* Andrew Reid & Co.
PMML Catalog #321992
Print Topic Category: Recruiting
Copyright: Public Domain

Print No. 20 England, 1915. *Every Fit Briton Should Join Our Brave Men at the Front.*
ES&A Robinson Ltd.
PMML Catalog #321743
Print Topic Category: Recruiting
Copyright: Public Domain

Print No. 21 France, 1915. *The Destruction of Reims Cathedral, 1914.* Gustave Fraipont
PMML Catalog #329403
Print Topic Category: Documentary
Copyright: Public Domain

Print No. 22 Russia, 1917.
Year 1914 (Our Resurrection).
PMML Catalog #320969
Print Topic Category: Literary
Translation: "1917 annual subscriptions are now available

(second year of publication).
You can now subscribe to *Year 1914 (Our Resurrection)*, a print magazine of literature, art, politics, and economics. "Published by the 'Year 1914 Society'—the revival of Russia and struggle against the German influence/the dominance of Germanness.
"The great struggle of Mankind against Germanness is a turning point in European history. This struggle has (already) raised innumerable burning issues; it is opening up wide prospects for a better and brighter future; it has set the grandiose goals for the upcoming creative work. Our magazine *Year 1914 (Our Resurrection)* aims to facilitate the decisive struggle against Germanness through merging the scientific and artistic forces in order to revive our Glorious and Long-suffering Motherland.
"Subscription fees: 1st edition yearly subscription 5 rubles; Half-year subscription 3 rubles; 2nd edition (printed on heavy paper) 10 rubles. Editorial Board and Main Office: 32, Sadovaya Str., Petrograd."
Copyright: Public Domain

Print No. 23 America, 1915.
If You Want to Fight! Join the Marines.
Howard Chandler Christy
PMML Catalog #321751
Print Topic Category: Recruiting
Copyright: Public Domain

Print No. 24 Ireland, 1915. *Irishmen Avenge the Lusitania.* John Shuley & Co.
PMML Catalog #321842
Print Topic Category: Recruiting
Copyright: Public Domain

Print No. 25 Germany, 1918. *9th Arrow: Subscribe to War Loans.* Fritz Erler
PMML Catalog #320552
Print Topic Category: War Loans
Copyright: Public Domain

Print No. 26 America, 1918.
Hearts of the World. Grant E. Hamilton

PMML Catalog #329612
Print Topic Category: Political
Copyright: Public Domain

Print No. 27 Germany, 1917.
That is How Your Money Helps You Fight!
Lucian Bernhard
PMML Catalog #320318
Print Topic Category: War Loans
Translation: "That is how your money helps you fight! Transformed into submarines, it keeps enemy grenades from your body. Therefore, subscribe to war loans."
Copyright: © 2017 Artists Rights Society (ARS), New York/VG Bild-Kunst, Bonn

Print No. 28 America, 1917-1918. *Help Women Physicians Fight Disease and Death in Serbia.* American Women's Hospitals
PMML Catalog #321963
Print Topic Category: Relief Funds
Copyright: Public Domain

Print No. 29 America, 1917-1918.
It's Our War Chest Against His. William Addison Ireland
PMML Catalog #320865
Print Topic Category: War Loans
Copyright: Public Domain

Print No. 30 Germany, 1918. *War Chronicle 1914-1918, of Emil Wilhelm Jock.* Elk Eber
PMML Catalog #329227
Print Topic Category: Documentary
Translation: "War Volunteer/Enlistee/in 2nd Rheinische Infantry Regiment von Goeben No. 28.
"Iron Cross 2nd Class—Wounded Badge in Silver—Front Fighter Honor Cross.
"He was born on 7 January, 1898 in Bretten. Entered active-duty as a volunteer enlistee after the outbreak of The World War on 5.11.14. Assigned to 1st Battalion, 171st Infantry Regiment. After his military training transferred to the field in January, 1915. Assigned to the Mobile 2nd Rheinische Infantry Regiment von Goeben, No. 28, 16th Infantry Division. Served honorably

in military operations. In the West: Against France; Winter Battle Campaign 1915 in Champagne; various battles in Champagne; Battle at Ballee-Arras, where near Souchez on 18.6.1915 he was gravely wounded from a direct hit from a hand grenade, suffering serious wounds to his head, chest, thighs and calves, his right foot, brain and eyes. Evacuated to hospital gravely wounded. Due to stiffening of his right arm, he was discharged from military service on 1 January, 1917 as a pensioned War Service–Disabled Veteran and returned to his home of record."
Copyright: Public Domain

Print No. 31 Germany, 1917. *Charity Evening: Driver Replacement Department.* Julius Ussy Engelhard
PMML Catalog #320631
Print Topic Category: Recruiting
Translation: "Charity Evening: Driver replacement department. November 24, 1917 at Löwenbrau Cellar."
Copyright: Public Domain

Print No. 32 America, 1917-1918. *The Prussian Blot.* State Council of Defense
PMML Catalog #320364
Print Topic Category: Political
Copyright: Public Domain

Print No. 33 France, 1915. *Heroes of the Marne: 117th Infantry Regiment, Republic of France.* Georges Scott
PMML Catalog #321983
Print Topic Category: Documentary
Copyright: Public Domain

Print No. 34 England, 1917. *The War of Munitions.* G.K.
PMML Catalog #320734
Print Topic Category: Production
Copyright: Public Domain

Print No. 35 Italy, 1914-1918. *Il Re Soldato (The Soldier King), Victor Emmanuel III, King of Italy, with His Troops.*
PMML Catalog #329182

Print Topic Category: Documentary
Copyright: Public Domain

Print No. 36 Russia, 1916. *Everything for the War!* Sokolova
PMML Catalog #320377
Print Topic Category: War Loans
Translation: "Everything for the war! Subscribe to the 5½% war loan."
Copyright: Public Domain

Print No. 37 America, 1918. *Side by Side—Britannia!* James Montgomery Flagg
PMML Catalog #320681
Print Topic Category: Political
Copyright: Public Domain

Print No. 38 France, 1919. *To the Memory of Albert Edward Hamilton, U.S. Navy.* Franklin Booth
PMML Catalog #329190
Print Topic Category: Memorial
Translation: "Those who piously died for the country are entitled to their crowd come to their coffin and pray. To the memory of Albert Edward Hamilton, U.S. Navy of the United States of America, who died for liberty during the Great War. A tribute from France in the name of the President of the republic."
Copyright: Public Domain

Print No. 39 America, 1917. *Only the Navy Can Stop This.* William Allen Rogers
PMML Catalog #321929
Print Topic Category: Recruiting
Copyright: Public Domain

Print No. 40 America, 1916. *Save Serbia Our Ally.* Theophile Alexandre Steinlen
PMML Catalog #321725
Print Topic Category: Relief Funds
Copyright: Public Domain

Print No. 41 America, 1917-1918. *Foch Says—"The Americans Are Fighters" Are You?* A.H. Gilbert
PMML Catalog #320863
Print Topic Category: Recruiting
Copyright: Public Domain

Print No. 42 France, 1916. *Save the Wine for Our Infantry Soldiers.* Suzanne Ferrand
PMML Catalog #321544
Print Topic Category: Conservation
Copyright: Public Domain

Print No. 43 France, 1917. *French Veterans of the Great War.* Geo Dorival & Georges Capon
PMML Catalog #321741
Print Topic Category: Documentary
Copyright: © 2017 Artists Rights Society (ARS), New York/ADAGP, Paris

Print No. 44 France, 1915. *To the Young Refugees—Here Used To Be Our Home.* Tancrede Synave
PMML Catalog #321753
Print Topic Category: Documentary
Copyright: Public Domain

Print No. 45 Germany, 1917. *England Fights Only Against German Industriousness!* Otto Eisner
PMML Catalog #329196
Print Topic Category: Production
Translation: "England fights only against the German Industriousness! At a dinner at the Constitutional Club in London on 20 November 1917 the English Minister Carson said: 'It is frequently recommended to bomb the housing of the Barbarians. In my view it is a far more valuable offensive, to bomb the businesses of the Huns, so that after the War they do not exist, that even their foundations are no longer to be found.' Times—from 21 November 1917."
Copyright: Public Domain

Print No. 46 France, 1917. *Hey You! Do Your Duty. If I Didn't Do Mine What Would You Call Me?* Jacques Carlu
PMML Catalog #321298
Print Topic Category: Production
Copyright: Public Domain

Print No. 47 America, 1918. *Treat 'em Rough!* August William Hutaf
PMML Catalog #320257

Print Topic Category: Recruiting
Copyright: Public Domain

Print No. 48 Russia, 1917. *Liberty Loan: War to Victory.* Petr Dmitrievich Buchkin
PMML Catalog #320203
Print Topic Category: War Loans
Copyright: Public Domain

Print No. 49 Russia, 1914-1915. *War Loan for the Country!* Aleksandr O. Maksimov
PMML Catalog #320484
Print Topic Category: War Loans
Copyright: Public Domain

Print No. 50 Russia, 1914-1915. *War Loan: Everything for Victory.*
PMML Catalog #329793
Print Topic Category: War Loans
Translation: "War Loan: Participation in the loan is everyone's patriotic duty. All for victory."
Copyright: Public Domain

Print No. 51 Russia, 1915. *Adjutant General Nikolai Ruzsky, the Hero of Lodz.*
Ivan D. Sytin
PMML Catalog #320199
Print Topic Category: Documentary
Copyright: Public Domain

Print No. 52 Germany, 1916. *Kaiser's Birthday Donation for Germany, Soldiers' Houses at the Front.* Max Antlers
PMML Catalog #320735
Print Topic Category: Political
Copyright: Public Domain

Print No. 53 America, 1918. *Lest We Forget Lithuania.* M. Dobuzinsky
PMML Catalog #321980
Print Topic Category: Relief Funds
Copyright: Public Domain

Print No. 54 England, 1915. *The Polish Victims Relief Fund.* Emile Antoine Verpilleux
PMML Catalog #320469
Print Topic Category: Relief Funds
Copyright: Public Domain

Print No. 55 England, 1915. *Are YOU in This?* Lt. General R.S.S. Baden-Powell
PMML Catalog #320553
Print Topic Category: Recruiting
Copyright: Public Domain

Print No. 56 Canada, 1917. *4 Reasons for Buying Victory Bonds.*
PMML Catalog #320502
Print Topic Category: War Loans
Copyright: Public Domain

Print No. 57 England, 1915. *Public Warning: German Airships, British Airships.*
Joseph Causton & Sons
PMML Catalog #329336
Print Topic Category: Public Notice
Copyright: Public Domain

Print No. 58 England, 1915. *Come Along, Boys!* W.H. Caffyn
PMML Catalog #320529
Print Topic Category: Recruiting
Copyright: Public Domain

Print No. 59 Germany, 1917. *The Best Savings Bank: War Loans.*
Louis Oppenheim
PMML Catalog #320603
Print Topic Category: War Loans
Copyright: Public Domain

Print No. 60 Italy, 1918. *For the Country My Eyes! For Peace Your Money.*
Alfredo Ortelli
PMML Catalog #320630
Print Topic Category: War Loans
Translation: "For the country my eyes! For peace your money." National Loan annual 5% income. Subscriptions are received. Press branches of banks that normally issue credit—savings banks, credit unions and cooperatives, banking companies, participants of the loan consortium."
Copyright: Public Domain

Print No. 61 America, 1918. *Where the Victims Are.* American Committee for Relief in the Near East

PMML Catalog #320488
Print Topic Category: Relief Funds
Copyright: Public Domain

Print No. 62 America, 1917-1918. *Defeat the Kaiser and His U-Boats.*
U.S. Food Administration
PMML Catalog #329015
Print Topic Category: Conservation
Copyright: Public Domain

Print No. 63 Japan, 1904-1905. *Japanese Battalion Charging Around Teish, Korea, Russo-Japanese War.* Tokyo Kandaku Minami Norimono Cho 15 banchi seiun-do, Kasai Torajiro
PMML Catalog #321415
Print Topic Category: Documentary
Translation: "This illustration of Japanese battalion charging around Teishu, Japan Russia Battle Illustrated Magazine Number 14, Meiji era 27th year April 7 Date of printing and issued in the same year on April 10. Drawn and printed by: Tokyo Kandaku Minami Norimono Cho 15 banchi seiun-do, Kasai Torajiro."
Copyright: Public Domain

Print No. 64 France, 1918. *One Last Effort and We Will Get Them.*
Eugene Courboin
PMML Catalog #329614
Print Topic Category: Recruiting
Copyright: Public Domain

Print No. 65 Greece, 1914-1918. *Get Back Bear.*
PMML Catalog #320737
Print Topic Category: Recruiting
Copyright: Public Domain

Print No. 66 Canada, 1918. *Canada's Pork Opportunity.* E. Henderson
PMML Catalog #321783
Print Topic Category: Production
Copyright: Public Domain

Print No. 67 Canada, 1918. *They Shall Overcome.*
PMML Catalog #329455

369

Print Topic Category: War Loans
Translation: "They shall overcome if you subscribe to the victory loan, 1918."
Copyright: Public Domain

Print No. 68 South Africa, 1918.
Africanders, Your Pals in Flanders Are in Danger. Government Printing and Stationery Office, Pretoria
PMML Catalog #321864
Print Topic Category: Recruiting
Copyright: Public Domain

Print No. 69 America, 1918.
America's Answer.
Paramount Advertising Corporation
PMML Catalog #321937
Print Topic Category: Political
Copyright: Public Domain

Print No. 70 America, 1917-1918.
For Every Fighter a Woman Worker.
Adolph Treidler
PMML Catalog #320556
Print Topic Category: Production
Copyright: Public Domain

Print No. 71 America, 1918.
United States Official War Films. Kerr
PMML Catalog #320314
Print Topic Category: Film
Copyright: Public Domain

Print No. 72 America, 1917. *Make Every Minute Count for Pershing.* Adolph Treidler
PMML Catalog #329337
Print Topic Category: Production
Copyright: Public Domain

Print No. 73 America, 1917.
Join the Air Service, Give 'er the Gun. W.Z.
PMML Catalog #320283
Print Topic Category: Recruiting
Copyright: Public Domain

Print No. 74 America, 1917-1918.
Spirit of Paul Jones. E.G. Renesch
PMML Catalog #329061
Print Topic Category: Documentary
Copyright: Public Domain

Print No. 75 America, 1918. *Railway Men: Your Nation's Needs and Your Part in It.* Ernest Hamlin Baker
PMML Catalog #320723
Print Topic Category: Recruiting
Copyright: Public Domain

Print No. 76 France, 1918.
Subscribe to the Liberation Loan! Simay
PMML Catalog #320509
Print Topic Category: War Loans
Translation: "Subscribe to the Liberation Loan! Lloyds Bank (France) and National Provincial Bank (France) Limited."
Copyright: Public Domain

Print No. 77 America, 1918. *British-Franco-American Army—August 1918.*
PMML Catalog #321870
Print Topic Category: Documentary
Copyright: Public Domain

Print No. 78 America, 1918.
On the Job for Victory. Jonas Lie
PMML Catalog #329649
Print Topic Category: Production
Copyright: Public Domain

Print No. 79 America, 1917.
The Ships Are Coming. James Daugherty
PMML Catalog #321701
Print Topic Category: Production
Copyright: Public Domain

Print No. 80 America, 1917.
Join the Navy, the Service for Fighting Men.
Richard Fayerweather Babcock
PMML Catalog #320196
Print Topic Category: Recruiting
Copyright: Public Domain

Print No. 81 America, 1917.
Follow the Flag. James Daugherty
PMML Catalog #320348
Print Topic Category: Recruiting
Copyright: Public Domain

Print No. 82 Canada, 1918. *Hurry His Return: Subscribe to the Victory Loan.*
PMML Catalog #329454

Print Topic Category: War Loans
Copyright: Public Domain

Print No. 83 America, 1914-1918.
You, Wireless Fans, Help the Navy Get the Hun Submarine. Charles Buckles Falls
PMML Catalog #321720
Print Topic Category: Recruiting
Copyright: Public Domain

Print No. 84 America, 1918.
Help Protect Liberty's Gateway.
PMML Catalog #320733
Print Topic Category: War Loans
Copyright: Public Domain

Print No. 85 America, 1918. *Gee!! I Wish I Were a Man.* Howard Chandler Christy
PMML Catalog #329117
Print Topic Category: Recruiting
Copyright: Public Domain

Print No. 86 America, 1918.
Hold Up Your End! W.B. King
PMML Catalog #321856
Print Topic Category: Relief Funds
Copyright: Public Domain

Print No. 87 Canada, 1918. *We Are Saving You, You Save Food.* E. Henderson
PMML Catalog #321739
Print Topic Category: Conservation
Copyright: Public Domain

Print No. 88 France, 1916.
Civilian Smokers, Save Tobacco for Our Soldiers. Andrée Menard
PMML Catalog #321549
Print Topic Category: Conservation
Copyright: Public Domain

Print No. 89 America, 1918.
Down with the Murderers. Up with Democracy.
Vojtech Preissig
PMML Catalog #320455
Print Topic Category: Political
Copyright: © 2017 Artists Rights Society (ARS), New York/OOA-S, Prague

Print No. 90 Germany, 1917.
We Need Books, Donate Money!
Max Antlers
PMML Catalog #320629
Print Topic Category: Literary
Translation: "German public donations
to purchase reading materials for the
army and navy. We need books,
donate money!"
Copyright: Public Domain

Print No. 91 England, 1914-1918.
Fight with National War Bonds.
Hill, Siffken, & Co.
PMML Catalog #320883
Print Topic Category: War Loans
Copyright: Public Domain

Print No. 92 America, 1917.
*Italy Has Need of Meat, Wheat, Fat
and Sugar.* George Illian
PMML Catalog #321853
Print Topic Category: Conservation
Translation: "Italy has need of meat,
wheat, fat and sugar. Eat less of these
foods because it must go to the people
and troops of Italy. United States
Food Administration."
Copyright: Public Domain

Print No. 93 America, 1918.
If I Fail He Dies. Arthur G. McCoy
PMML Catalog #321877
Print Topic Category: Recruiting
Copyright: Public Domain

Print No. 94 America, 1917.
I Want You for U.S. Army.
James Montgomery Flagg
PMML Catalog #320230
Print Topic Category: Recruiting
Copyright: Public Domain

Print No. 95 America, 1917-1918.
Even a Dog Enlists Why Not You?
Mildred Moody
PMML Catalog #320195
Print Topic Category: Recruiting
Copyright: Public Domain

Print No. 96 England & Canada, 1917.
Britishers, You're Needed, Come Across Now.
Lloyd Myers
PMML Catalog #329650
Print Topic Category: Recruiting
Copyright: Public Domain

Print No. 97 America, 1918.
Czechoslovaks! Join Our Free Colors!
Vojtech Preissig
PMML Catalog #320454
Print Topic Category: Recruiting
Copyright: © 2017 Artists Rights
Society (ARS), New York/OOA-S,
Prague

Print No. 98 America, 1917.
"Here he is, Sir." We Need Him and You Too!
Charles Dana Gibson
PMML Catalog #329489
Print Topic Category: Recruiting
Copyright: Public Domain

Print No. 99 America, 1917-1918.
You Are Wanted by U.S. Army.
K.M. Bara
PMML Catalog #320584
Print Topic Category: Recruiting
Copyright: Public Domain

Print No. 100 England, 1915.
Step into Your Place.
David Allen & Sons Ltd.
PMML Catalog #320505
Print Topic Category: Recruiting
Copyright: Public Domain

Print No. 101 America, 1917.
U.S. Marines: Active Service on Land and Sea.
Sidney H. Riesenberg
PMML Catalog #329331
Print Topic Category: Recruiting
Copyright: Public Domain

Print No. 102 America, 1917-1919.
Send Smokes to Sammy.
James Montgomery Flagg
PMML Catalog #320231
Print Topic Category: Relief Funds
Copyright: Public Domain

Print No. 103 America, 1918.
Join the Land Army. Lambert Guenther
PMML Catalog #321755
Print Topic Category: Production
Copyright: Public Domain

Print No. 104 America, 1917.
Keep it Coming. George John Illian
PMML Catalog #320448
Print Topic Category: Conservation
Copyright: Public Domain

Print No. 105 America, 1917.
Food Will Win the War.
Charles Edward Chambers
PMML Catalog #320439
Print Topic Category: Conservation
Translation: "Food will win the war.
You came here seeking freedom. You
must now help to preserve it. Wheat is
needed for the Allies. Waste nothing."
Copyright: Public Domain

Print No. 106 America, 1917-1918.
My Homing Pigeons—Birds of War.
Coles Phillips
PMML Catalog #329035
Print Topic Category: Production
Copyright: Public Domain

Print No. 107 America, 1918.
Hunger. Henry Raleigh
PMML Catalog #321917
Print Topic Category: Conservation
Copyright: Public Domain

Print No. 108 America, 1917-1918.
The Most Popular Button in America.
Arnold Binger
PMML Catalog #320186
Print Topic Category: War Loans
Copyright: Public Domain

Print No. 109 England, 1915.
We're Both Needed to Serve the Guns!
Chorley & Pickersgill Ltd.
PMML Catalog #329401
Print Topic Category: Recruiting
Copyright: Public Domain

Print No. 110 America, 1918-1919.
Load Him Up Again! Charles Buckles Falls
PMML Catalog #320610
Print Topic Category: Literary
Copyright: Public Domain

Print No. 111 Canada, 1918. *They Serve in France, Everyone Can Serve.* Based on a photograph by Brown Brothers
PMML Catalog #329652
Print Topic Category: War Loans
Translation: "They serve in France. Everyone can serve. Subscribe to the Victory Loan."
Copyright: Public Domain

Print No. 112 America, 1917.
Poles! Kosciuszko and Pulaski Fought for Liberty and Other Nations.
Wladyslaw Teodor Benda
PMML Catalog #320278
Print Topic Category: Recruiting
Copyright: Public Domain

Print No. 113 Germany, 1917.
Exhibition of War Loot. H. Wöbbeking
PMML Catalog #320373
Print Topic Category: Documentary
Translation: "Exhibition of war loot. Posen, August-October 1917, in Gaumers Friedrichspark. Stop: Tram nos. 6 and 7. Afternoons and evenings. Concerts in the garden. Day tickets: admission 50 pfennigs. Soldiers and children 25 pfennigs. Season tickets at 3, 2 and 1 mark from Bote and Bock, E. Simon and the other announced sales points."
Copyright: Public Domain

Print No. 114 America, 1918.
Keep This Hand of Mercy at Its Work.
P.G. Morgan
PMML Catalog #321761
Print Topic Category: Relief Funds
Copyright: Public Domain

Print No. 115 America, 1917.
Wake Up America Day, April 19, 1917.
James Montgomery Flagg
PMML Catalog #320229

Print Topic Category: Political
Copyright: Public Domain

Print No. 116 America, 1917.
Your Navy Calls for 2,000 Firemen.
Harold von Schmidt
PMML Catalog #320006
Print Topic Category: Recruiting
Copyright: Public Domain

Print No. 117 America, 1917. *Following the Paths of Our Fathers in the Ranks of the Polish Army.* Wladyslaw Teodor Benda
PMML Catalog #320725
Print Topic Category: Recruiting
Copyright: Public Domain

Print No. 118 Canada, 1918.
If Ye Break Faith—We Shall Not Sleep.
Frank Lucien Nicolet
PMML Catalog #321850
Print Topic Category: War Loans
Copyright: Public Domain

Print No. 119 America, 1917-1918.
Who Takes Sammy to France? R. Scott
PMML Catalog #320730
Print Topic Category: Recruiting
Copyright: Public Domain

Print No. 120 America, 1918. *They Flash the Light of Freedom Across the Seas.*
William Sato, Official Photographer of Great Lakes Naval Training Station
PMML Catalog #329820
Print Topic Category: Documentary
Copyright: Public Domain

Print No. 121 America, 1918.
Our Colored Heroes. E.G. Renesch
PMML Catalog #329184
Print Topic Category: Documentary
Copyright: Public Domain

Print No. 122 America, 1917. *A Wonderful Opportunity for You.* Charles E. Ruttan
PMML Catalog #320287
Print Topic Category: Recruiting
Copyright: Public Domain

Print No. 123 America, 1917. *You Drive a Car Here—Why Not a Transport in France?*
H. Blyleven Esselen
PMML Catalog #320007
Print Topic Category: Recruiting
Copyright: Public Domain

Print No. 124 America, 1917. *"Teufel Hunden," German Nickname for U.S. Marines.*
Charles Buckles Falls
PMML Catalog #320449
Print Topic Category: Recruiting
Copyright: Public Domain

Print No. 125 America, 1917. *Wanted! 500 Bakers for the U.S. Army.* Dewey
PMML Catalog #320522
Print Topic Category: Recruiting
Copyright: Public Domain

Print No. 126 America, 1918.
Our Boys Need SOX. L.N. Britton
PMML Catalog #320198
Print Topic Category: Production
Copyright: Public Domain

Print No. 127 America, 1917-1918.
Join the National Guard.
Citizens Preparedness Association
PMML Catalog #320294
Print Topic Category: Recruiting
Copyright: Public Domain

Print No. 128 America, 1917-1918. *First Division: First—Last—and All the Time.*
PMML Catalog #321160
Print Topic Category: Recruiting
Copyright: Public Domain

Print No. 129 America, 1917.
And They Thought We Couldn't Fight.
Victor Clyde Forsythe
PMML Catalog #329119
Print Topic Category: War Loans
Copyright: Public Domain

Print No. 130 America, 1917-1918.
Over the Top Illinois!
Illinois Litho. Co.
PMML Catalog #320289

Print Topic Category: War Loans
Copyright: Public Domain

Print No. 131 America, 1917.
Keep These off the U.S.A.
Strobridge Litho. Co.
PMML Catalog #329351
Print Topic Category: War Loans
Copyright: Public Domain

Print No. 132 America, 1918.
Help the Horse to Save the Soldier.
Fortunino Matania
PMML Catalog #320959
Print Topic Category: Relief Funds
Copyright: Public Domain

Print No. 133 America, 1917.
America's Answer, Photographed by the U.S. Signal Corps A.E.F. J.H. Tooker Litho.
PMML Catalog #320181
Print Topic Category: Film
Copyright: Public Domain

Print No. 134 America, 1918.
The Tidal Wave. Joseph Clement Coll
PMML Catalog #321705
Print Topic Category: Production
Copyright: Public Domain

Print No. 135 America, 1917-1918.
U.S. Naval Aviation, Sailors of the Air.
PMML Catalog #321991
Print Topic Category: Recruiting
Copyright: Public Domain

Print No. 136 America, 1918.
That Liberty Shall Not Perish From the Earth.
Joseph Pennell
PMML Catalog #320555
Print Topic Category: War Loans
Copyright: Public Domain

Print No. 137 America, 1917.
Official America War Films.
Harry Stoner
PMML Catalog #320192
Print Topic Category: Film
Copyright: Public Domain

Print No. 138 America, 1918.
Tag Your Shovel Day.
United States Fuel Administration
PMML Catalog #320562
Print Topic Category: Conservation
Copyright: Public Domain

Print No. 139 America, 1918.
The Chain Gang.
Paramount Advertising Corporation
PMML Catalog #329155
Print Topic Category: Political
Copyright: Public Domain

Print No. 140 America, 1917.
E-e-e-yah-yip. Charles Buckles Falls
PMML Catalog #321612
Print Topic Category: Recruiting
Copyright: Public Domain

Print No. 141 America, 1917.
Good Bye, Dad, I'm Off to Fight for Old Glory.
Lawrence Harris
PMML Catalog #321878
Print Topic Category: War Loans
Copyright: Public Domain

Print No. 142 America, 1917-1918.
How Much of Your Pay Do You Think You Can Keep if Germany Wins This War?
R.B. Cane
PMML Catalog #321895
Print Topic Category: War Loans
Copyright: Public Domain

Print No. 143 America, 1917.
U.S. Engineers: Foremost.
Charles Buckles Falls
PMML Catalog #321912
Print Topic Category: Recruiting
Copyright: Public Domain

Print No. 144 America, 1918. *They Give Their Lives, Do You Lend Your Savings?*
Horace Devitt Welsh
PMML Catalog #329373
Print Topic Category: War Loans
Copyright: Public Domain

Print No. 145 America, 1917-1919.
They Kept the Sea Lanes Open.
Leon Alaric Shafer
PMML Catalog #320453
Print Topic Category: War Loans
Copyright: Public Domain

Print No. 146 America, 1918.
Back Our Girls Over There.
Clarence F. Underwood
PMML Catalog #320051
Print Topic Category: Relief Funds
Copyright: Public Domain

Print No. 147 America, 1917.
For Our Aviators.
Charles Buckles Falls
PMML Catalog #320261
Print Topic Category: Conservation
Copyright: Public Domain

Print No. 148 Canada, 1917.
Your Money Plus 5½% Interest. Canada Is Your Guarantee.
PMML Catalog #329443
Print Topic Category: War Loans
Copyright: Public Domain

Print No. 149 America, 1917.
First to Fight. Charles Buckles Falls
PMML Catalog #320263
Print Topic Category: Recruiting
Copyright: Public Domain

Print No. 150 America, ca. 1917.
Lafayette We Are Here!
PMML Catalog #329194
Print Topic Category: Documentary
Copyright: Public Domain

Print No. 151 America, 1918.
Don't Let Up: Keep on Saving Food.
Francis Luis Mora
PMML Catalog #321828
Print Topic Category: Conservation
Copyright: Public Domain

Print No. 152 France, 1918.
The Victors of the Marne.
Eduardo Garcia Benito

PMML Catalog #320467
Print Topic Category: Documentary
Translation: "The victors of the Marne.
Honor and glory to those who have
saved the freedom of the world. Our
heroic soldiers in the red pants defeated
in 1914 on the sacred Marne will be
immortalized in the legends as the
brave among the brave. And you young
soldiers of great America, you have
entered history with the unpredictable
honor of having renewed these glorious
exploits alongside the French in 1918."
Copyright: Public Domain

Print No. 153 America, ca. 1919.
Back into "Cits," and the American Legion.
Ernest Hamlin Baker
PMML Catalog #320306
Print Topic Category: Veterans' Affairs
Copyright: Public Domain

Print No. 154 America, 1918.
Oh, Boy! That's the Girl.
George Mather Richards
PMML Catalog #329136
Print Topic Category: Relief Funds
Copyright: Public Domain

Print No. 155 America, 1918-1919.
Help Them on the Road Back. T.H. Friday
PMML Catalog #321966
Print Topic Category: Relief Funds
Copyright: Public Domain

Print No. 156 Germany, 1919. *Temporary
Volunteers, Let's Go! (Freikorps).* A.S.
PMML Catalog #320736
Print Topic Category: Recruiting
Copyright: Public Domain

Print No. 157 America, 1919-1920. *Put
Fighting Blood in Your Business.* Dan Smith
PMML Catalog #321390
Print Topic Category: Veterans' Affairs
Copyright: Public Domain

Print No. 158 Germany, 1919.
Who Will Save the Fatherland? (Freikorps).
Leo Impekoven

PMML Catalog #320858
Print Topic Category: Recruiting
Translation: "Who will save the
fatherland? This Is Lützow's wild,
fierce hunting. German Men! Soldiers
under Arms! Get into Our Ranks!
Volunteer Corps Lützow!"
Copyright: Public Domain

Print No. 159 America, ca. 1918.
V.F.W. America's "Old Guard."
Edward McCandlish
PMML Catalog #329364
Print Topic Category: Veterans' Affairs
Copyright: Public Domain

Print No. 160 America, 1919. *War Gardens
over the Top.* Maginel Wright Barney
PMML Catalog #320582
Print Topic Category: Conservation
Copyright: Public Domain

Print No. 161 America, 1918.
U.S. Government War Exposition.
Maginel Wright Barney
PMML Catalog #320438
Print Topic Category: Documentary
Copyright: Public Domain

Print No. 162 America, 2016.
Let's Do Our Part.
Pritzker Military Museum & Library
PMML Catalog #330029
Print Topic Category: Documentary
Copyright: Public Domain

Print No. 163 America, ca. 1919.
Roster of Company C, 109th U.S. Infantry.
Dan Smith
PMML Catalog #329198
Print Topic Category: Documentary
Copyright: Public Domain

Print No. 164 America, ca. 1919.
Roster of Company H, 38th U.S. Infantry.
Dan Smith
PMML Catalog #02784
Print Topic Category: Documentary
Copyright: Public Domain

Print No. 165 America, ca. 1919.
Roster of Company I, 3rd Illinois Infantry.
Dan Smith
PMML Catalog #320442
Print Topic Category: Documentary
Copyright: Public Domain

Print No. 166 America, 1918.
All For One and One for All! Vive La France!
James Montgomery Flagg
PMML Catalog #321050
Print Topic Category: Political
Copyright: Public Domain

PRINT NO.164 AMERICA, CA. 1919. "ROSTER OF COMPANY H, 38TH U.S. INFANTRY." DAN SMITH

PRITZKER MILITARY MUSEUM & LIBRARY WORLD WAR I RESOURCES

THIS LIST OF BOOKS and archival collections is organized by key World War I subject areas (e.g., 33rd Division, AEF, Meuse-Argonne Offensive, Poetry, etc.). It was created from the collections of the Pritzker Military Museum & Library. Explore these World War I resources and thousands more not included in this list at www.pritzkermilitary.org by using the search function 🔍.

GENERAL

American Battle Monuments Commission. *A Guide to the American Battle Fields in Europe.* Washington, D.C.: U.S. GPO, 1927.

———. *American Armies and Battlefields in Europe: A History, Guide, and Reference Book.* Washington, D.C.: Headquarters, U.S. Marine Corps, 1989.

Burg, David F., and L. Edward Purcell. *Almanac of World War I.* Lexington, KY: University Press of Kentucky, 1998.

The Chicago Daily News War Book for American Soldiers, Sailors and Marines. Chicago: Chicago Daily News, 1918.

French, John Denton Pinkstone. *1914.* Boston: Houghton Mifflin, 1919.

Frothingham, Thomas Goddard. *A Guide to the Military History of the World War, 1914-1918.* Boston: Little, Brown, 1920.

Gilbert, Martin. *The First World War: A Complete History.* New York: Henry Holt, 1994.

Hart, Albert Bushnell. *Harper's Pictorial Library of the World War.* New York: Harper, 1920.

Hastings, Max. *Catastrophe 1914: Europe Goes to War.* New York: Alfred A. Knopf, 2013.

Keegan, John. *The First World War.* New York: Alfred A. Knopf, 1999.

Kennedy, David M. *Over Here: The First World War and American Society.* New York: Oxford University Press, 1980.

Lafore, Laurence Davis. *The Long Fuse: An Interpretation of the Origins of World War I.* Philadelphia: Lippincott, 1965.

Marshall, S.L.A. *World War I.* New York: American Heritage Press, 1971.

McMaster, John Bach. *The United States in the World War.* New York: D. Appleton, 1918.

Reilly, Henry J. *America's Part.* New York: Cosmopolitan Book Corp., 1928.

Stevenson, David. *Cataclysm: The First World War as Political Tragedy.* New York: Basic Books, 2004.

Strachan, Hew. *The First World War.* New York: Viking, 2004.

AMERICAN EXPEDITIONARY FORCE

Allen, Henry T. *My Rhineland Journal.* Boston: Houghton Mifflin, 1923.

Carter, William H. *The American Army.* Indianapolis: Bobbs-Merrill Co., 1915.

Cooke, James J. *Pershing and His Generals: Command and Staff in the AEF.* Westport, CT: Praeger, 1997.

Eisenhower, John S.D., and Joanne Thompson Eisenhower. *Yanks: The Epic Story of the American Army in World War I.* New York: Free Press, 2001.

Freidel, Frank. *Over There: The Story of America's First Great Overseas Crusade.* Boston: Little, Brown, 1964.

Grotelueschen, Mark E. *The AEF Way of War: The American Army and Combat in World War I.* Cambridge, UK: Cambridge University Press, 2007.

Gutiérrez, Edward A. *Doughboys on the Great War: How American Soldiers Viewed Their Military Experience.* Lawrence, KS: University Press of Kansas, 2014.

Hallas, James H. *Doughboy War: The American Expeditionary Force in World War I.* Boulder, CO: Lynne Rienner Publishers, 2000.

Hamburger, Kenneth Earl. *The United States Army in World War I.* [Washington, D.C.]: U.S. Army Center of Military History, 2001.

House, John M. *Wolfhounds and Polar Bears: The American Expeditionary Force in Siberia, 1918-1920.* Tuscaloosa, AL: University of Alabama Press, 2016.

Lawrence, Joseph Douglas, and Robert H. Ferrell. *Fighting Soldier: The AEF in 1918.* Boulder, CO: Colorado Associated University Press, 1985.

Lengel, Edward G. *Thunder and Flames: Americans in the Crucible of Combat, 1917-1918.* Lawrence, KS: University Press of Kansas, 2015.

Matthews, William, and Dixon Wecter. *Our Soldiers Speak, 1775-1918.* Boston: Little, Brown, 1943.

Trask, David F. *The AEF and Coalition Warmaking, 1917-1918.* Lawrence, KS: University Press of Kansas, 1993.

Yockelson, Mitchell A. *Forty-Seven Days: How Pershing's Warriors Came of Age to Defeat the German Army in World War I.* New York: NAL Caliber/New American Library, 2016.

1ST DIVISION, AEF
American Battle Monuments Commission. *1st Division, Summary of Operations in the World War.* [Washington, D.C.]: U.S. GPO, 1944.

Davenport, Matthew J. *First over There: The Attack on Cantigny, America's First Battle of World War I.* New York: Thomas Dunne Books, St. Martin's Press, 2015.

Marshall, George C. *Memoirs of My Services in the World War, 1917-1918.* Boston: Houghton Mifflin, 1976.

Nelson, James Carl. *The Remains of Company D: A Story of the Great War.* New York: St. Martin's Press, 2009.

Society of the First Division. *History of the First Division During the World War, 1917-1919.* Philadelphia: John C. Winston, 1922.

————. *Memorial Album: Pictorial History of the 1st Division.* San Diego: The Society, 1950.

2ND DIVISION, AEF
Harbord, James G. *Leaves from a War Diary.* New York: Dodd, Mead, 1925.

Wise, Jennings C. *The Turn of the Tide: American Operations at Cantigny, Château Thierry, and the Second Battle of the Marne.* New York: H. Holt, 1920.

3RD DIVISION, AEF
American Battle Monuments Commission. *3d Division, Summary of*
Operations in the World War. Washington, D.C.: U.S. GPO, 1944.

7TH DIVISION, AEF
Fell, Edgar Tremlett. *History of the Seventh Division, United States Army, 1917-1919.* Philadelphia: n.p., 1927.

26TH DIVISION, AEF
Benwell, Harry A. *History of the Yankee Division.* Boston: Cornhill, 1919.

Shay, Michael E. *The Yankee Division in the First World War: In the Highest Tradition.* College Station, TX: Texas A&M University Press, 2008.

Sibley, Frank P. *With the Yankee Division in France.* Boston: Little, Brown, 1919.

Sirois, Edward D., William McGinnis, and John J. Hogan. *Smashing Through "the World War" with Fighting Battery C: 102nd F.A., 26th Division, "Yankee Division," 1917-1918-1919.* Salem, MA: Meek, 1919.

Taylor, Emerson Gifford. *New England in France, 1917-1919: A History of the Twenty-Sixth Division, U.S.A.* Boston: Houghton Mifflin, 1920.

Washburn, Slater. *One of the Y.D. (Yankee Division).* Boston: Houghton Mifflin, 1919.

28TH DIVISION, AEF
Andrews, James Henry Millar, J.S. Bradford, and Charles Elcock. *Soldiers of the Castle: A History of Company B, Engineer Battalion, National Guard of Pennsylvania, Afterward Company B, 103rd Engineers, 28th Division, A.E.F.* Philadelphia: Hoeflich Printing House, 1929.

Association of the 110th Infantry, Pennsylvania. *History of the 110th Infantry (10th Pa.) of the 28th Division, U.S.A., 1917-1919: A Compilation of Orders, Citations, Maps, Records and Illustrations Relating to the 3rd Pa. Inf., 10th Pa. Inf., and 110th U.S.*
Inf. N.p.: The Association, 1920

Gilbert, Eugène. *The 28th Division in France.* N.p.: N.p., 1919.

Martin, Edward, and Edwin Sherman Wallace. *The Twenty-Eighth Division: Pennsylvania's Guard in the World War.* Pittsburgh: 28th Division Publishing, 1923.

Proctor, H.G. *The Iron Division, National Guard of Pennsylvania, in the World War: The Authentic and Comprehensive Narrative of the Gallant Deeds and Glorious Achievements of the 28th Division in the World's Greatest War.* Philadelphia: John C. Winston, 1919.

U.S. Army. *Pennsylvania in the World War: An Illustrated History of the 28th Division.* Pittsburgh: States Publications Society, 1921.

32ND DIVISION, AEF
Barry, John W. *The Midwest Goes to War: The 32nd Division in the Great War.* Lanham, MD: Scarecrow Press, 2007.

National Council of the Young Men's Christian Associations of the United States of America. *The Thirty Second Division: American Expeditionary Forces, 1917-1919.* [New York?]: [YMCA], 1919.

Wisconsin War History Commission, and Michigan War History Commission. *The 32nd Division in the World War, 1917-1919.* Milwaukee, WI: Wisconsin Print, 1920.

33RD DIVISION, AEF
American Battle Monuments Commission. *33d Division, Summary of Operations in the World War.* Washington, D.C.: U.S. GPO, 1944.

Bilder, James G. *Artillery Scout: The Story of a Forward Observer with the U.S. Field Artillery in World War I.* Oxford, UK: Casemate, 2014.

Cioper, Nicole M. *Prairie Division: The Thirty-Third in the Great War, 1917-1919.* Springfield, IL: Illinois State Military Museum, 1997.

Harris, Barnett W. *33rd Division Across No-Man's Land.* n.p.: Harris & Nelson, 1919.

Huidekoper, Frederic Louis. *The History of the 33rd Division, A.E.F.* Springfield, IL: Illinois State Historical Library, 1921.

Payan, Jack Louis. *World War 1, 1918: Kankakee (Illinois) Doughboys, Company L, 129th Infantry, 33rd (Prairie) Division.* [Palos Heights, IL]: J.L. Payan, 2008.

States Publications Society. *Illinois in the World War: An Illustrated History of the Thirty-Third Division.* Chicago: States Publications Society, 1921.

35TH DIVISION, AEF

American Battle Monuments Commission. *35th Division, Summary of Operations in the World War.* [Washington, D.C.]: U.S. GPO, 1944.

Hoyt, Charles B., and Charles B. Lyon. *Heroes of the Argonne: An Authentic History of the Thirty-Fifth Division.* Kansas City, MO: Franklin Hudson, 1919.

Kenamore, Clair. *From Vauquois Hill to Exermont: A History of the Thirty-Fifth Division of the United States Army.* St. Louis: Guard, 1919.

37TH DIVISION, AEF

American Battle Monuments Commission. *37th Division, Summary of Operations in the World War.* [Washington, D.C.]: U.S. GPO, 1944.

Cole, Ralph D., and William Cooper Howells. *The Thirty-Seventh Division in the World War, 1917-1918.* Columbus, Ohio: The Thirty-Seventh Division Veterans Association, 1926.

42ND DIVISION, AEF

American Battle Monuments Commission. *42d Division, Summary of Operations in the World War.* [Washington, D.C.]: U.S. GPO, 1944.

Cheseldine, R.M. *Ohio in the Rainbow: Official Story of the 166th Infantry, 42nd Division, in the World War.* Columbus, Ohio: F.J. Heer, 1924.

Reilly, Henry J. *Americans All: The Rainbow at War—Official History of the 42nd Rainbow Division in the World War.* Columbus, Ohio: F.J. Heer, 1936.

Thompson, Hugh S., and Robert H. Ferrell. *Trench Knives and Mustard Gas: With the 42nd Rainbow Division in France.* College Station, TX: Texas A&M University Press, 2004.

Webster, Francis H., and Darrek D. Orwig. *Somewhere over There: The Letters, Diary, and Artwork of a World War I Corporal.* Norman, OK: University of Oklahoma Press, 2016.

Wolf, Walter B. *A Brief Story of the Rainbow Division.* New York: Rand, McNally, 1919.

77TH DIVISION, AEF

Ferrell, Robert H. *Five Days in October: The Lost Battalion of World War I.* Columbia, MO: University of Missouri Press, 2005.

Gaff, Alan D. *Blood in the Argonne: The "Lost Battalion" of World War I.* Norman, OK: University of Oklahoma Press, 2005.

78TH DIVISION, AEF

American Battle Monuments Commission. *78th Division, Summary of Operations in the World War.* [Washington, D.C.]: U.S. GPO, 1944.

Meehan, Thomas F. *History of the Seventy-Eighth Division in the World War,*

1917-18-19. New York: Dodd, Mead, 1921.

79TH DIVISION, AEF

U.S. Army. *History of Company F, 316th Infantry, 79th Division, A.E.F., in the World War, 1917-18-19.* Philadelphia: Company F Association of the 316th Infantry, 1930.

82ND DIVISION, AEF

American Battle Monuments Commission. *82d Division, Summary of Operations in the World War.* [Washington, D.C.]: U.S. GPO, 1944.

89TH DIVISION, AEF

Wright, William M., and Robert H. Ferrell. *Meuse-Argonne Diary: A Division Commander in World War I.* Columbia, MO: University of Missouri Press, 2004.

90TH DIVISION, AEF

American Battle Monuments Commission. *90th Division, Summary of Operations in the World War.* [Washington, D.C.]: U.S. GPO, 1944.

92ND DIVISION, AEF

Ferrell, Robert H. *Unjustly Dishonored: An African American Division in World War I.* Columbia, MO: University of Missouri Press, 2011.

Fisher, W. Douglas, and Joann H. Buckley. *African American Doctors of World War I: The Lives of 104 Volunteers.* Jefferson, NC: McFarland, 2016.

93RD DIVISION, AEF

Roberts, Frank E. *The American Foreign Legion: Black Soldiers of the 93d in World War I.* Annapolis, MD: Naval Institute Press, 2004.

THE 122ND FIELD ARTILLERY

Schwengel, Milton J., Milton J. Foreman, and George Burchill. *The 122nd Field Artillery.* San Jose, CA: George Burchill, 1974.

129TH INFANTRY REGIMENT

Payan, Jack Louis. *World War 1, 1918: Kankakee (Illinois) Doughboys, Company L, 129th Infantry, 33rd (Prairie) Division.* [Palos Heights, IL]: J.L. Payan, 2008.

131ST INFANTRY REGIMENT

Sanborn, Joseph Brown, and George Nathaniel Malstrom. *The 131st U.S. Infantry (First Infantry Illinois National Guard) in the World War: Narrative-Operations-Statistics.* Chicago: N.p., 1919.

132ND INFANTRY REGIMENT

Davis, Abel. *The Story of the 132d Infantry, A.E.F.* N.p.: N.p., 1919.

369TH INFANTRY REGIMENT

Harris, Stephen L. *Harlem's Hell Fighters: The African-American 369th Infantry in World War I.* Washington, D.C.: Brassey's, 2003.

Little, Arthur West. *From Harlem to the Rhine: The Story of New York's Colored Volunteers.* New York: Covici, Friede, 1936.

Nelson, Peter. *A More Unbending Battle: The Harlem Hellfighters' Struggle for Freedom in WWI and Equality at Home.* New York: Basic Civitas, 2009.

Sammons, Jeffrey T., and John Howard Morrow. *Harlem's Rattlers and the Great War: The Undaunted 369th Regiment and the African American Quest for Equality.* Lawrence, KS: University Press of Kansas, 2014.

Slotkin, Richard. *Lost Battalions: The Great War and the Crisis of American Nationality.* New York: H. Holt, 2005.

AMERICAN LEGION

Gray, Justin, and Victor H. Bernstein. *The Inside Story of the Legion.* New York: Boni & Gaer, 1948.

Littlewood, Thomas B. *Soldiers Back Home: The American Legion in Illinois, 1919-1939.* Carbondale, IL: Southern

Illinois University Press, 2004.

Moley, Raymond. *The American Legion Story.* New York: Duell, Sloan and Pearce, 1966.

Radtke, Terry. *The History of the Pennsylvania American Legion.* Mechanicsburg, PA: Stackpole Books, 1993.

Rumer, Thomas A. *The American Legion: An Official History, 1919-1989.* New York: M. Evans, 1990.

AMERICA'S ENTRY

Doenecke, Justus D. *Nothing Less Than War: A New History of America's Entry into World War I.* Lexington, KY: University Press of Kentucky, 2011.

ANIMALS (USE OF)

Bausum, Ann. *Sergeant Stubby: How a Stray Dog and His Best Friend Helped Win World War I and Stole the Heart of a Nation.* Washington, D.C.: National Geographic, 2014.

Baynes, Ernest Harold, and Owen Wister. *Animal Heroes of the Great War.* [New York]: Macmillan, 1925.

Great Britain War Office. *Carrier Pigeons in the War.* [London]: HMSO, 1918.

Street, Peter. *Animals in the First World War.* Stroud, UK: History Press, 2016.

ARMISTICE DAY

Best, Nicholas. *The Greatest Day in History: How, on the Eleventh Hour of the Eleventh Day of the Eleventh Month, the First World War Finally Came to an End.* New York: Public Affairs, 2008.

Persico, Joseph E. *Eleventh Month, Eleventh Day, Eleventh Hour: Armistice Day, 1918, World War I and Its Violent Climax.* New York: Random House, 2004.

Sanford, A.P., and Robert Haven

Schauffler. *Armistice Day: An Anthology of the Best Prose and Verse on Patriotism, the Great War, the Armistice.* New York: Dodd, Mead, 1927.

AUSTRALIAN EXPEDITIONARY FORCE

Bean, C.E.W. et al. *Official History of Australia in the War of 1914-18,* 12 vols. Sydney: Angus & Robertson, 1921-1942.

AVIATION

Bishop, William Avery, and Rothesay Stuart-Wortley. *The Flying Squad.* New York: Sun Dial Press, 1927.

Flood, Charles Bracelen. *First to Fly: The Story of the Lafayette Escadrille, the American Heroes Who Flew for France in World War I.* New York: Atlantic Monthly Press, 2015.

Franks, Norman L.R., and Frank W. Bailey. *Over the Front: A Complete Record of the Fighter Aces and Units of the United States and French Air Services, 1914-1918.* London: Grub Street, 1992.

Grider, John MacGavock, Elliott White Springs, and Clayton Knight. *War Birds: Diary of an Unknown Aviator.* New York: George H. Doran, 1926.

Hudson, James J. *Hostile Skies: A Combat History of the American Air Service in World War I.* Syracuse, NY: Syracuse University Press, 1968.

Johnson, Herbert Alan. *Wingless Eagle: U.S. Army Aviation Through World War I.* Chapel Hill, NC: University of North Carolina Press, 2001.

McConnell, James R. *Flying for France: With the American Escadrille at Verdun.* Garden City, NY: Doubleday, Page, 1917.

Mitchell, William. *Memoirs of World War I: "From Start to Finish of Our Greatest War."* New York: Random House, 1960.

Miller, Roger G. *Like a Thunderbolt: The Lafayette Escadrille and the Advent of American Pursuit in World War I.* Washington, D.C.: Air Force History and Museums Program, 2007.

Pardoe, Blaine Lee. *Terror of the Autumn Skies: The True Story of Frank Luke, America's Rogue Ace of World War I.* New York: Skyhorse, 2008.

Toulmin, Harry Aubrey. *Air Service, American Expeditionary Force, 1918.* New York: D. Van Nostrand, 1927.

Van Wyen, Adrian O. *Naval Aviation in World War I.* Washington, D.C.: Chief of Naval Operations, 1969.

BATTLE OF BELLEAU WOOD
Andriot, R. *Belleau Wood and the American Army: The 2nd and 26th Divisions (June and July 1918).* Foster, RI: Brass Hat, 1986.

Axelrod, Alan. *Miracle at Belleau Wood: The Birth of the Modern U.S. Marine Corps.* Guilford, CT: Lyons Press, 2007.

Bonk, David, and Peter Dennis. *Château Thierry & Belleau Wood 1918: America's Baptism of Fire on the Marne.* Oxford, UK: Osprey, 2007.

Nelson, James Carl. *I Will Hold: The Story of USMC Legend Clifton B. Cates, from Belleau Wood to Victory in the Great War.* New York: Caliber, 2016.

Simmons, Edwin H., and Joseph H. Alexander. *Through the Wheat: The U.S. Marines in World War I.* Annapolis, MD: Naval Institute Press, 2008.

BATTLE OF CANTIGNY
Davenport, Matthew J. *First over There: The Attack on Cantigny, America's First Battle of World War I.* New York: Thomas Dunne Books, St. Martin's Press, 2015.

Millett, Allan Reed. *Well Planned, Splendidly Executed: The Battle of Cantigny, May 28-31, 1918.* Chicago: Cantigny First Division Foundation, 2010.

Nelson, James Carl. *The Remains of Company D: A Story of the Great War.* New York: St. Martin's Press, 2009.

Ralphson, G. Harvey. *Over There with Pershing's Heroes at Cantigny.* Chicago: M.A. Donohue, 1919.

Wise, Jennings C. *The Turn of the Tide: American Operations at Cantigny, Château Thierry, and the Second Battle of the Marne.* New York: H. Holt, 1920.

BATTLE OF VERDUN
The Battle of Verdun (1914-1918). Clermont-Ferrand, France: Michelin & Cie, 1920.

Hermanns, William. *The Holocaust: From a Survivor of Verdun.* New York: Harper & Row, 1972.

Horne, Alistair. *The Price of Glory: Verdun 1916.* New York: St. Martin's Press, 1963.

Jankowski, Paul. *Verdun: The Longest Battle of the Great War.* New York: Oxford University Press, 2013.

Martin, William. *Verdun 1916: "They Shall Not Pass."* Westport, CT: Praeger, 2004.

Ousby, Ian. *The Road to Verdun: World War I's Most Momentous Battle and the Folly of Nationalism.* New York: Doubleday, 2002.

Wolfe, Royce, William C. Harvey, and Eric T. Harvey. *Letters from Verdun: Frontline Experiences of an American Volunteer in World War I France.* Philadelphia: Casemate, 2008.

BRITISH EXPEDITIONARY FORCE
Becke, Archibald F. *Order of Battle of Divisions.* Nottingham, UK: Sherwood Press, 1979.

Edmonds, James E. *Military Operations, France and Belgium, 1918: May-July, the German Diversion Offensives and the First Allied Counter-Offensive.* London: Macmillan, 1939.

Gallagher, Bernard J., Christopher J. Gallagher, and Mary E. Malloy. *The Cellars of Marcelcave: A Yank Doctor in the BEF.* Shippensburg, PA: Burd Street Press, 1998.

Gordon, George Stuart, and John Denton Pinkstone French. *Mons and the Retreat.* London: Constable, 1918.

Great Britain Committee of Imperial Defence. *Military Operations: France and Belgium, 1918 : Maps,* Vols. 1 and 2. London: Macmillan, 1927.

Harris, J.P., and Niall Barr. *Amiens to the Armistice: The BEF in the Hundred Days' Campaign, 8 August-11 November 1918.* London: Brassey's, 1998.

Jonas, Lucien. *B.E.F.* [Paris]: [Dorbon-aîné], 1918.

Macdonald, Lyn. *To the Last Man: Spring 1918.* New York: Carroll & Graf, 1999.

Moberly, F.J. *The Campaign in Mesopotamia, 1914-1918.* London: HMSO, 1923.

CAMP TRAVIS
Johns, Edward Bradford. *Camp Travis and Its Part in the World War.* New York: E.B. Johns, 1919.

CAUSES
Clark, Christopher M. *The Sleepwalkers: How Europe Went to War in 1914.* New York: Harper, 2013.

Joll, James. *The Origins of the First World War*. London: Longman, 1984.

Kennan, George F. *The Fateful Alliance: France, Russia, and the Coming of the First World War*. New York: Pantheon Books, 1984.

Lafore, Laurence Davis. *The Long Fuse: An Interpretation of the Origins of World War I*. Philadelphia: Lippincott, 1965.

Laqueur, Walter, and George L. Mosse. *1914: The Coming of the First World War*. New York: Harper & Row, 1966.

Remak, Joachim. *The Origins of World War I, 1871-1914*. New York: Holt, Rinehart and Winston, 1967.

CITIZENS' MILITARY TRAINING CAMPS
Clifford, J. Garry. *The Citizen Soldiers: The Plattsburg Training Camp Movement, 1913-1920*. [Lexington, KY]: University Press of Kentucky, 1972.

James, George F. *The Call of the Camps: Six Years of the Citizens' Military Training Camps*. Chicago: Military Training Camps Association of the United States, 1926.

The Plattsburger. [New York]: [Wynkoop, Hallenbeck, Crawford], 1917.

COAST GUARD
Larzelere, Alex. *The Coast Guard in World War I: An Untold Story*. Annapolis, MD: Naval Institute Press, 2003.

Ostrom, Thomas P. *The United States Coast Guard and National Defense: A History from World War I to the Present*. Jefferson, NC: McFarland, 2012.

COMMITTEE ON PUBLIC INFORMATION
Creel, George. *How We Advertised America: The First Telling of the Amazing Story of the Committee on Public Information That Carried the Gospel of Americanism to Every Corner of the Globe*. [Whitefish, MT]: Kessinger, 2008.

U.S. Committee on Public Information. *The Battle Line of Democracy: Prose and Poetry of the World War*. Washington, D.C.: GPO, 1917.

Wilson, Woodrow, and Wallace Notestein. *The President's Flag Day Address, With Evidence of Germany's Plans*. [Washington, D.C.]: [GPO], 1917.

FAMINE RELIEF
Fisher, Harold H. *The Famine in Soviet Russia, 1919-1923: The Operations of the American Relief Administration*. New York: Macmillan, 1927.

Surface, Frank M., and Raymond L. Bland. *American Food in the World War and Reconstruction Period: Operations of the Organizations Under the Direction of Herbert Hoover, 1914 to 1924*. Stanford, CA: Stanford University Press, 1931.

FOCH, FERDINAND
Aston, George. *The Biography of the Late Marshal Foch*. New York: Macmillan, 1929.

Atteridge, A. Hilliard. *Marshal Ferdinand Foch: His Life and His Theory of Modern War*. New York: Dodd, Mead, 1919.

Bugnet, Charles, and Russell Green. *Foch Speaks*. New York: L. MacVeagh, the Dial Press, 1929.

Foch, Ferdinand, and Thomas Bentley Mott. *The Memoirs of Marshal Foch*. Garden City, NY: Doubleday, Doran, 1931.

Laughlin, Clara E. *Foch the Man: A Life of the Supreme Commander of the Allied Armies*. New York: Fleming H. Revell, 1918.

Neiberg, Michael S. *Foch: Supreme Allied Commander in the Great War*. Washington, D.C.: Brassey's, 2003.

Recouly, Raymond, and Mary Cadwalader Jones. *Foch, the Winner of the War*. New York: C. Scribner's Sons, 1920.

FORT DEVENS, MASSACHUSETTS
Robinson, William J. *Forging the Sword: The Story of Camp Devens, New England's Army Cantonment*. Concord, NH: Rumford Press, 1920.

HOME FRONT
Kingsbury, Celia Malone. *For Home and Country: World War I Propaganda on the Home Front*. Lincoln, NE: University of Nebraska Press, 2010.

Kennedy, David M. *Over Here: The First World War and American Society*. New York: Oxford University Press, 1980.

Sterba, Christopher M. *Good Americans: Italian and Jewish Immigrants During the First World War*. Oxford, UK: Oxford University Press, 2003.

LEADERS
Birdwood, William Riddell. *Khaki and Gown: An Autobiography*. London: Ward, Lock, 1941.

Carter, Miranda. *George, Nicholas and Wilhelm: Three Royal Cousins and the Road to World War I*. New York: Alfred A. Knopf, 2010.

Maurice, Frederick. *The Last Four Months: How the War Was Won*. Boston: Little, Brown, 1919.

LEAGUE OF NATIONS
Erzberger, Matthias, and Bernard Miall. *The League of Nations: The Way to the World's Peace*. New York: Henry Holt, 1919.

House, Edward Mandell, and Charles Seymour. *The Intimate Papers of Colonel House*. Boston: Houghton Mifflin, 1926.

Jones, Robert, and Stanley Simon Sherman. *The League of Nations from Idea*

to Reality, Its Place in History and in the World of To-Day. London: Sir I. Pitman & Sons, 1927.

Lansing, Robert. The Peace Negotiations: A Personal Narrative. Boston: Houghton Mifflin, 1921.

Stone, Ralph A. Wilson and the League of Nations: Why America's Rejection? New York: Holt, Rinehart and Winston, 1967.

Walters, F.P. A History of the League of Nations. London: Oxford University Press, 1967.

Wells, H.G. In the Fourth Year: Anticipations of World Peace. London: Chatto & Windus, 1918.

MARINE CORPS
Clark, George B. Devil Dogs: Fighting Marines of World War I. Novato, CA: Presidio Press, 1999.

Simmons, Edwin H., and Joseph H. Alexander. Through the Wheat: The U.S. Marines in World War I. Annapolis, MD: Naval Institute Press, 2008.

U.S. Marine Corps. History of the 96th Company, 6th Marine Regiment in World War I. [Washington, D.C.]: [U.S. Marine Corps], 1967.

MEDICAL CORPS
Ginn, Richard V.N. The History of the U.S. Army Medical Service Corps. Washington, D.C.: Office of the Surgeon General and Center of Military History, U.S. Army, 1997.

McGaugh, Scott. Battlefield Angels: Saving Lives under Enemy Fire from Valley Forge to Afghanistan. Long Island City, NY: Osprey, 2011.

MEUSE-ARGONNE OFFENSIVE
Belmonte, Peter L. Days of Perfect Hell:

October-November 1918—The U.S. 26th Infantry Regiment in the Meuse-Argonne Offensive. Atglen, PA: Schiffer, 2015.

Gaff, Alan D. Blood in the Argonne: The "Lost Battalion" of World War I. Norman, OK: University of Oklahoma Press, 2005.

Lengel, Edward G. To Conquer Hell: The Meuse-Argonne, 1918. New York: H. Holt, 2008.

Mastriano, Douglas V. Alvin York: A New Biography of the Hero of the Argonne. Lexington, KY: University Press of Kentucky, 2014.

Palmer, Frederick. Our Greatest Battle: The Meuse-Argonne. New York: Dodd, Mead, 1919.

Wright, William M., and Robert H. Ferrell. Meuse-Argonne Diary: A Division Commander in World War I. Columbia, MO: University of Missouri Press, 2004.

Yockelson, Mitchell A. Forty-Seven Days: How Pershing's Warriors Came of Age to Defeat the German Army in World War I. New York: NAL Caliber/New American Library, 2016.

NAVY
Frothingham, Thomas Goddard. The Naval History of the World War. Cambridge, MA: Harvard University Press, 1924.

Gleaves, Albert. A History of the Transport Service: Adventures and Experiences of United States Transports and Cruisers in the World War. New York: George H. Doran, 1921.

Halpern, Paul G. A Naval History of World War I. Annapolis, MD: Naval Institute Press, 1994.

Jones, Jerry W. U.S. Battleship Operations in World War I. Annapolis, MD: Naval Institute Press,1998.

Pollen, Arthur Joseph Hungerford. The British Navy in Battle. Garden City, NY: Doubleday, Page, 1919.

Ruggles, Logan E., and Owen W. Norton. The Part the U.S.S. Von Steuben Played in the Great War. Brooklyn, NY: Brooklyn Eagle Press, 1919.

Still, William N. Crisis at Sea: The United States Navy in European Waters in World War I. Gainesville, FL: University Press of Florida, 2006.

PEACE
Erzberger, Matthias. Wer hat den krieg verlängert?: Die vereitelung der friedensmöglichkeiten 1916 und 1917—Eine zusammenstellung der ministerreden vom 25.-28.juli 1919. [Berlin]: [Druck von J. Graetz], 1919.

Wheeler-Bennett, John W. Brest-Litovsk: The Forgotten Peace, March 1918. London: Macmillan, 1966.

PERSHING, JOHN J.
Braddy, Haldeen. Pershing's Mission in Mexico. El Paso, TX: Texas Western Press,1966.

Lacey, Jim. Pershing. New York: Palgrave Macmillan, 2008.

O'Connor, Richard. Black Jack Pershing. Garden City, NY: Doubleday, 1961.

Palmer, Frederick. John J. Pershing, General of the Armies: A Biography. Harrisburg, PA: Military Service Publishing Company, 1948.

Perry, John. Pershing: Commander of the Great War. Nashville, TN: Thomas Nelson, 2011.

Pershing, John J. My Experiences in the World War. New York: Frederick A. Stokes, 1931.

Pershing, John J., and John T. Greenwood. *My Life Before the World War, 1860-1917: A Memoir.* Lexington, KY: University Press of Kentucky, 2013.

Smythe, Donald. *Pershing, General of the Armies.* Bloomington, IN: Indiana University Press, 1986.

Vandiver, Frank Everson. *Black Jack: The Life and Times of John J. Pershing.* College Station, TX: Texas A&M University Press, 1977.

Welsome, Eileen. *The General and the Jaguar: Pershing's Hunt for Pancho Villa—A True Story of Revolution and Revenge.* New York: Little, Brown, 2006.

POETRY
Clarke, George Herbert. *A Treasury of War Poetry: British and American Poems of the World War, 1914-1917.* Boston: Houghton Mifflin, 1917.

Cunliffe, John William. *Poems of the Great War.* New York: Macmillan, 1916.

Gibbons, Herbert Adams. *Songs from the Trenches: The Soul of the A.E.F.* New York: Harper & Bros., 1918.

McCollum, Lee Charles. *History and Rhymes of the Lost Battalion.* [Columbus, Ohio]: N.p., 1928.

Roosevelt, Theodore, and Grantland Rice. *Taps: Selected Poems of the Great War.* Garden City, NY: Doubleday, Doran, 1932.

Sanford, A.P., and Robert Haven Schauffler. *Armistice Day: An Anthology of the Best Prose and Verse on Patriotism, the Great War, the Armistice.* New York: Dodd, Mead, 1927.

Service, Robert W. *Rhymes of a Red Cross Man.* New York: Barse & Hopkins, 1916.

Tulloch, Donald. *Songs and Poems of the Great World War.* Worcester, MA: Davis Press,1915.

War Poems from the Yale Review. New Haven, CT: Yale University Press, 1918.

Yanks: A Book of A.E.F. Verse. New York: G.P. Putnam's Sons, 1919.

PREPAREDNESS MOVEMENT
Bandholtz, Harry H. *A Proper Military Policy for the United States.* [Washington, D.C.]: [GPO], 1915.

Butler, Nicholas Murray. *The Preparedness of America.* [New York]: [Carnegie Endowment for International Peace], 1914.

RED CROSS
American Red Cross. *The Work of the American Red Cross During the War: A Statement of Finances and Accomplishments for the Period July 1, 1917 to February 28, 1919.* Washington, D.C.: American Red Cross, 1919.

Butler, Henry A. *Overseas Sketches: Being a Journal of My Experiences in Service with the American Red Cross in France.* [Cleveland, Ohio]: [Edwards & Franklin], 1921

Davison, Henry Pomeroy. *The American Red Cross in the Great War.* New York: Macmillan, 1919.

Harrison, Carter H. *With the American Red Cross in France, 1918-1919.* Chicago: R.F. Seymour, 1947.

Hungerford, Edward. *With the Doughboy in France: A Few Chapters of an American Effort.* New York: Macmillan, 1920.

Hutchinson, John F. *Champions of Charity: War and the Rise of the Red Cross.* Boulder, CO: Westview Press, 1996.

Moorehead, Caroline. *Dunant's Dream: War, Switzerland and the History of the Red Cross.* New York: Carroll & Graf, 1999.

Toland, Edward Dale. *The Aftermath of Battle: With the Red Cross in France.* New York: Macmillan,1916.

Van Schaick, John. *The Little Corner Never Conquered: The Story of the American Red Cross Work for Belgium.* New York: Macmillan, 1922.

REPARATIONS
Auld, George P. *The Dawes Plan and the New Economics.* Garden City, NY: Doubleday, Page, 1928.

Dunlap, Annette. *Charles Gates Dawes: A Life.* Evanston, IL: Northwestern University Press and the Evanston History Center, 2016.

Fabre-Luce, Alfred, and Constance Vesey. *The Limitations of Victory.* London: G. Allen & Unwin, 1926.

Hoetzsch, Otto. *Die Deutschnationalen und das Dawes-Gutachten; Reichstagsrede am 26. Juli 1924.* Berlin: N.p.,1924.

Moulton, Harold Glenn, and Leo Pasvolsky. *World War Debt Settlements.* New York: Macmillan, 1926.

RUSSIAN REVOLUTION
Cantacuzène, Julia. *Revolutionary Days: Recollections of Romanoffs and Bolsheviki, 1914-1917.* Boston: Small, Maynard, 1919.

Gurko, Vasilii Iosifovich. *War and Revolution in Russia, 1914-1917.* New York: Macmillan, 1919.

Steinberg, Mark D., and Vladimir M. Khrustalëv. *The Fall of the Romanovs: Political Dreams and Personal Struggles in a Time of Revolution.* New Haven, CT: Yale University Press, 1995.

Trotsky, Leon. *The Russian Revolution: The Overthrow of Tzarism and the Triumph of the Soviets*. Garden City, NY: Doubleday, 1959.

Wade, Rex A. *The Bolshevik Revolution and Russian Civil War*. Westport, CT: Greenwood Press, 2001.

SPANISH FLU
Crosby, Alfred W. *America's Forgotten Pandemic: The Influenza of 1918*. Cambridge, UK: Cambridge University Press, 2003.

Davies, Pete. *The Devil's Flu: The World's Deadliest Influenza Epidemic and the Scientific Hunt for the Virus That Caused It*. New York: Henry Holt, 2000.

TECHNOLOGY
Johnson, Hubert C. *Breakthrough!: Tactics, Technology, and the Search for Victory on the Western Front in World War I*. Novato, CA: Presidio, 1994.

Winkler, Jonathan Reed. *Nexus: Strategic Communications and American Security in World War I*. Cambridge, MA: Harvard University Press, 2008.

TERRITORIAL QUESTIONS
"Schutz den Schwachen!" das Geheimabkommen der Entente über die Niederländischen Kolonien (nach den Veröffentlichungen der "Iswestia"). Bern: Wyss, 1918.

TREATY OF VERSAILLES
Hodgson, Godfrey. *Woodrow Wilson's Right Hand: The Life of Colonel Edward M. House*. New Haven, CT: Yale University Press, 2006.

House, Edward Mandell, and Charles Seymour. *The Intimate Papers of Colonel House*. Boston: Houghton Mifflin, 1926.

MacMillan, Margaret. *Paris 1919: Six Months That Changed the World*. New York: Random House, 2002.

Mee, Charles L. *The End of Order: Versailles, 1919*. New York: Dutton, 1980.

WAR GARDENS
Hayden-Smith, Rose. *Sowing the Seeds of Victory: American Gardening Programs of World War I*. Jefferson, NC: McFarland, 2014.

Pack, Charles Lathrop. *The War Garden Victorious*. Philadelphia: J.P. Lippincott, 1919.

Weiss, Elaine F. *Fruits of Victory: The Woman's Land Army of America in the Great War*. Washington, D.C.: Potomac Books, 2008.

WILSON, WOODROW
Auchincloss, Louis. *Woodrow Wilson*. New York: Viking, 2000.

Baker, Ray Stannard. *Woodrow Wilson: Life and Letters*. Garden City, NY: Doubleday, Page, 1927.

Brands, H.W. *Woodrow Wilson*. New York: Times Books, 2003.

Cooper, John Milton. *Woodrow Wilson: A Biography*. New York: Alfred A. Knopf, 2009.

Daniels, Josephus. *The Life of Woodrow Wilson, 1856-1924*. N.p.: [Will H. Johnston?], 1924.

Ferrell, Robert H. *Woodrow Wilson and World War I, 1917-1921*. New York: Harper & Row, 1985.

Kennedy, Ross A. *The Will to Believe: Woodrow Wilson, World War I, and America's Strategy for Peace and Security*. Kent, Ohio: Kent State University Press, 2009.

MacMillan, Margaret. *Paris 1919: Six Months That Changed the World*. New York: Random House, 2002.

Tucker, Robert W. *Woodrow Wilson and the Great War: Reconsidering America's Neutrality, 1914-1917*. Charlottesville, VA: University of Virginia Press, 2007.

Tumulty, Joseph P. *Woodrow Wilson As I Know Him*. Printed exclusively for the *Literary Digest*, 1921.

Smyth, Clifford. *Woodrow Wilson, Who Strove to Make the World Safe for Democracy*. New York: Funk & Wagnalls, 1931.

Striner, Richard. *Woodrow Wilson and World War I: A Burden Too Great to Bear*. Lanham, MD: Rowman & Littlefield, 2014.

Wilson, Woodrow. *War Addresses of Woodrow Wilson*. Boston: Ginn, 1918.

WOMEN
Brown, Carrie. *Rosie's Mom: Forgotten Women Workers of the First World War*. Boston: Northeastern University Press, 2002.

Ebbert, Jean, and Marie-Beth Hall. *The First, the Few, the Forgotten: Navy and Marine Corps Women in World War I*. Annapolis, MD: Naval Institute Press, 2002.

Gavin, Lettie. *American Women in World War I: They Also Served*. Niwot, CO: University Press of Colorado, 1997.

Jensen, Kimberly. *Mobilizing Minerva: American Women in the First World War*. Urbana, IL: University of Illinois Press, 2008.

MacArthur Brothers Company. *The Girl, Behind the Man, Behind the Gun: Co-Workers in Winning the War*. Woodbury, NJ: MacArthur Bros., 1918.

Oakes, Claudia M. *United States Women in Aviation Through World War I*. Washington, D.C.: Smithsonian Institution Press, 1978.

Schneider, Dorothy, and Carl J. Schneider. *Into the Breach: American Women Overseas in World War I*. New York: Viking, 1991.

Smith, Angela K. *The Second Battlefield: Women, Modernism and the First World War*. Manchester, UK: Manchester University Press, 2000.

Treadwell, Mattie E. *The Women's Army Corps*. Washington, D.C.: Office of the Chief of Military History, Dept. of the Army, 1954.

Weiss, Elaine F. *Fruits of Victory: The Woman's Land Army of America in the Great War*. Washington, D.C.: Potomac Books, 2008.

Zeiger, Susan. *In Uncle Sam's Service: Women Workers with the American Expeditionary Force, 1917-1919*. Ithaca, NY: Cornell University Press, 1999.

ARCHIVAL COLLECTIONS
[149th Field Artillery Newspaper Collection]. Newspapers, 1918.

[William McCormick Blair Collection]. The Four Minute Men, 1917-1924.

[Casey Family Collection]. Family Letters, 1887-1935.

[Dane S. Claussen Collection]. Photograph Postcards, 1917-1918.

[Mary Cutter Collection]. World War I Nurse, 1918.

[Don Eaves Collection]. 304th Motor Car Company, 1909-1920.

[Elmer Emery Collection]. 34th Infantry, 1918-1919.

[Bernard Flexner Collection]. Red Cross in Romania, 1917-1928.

Flint, Robert J. *One Doughboy's Experience in the World War of 1917-1918: Reminiscences of Sgt. Robert J. Flint*. Memoir Manuscript, 1940.

[Carl Freese Collection]. Letters Home, 1911-1919.

[Herbert J. Goldsmith Collection]. Hospitals, 1916-1918.

[Louis P. Hart Collection]. Supply Company 309, Quartermasters Corps, 1918-1919.

[Glenn Harvey Collection]. Cattaraugus County, New York, 1917-1918.

[Peter N. Henn World War I Letters]. 33rd Infantry Division, 1918.

[Robert T. Herz Collection]. 136th Field Artillery, 1918-1945.

[SSgt. Walter R. Jager Collection]. Flight, 1917-1983.

[Robert Johnston Collection]. United States Navy, 1892-1920.

[Mabel V. Ljungberg Collection]. Army Nurse Corps, 1918-1919.

[John G. McDonald Collection]. 79th Infantry Division, 1918-1919.

[Anthony Ney Collection]. 168th Infantry, 1917-1919.

[Harlan Richards Collection]. 1st Infantry Division, 1915-1926.

[Robert B. Rigoulot and Barbara Hayler Collection]. 3rd Infantry Division, 1916-1986.

[Herman N. Rosenberg Collection]. Motor Truck Company 415, 1918-1958.

[The John N. Schufreider Collection]. Promotion Certificates, 1916-1919.
[Lawrence Shea Collection].

112th Engineers, 1918-1921.

[Margery Shurman Collection]. Aeronautics, 1918-1988.

[W. Jack Strickfaden Collection]. Tank Corps, 1918-2013.

[Amy Tuttle Collection]. 602nd Engineers, 1918-1919.

[Lt. Lawrence Westerman Collection]. Illinois National Guard, 1916-1997.

[WFMT "War Letters" Collection]. War Letters, 1776-2001.

[Lt. Felix R. Zaugg Collection]. Air Corps, 1918-1940.

[Herbert Zipf Collection]. Reserve Ordnance Corps, 1917-1918.

ABOUT THE CONTRIBUTORS

WRITERS

MICHAEL W. ROBBINS is a historian and award-winning writer and editor of magazines and books. Recently retired as editor of *MHQ: the Quarterly Journal of Military History*, he was also editor of *Military History* magazine and previously served as editor of *Audubon*. Robbins has a Ph.D. in American history from George Washington University. He is a partner in the book-packaging firm of Palitz + Robbins, and resides in Kinderhook, New York.

COLONEL (IL) JENNIFER N. PRITZKER, IL ARNG (RETIRED) is the Founder & Chair of the Pritzker Military Museum & Library, which she created in 2003; President & Founder of the Pritzker Military Foundation and the Tawani Foundation; and President & CEO of Tawani Enterprises, Inc. She is founder and Executive Editor of the Pritzker Military Museum & Library's publications. In 1974, Pritzker enlisted in the U.S. Army, serving until 1977 with the 82nd Airborne Division where she rose to the rank of Sergeant. She was commissioned in 1979 and served on active duty until 1985 with the 101st Airborne Division and VII Corps Germany. From 1985 to 2001, she served in the U.S. Army Reserves and the Illinois Army National Guard. She retired with the rank of Lieutenant Colonel and subsequently received an honorary promotion to full Colonel in the Illinois Army National Guard. Pritzker holds an honorary doctorate from Norwich University and in 2016 received the U.S. Department of Defense Spirit of Hope Award from the U.S. Army.

SIR HEW STRACHAN is the author of 14 major publications, including the first installment of his groundbreaking three-volume work on the Great War, *The First World War (To Arms)*. Strachan is known for his detailed and carefully researched writings. His research interests center on military history and strategic studies, with particular interest in the First World War and the history of the British army. Strachan has been significantly involved in the preparations for the centenary of the First World War, serving on the UK and Scotland national advisory committees and on the Comité Scientifique of the Mission du Centenaire in France. Strachan served as chair of the Imperial War Museum's academic advisory committee for its new First World War galleries and the Commonwealth War Graves Commission's 2014-18 committee.

COLONEL ROBERT J. DALESSANDRO, U.S. ARMY (RETIRED) serves as the Chairman of the United States World War One Centennial Commission and is an American historian and author who has written and presented extensively on the American Expeditionary Force's contributions to the First World War. Dalessandro is the Acting Secretary of the American Battle Monuments Commission and former Director of the United States Army Center of Military History at Fort Lesley J. McNair, Washington, D.C. He frequently leads battlefield tours to sites in the United States, France, and Italy. Dalessandro is widely published on the lifeways and material culture of the American soldier in the 18th, 19th, and 20th centuries. He is co-author of *Organization and Insignia of the American Expeditionary Force, 1917-1923*, which received the Army Historical Foundation's award for excellence in writing.

CREATIVE DIRECTORS

KENNETH CLARKE serves as President and CEO of the Pritzker Military Museum & Library and is an Executive Editor and Creative Director of the Museum & Library's publications, including *On War: The Best Military Histories* (2013), *The History and Heritage of U.S. Navy Seals* (2014), *Dignity of Duty: The Journals of Erasmus Corwin Gilbreath, 1861-1898* (2015), and *The General: William Levine, Citizen Soldier and Liberator* (2016). While Executive Director of the Poetry Center of Chicago at the School of the Art Institute of Chicago (2000-2005), Clarke published a series of broadsides featuring art and poetry by award-winning and emerging artists that are now in the collections of the University of Chicago, Yale University, and Brown University.

WENDY PALITZ is Creative Director of the book-packaging firm Palitz + Robbins. She has spent her working life in publishing. As a magazine art director, she has won awards for covers and photography, special sections, and for overall magazine design. She was a book designer at Workman Publishing and was the Creative Director at Storey Publishing (a division of Workman). Recent book projects include *The Oregon Trail*, for Quarto (Zenith Press), and several titles for the Pritzker Military Museum & Library.

PRINT NO. 165 AMERICA, CA. 1919. "ROSTER OF COMPANY I, 3RD ILLINOIS INFANTRY." DAN SMITH

ILLUSTRATION CREDITS

Cover: U.S. Army/National Archives

Pritzker Military Museum & Library:
Pages v, vi, ix, xiii, 2, 5, 7, 9, 11, 15, 16, 19, 21,
23, 25, 27, 29, 31, 33, 34, 37, 39, 41, 43, 45,
47, 49, 53, 55, 59, 61, 63, 65, 67, 71, 73, 75,
77, 79, 81, 83, 85, 86, 89, 91, 95, 97, 99, 101,
105, 107, 109, 111, 113, 115, 117, 118, 121,
123, 125, 127, 129, 131, 133, 135, 136, 139,
141, 143, 145, 147, 149, 151, 152, 155, 157,
159, 161, 163, 165, 167, 169, 171, 175, 177,
179, 181, 183, 185, 187, 188, 191, 193, 195,
199, 201, 203, 205, 208, 209, 211, 213, 217,
219, 221, 223, 227, 229, 231, 233, 235, 237,
239, 241, 243, 247, 249, 251, 253, 255, 257,
259, 261, 263, 264, 267, 269, 271, 273, 275,
277, 279, 281, 283, 284, 287, 289, 291, 293,
295, 297, 299, 301, 302, 305, 307, 309, 311,
313, 315, 317, 319, 320, 323, 325, 327, 329,
331, 333, 335, 337, 341, 343, 345, 347, 349,
351, 353, 355, 357

Library of Congress:
Pages 4, 6, 10, 12, 18, 20, 22, 28, 30, 32, 38,
40, 44, 48, 50, 52, 58, 60, 64, 66, 68, 70, 72,
74, 76, 80, 84, 88, 90, 94, 96, 100, 102, 104,
106, 108, 110, 112, 114, 116, 120, 124, 126,
128, 138, 140, 142, 146, 148, 158, 172, 174,
192, 194, 196, 198, 200, 202, 206, 210, 212,
214, 216, 218, 220, 222, 224, 226, 228, 230,
232, 234, 238, 240, 242, 244, 246, 248, 262,
266, 270, 272, 274, 276, 278, 280, 282, 294,
296, 300, 314, 336, 338, 340, 342, 344, 346,
348, 350, 352, 354

Photo Archives of Walter A. Heinsen:
Page 8

Louis Raemaekers © Louis Raemaekers
Foundation/Pritzker Military Museum & Library:
Page 13

National Archives:
Pages 14, 24, 26, 42, 54, 56, 62, 78, 92, 122,
130, 132, 134, 144, 150, 154, 156, 160, 162,
164, 166, 168, 170, 176, 182, 184, 190, 204,
236, 252, 254, 256, 258, 260, 268, 286, 288,
290, 292, 298, 304, 306, 308, 310, 312, 316,
318, 322, 324, 326, 328, 330, 332, 334, 356

Lucian Bernhard © 2017 Artists Rights
Society (ARS), New York/VG Bild-Kunst,
Bonn/Pritzker Military Museum & Library:
Page 57

Geo Dorival & Georges Capon © 2017 Artists
Rights Society (ARS), New York/ADAGP,
Paris/Pritzker Military Museum & Library:
Page 93

U.S. Naval History and Heritage Command:
Pages 178, 180, 186, 250

Vojtech Preissig © 2017 Artists Rights
Society (ARS), New York/OOA-S, Prague/
Pritzker Military Museum & Library:
Pages 197, 215

PRINT NO. 166 AMERICA, 1918. "ALL FOR ONE AND ONE FOR ALL! VIVE LA FRANCE!" JAMES MONTGOMERY FLAGG

ACKNOWLEDGMENTS

U.S. WWI CENTENNIAL COMMISSION LEADERSHIP

HONORARY CO-CHAIRS
FORMER PRESIDENTS
President Jimmy Carter
President George H.W. Bush
President William J. Clinton
President George W. Bush
President Barack H. Obama

FORMER SECRETARIES OF STATE
Secretary George P. Schultz
Secretary Madeleine Albright
General Colin L. Powell

FORMER SECRETARIES OF DEFENSE
Secretary Robert M. Gates
Secretary Leon E. Panetta

COMMISSIONERS
Chief Warrent Officer 3 Terry Hamby, USA (Ret.), Chair
Edwin L. Fountain, Vice Chair
Debra L. Anderson
Jerry L. Hester
Colonel Thomas Moe, USAF (Ret.)
John A. Monahan
Dr. Matthew Naylor
Dr. Libby O'Connell
Ambassador Theodore Sedgwick (Ret.)
Monique Brouillet Seefried, Ph.D.
Major General Alfred Valenzuela, USA (Ret.)
Colonel Robert Dalessandro, USA (Ret.), Chair 2013–2017

STAFF
Captain Daniel S. Dayton, USN (Ret.), Executive Director
Dale Archer, Program Manager, National WWI Memorial at Pershing Park
Meredith Carr, Deputy Director
Captain Chris Christopher, USN (Ret.), Special Assistant
Ryan Hegg, Program Manager
Halsey Hughes, Staff Assistant
Chris Isleib, Director of Communications
Theo Mayer, Chief Technologist
Andrew McGreal, Program Manager

SPECIAL ADVISORS TO THE COMMISSION
Vint Cerf, VP & Chief Internet Evangelist at Google
Sergeant Major Bryan B. Battaglia, USMC (Ret.)
Commissioner Ray Kelly, Vice Chairman, K2 Intelligence and former NYPD Commissioner
General Barry McCaffrey, USA (Ret.), News commentator, business consultant
Admiral Mike Mullen, USN (Ret.), former Chairman of the Joint Chiefs of Staff
John Nau, President & CEO of Silver Eagle Distributors, L.P.
Secretary Leon Panetta, Chair, Panetta Institute for Public Policy, former Secretary of Defense
Helen Ayer Patton, Granddaughter of General George S. Patton
Sandra Sinclair Pershing, Granddaughter-in-law of General John J. Pershing
Gary Sinise, Actor/Philanthropist
Joseph Suarez, Director of Community Partnerships for Booz Allen Hamilton
General Gordon Sullivan, USA (Ret.)
Senator John Warner

DIPLOMATIC ADVISORY BOARD
Governor James Blanchard
Ambassador Jeffrey L. Bleich (Ret.)
Ambassador Timothy Broas (Ret.)
Ambassador James P. Cain (Ret.)
Ambassador Timothy Chorba (Ret.)
Ambassador William Eacho (Ret.)
Ambassador Laurie S. Fulton (Ret.)
Ambassador Mark Gitenstein (Ret.)
Ambassador James E. Goodby (Ret.)
Ambassador Howard Gutman (Ret.)
Ambassador Stuart Holliday (Ret.)
Ambassador Allen Katz (Ret.)
Ambassador Eleni Tsakopoulos Kounalakis (Ret.)
Ambassador Howard H. Leach (Ret.)
Gerald Loftus
Ambassador James G. Lowenstein (Ret.)
Ambassador Gerald McGowan (Ret.)
Ambassador Carol Elizabeth Moseley Braun (Ret.)
Ambassador Louise Oliver (Ret.)
Ambassador Penne Korth Peacock (Ret.)
Ambassador Thomas R. Pickering (Ret.)
Ambassador Charles Rivkin (Ret.)
Ambassador Paul Russo (Ret.)
Ambassador Tod Sedgwick (Ret.)
Ambassador Carl Spielvogel (Ret.)
Ambassador Craig Roberts Stapleton (Ret.)
Ambassador Ron Weiser (Ret.)
Ambassador Faith Whittlesey (Ret.)

HISTORICAL ADVISORY BOARD
Doran Cart
Mark Facknitz
Dr. Jennifer Keene
Edward Lengel, Ph.D.
Dr. Erin Mahan
Dr. John Morrow, Jr.
Dr. Libby O'Connell
Jeffrey Sammons, Ph.D.
Monique Seefried, Ph.D.
Dr. Steven Trout
Herman Viola, Ph.D.
Mitch Yockelson, Ph.D.
Susan Zeiger, Ph.D.

BOARD MEMBERS, U.S. FOUNDATION FOR THE COMMEMORATION OF THE WORLD WARS
Captain Daniel S. Dayton, USN (Ret.), President
Dan Basta
Captain Chris Christopher, USN (Ret.), Treasurer and Secretary
The Honorable Emanuel Cleaver II
Dr. Mary Davidson
Ambassador Carol Moseley Braun (Ret.)
Dr. Libby O'Connell
Russell Orban
The Honorable Ted Poe
Ambassador Tod Sedgwick
Major General Alfred Valenzuela, USA (Ret.)

The Pritzker Military Museum & Library is the founding sponsor of the World War One Centennial Commission.

THE UNITED STATES
WORLD WAR ONE
CENTENNIAL COMMISSION

ACKNOWLEDGMENTS

LEST WE FORGET TEAM
Colonel (IL) Jennifer N. Pritzker, IL ARNG (Ret.): Executive Editor
Kenneth Clarke: Executive Editor, Creative Director
Wendy Palitz: Designer, Creative Director
Michael W. Robbins: Author, Consulting Editor
Jennifer E. Berry: Photo Researcher
Christine M. Kreiser: Copyeditor
Richard Ernsberger, Jr.: Contributing Writer
Laurie Baker: Designer
Kat Latham: PMML Archives & Special Collections Services
Teri Embrey: PMML Library Services
Scott Manning: Marketing
Megan Williams: Marketing
Sharon Brinkman: Proofreader
Stephen Callahan: Index

SPECIAL THANKS
General David Bramlett, USA (Ret.), Reader
Bella Gribkova, Russian translation
Aniceto Rivera, Japanese translation
Monique Seefried, Ph.D., French translation
Hew Strachan, Reader
Admiral James Stavridis, USN (Ret.), Reader

PRITZKER MILITARY MUSEUM & LIBRARY BOARD OF DIRECTORS
Colonel (IL) Jennifer N. Pritzker, IL ARNG (Ret.), Founder & Chair
Norman R. Bobins
Tyrone C. Fahner
Lieutenant Commander Arie Friedman, M.D., USNR-R (MC) (Ret.)
Major General James Mukoyama, USA (Ret.)
Scott Murray
Master Sergeant Ginny Narsete, USAF (Ret.)
John W. Rowe
Robert E. Sarazen
John H. Schwan
Captain John A. Williams, Ph.D., USNR (Ret.)
Kenneth Clarke, Ex-Officio

PRITZKER MILITARY MUSEUM & LIBRARY STAFF
Kenneth Clarke, President & CEO
Teri Embrey, Chief Librarian
Kat Latham, Director of Collections Management
Lee May, Development Officer
Antina Redmond, Director of Administration & Operations
Megan Williams, Director of External Affairs
Martin Billheimer, Library Clerk
Olivia Button, Digital Collections Coordinator
Dustin DePue, Special Collections Librarian

Alana Embury, Membership and Development Coordinator
Paul W. Grasmehr, Reference Coordinator
Brad Guidera, Production Manager
Rachel Kosmal, Marketing & Communications Coordinator
Tina Louise Happ, Associate Chief Librarian
John LaPine, Collection Services Manager
Susan Mennenga, WWI Centennial Project Manager
Chris Meter, Administrative Assistant
Aaron Pylinski, Production Coordinator
Katie Strandquist, Special Events Manager
Lindsey Sturch, Librarian

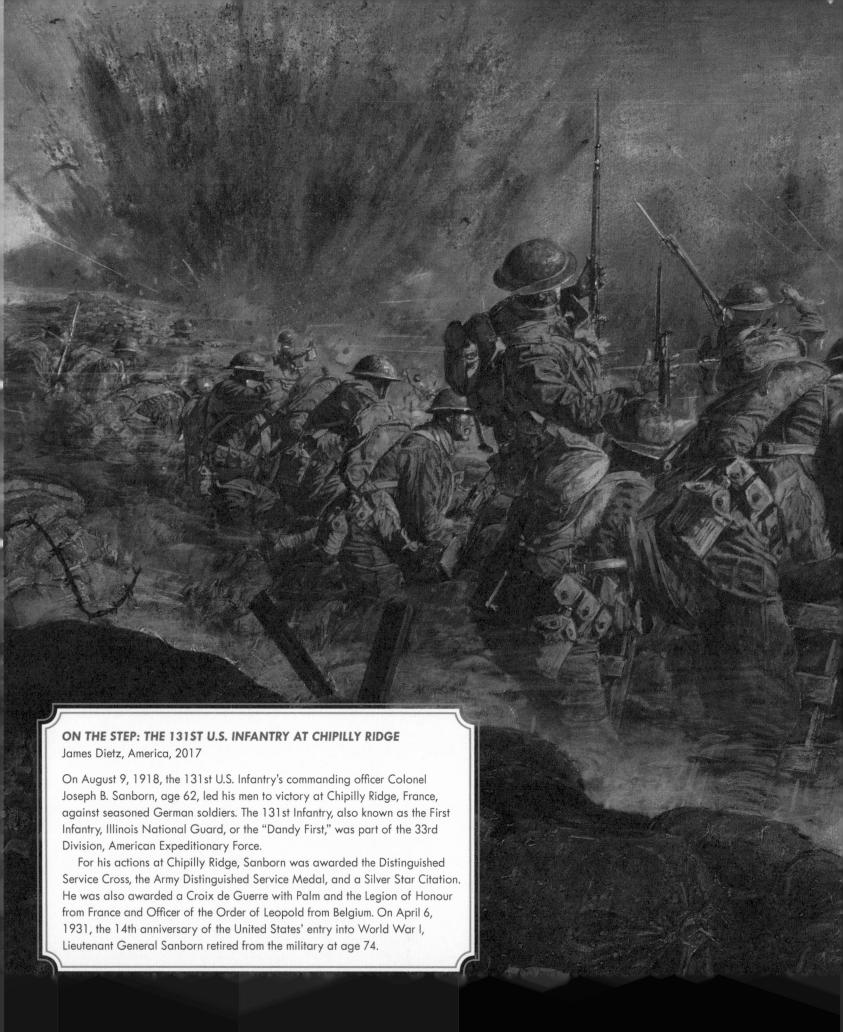

ON THE STEP: THE 131ST U.S. INFANTRY AT CHIPILLY RIDGE
James Dietz, America, 2017

On August 9, 1918, the 131st U.S. Infantry's commanding officer Colonel
Joseph B. Sanborn, age 62, led his men to victory at Chipilly Ridge, France,
against seasoned German soldiers. The 131st Infantry, also known as the First
Infantry, Illinois National Guard, or the "Dandy First," was part of the 33rd
Division, American Expeditionary Force.

For his actions at Chipilly Ridge, Sanborn was awarded the Distinguished
Service Cross, the Army Distinguished Service Medal, and a Silver Star Citation.
He was also awarded a Croix de Guerre with Palm and the Legion of Honour
from France and Officer of the Order of Leopold from Belgium. On April 6,
1931, the 14th anniversary of the United States' entry into World War I,
Lieutenant General Sanborn retired from the military at age 74.